T0364621

THE ART OF
DEUS EX
UNIVERSE™

FOREWORD BY WARREN SPECTOR

WRITTEN BY JONATHAN JACQUES-BELLETÊTE AND MARTIN DUBEAU WITH PAUL DAVIES

TITAN BOOKS

THE ART OF DEUS EX UNIVERSE

ISBN: 9781783290987

Limited Edition ISBN: 9781783294923

Published by Titan Books

A division of Titan Publishing Group Ltd.

144 Southwark St.

London

SE1 0UP

First edition: August 2016

10 9 8 7 6 5 4 3 2

Deus Ex: Mankind Divided © 2016 Square Enix Ltd. All rights reserved. Developed
by Eidos-Montréal. Deus Ex, Deus Ex: Mankind Divided, Deus Ex Universe, the Deus
Ex Universe logo, Eidos-Montréal and the Eidos-Montréal logo are trademarks or
registered trademarks of Square Enix Ltd. SQUARE ENIX and the SQUARE ENIX logo are
registered trademarks of Square Enix Holdings Co., Ltd. All other trademarks are property
of their respective owners.

To receive advance information, news, competitions, and exclusive offers online, please sign up
for the Titan newsletter on our website: www.titanbooks.com

Did you enjoy this book? We love to hear from our readers. Please e-mail us at: readerfeedback@
titanemail.com or write to Reader Feedback at the above address.

No part of this publication may be reproduced, stored in a retrieval system, or transmitted, in any form or
by any means without the prior written permission of the publisher, nor be otherwise circulated in any form
of binding or cover other than that in which it is published and without a similar condition being imposed on
the subsequent purchaser.

A CIP catalogue record for this title is available from the British Library.

Printed and bound in China.

Book design by Amazing15.com

CONTENTS

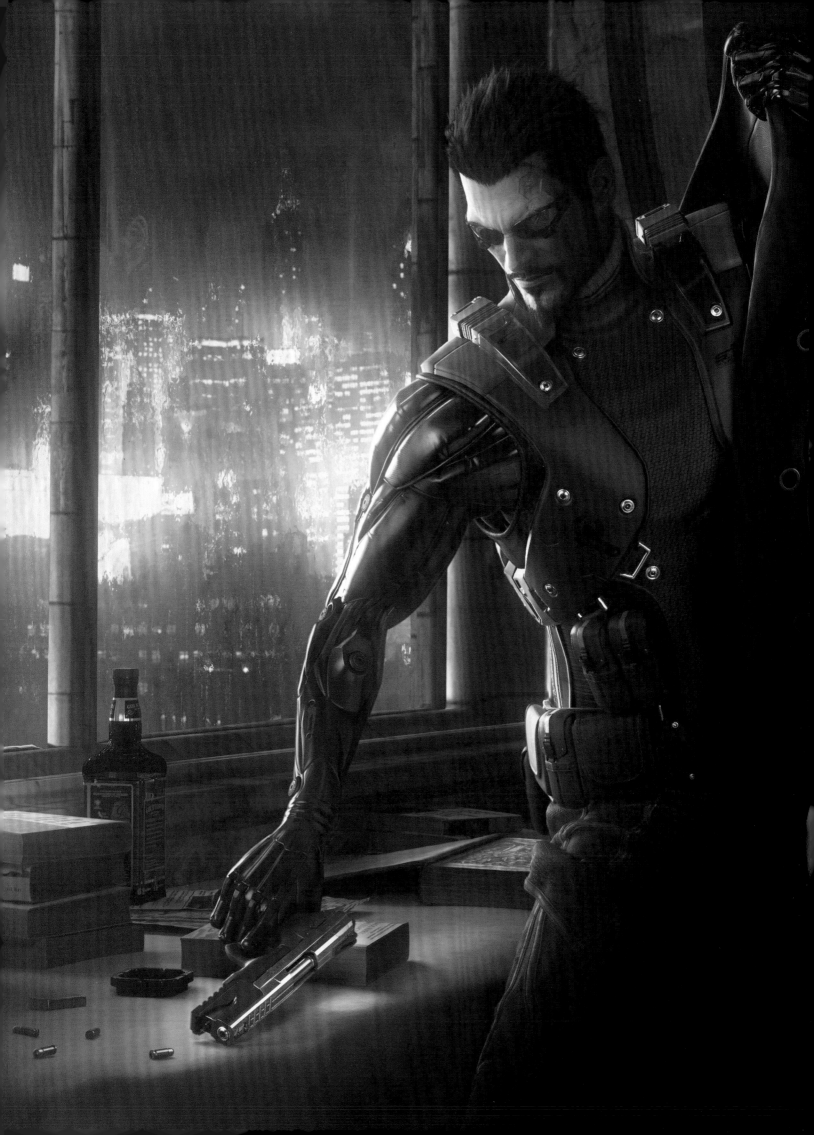

FOREWORD

BY WARREN SPECTOR

HAS IT REALLY BEEN more than fifteen years since the first *Deus Ex* game was released? And is it really the case that people still care about its world and the gameplay the Ion Storm Austin team created? It's kind of mind-blowing, if you want to know the truth, but truth it is. And perhaps the best evidence that people still care is the work being done by the team at Eidos-Montréal to continue the series in games like *Deus Ex: Human Revolution* and *Deus Ex: Mankind Divided*.

People ask me all the time how I feel about the new *Deus Ex* games, expecting me, I think, to be upset or somehow critical. But, really, I couldn't be happier. That's partly because there's something special about having been a part of something bigger than yourself, but there's more to it than that. Ion Storm's baby, if you will, is in great hands, ready to leave home and strike out on its own. The people working on the new *Deus Ex* games clearly care about the universe my old team created and 'get' the gameplay experience we were trying to deliver. In other words, the new guys respect the franchise, which is awesome.

Nowhere is that respect better expressed than on the graphical side of things. And nowhere can you see how far games have come than in a comparison of the old game's graphics with the new game's stunning imagery. I mean, flip through this book and then take a look at the original game and you'll be amazed what a difference fifteen years makes.

And yet, maybe the differences aren't as profound as you might think…

There are three things that, for me, define a *Deus Ex* game—the idea of player choice, game consequences and recovery, the overall sound (music and sound effects), and the look and feel of the graphics. The first two are, obviously, hard to capture in a book, but that last one—graphics—is another story.

The graphics in *Deus Ex* are characterized, first, by fidelity to the look and feel of the real world, extrapolated out to the near future. Objects, tech, people, and locations have to be recognizable, yet subtly different. Players have to feel they're in places familiar enough that they can engage in activities in those locations but able to act in ways (usually transgressive) that they can't in the real world. And they have to engage with characters and be empowered by technology that is a logical extension of where we are today. Familiarity and strangeness must live in perfect harmony and exquisite balance. And, second, there must be darkness or, more precisely, contrast between light and dark. The world of *Deus Ex* is neither happy nor particularly hopeful, but it is a place where one person—the right person—can make a real difference. Only someone who thrives in darkness and knows when to step into the light can survive and thrive in *Deus Ex*'s future world.

In the original *Deus Ex* games, we adhered to these rules as best we could, given the graphical limitations of the time. In this book, you'll see that the creators of the new *Deus Ex* game express the same tenets, but with much greater detail and fidelity than the Ion Storm team could even imagine.

Everything about our game, from concept art to finished product, was crude—wonderful, but crude. In the pages that follow, you'll see that crudeness simply isn't a word that applies. There's a discomfiting beauty in the darkness of these new images… a necessary feeling of what might be called 'futurist realism'… and a level of quality that supports and enhances gameplay I always call "*Deus Ex-y*."

As in all ways, the creators of the new *Deus Ex* games honor the past while looking to the future. And as one of the creators of that past, I'm honored by the work in the pages that follow and look forward to seeing what comes next, both for the game and the real world whose future it captures so well.

WARREN SPECTOR

SEEING THE INVISIBLE

WHEN WE SET OUT to create a new game in the *Deus Ex* franchise, I had one major goal for the aesthetic design: I wanted it to stand out. I wanted people to be systematically absorbed and bewildered by the visuals of the game—not necessarily because of its technological prowess, as is often the case in our industry, but mainly through robust and unexpected visual metaphors and aesthetic recipes. I wanted the visuals to communicate messages as strong and as important as the story itself. The game had to propose a visual flavor nobody had tasted before—something so peculiar and different that it would pique people's curiosity, lingering on long after they played or heard about the game. This meant that extraordinary design distinctions had to be at the core of the art direction. I was convinced that, if the visuals were strongly distinguishable, people would be naturally attracted to the game. It was a gamble, but one I was eager to test and prove. With transhumanism (the game's central theme) in mind, I isolated myself for many weeks, plunged into my research and studies, trying to find that magical idea that would pave the way for this elusive design distinction. That's how we began our way towards coming up with the concepts of Cyber-Renaissance and the Icarus myth analogy.

While I was reading everything I could on the subject of transhumanism, I eventually stumbled upon Leonardo Da Vinci's famous anatomical sketches.

INTRO

The unusual visual resemblance between Da Vinci's studies of dissections and cybernetic prosthetics struck me as something I should investigate further. I had studied the Renaissance era in art school quite a bit, but now that I was comparing and overlapping it with transhumanism, it became clear that the two periods had a lot in common. The more I juxtaposed them together, the more I became convinced that we could fuse them to create a new sub-genre of cyberpunk. The idea was to extract the most interesting and relevant artistic variables of the Renaissance period and somehow mash them with elements of cyberpunk and contemporary design. Needless to say, for me and the entire art department, that was much easier said than done!

Soon after, I also began searching for an even higher level allegory that could pretty much describe the entirety of our game's universe and themes in one elegant sweep. Of course, it also had to be something that would firmly supplement the art direction, effectively giving it a second layer of visual language. I must've read at least a hundred fables, poems, and myths trying to get the right fit or inspiration. Then came the day I read the myth of Icarus which, just like the Renaissance period, was a story I was already quite familiar with.

However, when reading it with our game's themes in mind, it proved to be a revelation. The myth of Icarus was indeed a perfect allegory for the

dangers of overindulging in transhuman technologies. The text was simply overflowing with symbols and metaphors we could use both for the story and the art direction. Icarus is basically a symbol for a transhuman, someone augmented with artificial wings. As he soars the sky, flying like a bird, Daedalus warns Icarus that flying too close to the sun could melt the wax holding the wings together, making him fall to his death. This also gave us a great symbol for the darker and dangerous side of overindulging in cybernetic augmentations, the sun. Eventually, even the Greek myth of the Labyrinth and the Minotaur would find a suitable place within the game's symbology. So we now had everything we needed to create a recipe, providing flavors people had never seen in a video game before. We felt confident that we had all the elements needed to achieve these design distinctions we so frantically searched for, but the real test still lay ahead. How would we mix all these eclectic visual variables together? Making sense of it as a global idea was easy, but literally giving life to something that had never been attempted before proved to be immensely more painful than expected. However, none of these ideas would mean anything at all if we wouldn't have had some of the most talented concept artists in all the visual entertainment industries put together. These brilliant artists had to come to

UCTION

grips with untrodden paths, bringing their own light to what was, at first, a very obscure and frustrating direction. Even so, they kept on working, trying new and different combinations. After countless hours of work, they succeeded in giving life to one of the most memorable art directions of the last generation of gaming consoles. I will forever be in debt to their hard work and incredible talent. Without them, I wouldn't be typing these words. Here they are below, in no particular order.

Thank you,

JONATHAN JACQUES-BELLETÊTE, EXECUTIVE ART DIRECTOR

Art Director, *Mankind Divided*: Martin Dubeau
Concept artists: Bruno Gauthier-Leblanc, Donglu Yu, Michel Chassagne, Richard Dumont, Jim Murray, Frédéric Bennett, Thierry Doizon, Trong-Kim Nguyen, Nicolas Lizotte, Brian Dugan, Martin Sabran, Éric Gagnon, Hervé Groussin, Mathieu Latour-Duhaime, Gabriel Van de Walle, Yohann Schepacz, Nicolas Francoeur-Jérémie, Alp Altiner, Yun Ling, Sébastien Larroudé.

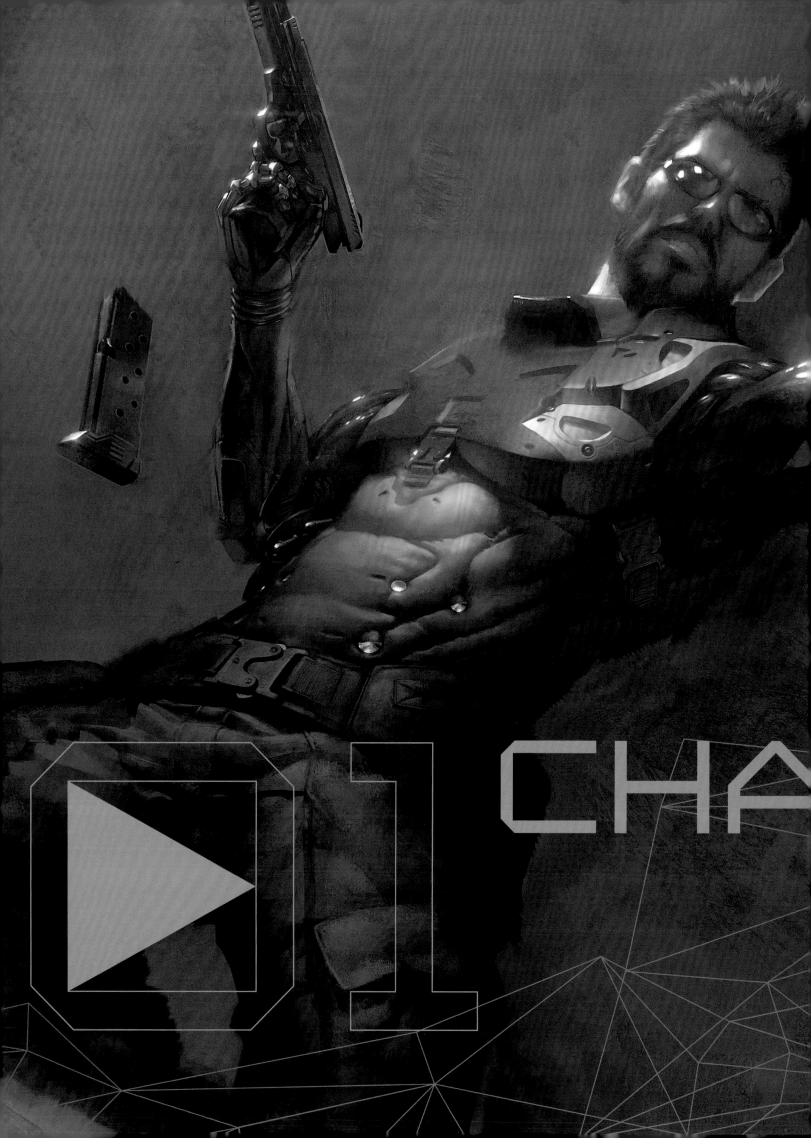

01 CHA

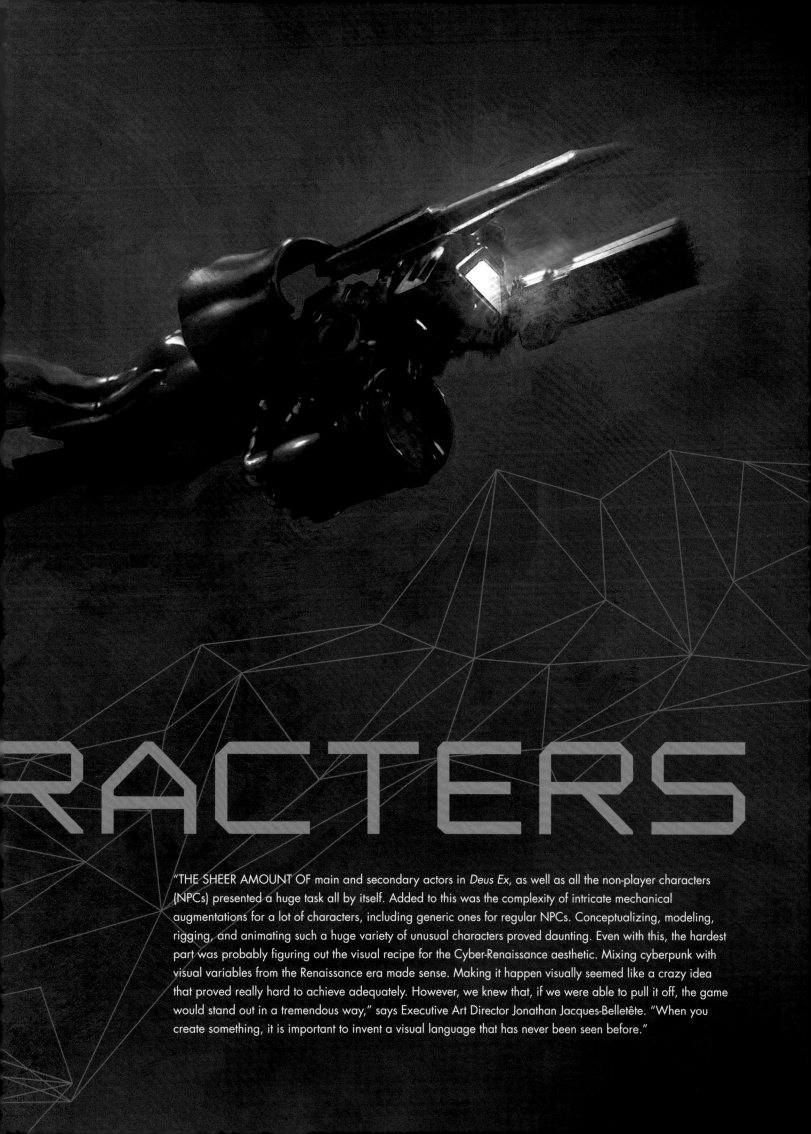

RACTERS

"THE SHEER AMOUNT OF main and secondary actors in *Deus Ex*, as well as all the non-player characters (NPCs) presented a huge task all by itself. Added to this was the complexity of intricate mechanical augmentations for a lot of characters, including generic ones for regular NPCs. Conceptualizing, modeling, rigging, and animating such a huge variety of unusual characters proved daunting. Even with this, the hardest part was probably figuring out the visual recipe for the Cyber-Renaissance aesthetic. Mixing cyberpunk with visual variables from the Renaissance era made sense. Making it happen visually seemed like a crazy idea that proved really hard to achieve adequately. However, we knew that, if we were able to pull it off, the game would stand out in a tremendous way," says Executive Art Director Jonathan Jacques-Belletête. "When you create something, it is important to invent a visual language that has never been seen before."

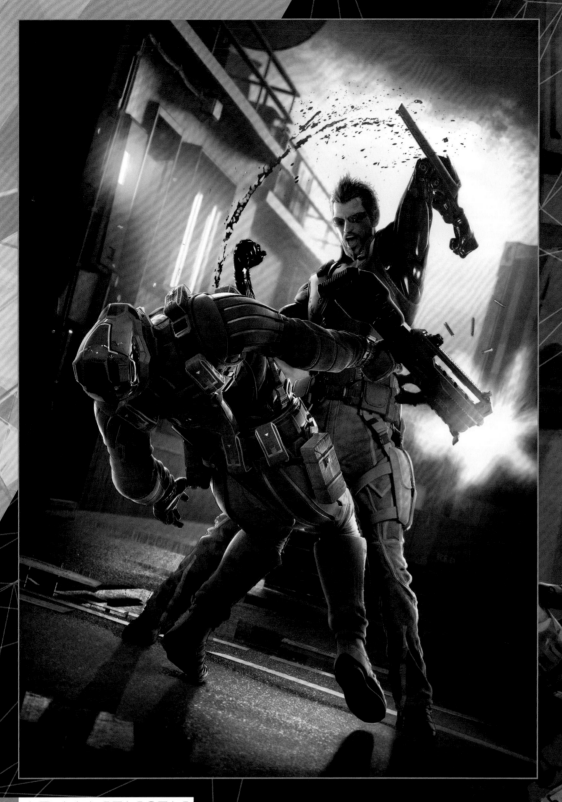

ADAM JENSEN

"Adam Jensen's visual design was a two-year endeavor, representing the combined efforts of many very talented artists contributing to the iconic hero we have today. Adam was to be a vessel for the transhuman themes found at the core of the games. He had to represent what it meant to have your body augmented way beyond its natural and biological capabilities," explains Jacques-Belletête. "We wanted him to be a protagonist that displayed both the physical and aesthetic results of such a transformation, as well as allowing players to ponder the profound psychological ramifications. Mostly, we hoped that Adam would resonate with people narratively and visually. For this, there are no magic recipes."

▶ "This illustration marked a very important milestone for the team. We knew that we had something special in our hands. We could finally, in all confidence and control, extract our hero from model sheets and countless concept art pieces to create very powerful images."
—Jonathan Jacques-Belletête

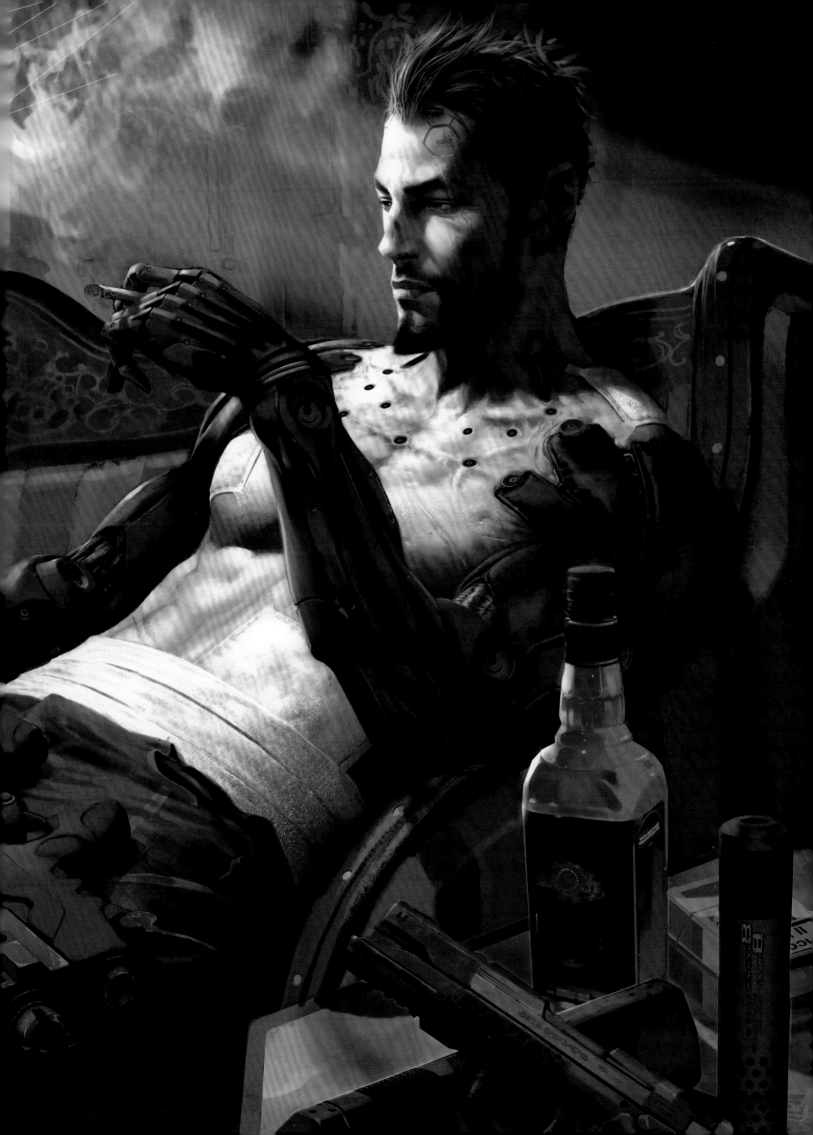

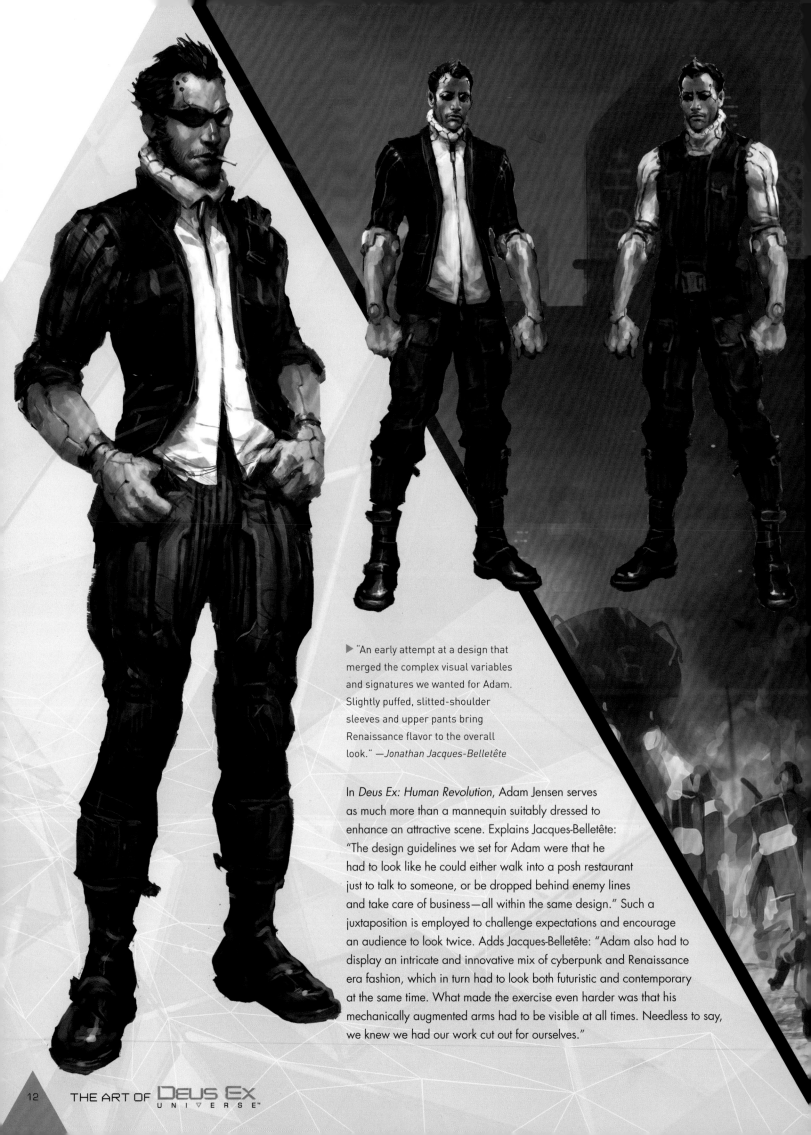

▶ "An early attempt at a design that merged the complex visual variables and signatures we wanted for Adam. Slightly puffed, slitted-shoulder sleeves and upper pants bring Renaissance flavor to the overall look." —*Jonathan Jacques-Belletête*

In *Deus Ex: Human Revolution*, Adam Jensen serves as much more than a mannequin suitably dressed to enhance an attractive scene. Explains Jacques-Belletête: "The design guidelines we set for Adam were that he had to look like he could either walk into a posh restaurant just to talk to someone, or be dropped behind enemy lines and take care of business—all within the same design." Such a juxtaposition is employed to challenge expectations and encourage an audience to look twice. Adds Jacques-Belletête: "Adam also had to display an intricate and innovative mix of cyberpunk and Renaissance era fashion, which in turn had to look both futuristic and contemporary at the same time. What made the exercise even harder was that his mechanically augmented arms had to be visible at all times. Needless to say, we knew we had our work cut out for ourselves."

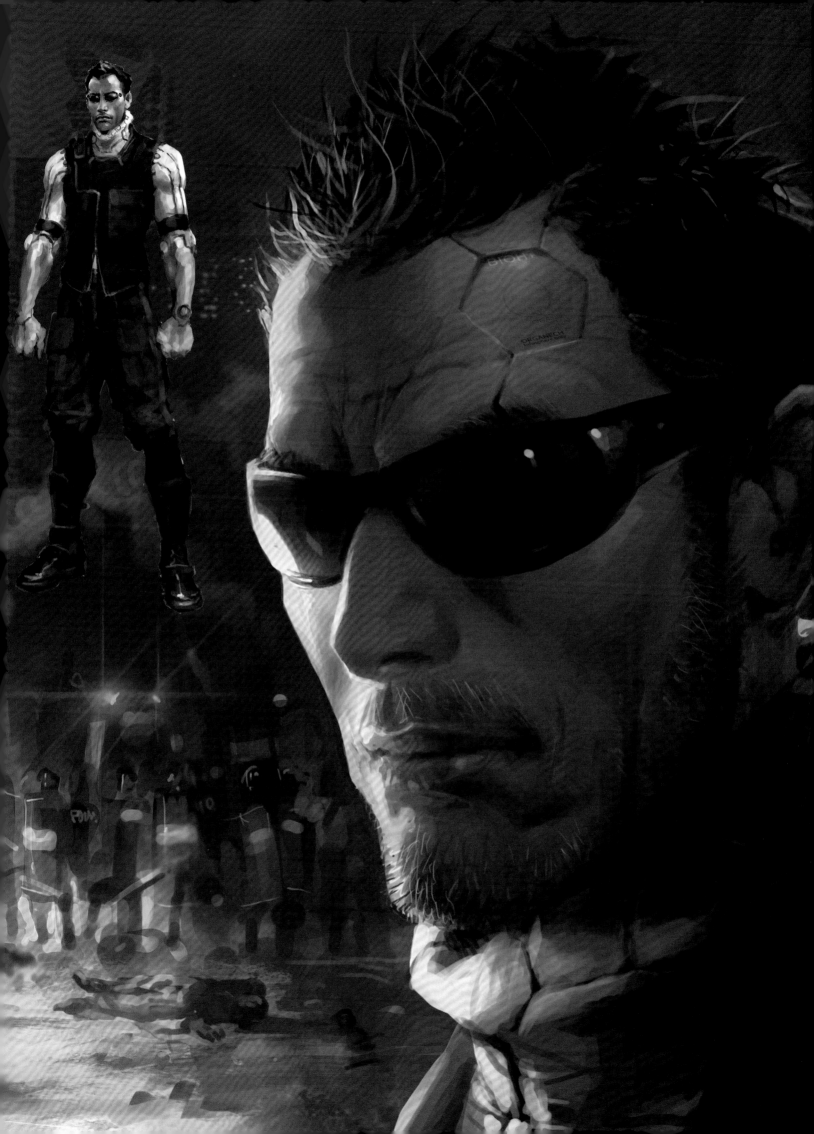

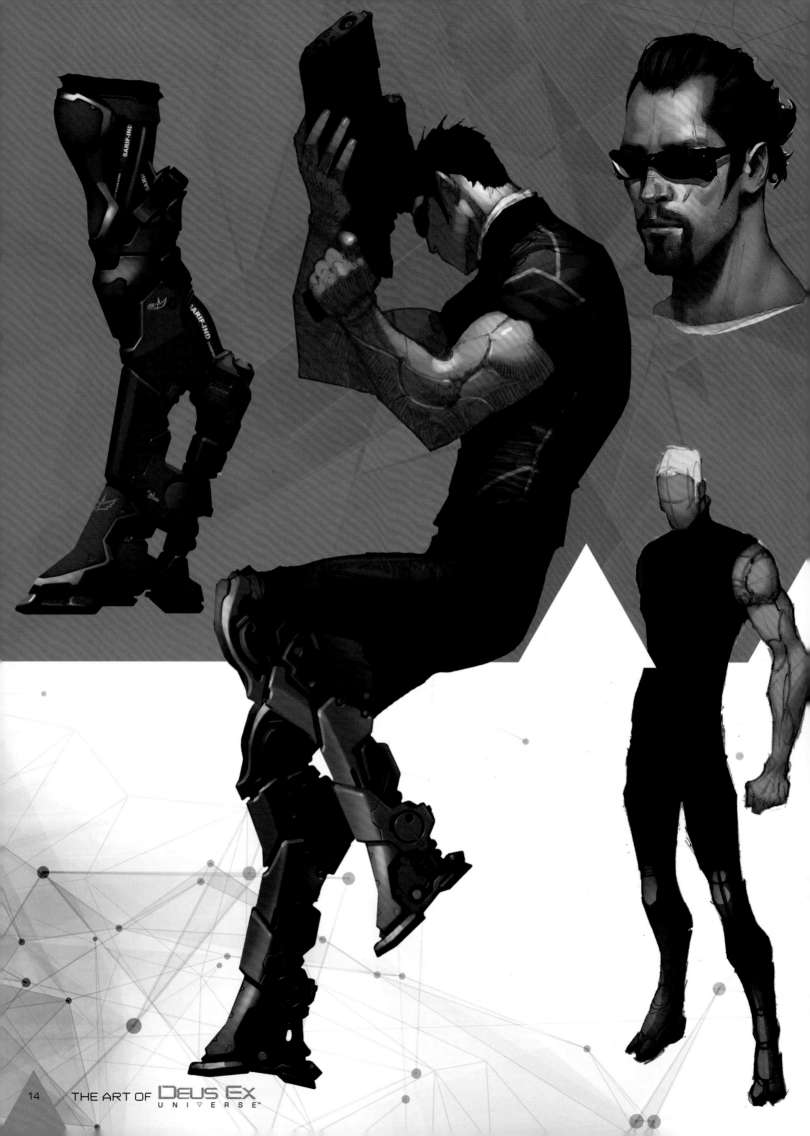

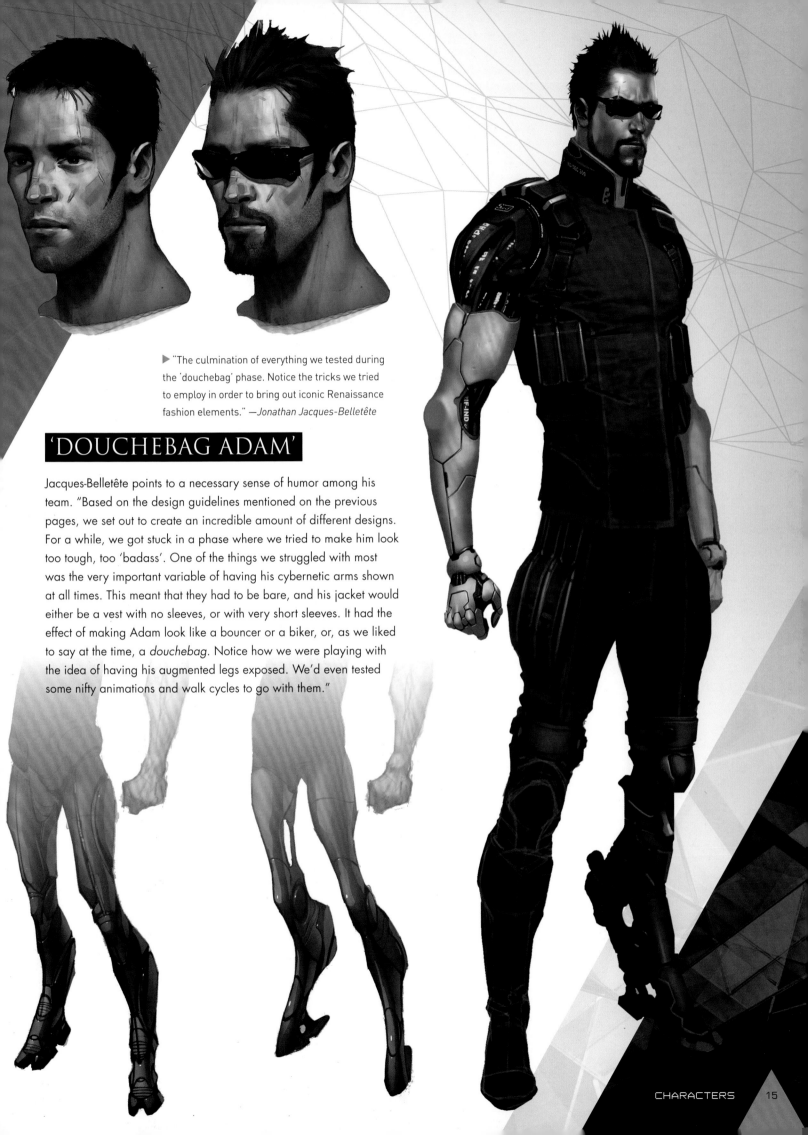

▶ "The culmination of everything we tested during the 'douchebag' phase. Notice the tricks we tried to employ in order to bring out iconic Renaissance fashion elements." —*Jonathan Jacques-Belletête*

'DOUCHEBAG ADAM'

Jacques-Belletête points to a necessary sense of humor among his team. "Based on the design guidelines mentioned on the previous pages, we set out to create an incredible amount of different designs. For a while, we got stuck in a phase where we tried to make him look too tough, too 'badass'. One of the things we struggled with most was the very important variable of having his cybernetic arms shown at all times. This meant that they had to be bare, and his jacket would either be a vest with no sleeves, or with very short sleeves. It had the effect of making Adam look like a bouncer or a biker, or, as we liked to say at the time, a *douchebag*. Notice how we were playing with the idea of having his augmented legs exposed. We'd even tested some nifty animations and walk cycles to go with them."

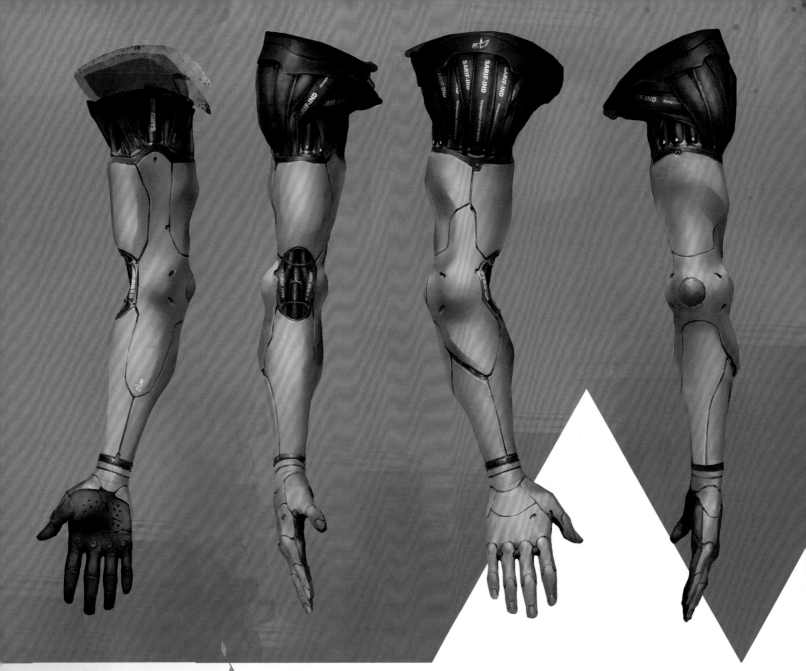

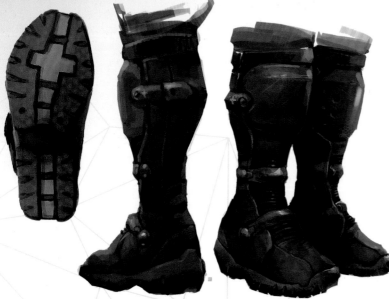

▶ The hinged, 'mechanized' look appears to continue with everything, right down to these heavy duty boots on Adam's feet. It's a statement that's tough to carry off.

'PINOCCHIO ADAM'

At various stages during a game's development, members of the creative team present their ideas to the publisher. Often, this results in feedback that artists need not take too closely to heart. Recalls Jacques-Belletête: "The next design phase was eventually called the 'Pinocchio Adam'. During an important greenlight meeting, one of the executives felt that, because Adam's augmented arms were flesh colored, it made him look like a living mannequin, or some sort of futuristic Pinocchio. We all laughed and the name stuck for a while. It was funny, but we knew this design couldn't stay—and we had a long way to go yet."

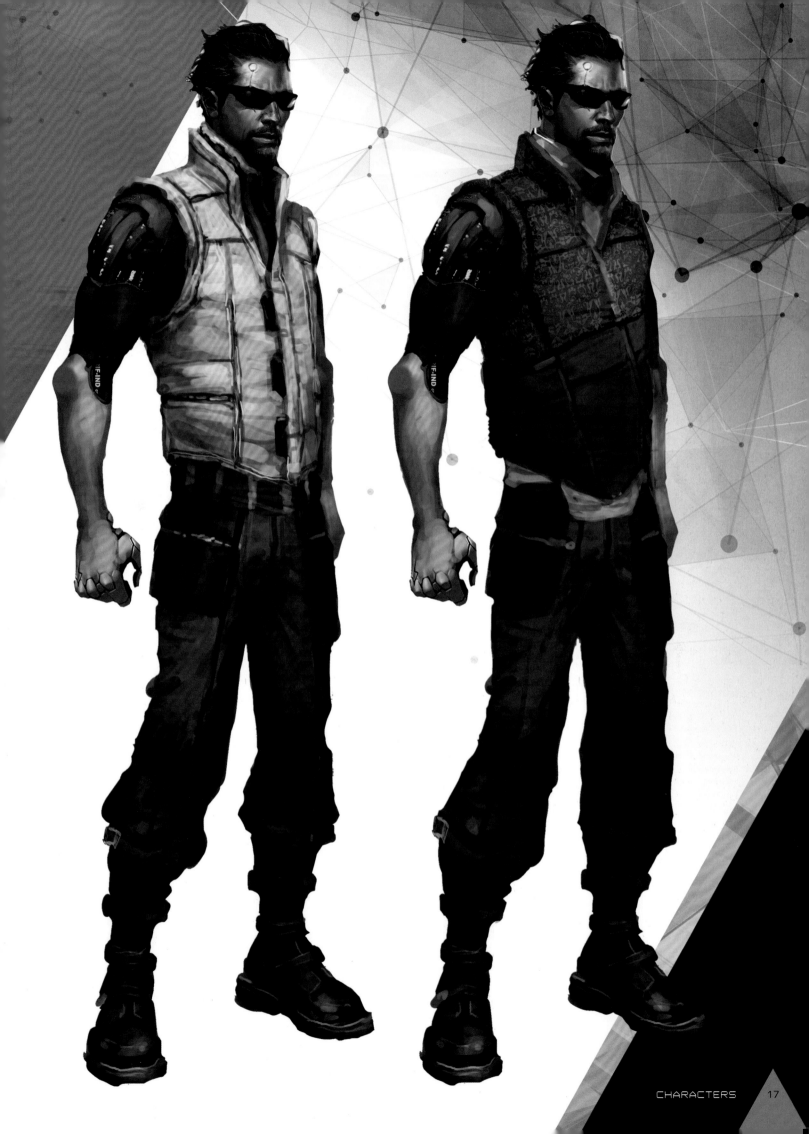

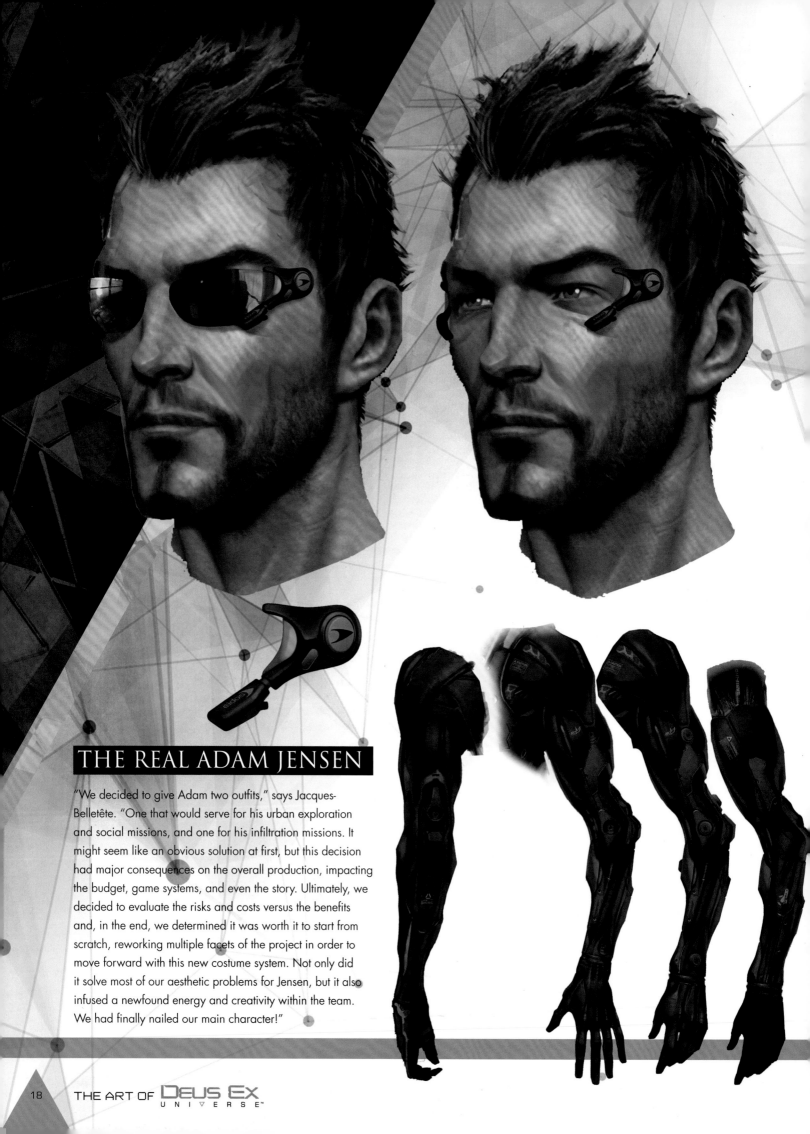

THE REAL ADAM JENSEN

"We decided to give Adam two outfits," says Jacques-Belletête. "One that would serve for his urban exploration and social missions, and one for his infiltration missions. It might seem like an obvious solution at first, but this decision had major consequences on the overall production, impacting the budget, game systems, and even the story. Ultimately, we decided to evaluate the risks and costs versus the benefits and, in the end, we determined it was worth it to start from scratch, reworking multiple facets of the project in order to move forward with this new costume system. Not only did it solve most of our aesthetic problems for Jensen, but it also infused a newfound energy and creativity within the team. We had finally nailed our main character!"

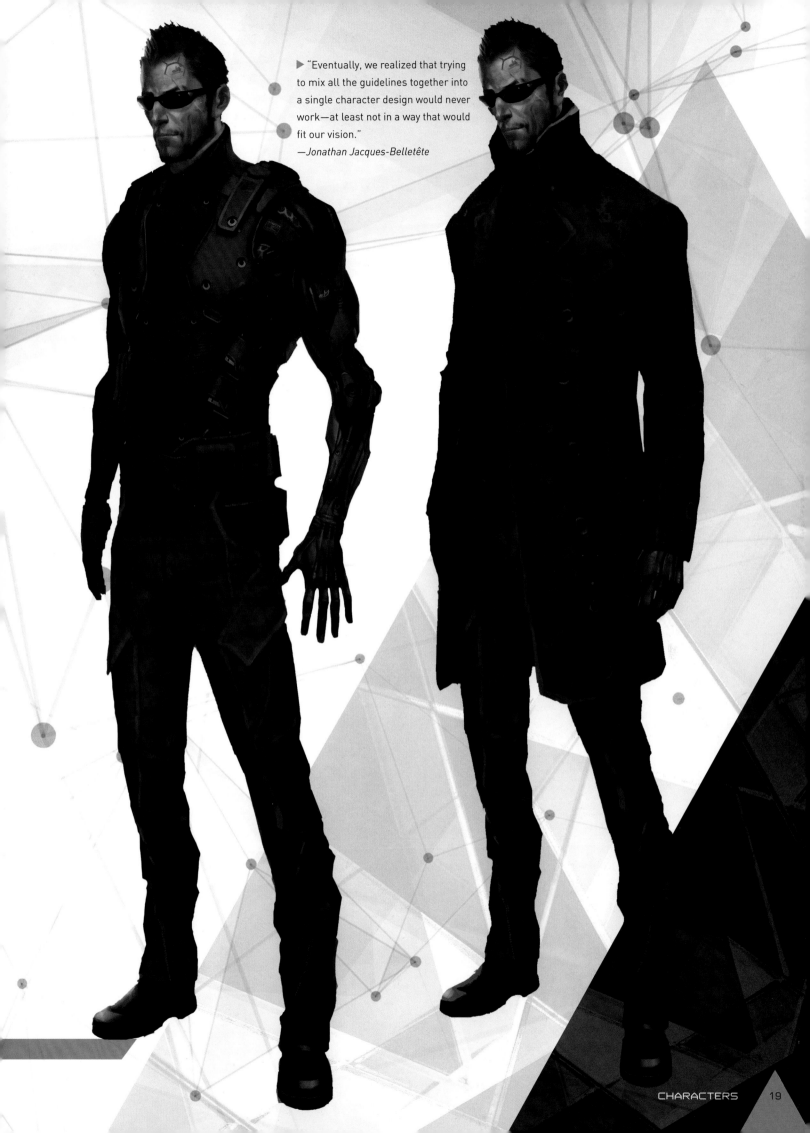

▶ "Eventually, we realized that trying to mix all the guidelines together into a single character design would never work—at least not in a way that would fit our vision."

—Jonathan Jacques-Belletête

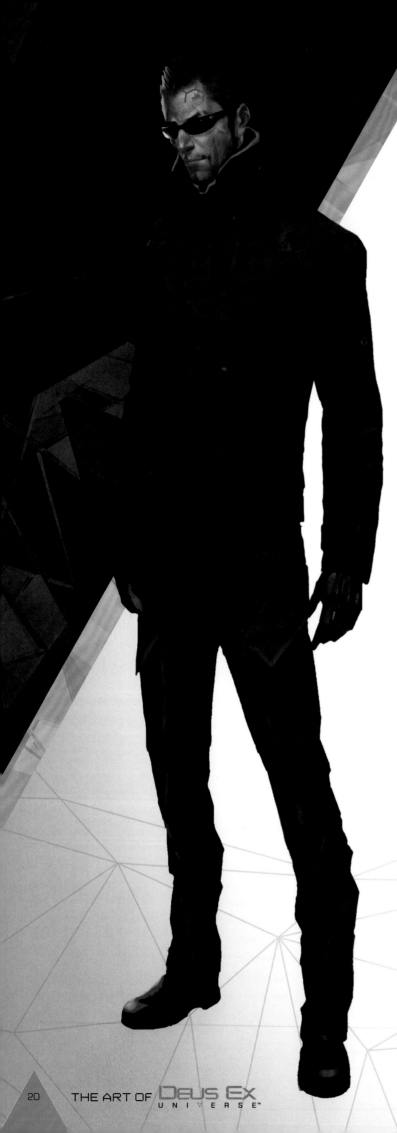

UPON FINAL REVIEW

"We went through numerous designs for both the armored commando and trench coat variants. Since we felt that we were finally going in the right direction, all these iterations were created quite naturally. The review process was kept short and focused and, in just a few weeks, we approved the final designs. During this time, we came up with the branchless and bridgeless glasses which, with their retractable lenses, became an important and iconic part of Adam Jensen's look," reveals Jacques-Belletête.

LONG AND SHORT OF IT

On Jensen's clothing, Jacques-Belletête explains Eidos-Montréal's processes. "After agreeing that Adam would have two outfits, we experimented with several variations of his jacket. We even tried a short version—the idea being to get away from the cyberpunk trench coat cliché. Opinions were so divided on this that we decided to have a studio-wide vote. Although a lot of people voted for the short jacket due to its originality, the trench coat came out as the clear winner. Sometimes, even when trying to break conventions, it's a good idea to stick to the good old classics."

ICONIC

When designing *Deus Ex*'s lead character, smarter solutions were demanded by Jacques-Belletête and his team at every level, ensuring that Jensen would visibly demonstrate his personality and position within the transhumanism debate at every opportunity. Cinematic scenes involving Jensen often focus on his face, and the high-fashion accessory over his eyes—drawing attention to how Adam has become human 2.0.

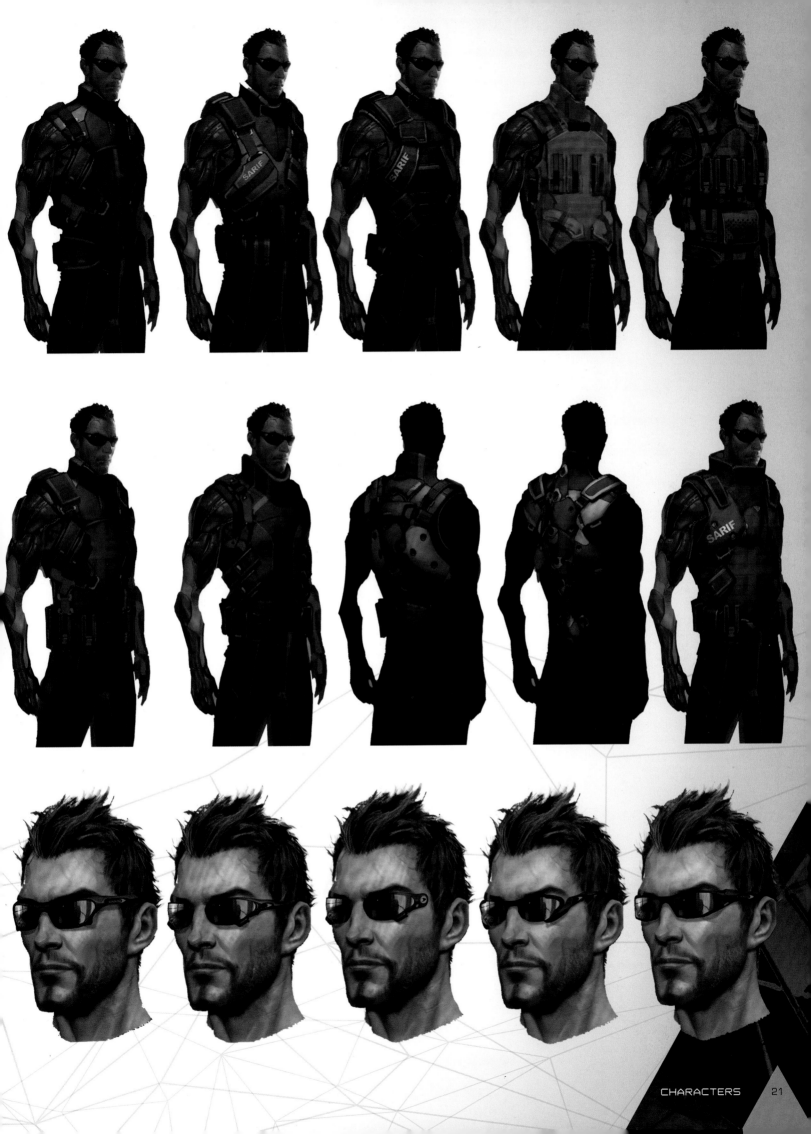

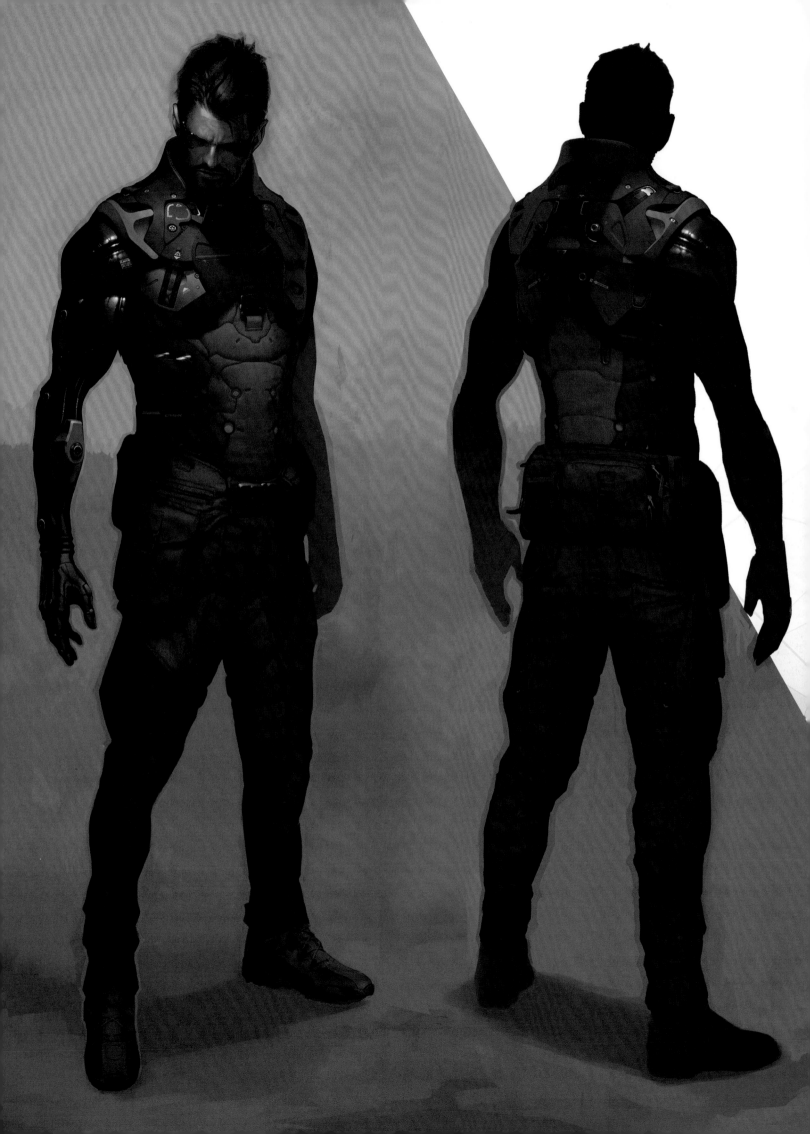

COMMANDO SUIT

Across video game design, military gear ranks as some of the most recognizable character outfits. The team explored a variety of options, conceptualizing designs that were immediately recognizable as combat gear, but still made to fit in with *Deus Ex*'s near-future aesthetic. *Deus Ex: Mankind Divided*'s Art Director Martin Dubeau goes on to explain: "When we first started the new design for Jensen's commando suit, we opted for a more functional/tactical approach, bringing the visuals closer to that of an actual bullet proof vest (*below right*). The initial results were not convincing enough—perhaps due to the fact that our designs were too close to armor vests that already existed. Therefore, we kept the tight aspect of the body armor that I liked, while incorporating various touches of military elements into the final version. Note the ejection strap on the front, a detail that references air force military. We also brought back the collar from Adam's original commando suit, as we felt it added a nice visual touch, reinforcing the Renaissance aesthetic. I'm especially proud of the in-game result that the character modeling team achieved (*upper right*)."

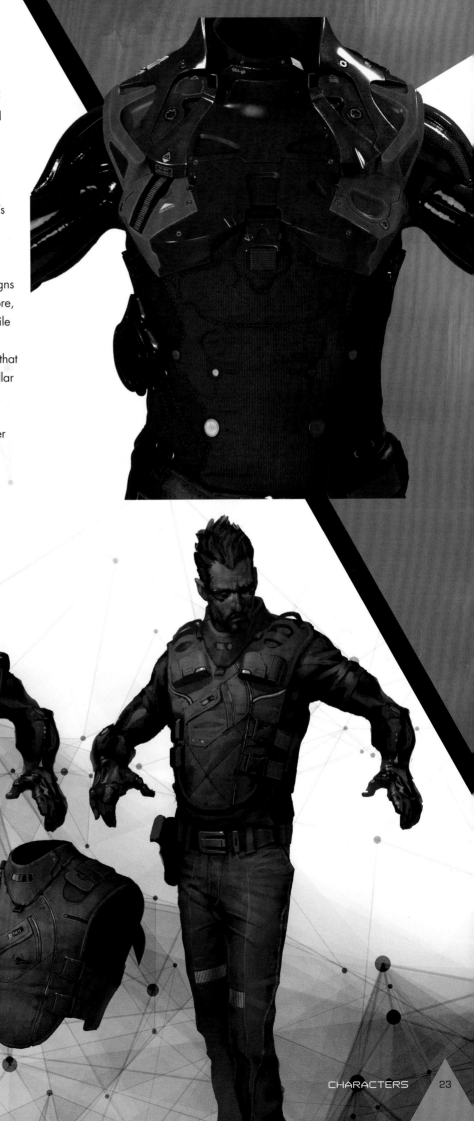

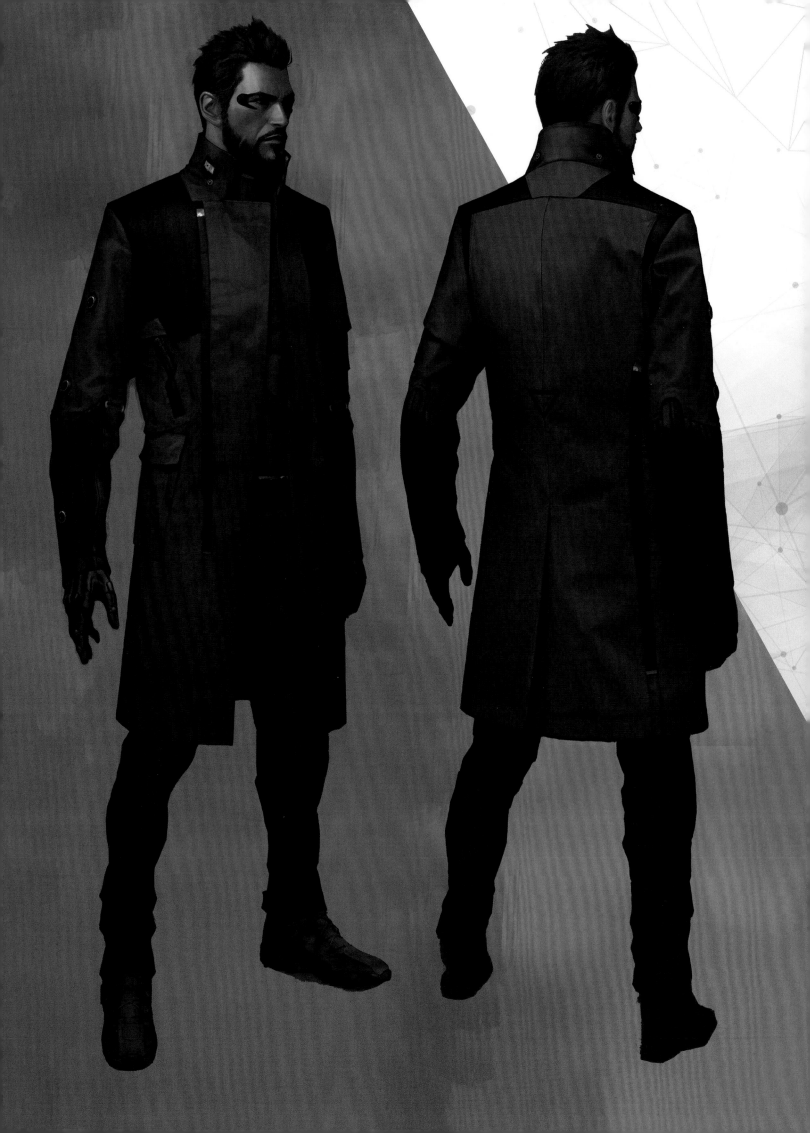

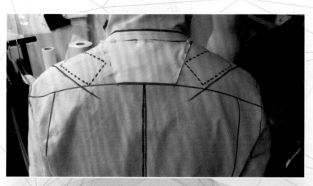

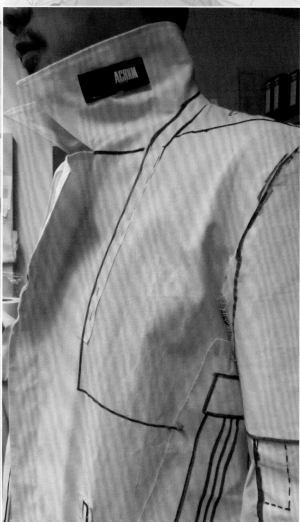

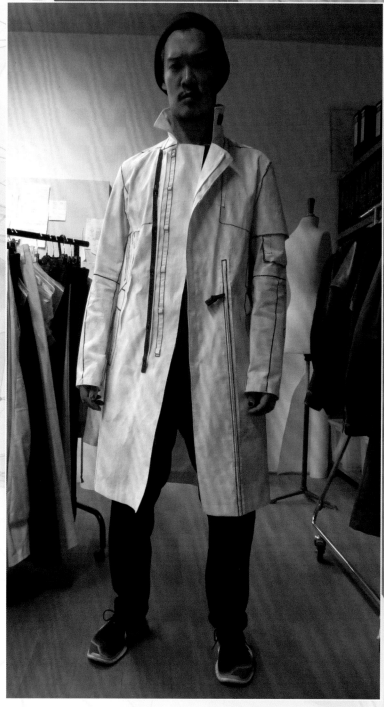

TRENCH COAT

In building *Deus Ex*'s Cyber-Renaissance aesthetic, the team at Eidos-Montréal looked to different industries for inspiration and guidance. Dubeau recalls the think-tank sessions that were ultimately responsible for the trench coat, and the startling degree of reasoning required. Uniquely, this led to the studio working with a fashion agency. "We also decided to revisit the trench coat's visuals in the last opus," remembers Martin. "The main challenge was to keep it unique, desirable, and sleek, while still remaining suitable for an agent such as Jensen. We wanted to design a garment that was complex, yet functional. After a few weeks of continually re-iterating the design, we discovered a company that would be a great fit to work with collaboratively on this challenge: Acronym©. From there, I worked directly with Errolson Hugh, co-founder of the company, to achieve the final result. It was quite impressive how different our creative process was; he was literally tailoring the trench coat from scratch, taking our collaborative creative vision and bringing it to life. His experience in the fashion industry brought our perspective on designing clothing to a whole new level."

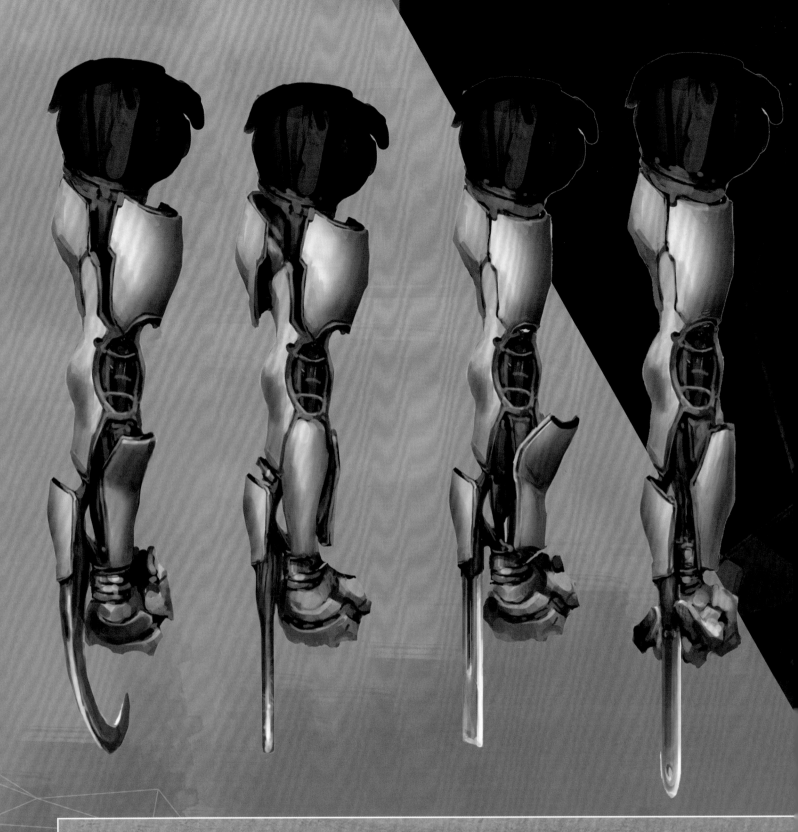

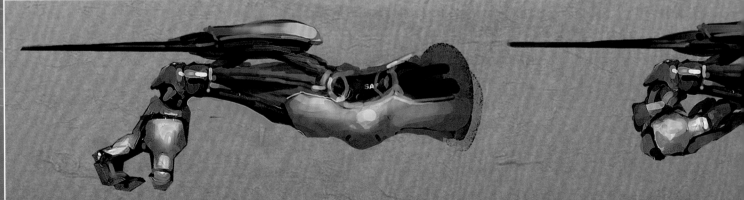

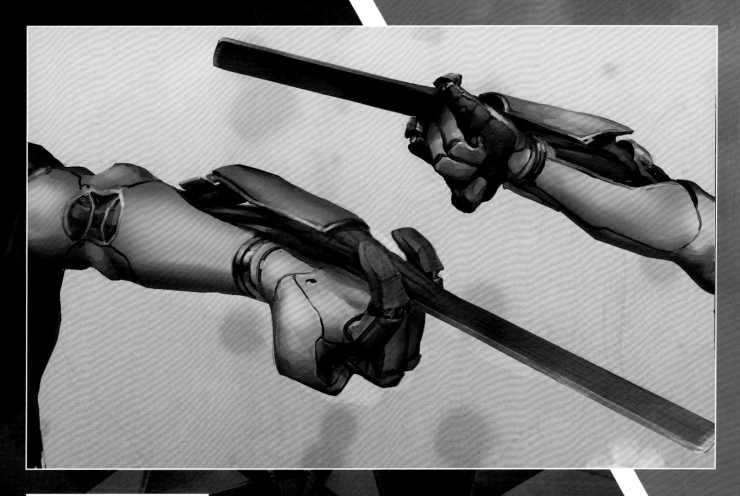

NANO BLADES

"We went through many ideas for the augmentations associated with Adam's melee and takedown abilities," explains Jacques-Belletête. "We knew that we wanted to give him an assortment of different moves and augmentations to neutralize his targets, but we also wanted to give him a signature weapon—something only Adam would have. That's where the idea of the Nano Blades, originating within his forearms, came up. In truth, having a blade or blades coming out of one's hands or arms wasn't an entirely new concept. However, we aimed to truly make it our own by deciding to make the blades into slick slabs of ebony black, opting for a flat and square tip instead of the de facto pointy shape all regular blades have. Giving Adam the ability to protract the blades backwards over his elbows helped in creating a unique and original feel to his combat as well, opening up the possibilities for some pretty slick and unconventional moves."

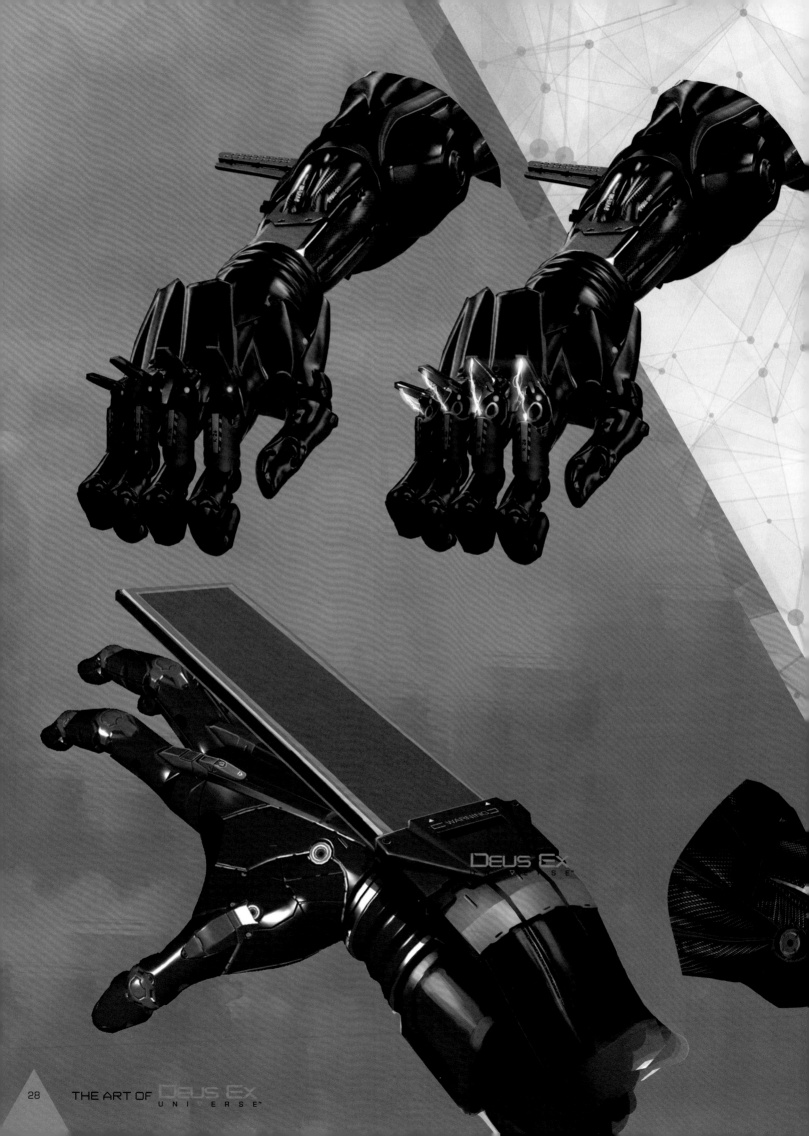

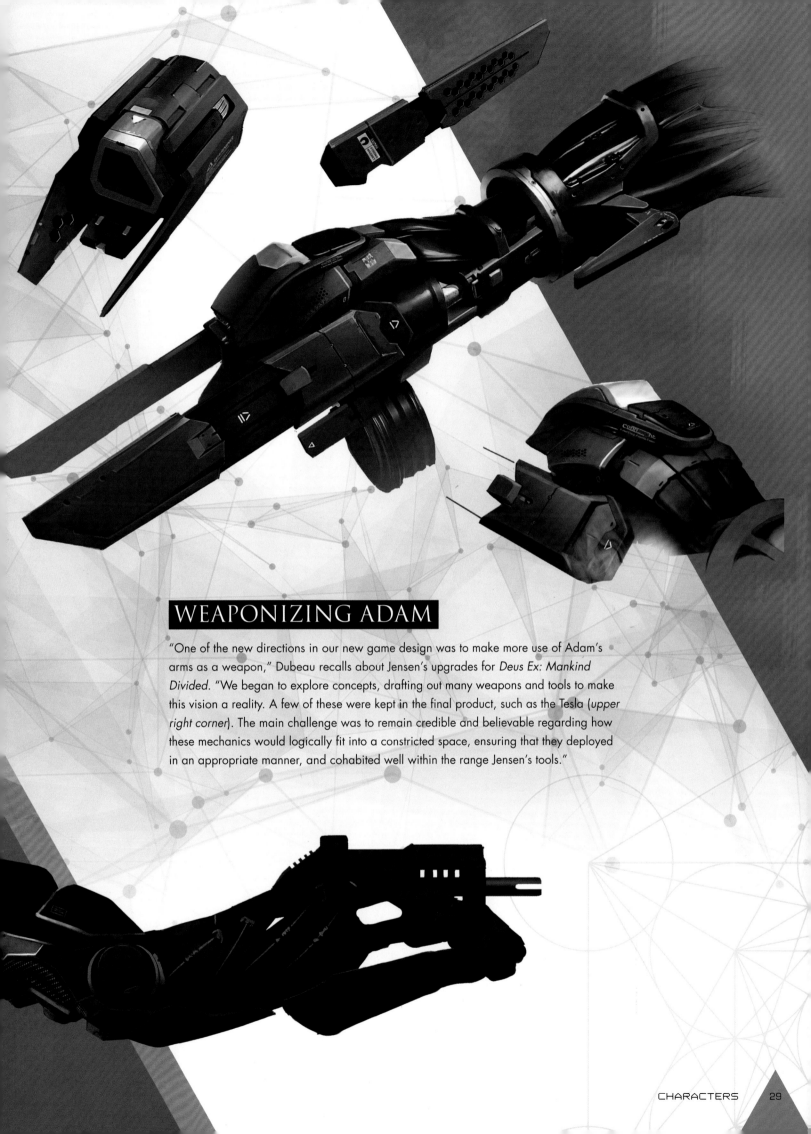

WEAPONIZING ADAM

"One of the new directions in our new game design was to make more use of Adam's arms as a weapon," Dubeau recalls about Jensen's upgrades for *Deus Ex: Mankind Divided*. "We began to explore concepts, drafting out many weapons and tools to make this vision a reality. A few of these were kept in the final product, such as the Tesla (*upper right corner*). The main challenge was to remain credible and believable regarding how these mechanics would logically fit into a constricted space, ensuring that they deployed in an appropriate manner, and cohabited well within the range Jensen's tools."

TITAN GAMEPLAY

Often, the concept team is approached to enhance specific gameplay scenarios. Explains Dubeau: "There was a request from the designers to add a new protection system on Adam, initially called dermal plating. The conventional Kevlar protection as the 'magical invisible shield' wasn't an artistic option. Instead, we embraced the idea of a kind of self-organizing-nano-tech-liquid that would be able to create this barrier. Ferrofluid art installations were a primary source of inspiration, particularly from a visual perspective."

TITAN CINEMATIC

Visual Works is a Japan-based Square Enix studio that excels in creating high-end computer-generated imagery (CGI). The CGI they create is usually featured in cinematic trailers, or within storytelling cut-scenes. Visual Works' incredibly detailed and high end CGI helped to materialize some of the ideas that the team in Montréal initially conceptualized. Adds Dubeau: "With the talent of Kazuyuki Ikumori and his team at the Visual Works studio, the whole effect of this definitive visual was brought to life for the first time. Until reaching that point, there was a lot of uncertainty as to how we would achieve a fluid and believable effect... It was a key moment in the first trailer we released for *Mankind Divided*."

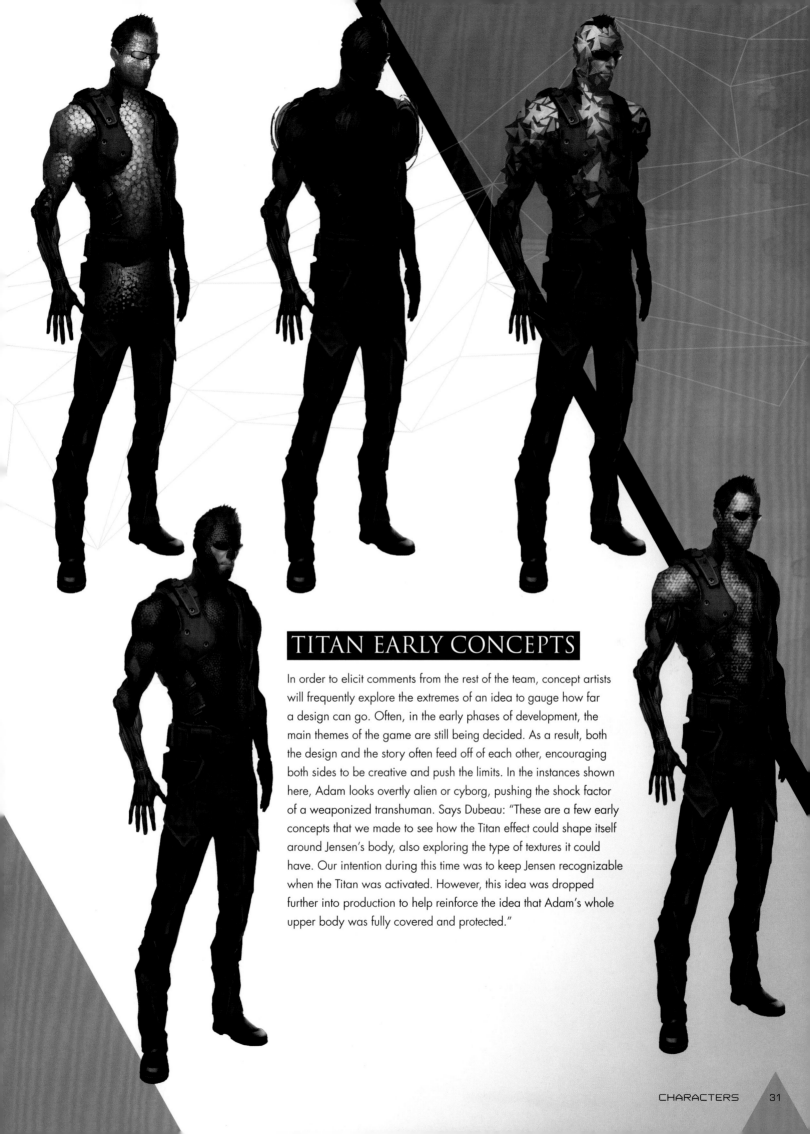

TITAN EARLY CONCEPTS

In order to elicit comments from the rest of the team, concept artists will frequently explore the extremes of an idea to gauge how far a design can go. Often, in the early phases of development, the main themes of the game are still being decided. As a result, both the design and the story often feed off of each other, encouraging both sides to be creative and push the limits. In the instances shown here, Adam looks overtly alien or cyborg, pushing the shock factor of a weaponized transhuman. Says Dubeau: "These are a few early concepts that we made to see how the Titan effect could shape itself around Jensen's body, also exploring the type of textures it could have. Our intention during this time was to keep Jensen recognizable when the Titan was activated. However, this idea was dropped further into production to help reinforce the idea that Adam's whole upper body was fully covered and protected."

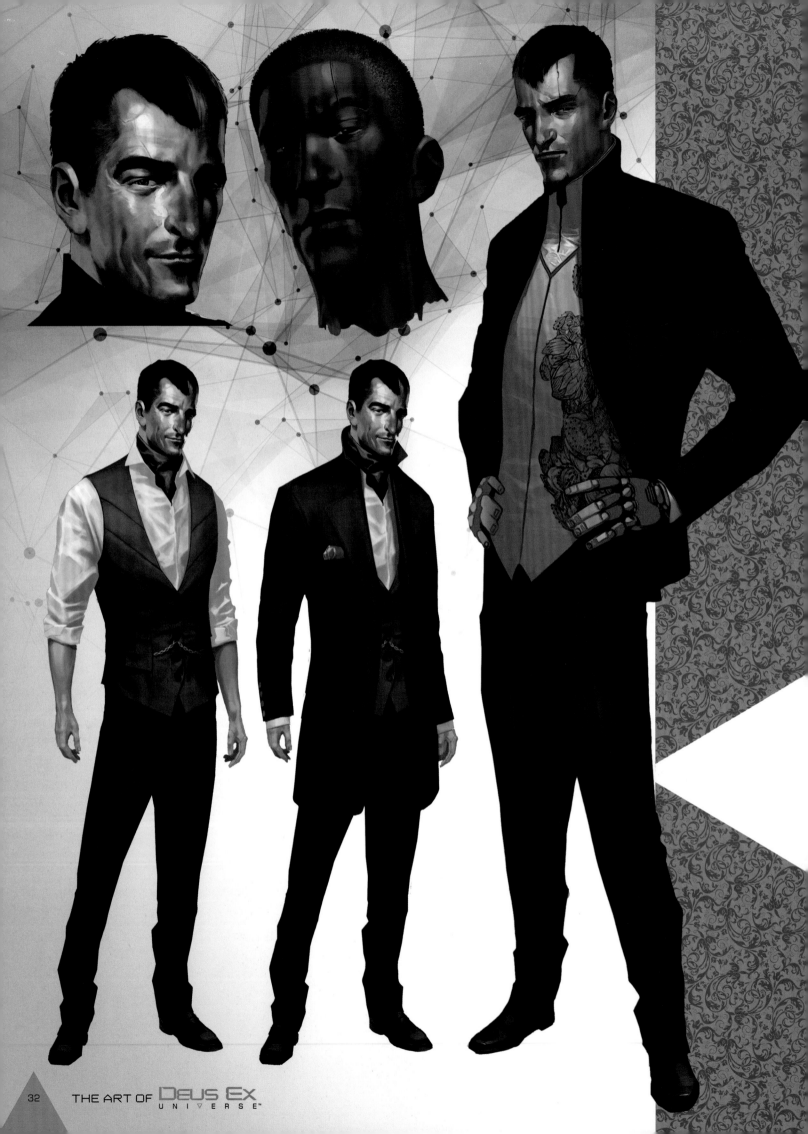

DAVID SARIF

At first, designing David Sarif, Adam's boss and CEO of Sarif Industries, posed a challenge. Explains Jacques-Belletête: "Sarif is an ambitious self-made man who almost single-handedly rejuvenated the economy of an entire city through his cybernetic company. Visually, he had to look corporate, yet somewhat easy-going and relaxed. That's where the rolled-up sleeves and Steve Jobs-ish look came in. During the entire period where we were struggling with how to properly create this new Cyber-Renaissance fashion and aesthetic, David Sarif made us question many things. How do we mix corporate attires with cyberpunk and Renaissance fashion? Is it even possible? Is it necessary? We ended up concentrating on the NPC designs for the office workers first in order to try and answer these questions. Once we figured them out, and felt comfortable with our solutions, we came back and applied them to Sarif's design."

▶ "Based on his achievements and personality, David Sarif's arm needed to look like the finest available. Worn almost like an advertisement, the idea was to portray that he probably updated and replaced the arm to boast the latest and slickest designs he could offer clients. It also plays well with the idea of having him roll up his sleeves." —Jonathan Jacques-Belletête

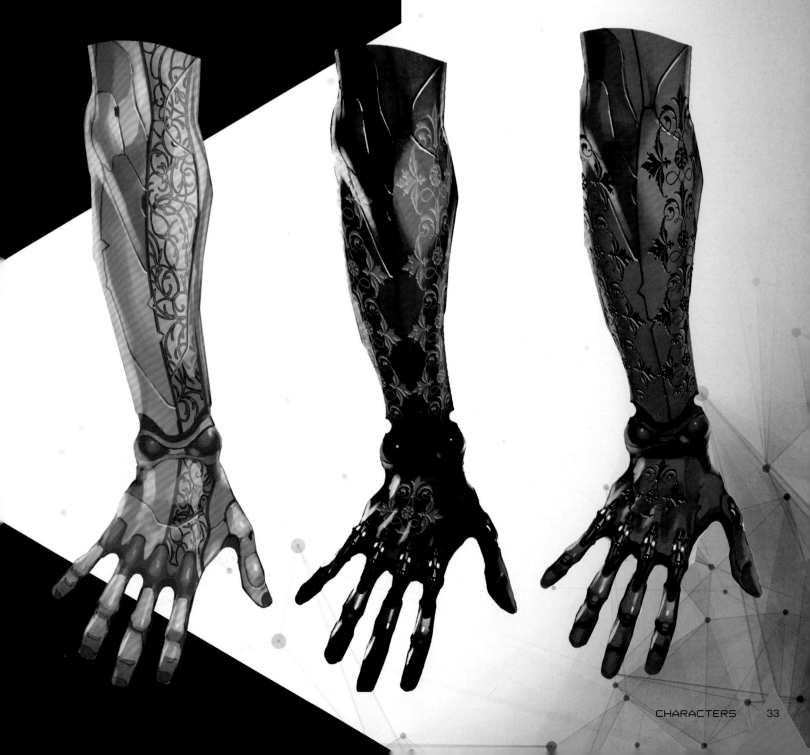

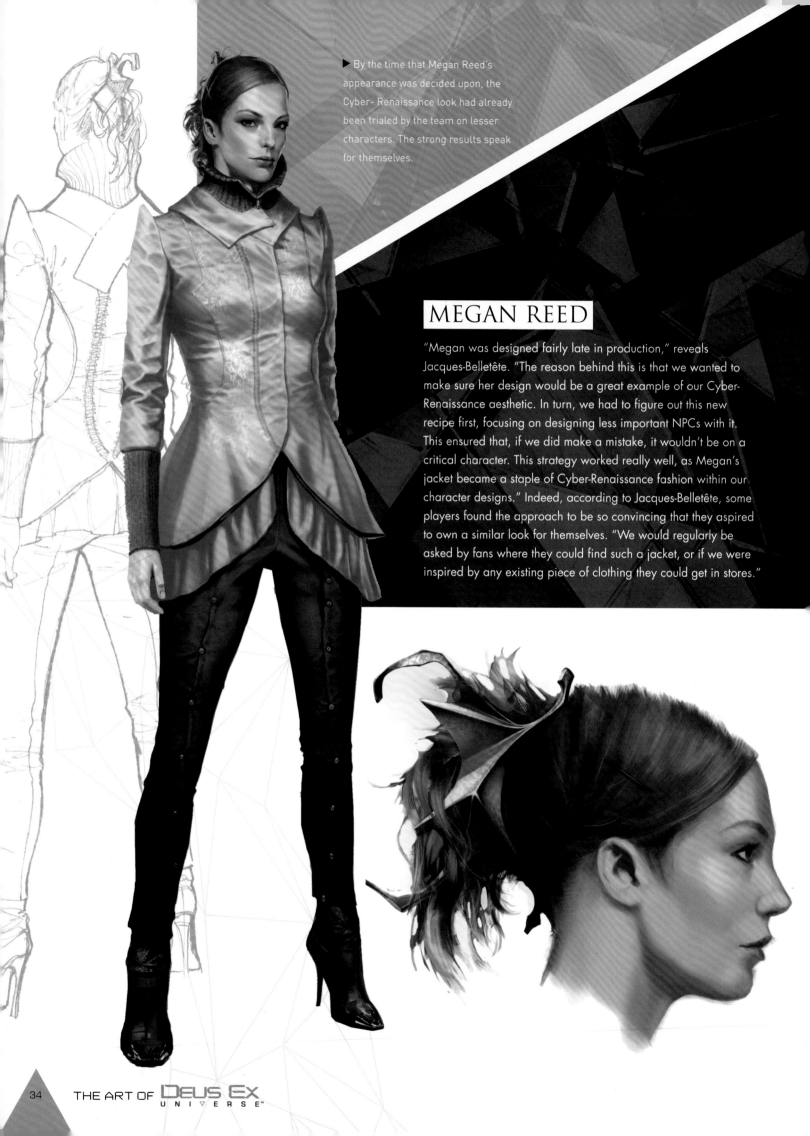

▶ By the time that Megan Reed's appearance was decided upon, the Cyber-Renaissance look had already been trialed by the team on lesser characters. The strong results speak for themselves.

MEGAN REED

"Megan was designed fairly late in production," reveals Jacques-Belletête. "The reason behind this is that we wanted to make sure her design would be a great example of our Cyber-Renaissance aesthetic. In turn, we had to figure out this new recipe first, focusing on designing less important NPCs with it. This ensured that, if we did make a mistake, it wouldn't be on a critical character. This strategy worked really well, as Megan's jacket became a staple of Cyber-Renaissance fashion within our character designs." Indeed, according to Jacques-Belletête, some players found the approach to be so convincing that they aspired to own a similar look for themselves. "We would regularly be asked by fans where they could find such a jacket, or if we were inspired by any existing piece of clothing they could get in stores."

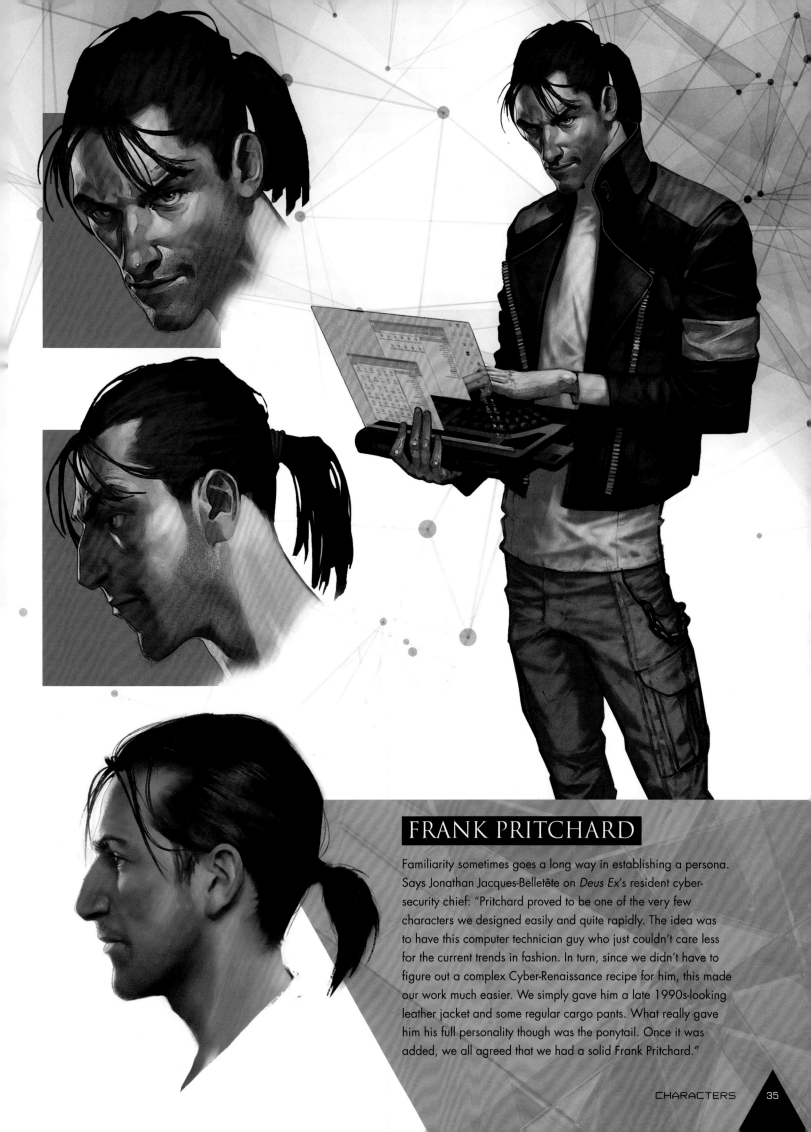

FRANK PRITCHARD

Familiarity sometimes goes a long way in establishing a persona. Says Jonathan Jacques-Belletête on *Deus Ex*'s resident cyber-security chief: "Pritchard proved to be one of the very few characters we designed easily and quite rapidly. The idea was to have this computer technician guy who just couldn't care less for the current trends in fashion. In turn, since we didn't have to figure out a complex Cyber-Renaissance recipe for him, this made our work much easier. We simply gave him a late 1990s-looking leather jacket and some regular cargo pants. What really gave him his full personality though was the ponytail. Once it was added, we all agreed that we had a solid Frank Pritchard."

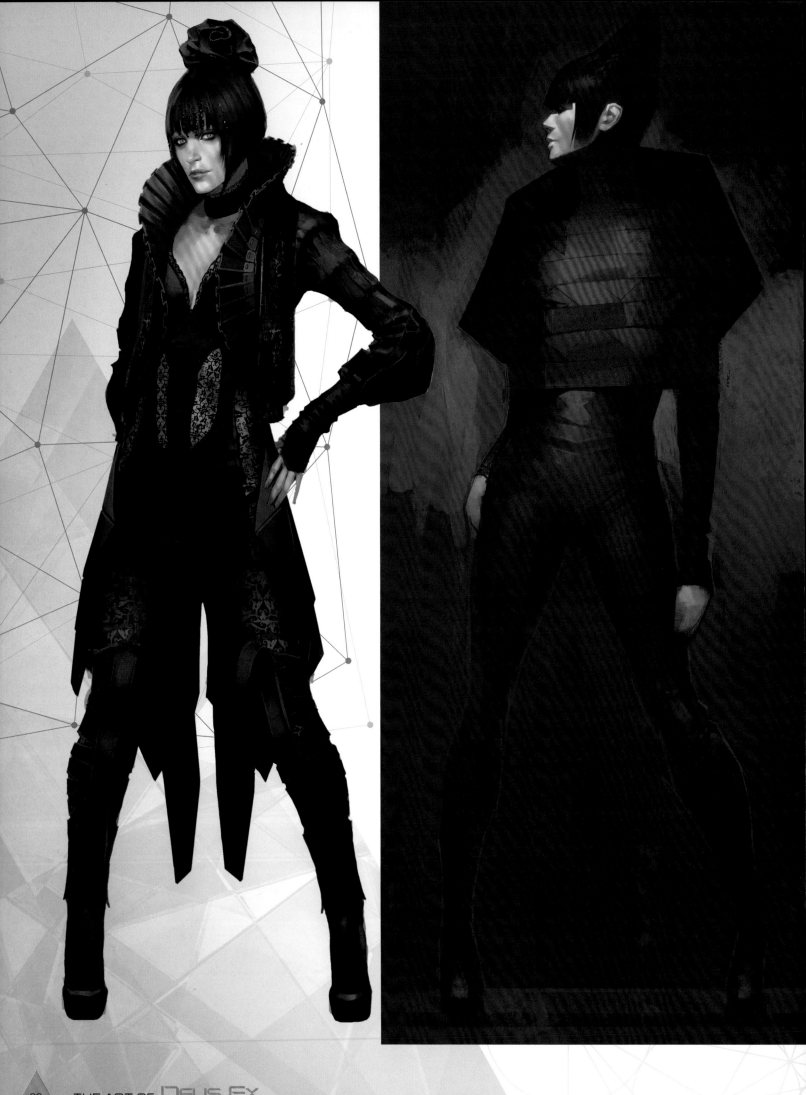

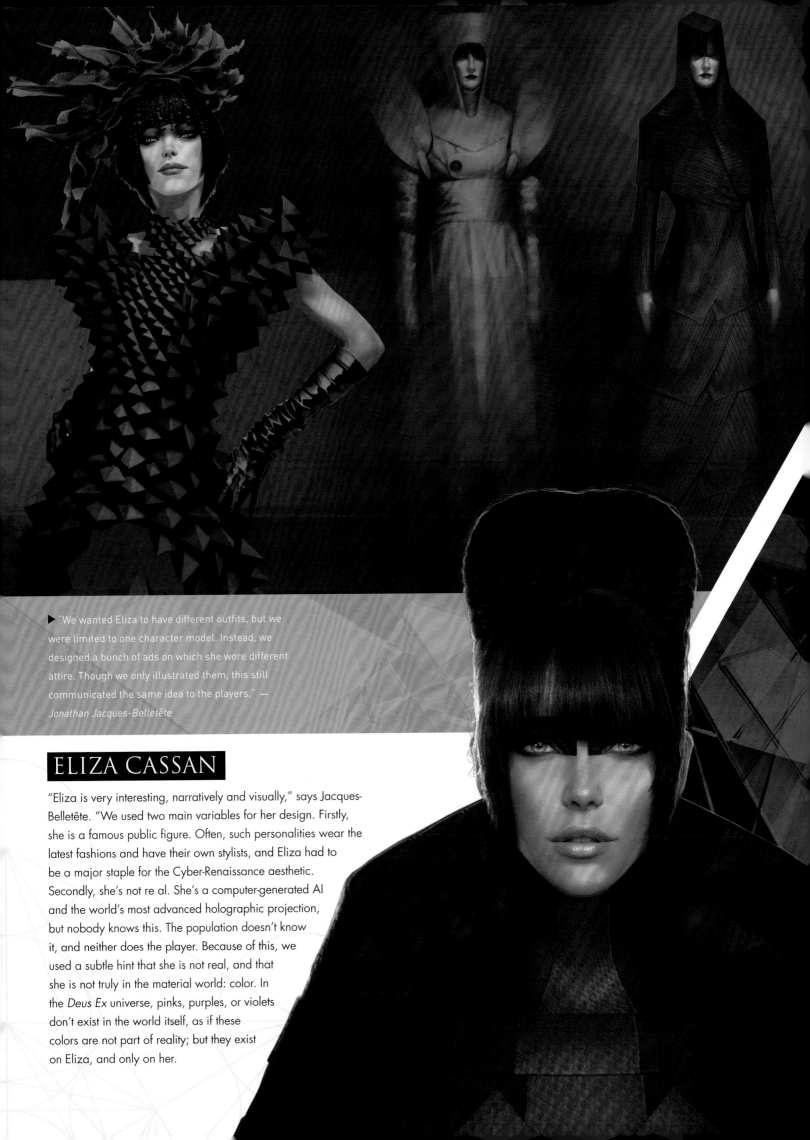

▶ "We wanted Eliza to have different outfits, but we were limited to one character model. Instead, we designed a bunch of ads on which she wore different attire. Though we only illustrated them, this still communicated the same idea to the players." — *Jonathan Jacques-Belletête*

ELIZA CASSAN

"Eliza is very interesting, narratively and visually," says Jacques-Belletête. "We used two main variables for her design. Firstly, she is a famous public figure. Often, such personalities wear the latest fashions and have their own stylists, and Eliza had to be a major staple for the Cyber-Renaissance aesthetic. Secondly, she's not re al. She's a computer-generated AI and the world's most advanced holographic projection, but nobody knows this. The population doesn't know it, and neither does the player. Because of this, we used a subtle hint that she is not real, and that she is not truly in the material world: color. In the *Deus Ex* universe, pinks, purples, or violets don't exist in the world itself, as if these colors are not part of reality; but they exist on Eliza, and only on her.

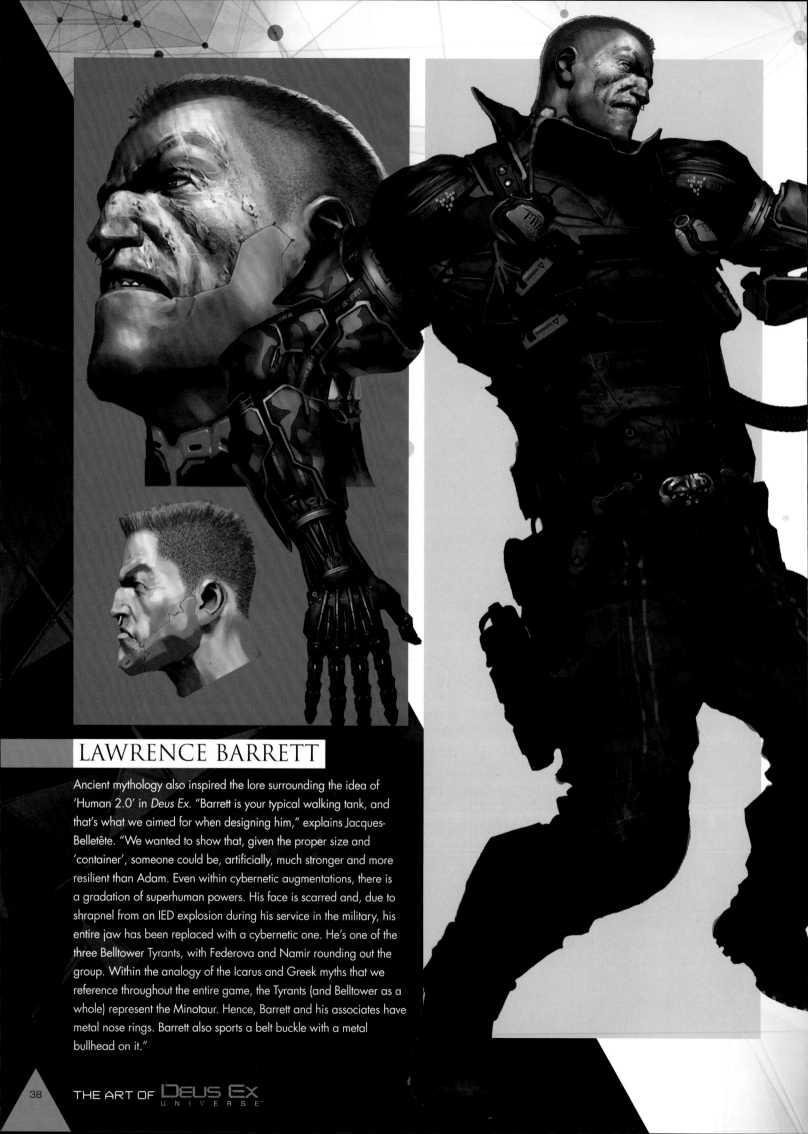

LAWRENCE BARRETT

Ancient mythology also inspired the lore surrounding the idea of 'Human 2.0' in *Deus Ex*. "Barrett is your typical walking tank, and that's what we aimed for when designing him," explains Jacques-Belletête. "We wanted to show that, given the proper size and 'container', someone could be, artificially, much stronger and more resilient than Adam. Even within cybernetic augmentations, there is a gradation of superhuman powers. His face is scarred and, due to shrapnel from an IED explosion during his service in the military, his entire jaw has been replaced with a cybernetic one. He's one of the three Belltower Tyrants, with Federova and Namir rounding out the group. Within the analogy of the Icarus and Greek myths that we reference throughout the entire game, the Tyrants (and Belltower as a whole) represent the Minotaur. Hence, Barrett and his associates have metal nose rings. Barrett also sports a belt buckle with a metal bullhead on it."

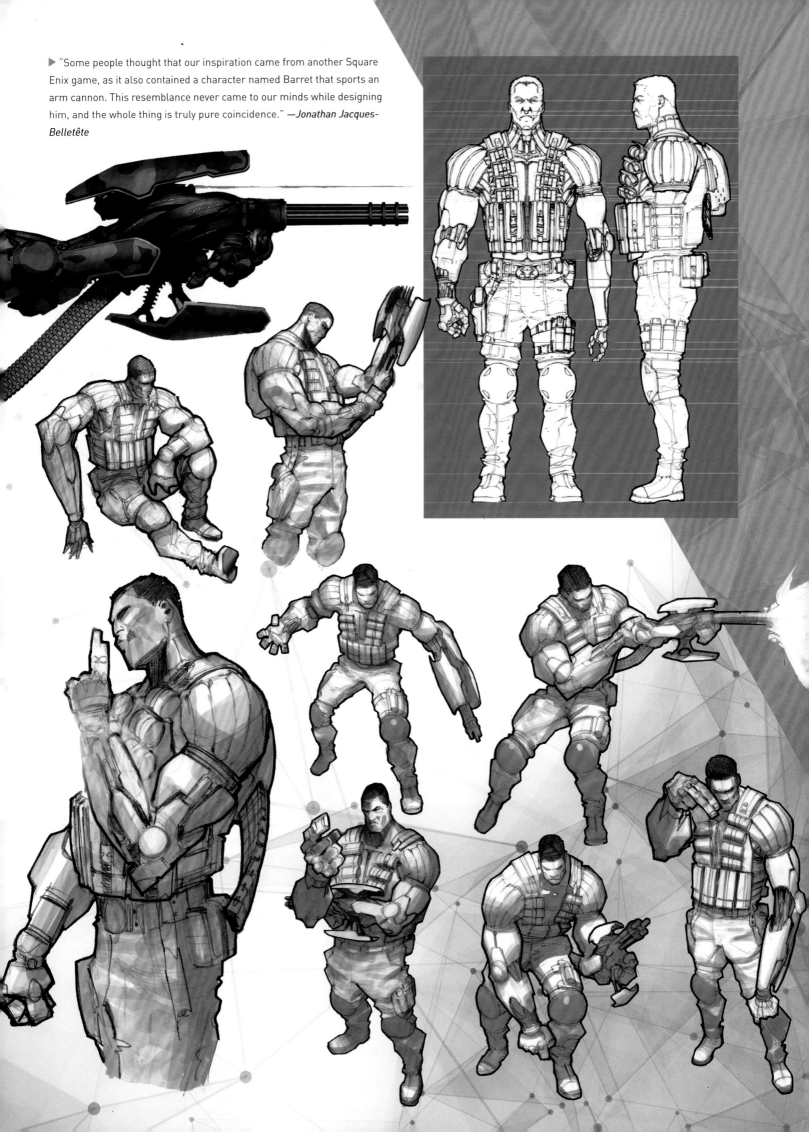

▶ "Some people thought that our inspiration came from another Square Enix game, as it also contained a character named Barret that sports an arm cannon. This resemblance never came to our minds while designing him, and the whole thing is truly pure coincidence." —*Jonathan Jacques-Belletête*

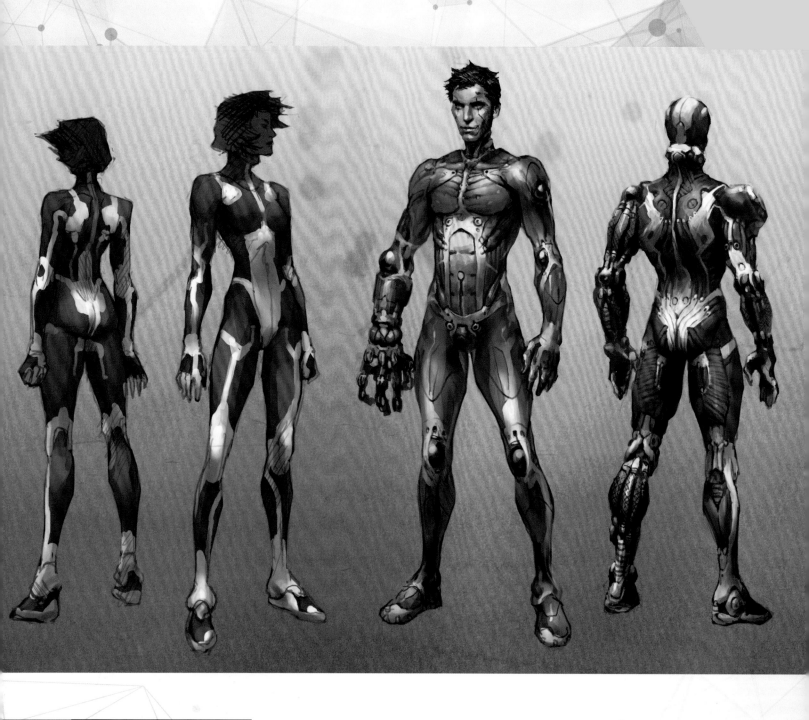

JARON NAMIR

"Jaron Namir is truly one of the great concepts we came up with during the development of the game," asserts Jacques-Belletête. "Back in the summer of 2007, the Body World exhibition was in Montréal, and it had a huge impact on all of us. That's where the inspiration came from for a character who's entire body is augmented. We also made the decision to make it look like his skin was completely flayed off, leaving only muscles, ligaments, and cartilage exposed. At first, we thought this look could be given to a squad of assassins, but we eventually kept it only for Namir. This gave him something unique and striking, especially since players didn't find out that these augmentations went beyond his arms, and covered his entire body, until the end of the game. The real stroke of genius was when we decided to set his boss fight inside a room full of real 'body world' statues, having him standing among them, completely still. It worked really well."

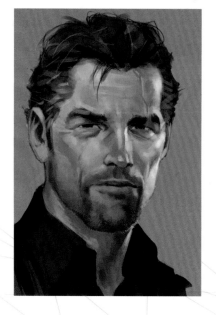
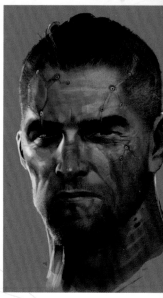

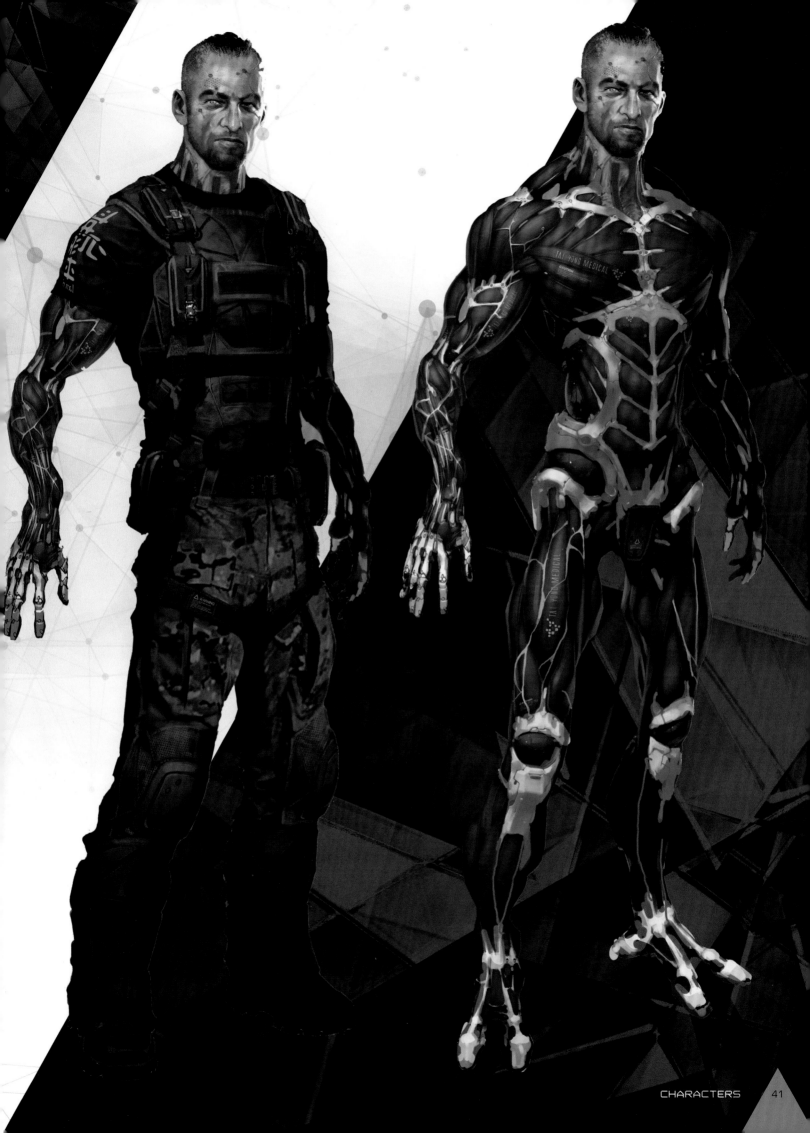

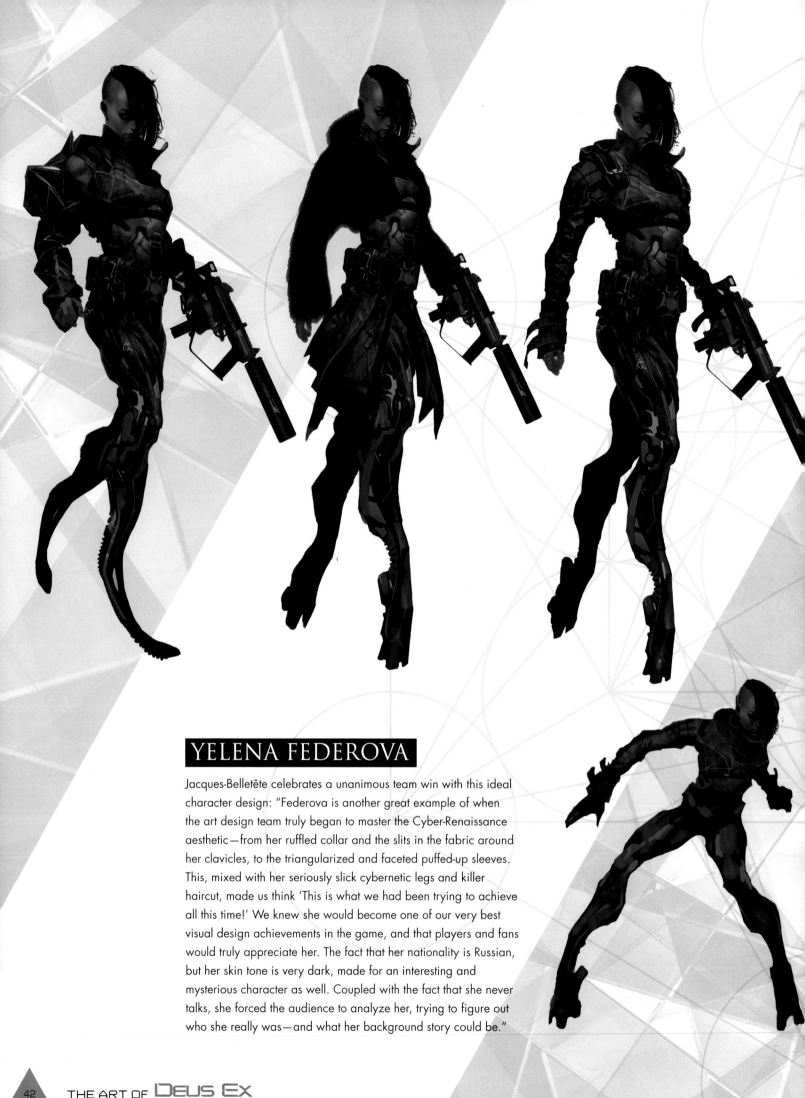

YELENA FEDEROVA

Jacques-Belletête celebrates a unanimous team win with this ideal character design: "Federova is another great example of when the art design team truly began to master the Cyber-Renaissance aesthetic—from her ruffled collar and the slits in the fabric around her clavicles, to the triangularized and faceted puffed-up sleeves. This, mixed with her seriously slick cybernetic legs and killer haircut, made us think 'This is what we had been trying to achieve all this time!' We knew she would become one of our very best visual design achievements in the game, and that players and fans would truly appreciate her. The fact that her nationality is Russian, but her skin tone is very dark, made for an interesting and mysterious character as well. Coupled with the fact that she never talks, she forced the audience to analyze her, trying to figure out who she really was—and what her background story could be."

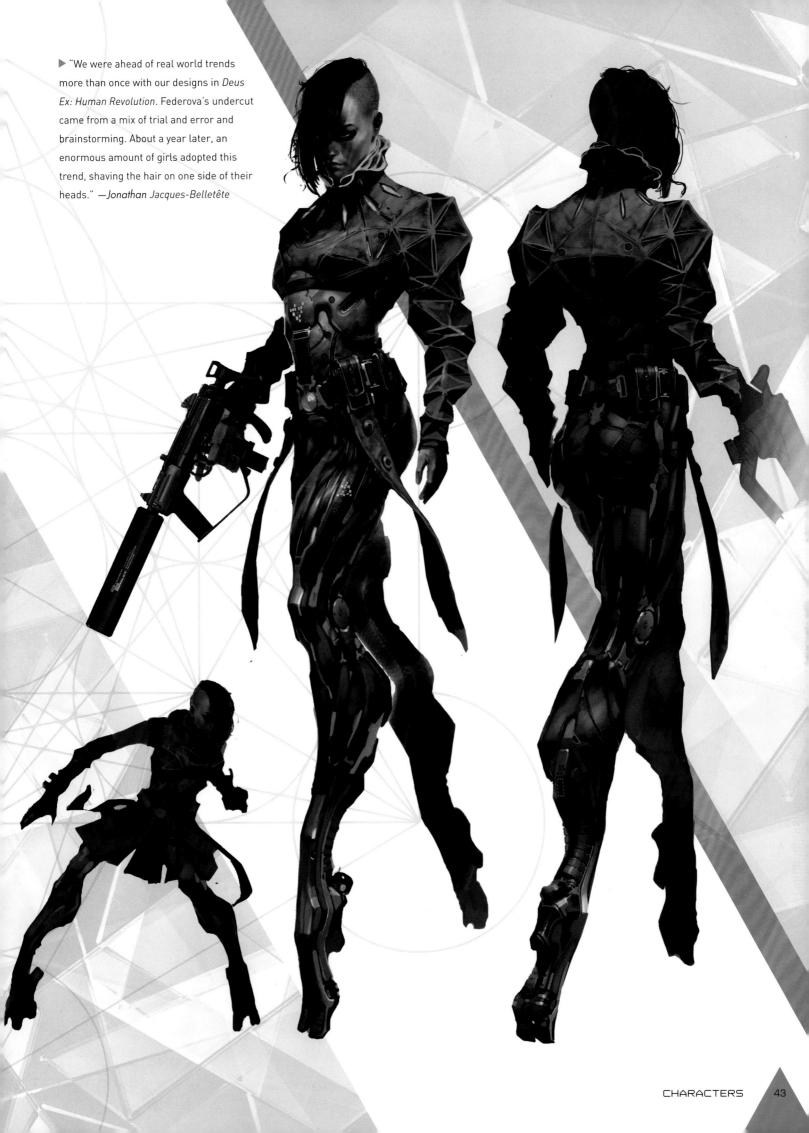

▶ "We were ahead of real world trends more than once with our designs in *Deus Ex: Human Revolution*. Federova's undercut came from a mix of trial and error and brainstorming. About a year later, an enormous amount of girls adopted this trend, shaving the hair on one side of their heads." —*Jonathan Jacques-Belletête*

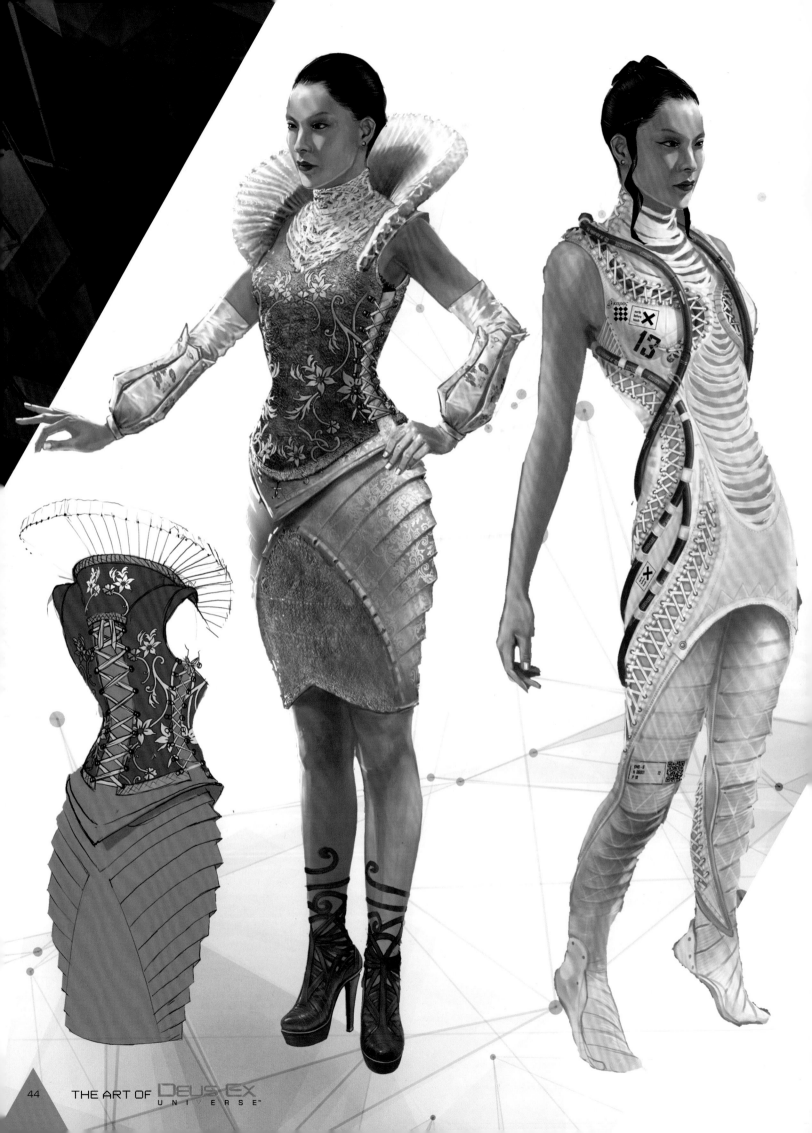

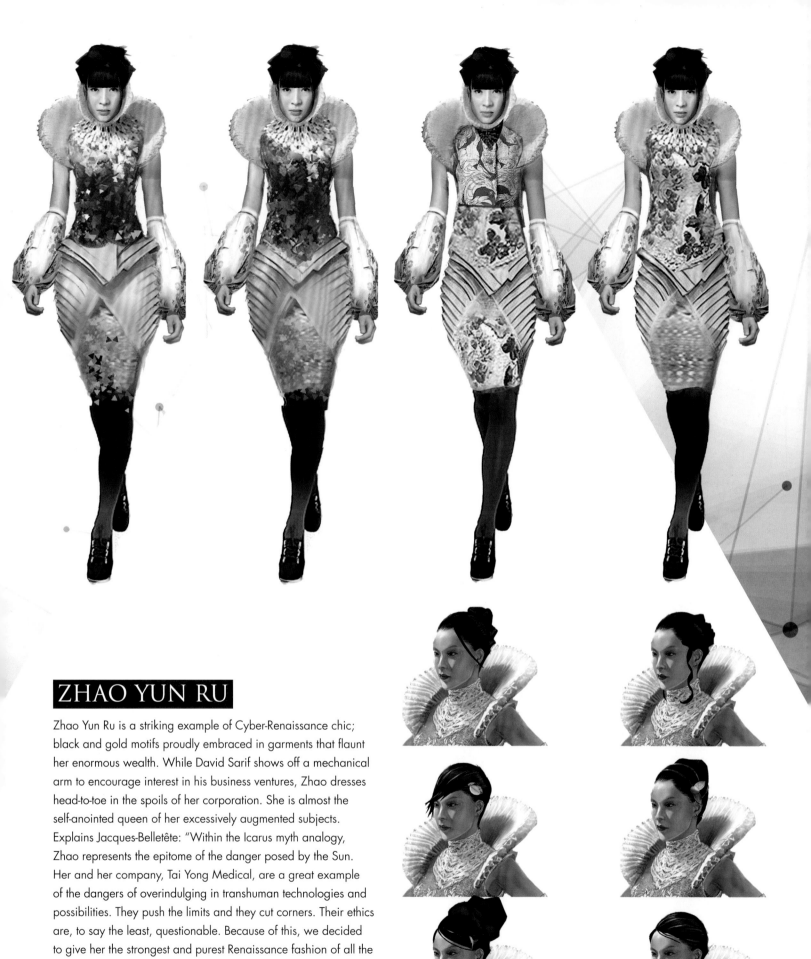

ZHAO YUN RU

Zhao Yun Ru is a striking example of Cyber-Renaissance chic; black and gold motifs proudly embraced in garments that flaunt her enormous wealth. While David Sarif shows off a mechanical arm to encourage interest in his business ventures, Zhao dresses head-to-toe in the spoils of her corporation. She is almost the self-anointed queen of her excessively augmented subjects. Explains Jacques-Belletête: "Within the Icarus myth analogy, Zhao represents the epitome of the danger posed by the Sun. Her and her company, Tai Yong Medical, are a great example of the dangers of overindulging in transhuman technologies and possibilities. They push the limits and they cut corners. Their ethics are, to say the least, questionable. Because of this, we decided to give her the strongest and purest Renaissance fashion of all the characters in *Human Revolution*."

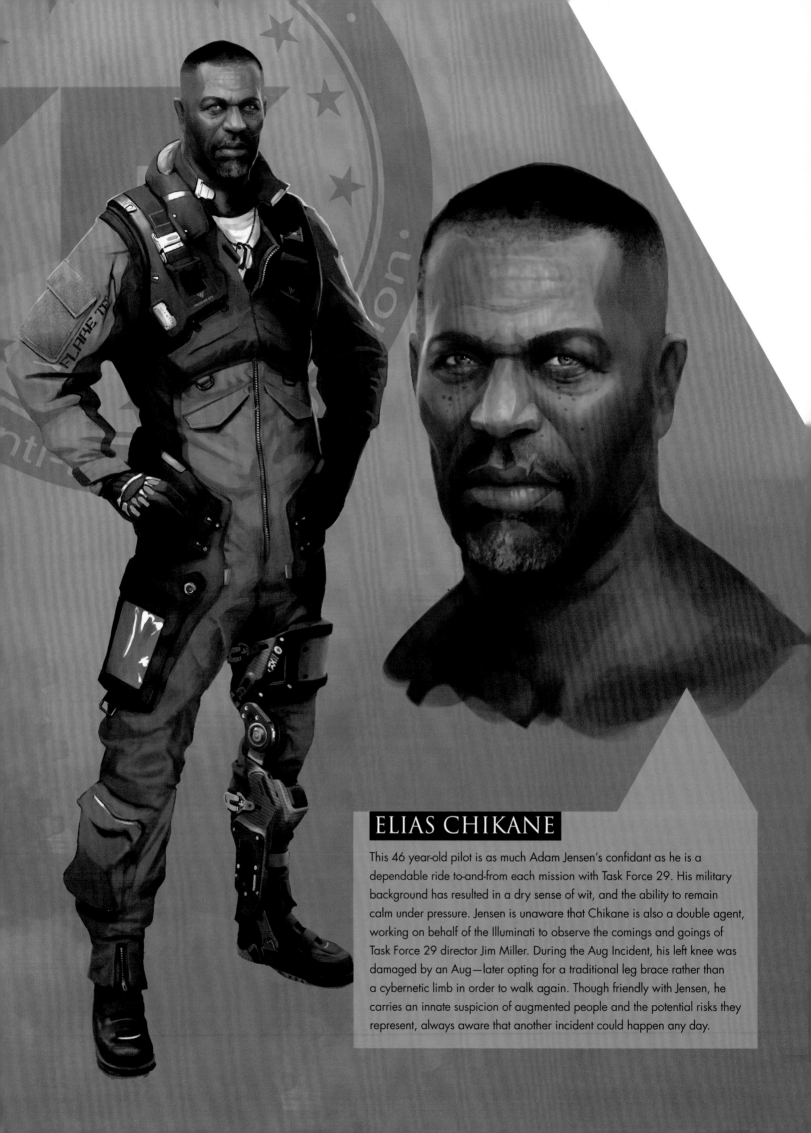

ELIAS CHIKANE

This 46 year-old pilot is as much Adam Jensen's confidant as he is a dependable ride to-and-from each mission with Task Force 29. His military background has resulted in a dry sense of wit, and the ability to remain calm under pressure. Jensen is unaware that Chikane is also a double agent, working on behalf of the Illuminati to observe the comings and goings of Task Force 29 director Jim Miller. During the Aug Incident, his left knee was damaged by an Aug—later opting for a traditional leg brace rather than a cybernetic limb in order to walk again. Though friendly with Jensen, he carries an innate suspicion of augmented people and the potential risks they represent, always aware that another incident could happen any day.

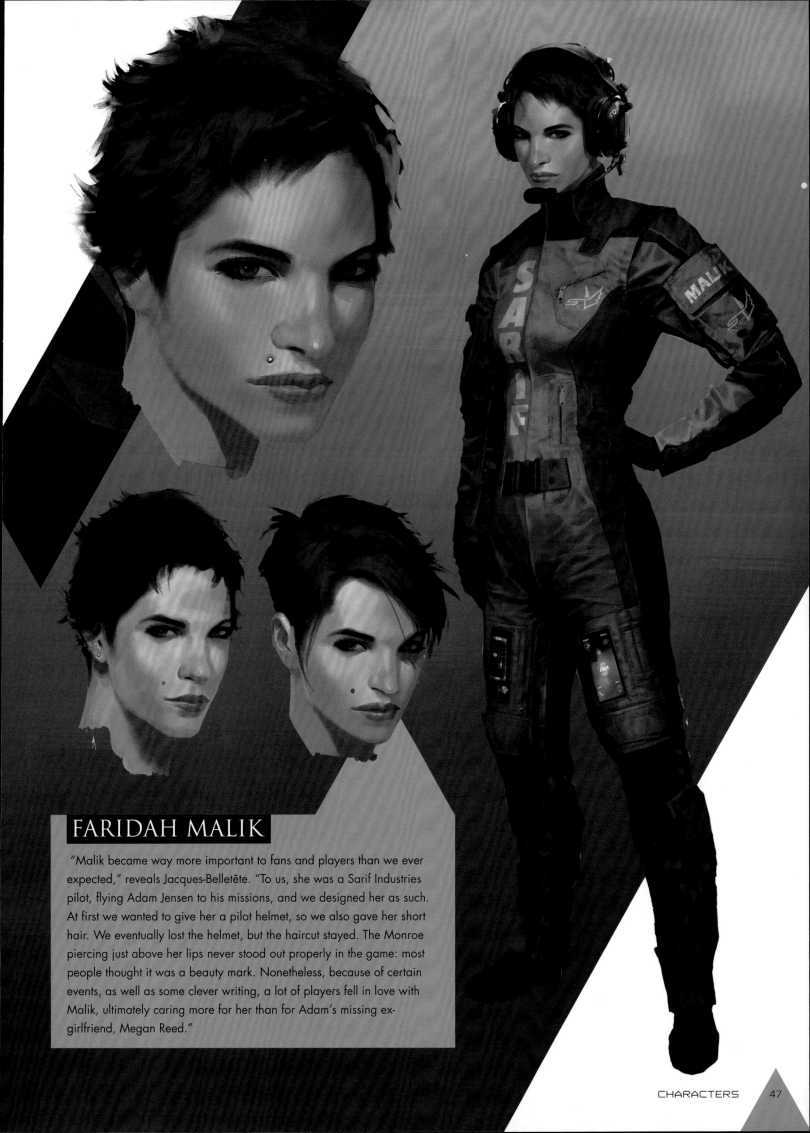

FARIDAH MALIK

"Malik became way more important to fans and players than we ever expected," reveals Jacques-Belletête. "To us, she was a Sarif Industries pilot, flying Adam Jensen to his missions, and we designed her as such. At first we wanted to give her a pilot helmet, so we also gave her short hair. We eventually lost the helmet, but the haircut stayed. The Monroe piercing just above her lips never stood out properly in the game: most people thought it was a beauty mark. Nonetheless, because of certain events, as well as some clever writing, a lot of players fell in love with Malik, ultimately caring more for her than for Adam's missing ex-girlfriend, Megan Reed."

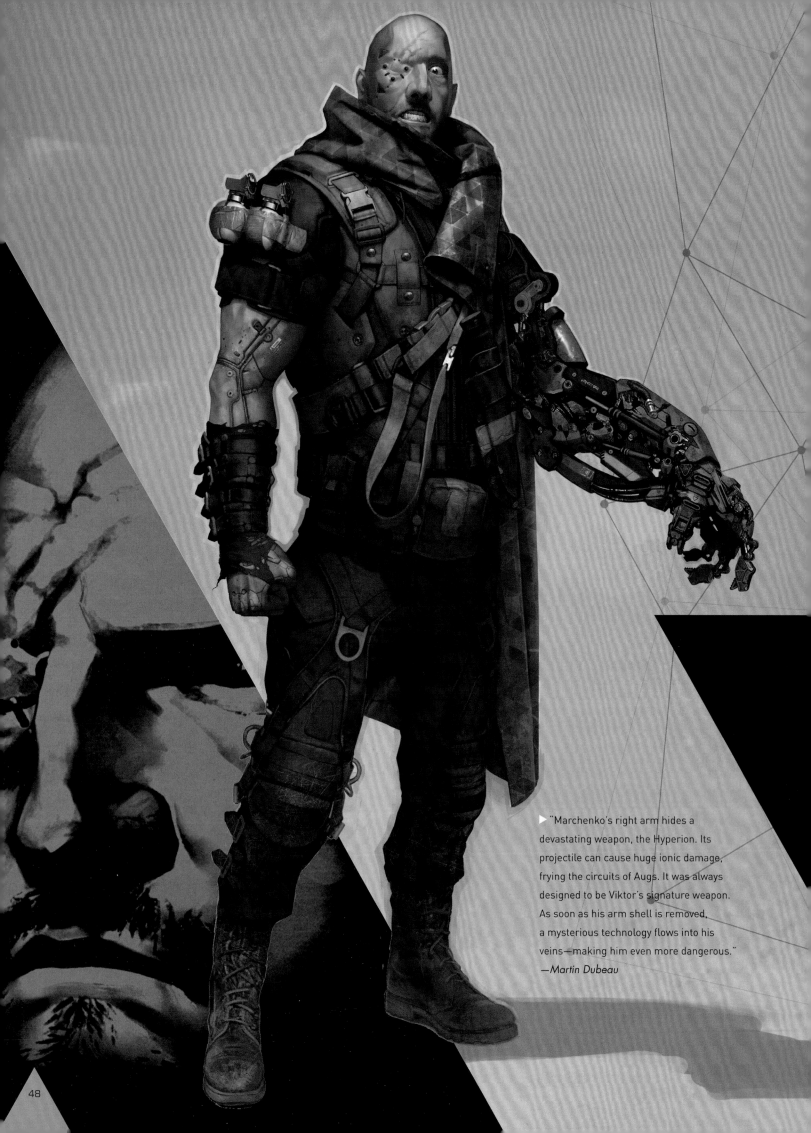

▶ "Marchenko's right arm hides a devastating weapon, the Hyperion. Its projectile can cause huge ionic damage, frying the circuits of Augs. It was always designed to be Viktor's signature weapon. As soon as his arm shell is removed, a mysterious technology flows into his veins—making him even more dangerous."
—Martin Dubeau

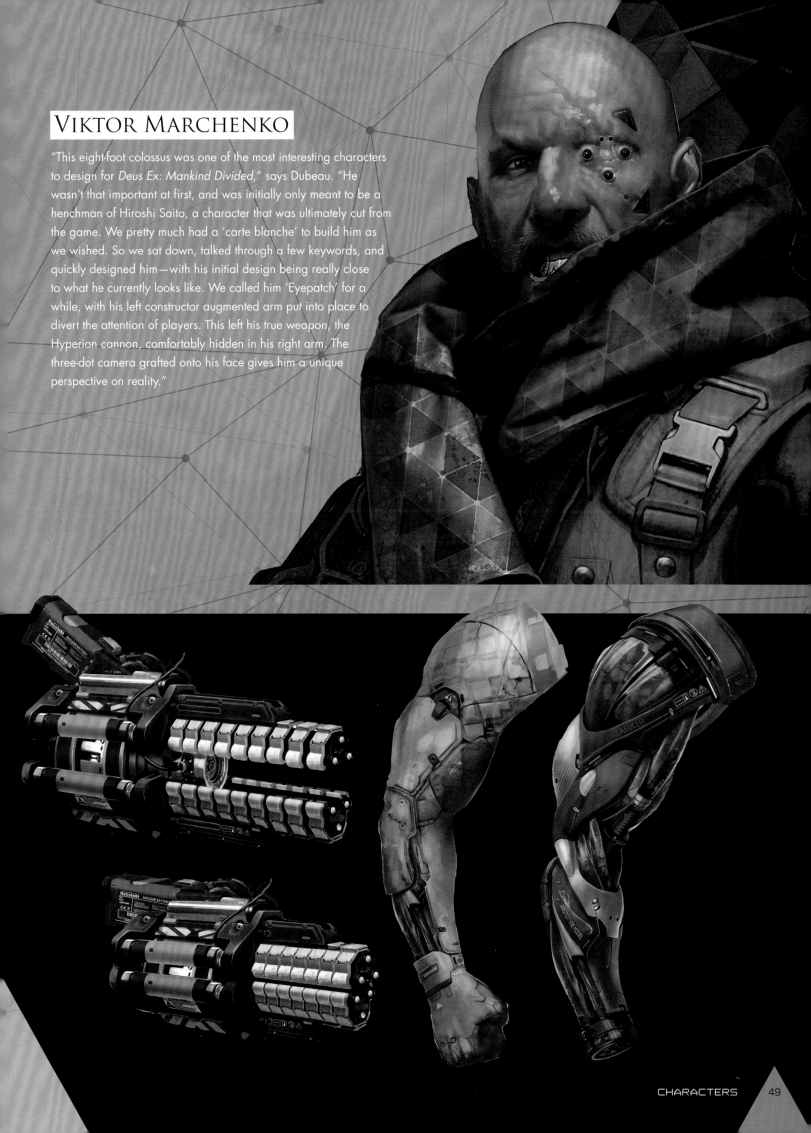

VIKTOR MARCHENKO

"This eight-foot colossus was one of the most interesting characters to design for *Deus Ex: Mankind Divided*," says Dubeau. "He wasn't that important at first, and was initially only meant to be a henchman of Hiroshi Saito, a character that was ultimately cut from the game. We pretty much had a 'carte blanche' to build him as we wished. So we sat down, talked through a few keywords, and quickly designed him—with his initial design being really close to what he currently looks like. We called him 'Eyepatch' for a while, with his left constructor augmented arm put into place to divert the attention of players. This left his true weapon, the Hyperion cannon, comfortably hidden in his right arm. The three-dot camera grafted onto his face gives him a unique perspective on reality."

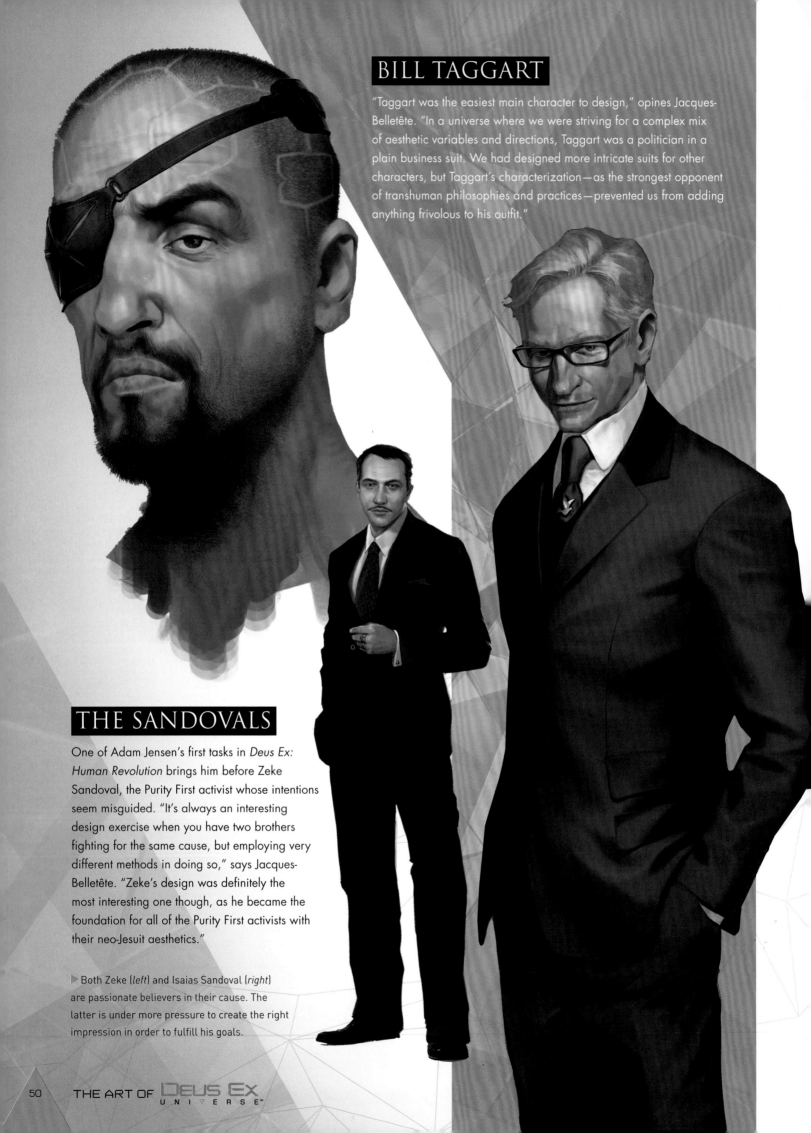

BILL TAGGART

"Taggart was the easiest main character to design," opines Jacques-Belletête. "In a universe where we were striving for a complex mix of aesthetic variables and directions, Taggart was a politician in a plain business suit. We had designed more intricate suits for other characters, but Taggart's characterization—as the strongest opponent of transhuman philosophies and practices—prevented us from adding anything frivolous to his outfit."

THE SANDOVALS

One of Adam Jensen's first tasks in *Deus Ex: Human Revolution* brings him before Zeke Sandoval, the Purity First activist whose intentions seem misguided. "It's always an interesting design exercise when you have two brothers fighting for the same cause, but employing very different methods in doing so," says Jacques-Belletête. "Zeke's design was definitely the most interesting one though, as he became the foundation for all of the Purity First activists with their neo-Jesuit aesthetics."

▶ Both Zeke (*left*) and Isaias Sandoval (*right*) are passionate believers in their cause. The latter is under more pressure to create the right impression in order to fulfill his goals.

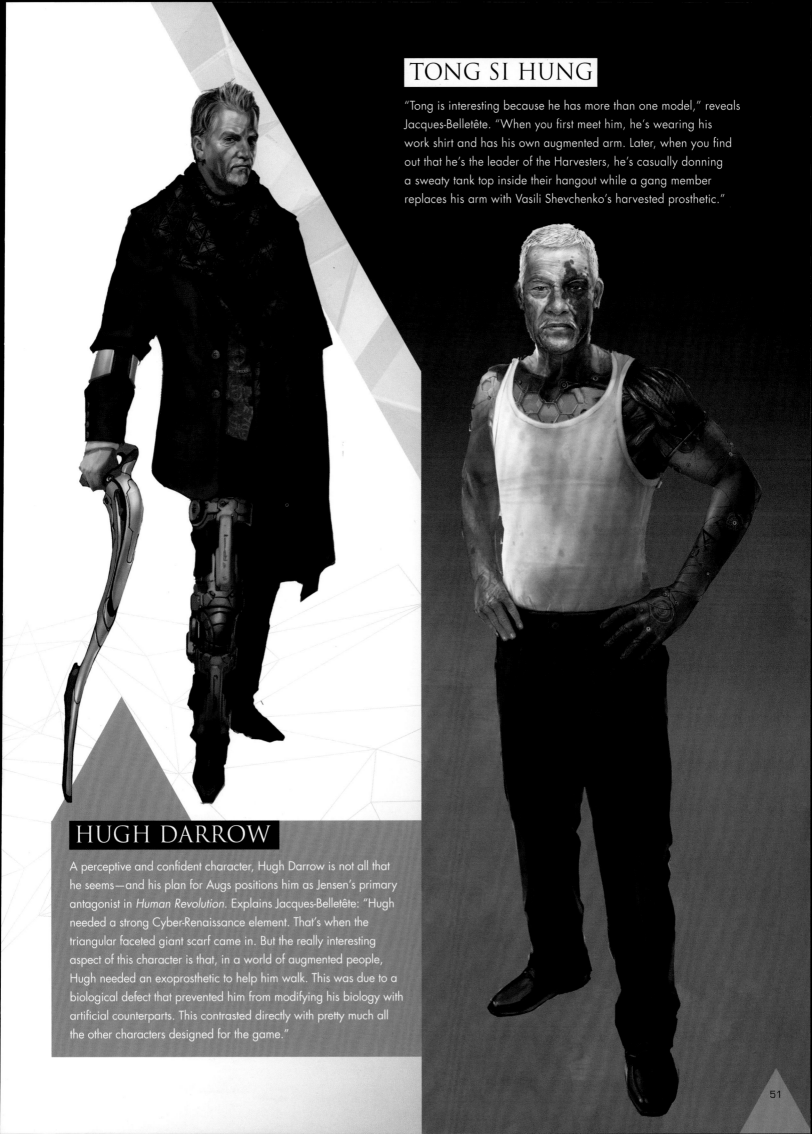

TONG SI HUNG

"Tong is interesting because he has more than one model," reveals Jacques-Belletête. "When you first meet him, he's wearing his work shirt and has his own augmented arm. Later, when you find out that he's the leader of the Harvesters, he's casually donning a sweaty tank top inside their hangout while a gang member replaces his arm with Vasili Shevchenko's harvested prosthetic."

HUGH DARROW

A perceptive and confident character, Hugh Darrow is not all that he seems—and his plan for Augs positions him as Jensen's primary antagonist in *Human Revolution*. Explains Jacques-Belletête: "Hugh needed a strong Cyber-Renaissance element. That's when the triangular faceted giant scarf came in. But the really interesting aspect of this character is that, in a world of augmented people, Hugh needed an exoprosthetic to help him walk. This was due to a biological defect that prevented him from modifying his biology with artificial counterparts. This contrasted directly with pretty much all the other characters designed for the game."

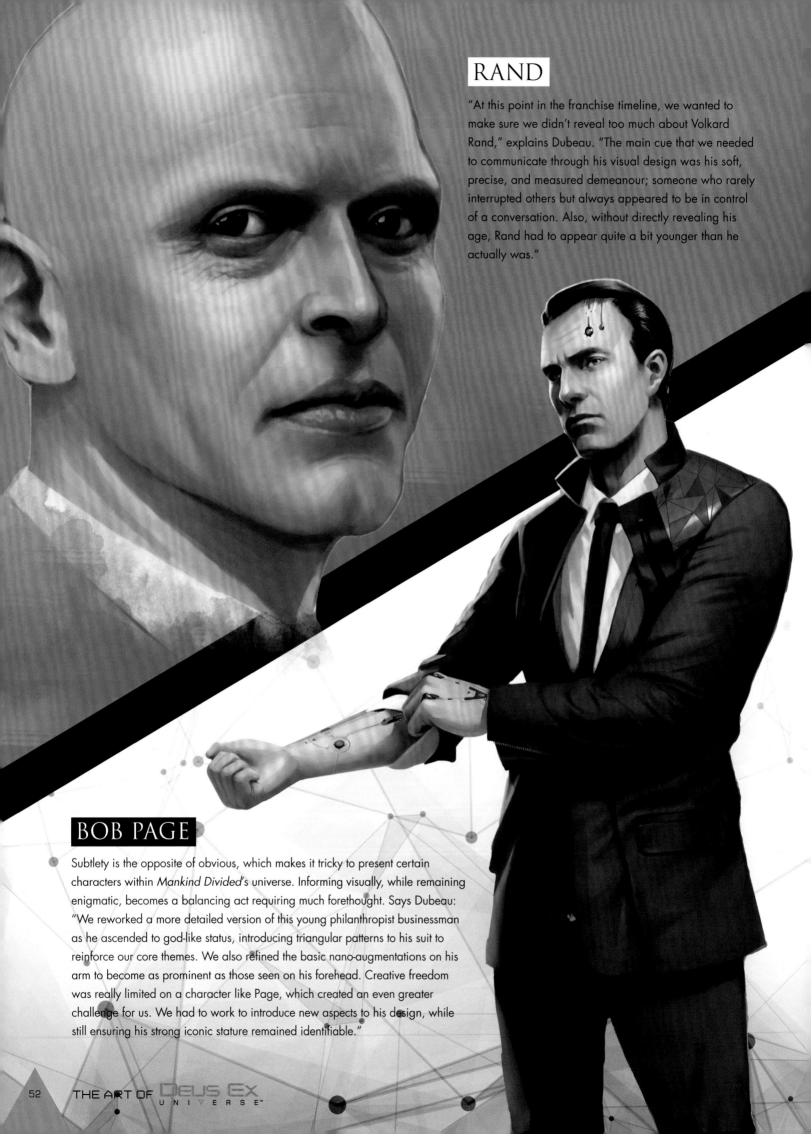

RAND

"At this point in the franchise timeline, we wanted to make sure we didn't reveal too much about Volkard Rand," explains Dubeau. "The main cue that we needed to communicate through his visual design was his soft, precise, and measured demeanour; someone who rarely interrupted others but always appeared to be in control of a conversation. Also, without directly revealing his age, Rand had to appear quite a bit younger than he actually was."

BOB PAGE

Subtlety is the opposite of obvious, which makes it tricky to present certain characters within *Mankind Divided*'s universe. Informing visually, while remaining enigmatic, becomes a balancing act requiring much forethought. Says Dubeau: "We reworked a more detailed version of this young philanthropist businessman as he ascended to god-like status, introducing triangular patterns to his suit to reinforce our core themes. We also refined the basic nano-augmentations on his arm to become as prominent as those seen on his forehead. Creative freedom was really limited on a character like Page, which created an even greater challenge for us. We had to work to introduce new aspects to his design, while still ensuring his strong iconic stature remained identifiable."

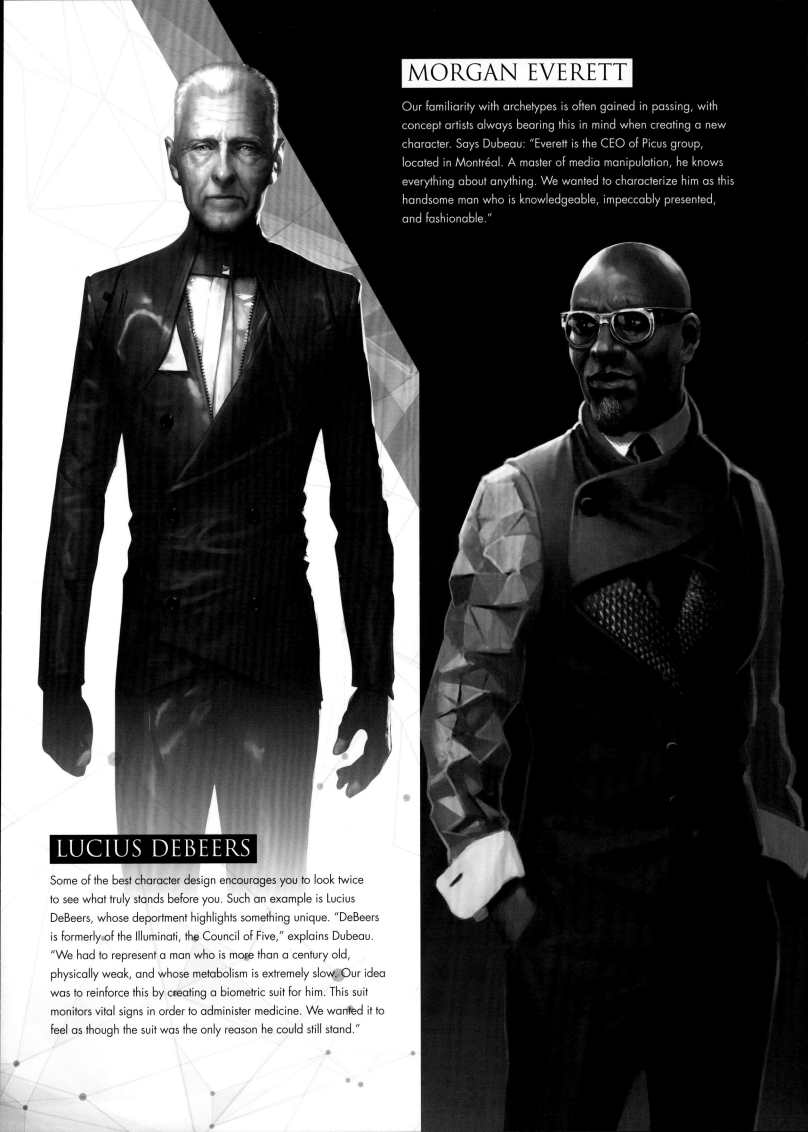

MORGAN EVERETT

Our familiarity with archetypes is often gained in passing, with concept artists always bearing this in mind when creating a new character. Says Dubeau: "Everett is the CEO of Picus group, located in Montréal. A master of media manipulation, he knows everything about anything. We wanted to characterize him as this handsome man who is knowledgeable, impeccably presented, and fashionable."

LUCIUS DEBEERS

Some of the best character design encourages you to look twice to see what truly stands before you. Such an example is Lucius DeBeers, whose deportment highlights something unique. "DeBeers is formerly of the Illuminati, the Council of Five," explains Dubeau. "We had to represent a man who is more than a century old, physically weak, and whose metabolism is extremely slow. Our idea was to reinforce this by creating a biometric suit for him. This suit monitors vital signs in order to administer medicine. We wanted it to feel as though the suit was the only reason he could still stand."

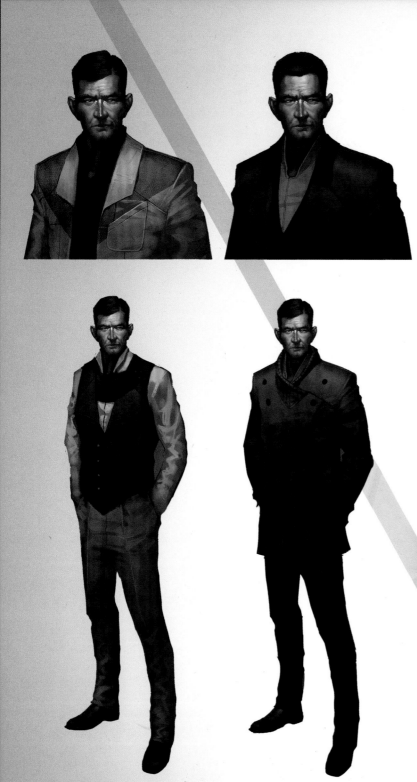

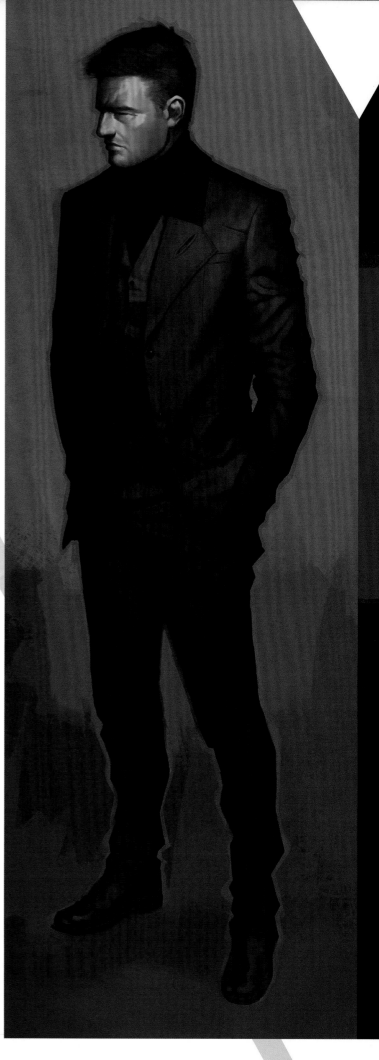

JIM MILLER

"Jim is the leader of Task Force 29, a covert, Interpol-sanctioned Task Force, dedicated to fighting the rising tide of organized Aug crime and terrorism. He has two sides to his character: Jim is most favorably observed as a relatable, capable, and principled leader— however, Jim is also secretive and evasive, sometimes impatient, and, on occasion, introspective," reveals Dubeau on the design origins of Miller. "We also wanted to represent him as a paternal figure. We created many variations of Jim throughout production, but the definitive one clearly represents the character we originally envisioned. The latest version of Jim was inspired by Rutger Hauer, a 'clin d'oeil' to the character of Roy Batty in *Blade Runner*."

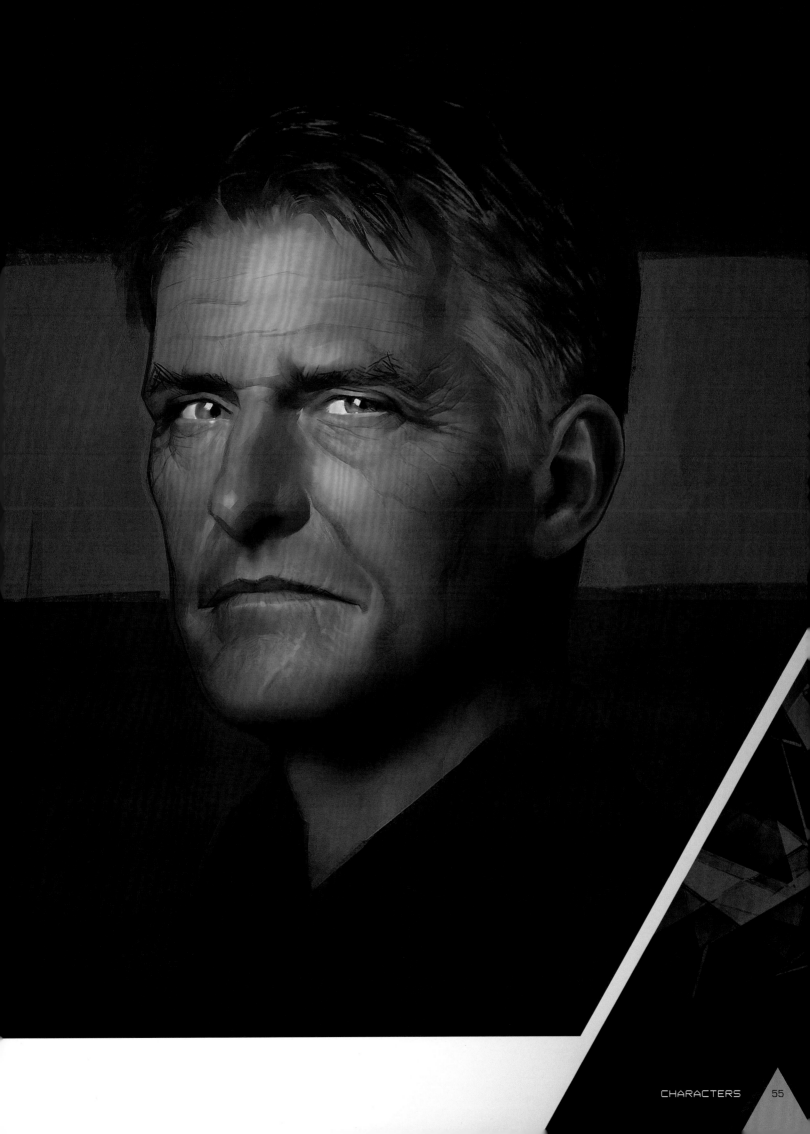

OTAR BOTKOVELI

"Otar is Radich Nikoladze's lieutenant in the Prague chapter of the Dvali crime family. His loyalty to Radich and the Dvalis is impervious; he does what he's told, and he achieves it with callous flair," states Dubeau. On his brick-like physique, Dubeau explains, "Otar is a little bit too wide for his height. He's not obese, just thick. His age is visible on his face, and he relentlessly slicks back his graying hair. Otar's visual design was previously assigned to Radich but, later in production, they ended up becoming two distinct characters."

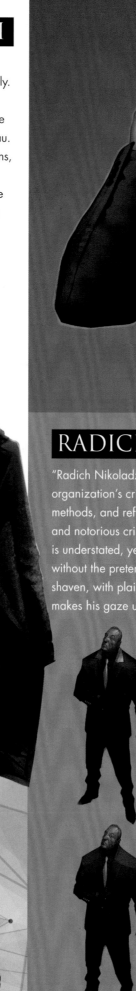

RADICH NIKOLADZE

"Radich Nikoladze is the young, driven, and ruthless leader of the Dvali organization's criminal operations in Prague. His strategic mind, callous methods, and refusal to compromise, make him one of the most feared and notorious crime lords in the EU," explains Dubeau. "Radich's look is understated, yet stylish, and easily conveys power and sophistication without the pretentiousness of typical gangsters. He is always clean-shaven, with plain, but perfectly styled hair. The absence of eyebrows makes his gaze uncomfortable for those trying to deal with him."

Maybe no eyebrows, less expression, more difficult to read...

Scar?

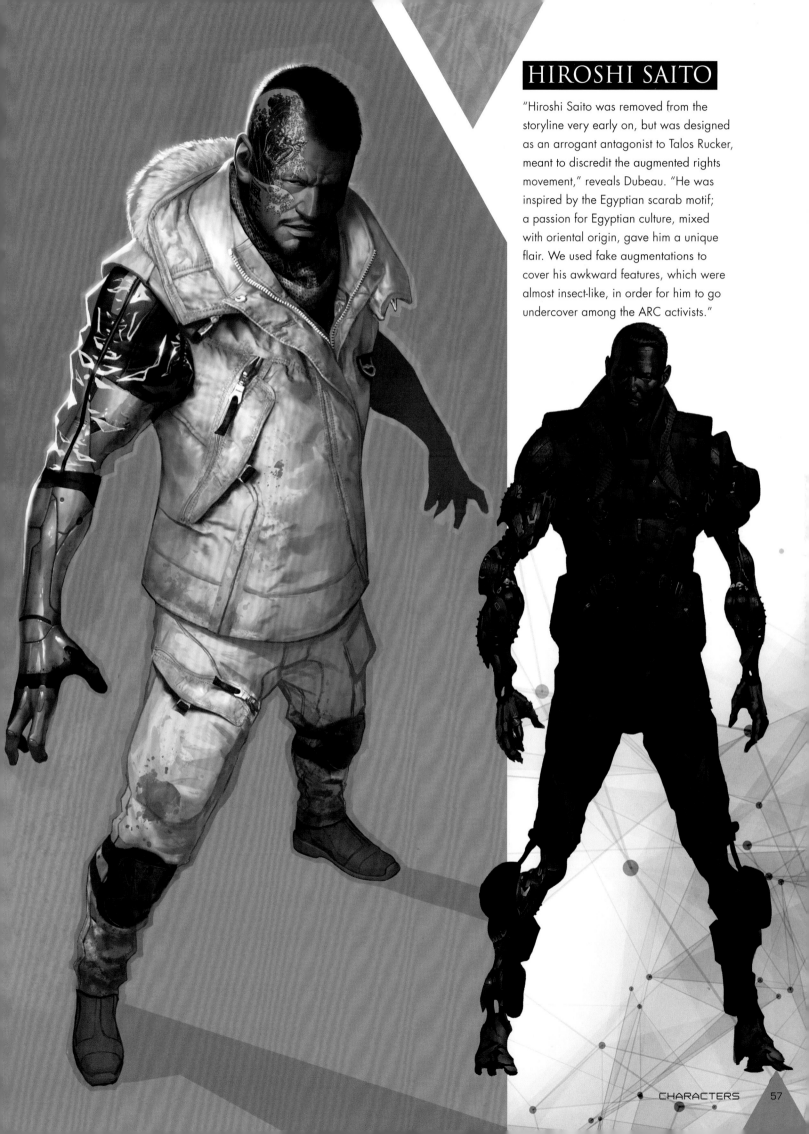

HIROSHI SAITO

"Hiroshi Saito was removed from the storyline very early on, but was designed as an arrogant antagonist to Talos Rucker, meant to discredit the augmented rights movement," reveals Dubeau. "He was inspired by the Egyptian scarab motif; a passion for Egyptian culture, mixed with oriental origin, gave him a unique flair. We used fake augmentations to cover his awkward features, which were almost insect-like, in order for him to go undercover among the ARC activists."

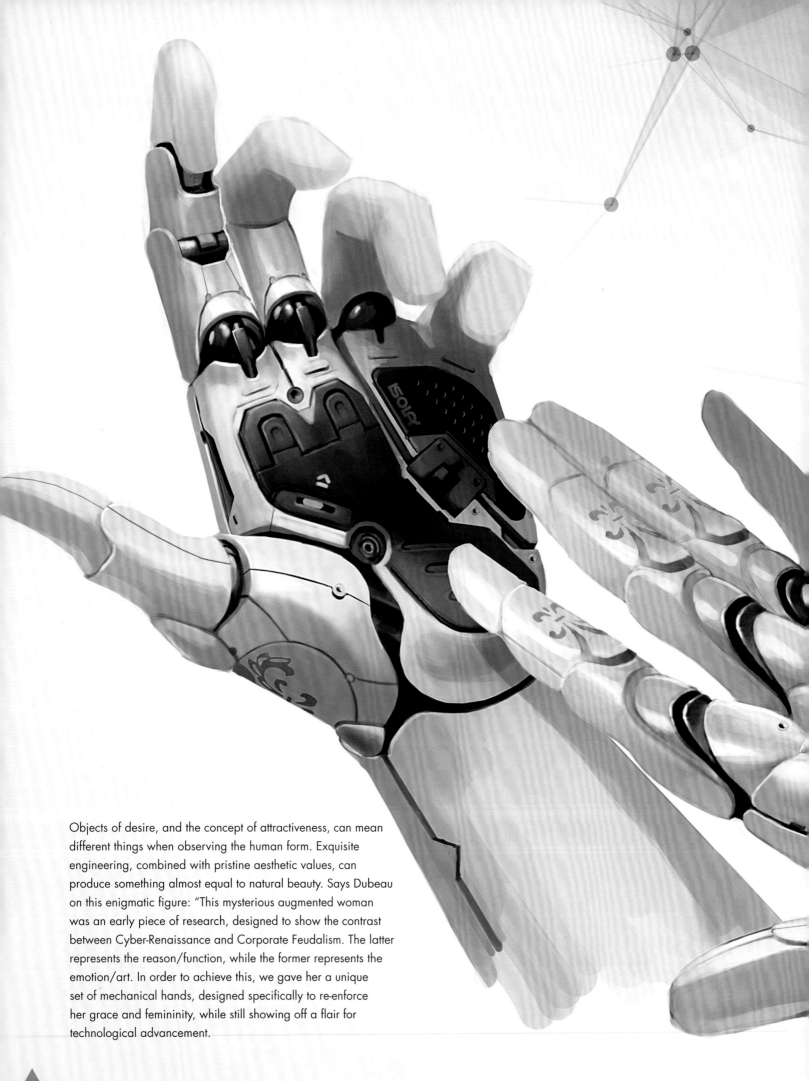

Objects of desire, and the concept of attractiveness, can mean different things when observing the human form. Exquisite engineering, combined with pristine aesthetic values, can produce something almost equal to natural beauty. Says Dubeau on this enigmatic figure: "This mysterious augmented woman was an early piece of research, designed to show the contrast between Cyber-Renaissance and Corporate Feudalism. The latter represents the reason/function, while the former represents the emotion/art. In order to achieve this, we gave her a unique set of mechanical hands, designed specifically to re-enforce her grace and femininity, while still showing off a flair for technological advancement.

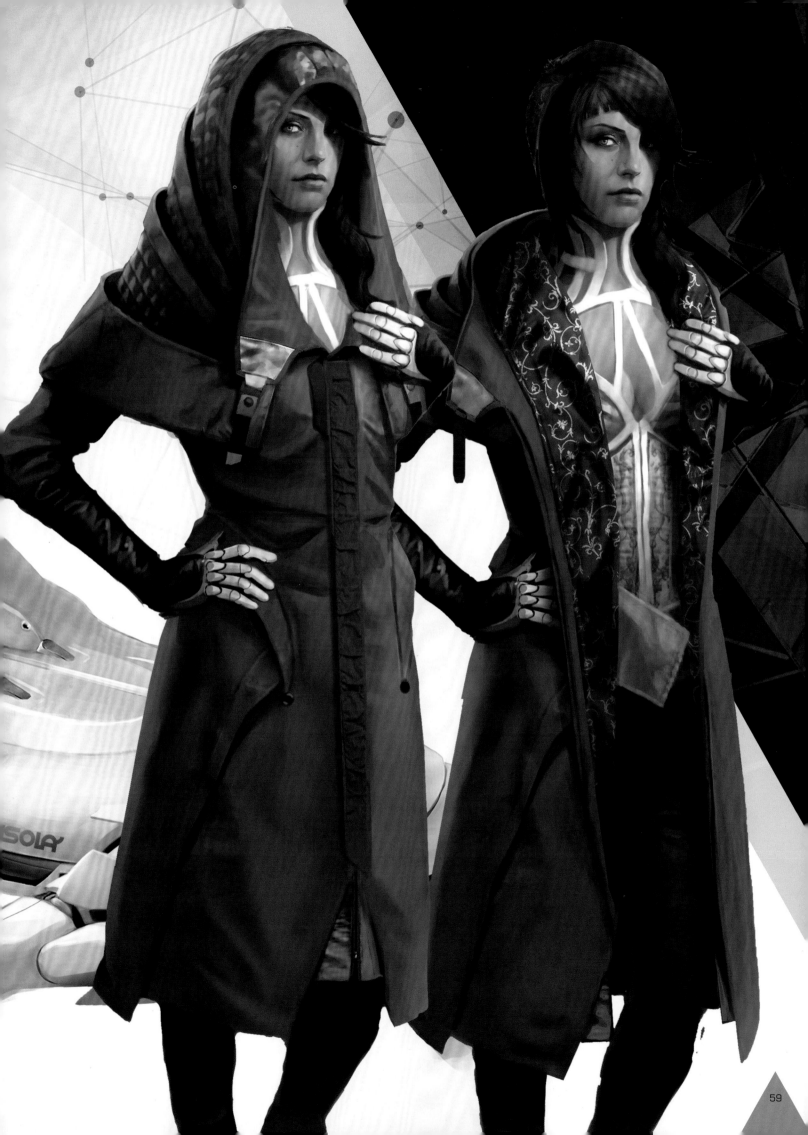

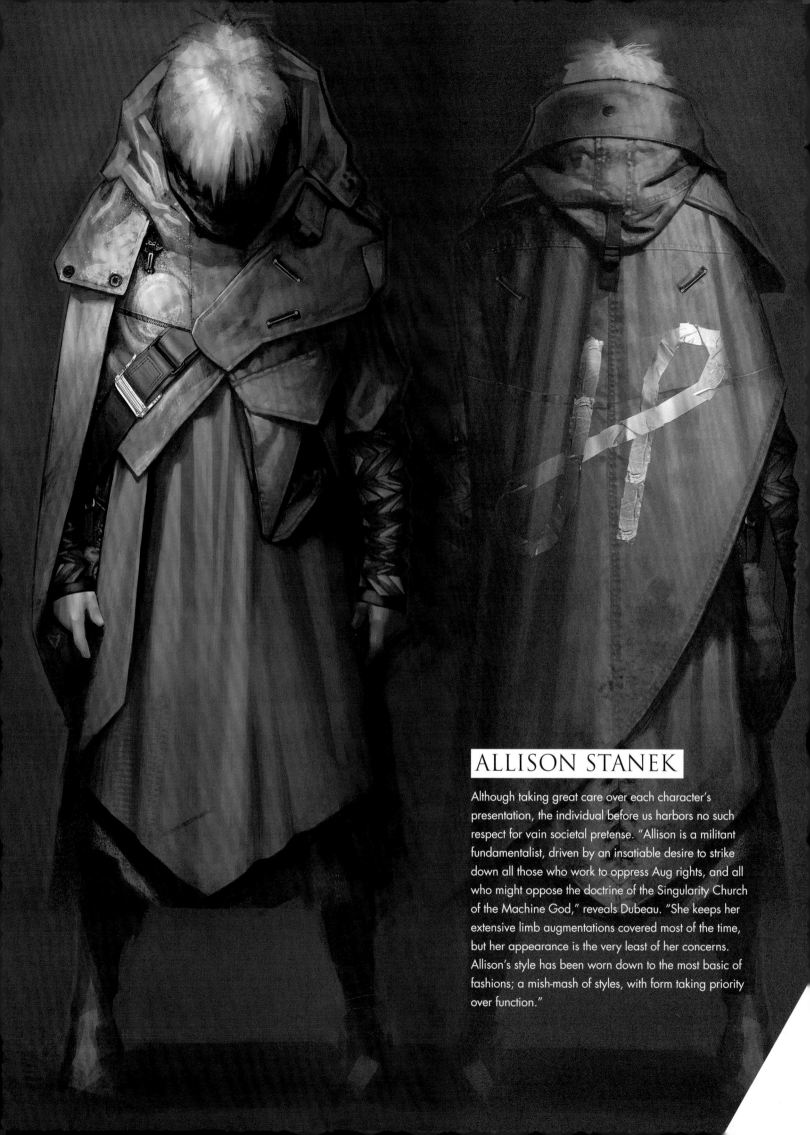

ALLISON STANEK

Although taking great care over each character's presentation, the individual before us harbors no such respect for vain societal pretense. "Allison is a militant fundamentalist, driven by an insatiable desire to strike down all those who work to oppress Aug rights, and all who might oppose the doctrine of the Singularity Church of the Machine God," reveals Dubeau. "She keeps her extensive limb augmentations covered most of the time, but her appearance is the very least of her concerns. Allison's style has been worn down to the most basic of fashions; a mish-mash of styles, with form taking priority over function."

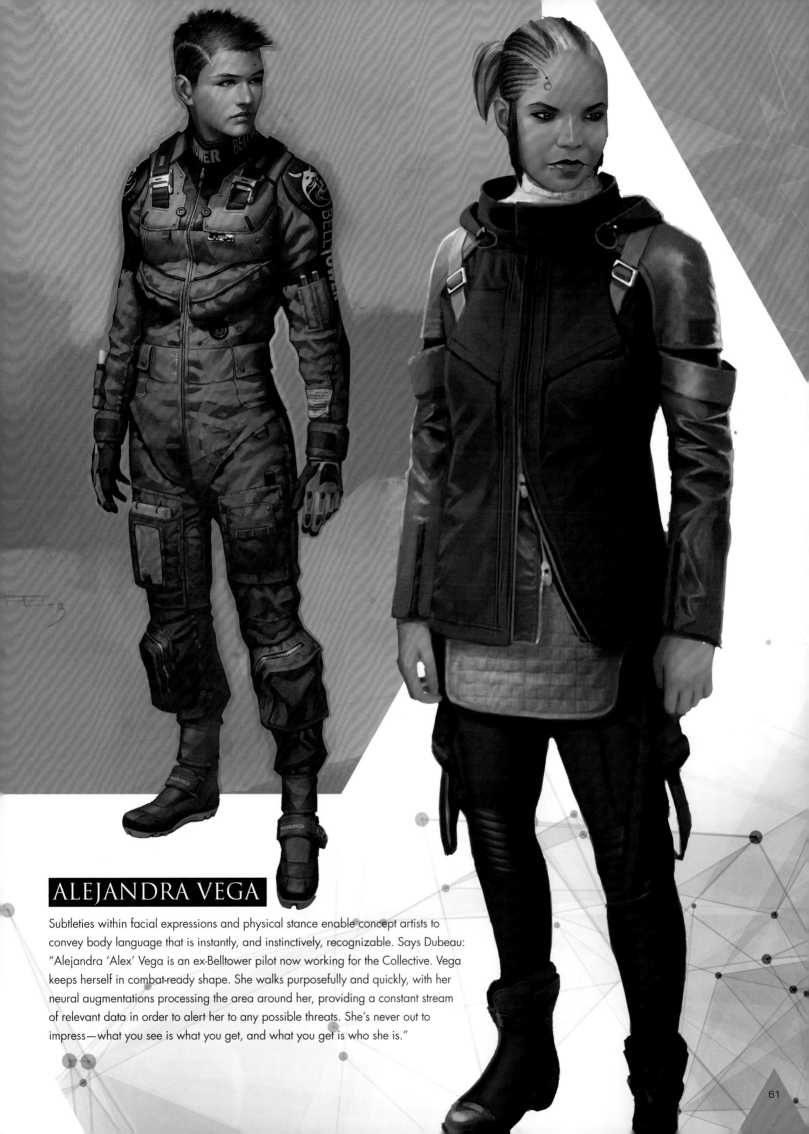

ALEJANDRA VEGA

Subtleties within facial expressions and physical stance enable concept artists to convey body language that is instantly, and instinctively, recognizable. Says Dubeau: "Alejandra 'Alex' Vega is an ex-Belltower pilot now working for the Collective. Vega keeps herself in combat-ready shape. She walks purposefully and quickly, with her neural augmentations processing the area around her, providing a constant stream of relevant data in order to alert her to any possible threats. She's never out to impress—what you see is what you get, and what you get is who she is."

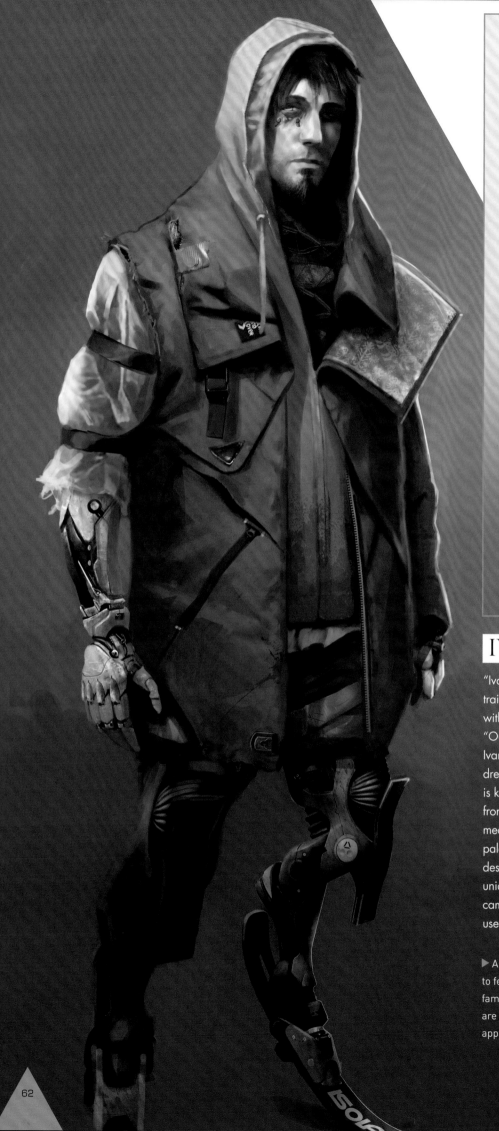

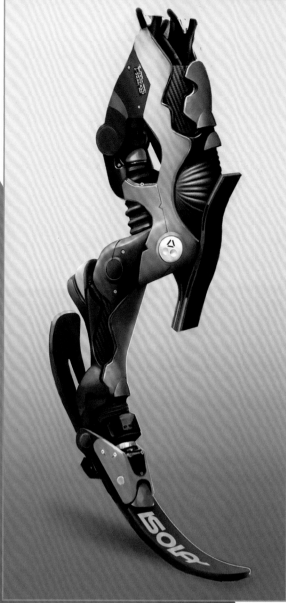

IVAN BERK

"Ivan was first created as a character for the project's trailer. It was only later that we decided to include him within the storyline of the game," informs Dubeau. "Our present day references allow us to recognize Ivan as an exceptional athlete of sorts; proudly dressed, though function comes first, and every detail is key. Ivan was designed with strong archetypes from the ARC Revolutionaries: facial augmentations, mechanical arms, jumping blades, and a golden palette. The upper right image shows the original design for the jumping blades, an augment that is unique to ARC combatants. Our inspiration for these came from the Flex-Foot Cheetah prosthetic, commonly used amongst paralympians."

▶ A near-future premise allows for present day objects to feel welcome within a fictional setting. In a way, familiarity helps to make everything feel consistent. We are surrounded by imagery of fast-moving technology that appears to be ahead of its time.

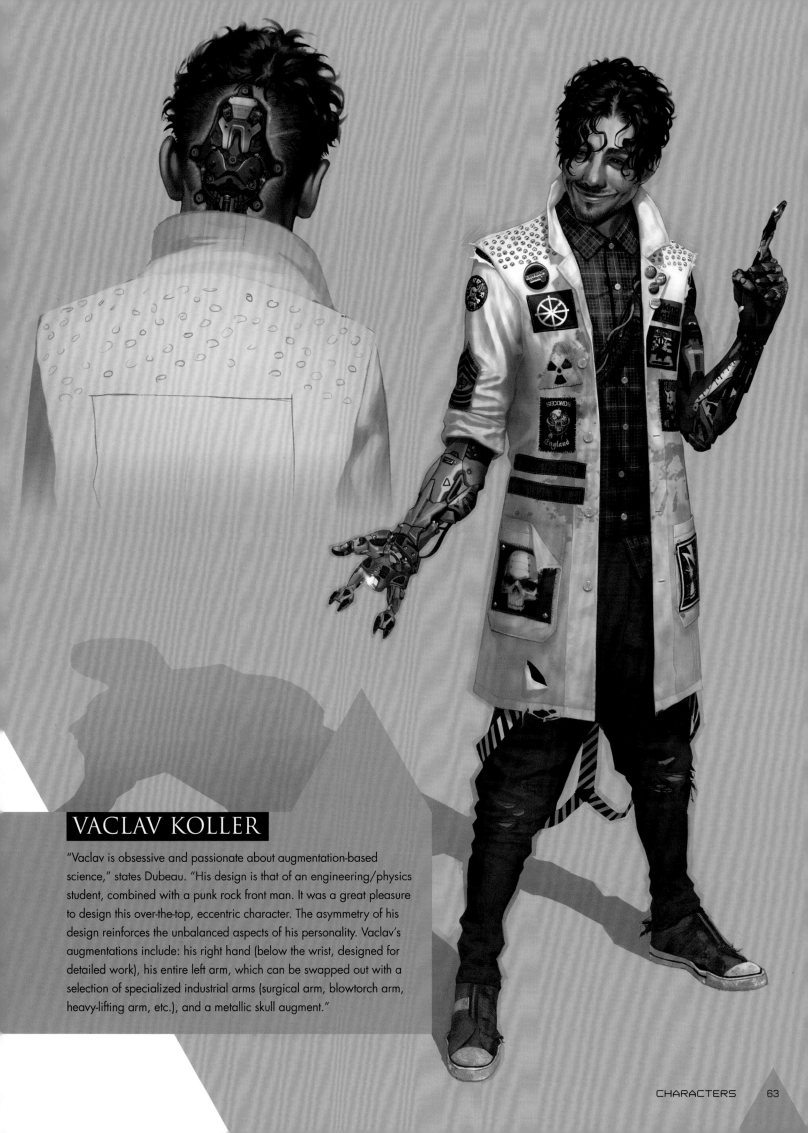

VACLAV KOLLER

"Vaclav is obsessive and passionate about augmentation-based science," states Dubeau. "His design is that of an engineering/physics student, combined with a punk rock front man. It was a great pleasure to design this over-the-top, eccentric character. The asymmetry of his design reinforces the unbalanced aspects of his personality. Vaclav's augmentations include: his right hand (below the wrist, designed for detailed work), his entire left arm, which can be swapped out with a selection of specialized industrial arms (surgical arm, blowtorch arm, heavy-lifting arm, etc.), and a metallic skull augment."

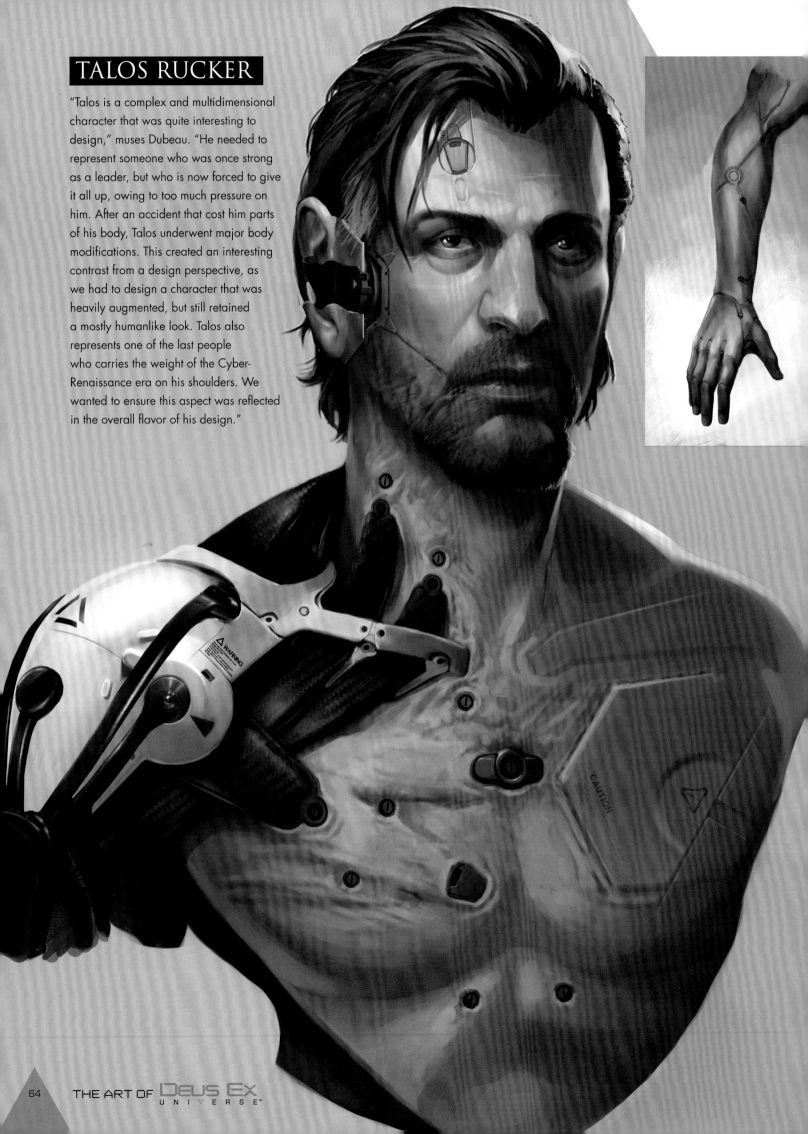

TALOS RUCKER

"Talos is a complex and multidimensional character that was quite interesting to design," muses Dubeau. "He needed to represent someone who was once strong as a leader, but who is now forced to give it all up, owing to too much pressure on him. After an accident that cost him parts of his body, Talos underwent major body modifications. This created an interesting contrast from a design perspective, as we had to design a character that was heavily augmented, but still retained a mostly humanlike look. Talos also represents one of the last people who carries the weight of the Cyber-Renaissance era on his shoulders. We wanted to ensure this aspect was reflected in the overall flavor of his design."

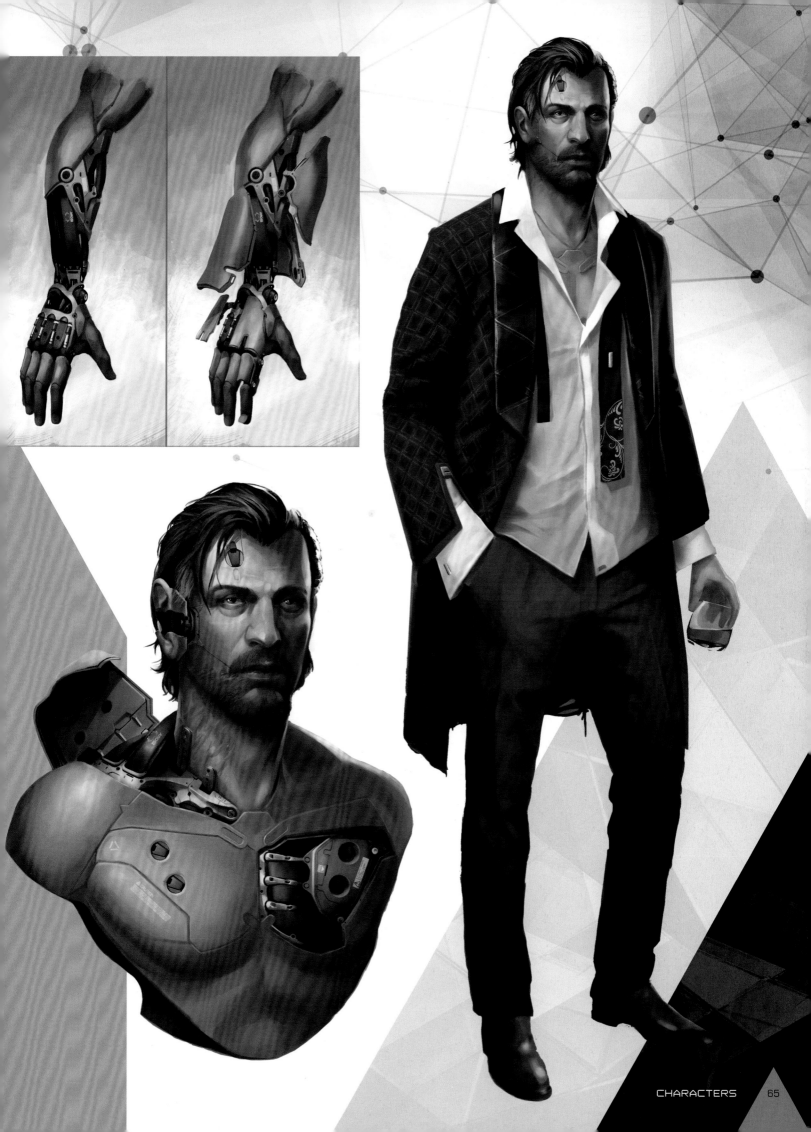

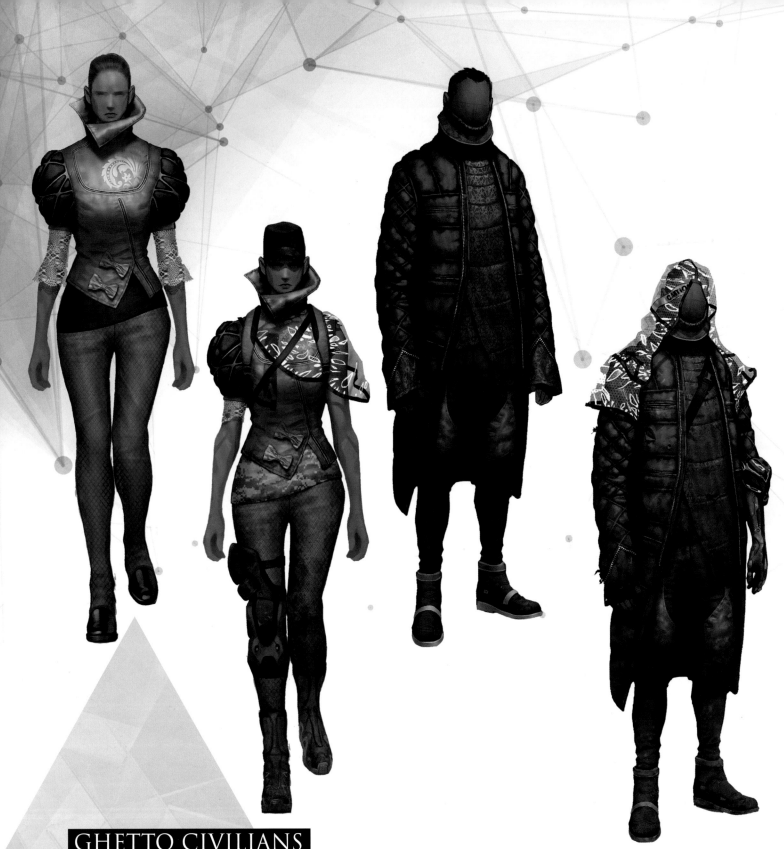

GHETTO CIVILIANS

"When the idea of segregating augmented people into a favela was brought to the table, it was clear in my mind that we needed to start from a Cyber-Renaissance aesthetic, but speak to the degradation of appearance owing to a life of poverty," reveals Dubeau. "In order to retain this essence, we started our concepts with a clean Cyber-Renaissance version, then we introduced age, damage, wear, and various types of patches. The result was quite satisfying; I really enjoyed the usage of transparent plastic sheets as part of the design. Starting from a mix of different contemporary garment designs and scavenged materials, we added a look that hinted at the fact that these people were wearing their clothes for a long time. They are not hobos, but they are clearly limited in their personal effects, reinforced with wear and tear scuffs. They also have to face Prague's cruel weather during Fall, and are directly linked to our Cyber-Renaissance design code."

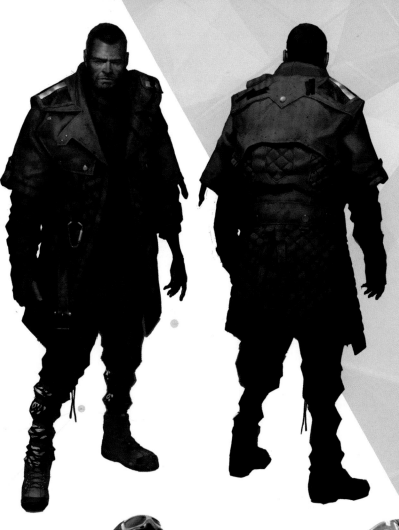

ARC REVOLUTIONARIES

While creating imagery for reference purposes, concept artists must bear in mind the ultimate goal, which is to bring everything to life within complex, animated, and interactive worlds. Video games now feature elaborate lighting and atmospheric effects to set the scene and enhance drama. Concepts must work well within these environments. Says Dubeau: "As part of our production milestones, we have to produce what we call a 'technical demo'. This concept of Quinn (left), adapted in the ghetto style, was designed to test our materials, animation, and modeling pipeline (Quinn was previously seen in *Deus Ex: The Missing Link*). The images below represent some of the concepts for the ARC revolutionaries. They were not supposed to represent war machines—rather, just ordinary, augmented, segregated people who want to fight for their freedom."

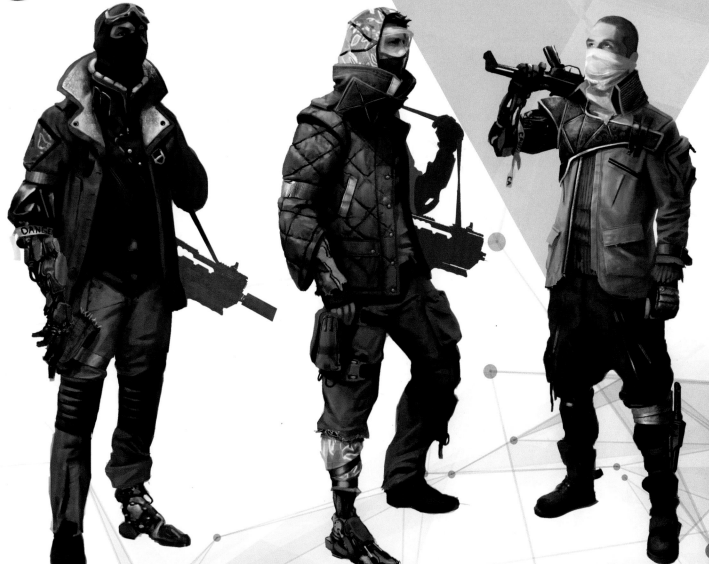

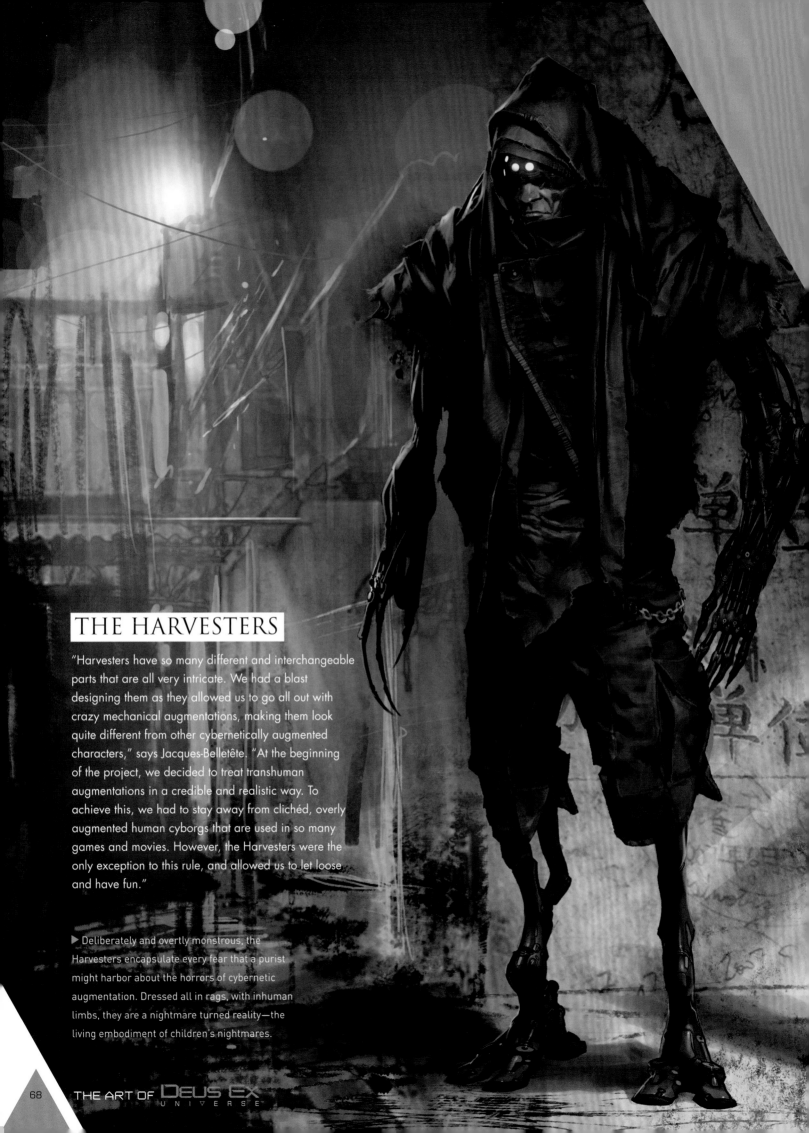

THE HARVESTERS

"Harvesters have so many different and interchangeable parts that are all very intricate. We had a blast designing them as they allowed us to go all out with crazy mechanical augmentations, making them look quite different from other cybernetically augmented characters," says Jacques-Belletête. "At the beginning of the project, we decided to treat transhuman augmentations in a credible and realistic way. To achieve this, we had to stay away from clichéd, overly augmented human cyborgs that are used in so many games and movies. However, the Harvesters were the only exception to this rule, and allowed us to let loose and have fun."

▶ Deliberately and overtly monstrous, the Harvesters encapsulate every fear that a purist might harbor about the horrors of cybernetic augmentation. Dressed all in rags, with inhuman limbs, they are a nightmare turned reality—the living embodiment of children's nightmares.

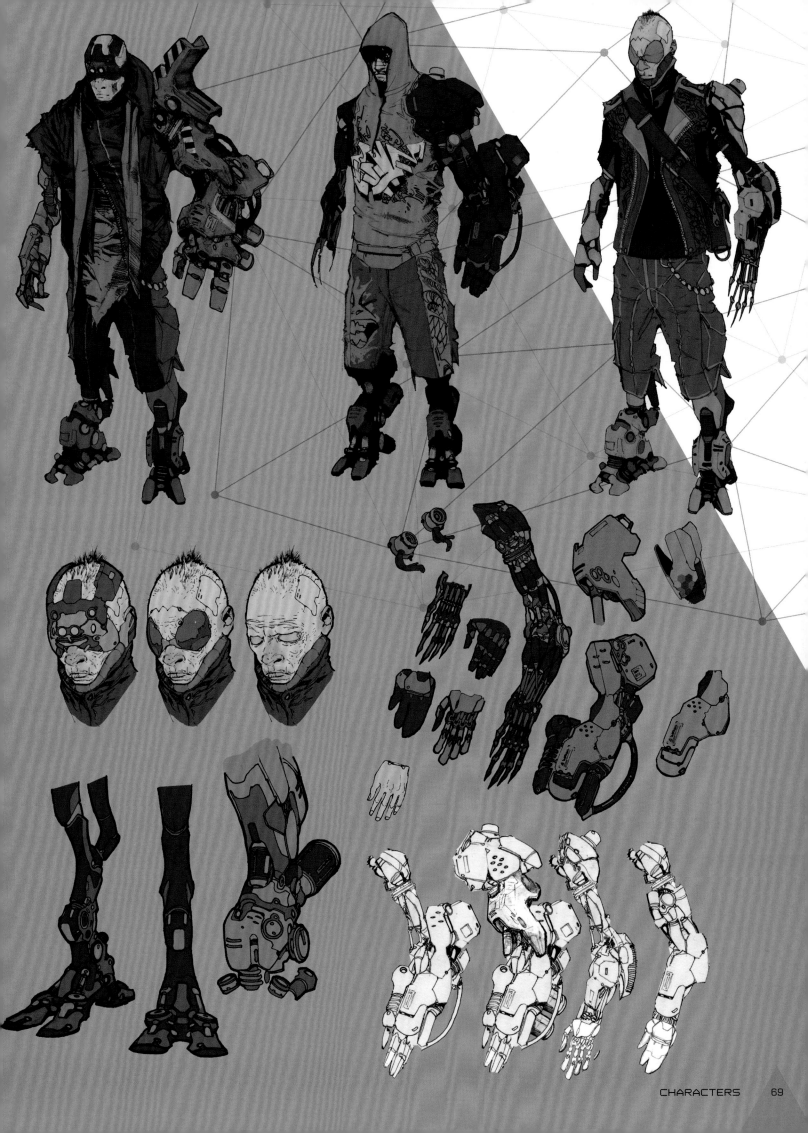

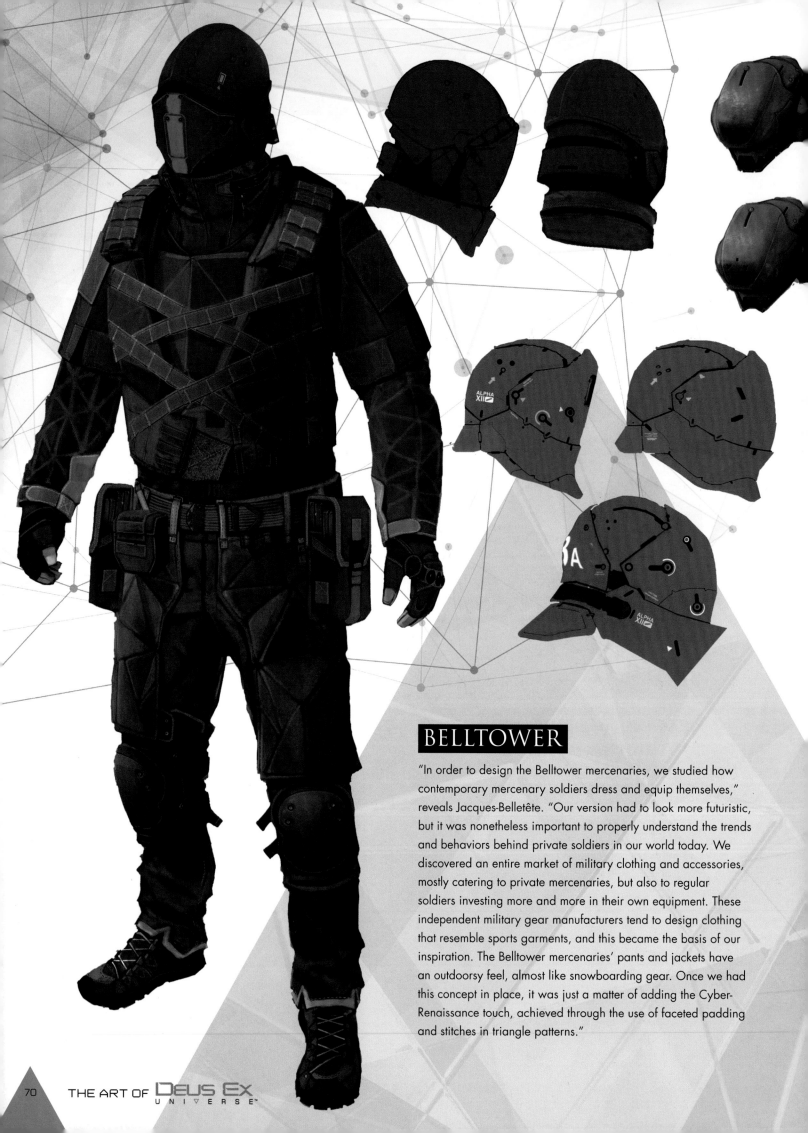

BELLTOWER

"In order to design the Belltower mercenaries, we studied how contemporary mercenary soldiers dress and equip themselves," reveals Jacques-Belletête. "Our version had to look more futuristic, but it was nonetheless important to properly understand the trends and behaviors behind private soldiers in our world today. We discovered an entire market of military clothing and accessories, mostly catering to private mercenaries, but also to regular soldiers investing more and more in their own equipment. These independent military gear manufacturers tend to design clothing that resemble sports garments, and this became the basis of our inspiration. The Belltower mercenaries' pants and jackets have an outdoorsy feel, almost like snowboarding gear. Once we had this concept in place, it was just a matter of adding the Cyber-Renaissance touch, achieved through the use of faceted padding and stitches in triangle patterns."

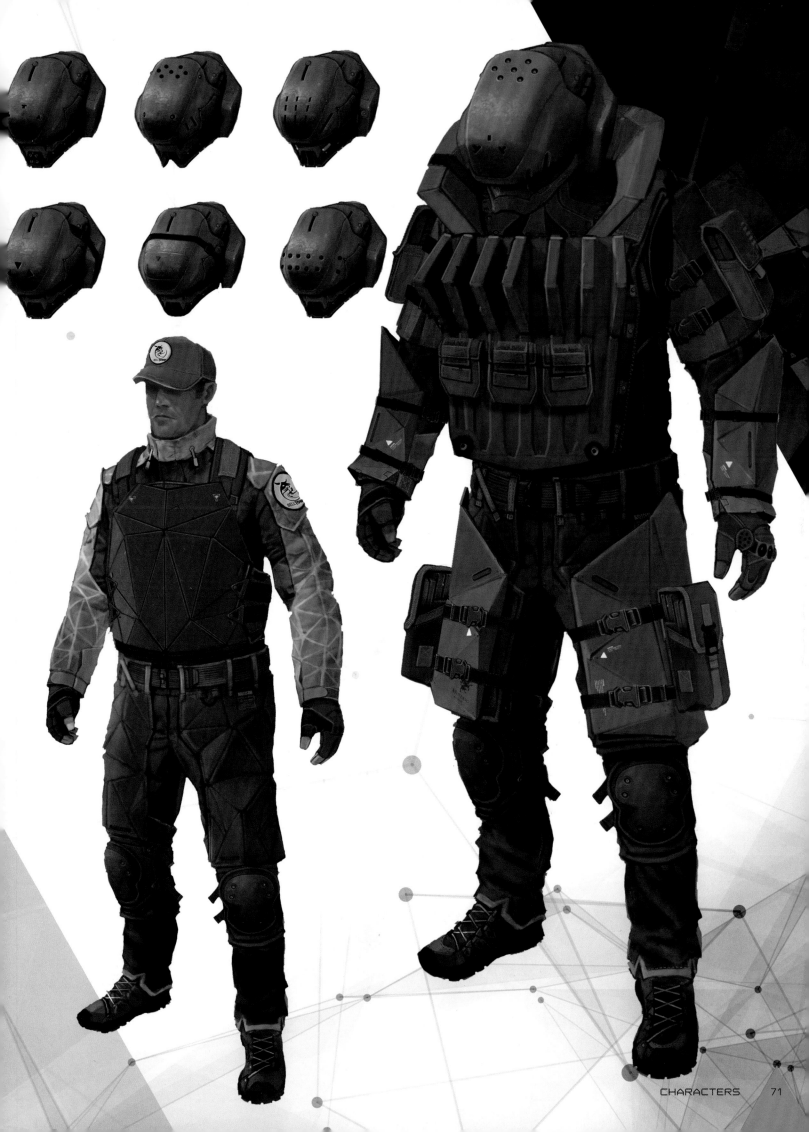

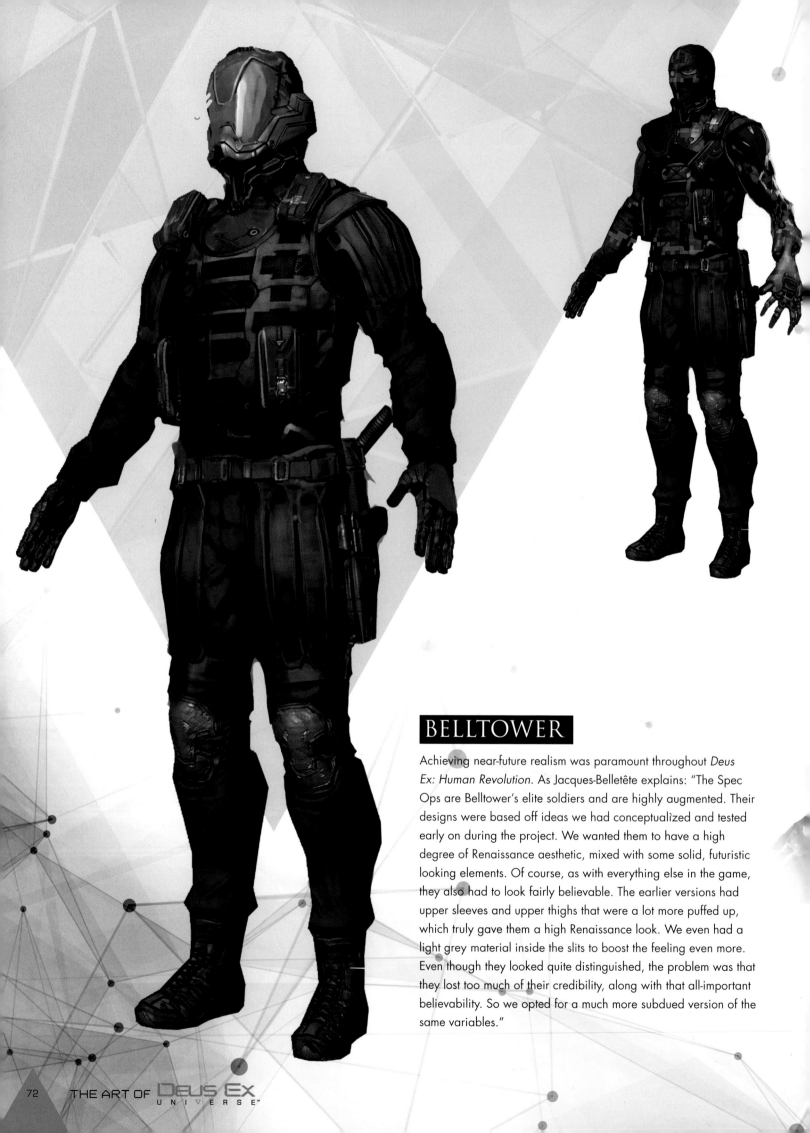

BELLTOWER

Achieving near-future realism was paramount throughout *Deus Ex: Human Revolution*. As Jacques-Belletête explains: "The Spec Ops are Belltower's elite soldiers and are highly augmented. Their designs were based off ideas we had conceptualized and tested early on during the project. We wanted them to have a high degree of Renaissance aesthetic, mixed with some solid, futuristic looking elements. Of course, as with everything else in the game, they also had to look fairly believable. The earlier versions had upper sleeves and upper thighs that were a lot more puffed up, which truly gave them a high Renaissance look. We even had a light grey material inside the slits to boost the feeling even more. Even though they looked quite distinguished, the problem was that they lost too much of their credibility, along with that all-important believability. So we opted for a much more subdued version of the same variables."

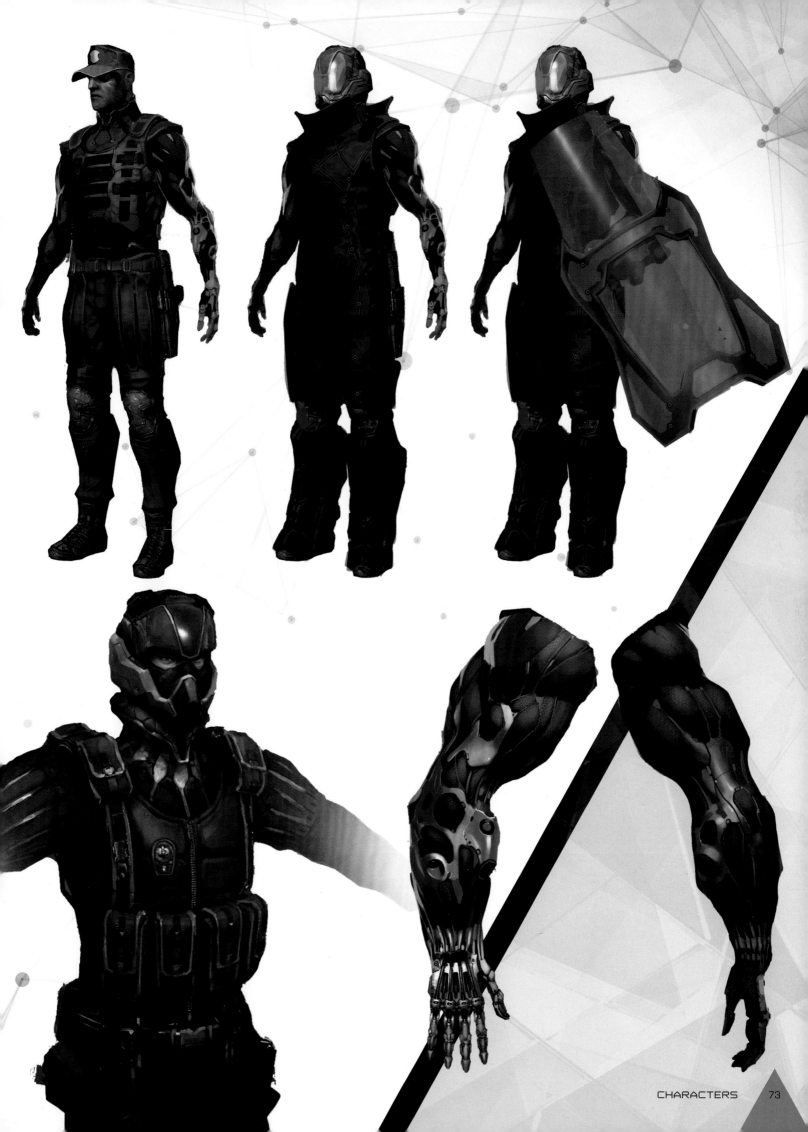

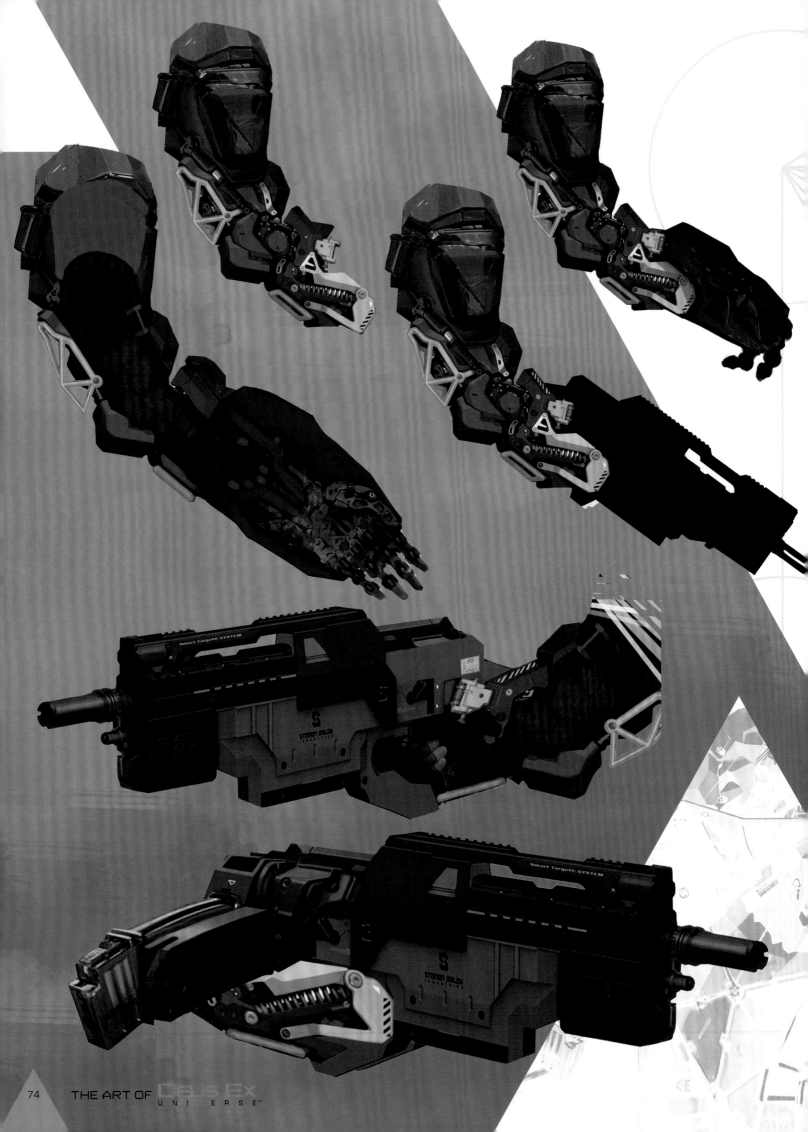

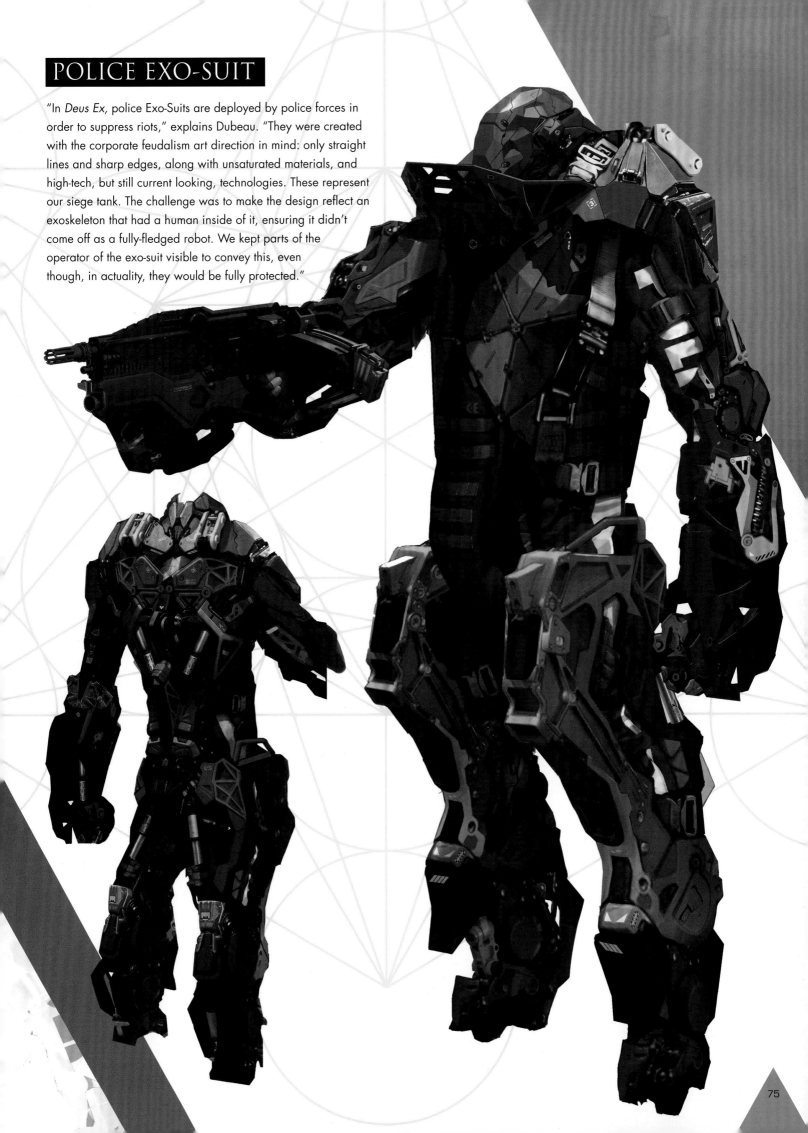

POLICE EXO-SUIT

"In *Deus Ex*, police Exo-Suits are deployed by police forces in order to suppress riots," explains Dubeau. "They were created with the corporate feudalism art direction in mind: only straight lines and sharp edges, along with unsaturated materials, and high-tech, but still current looking, technologies. These represent our siege tank. The challenge was to make the design reflect an exoskeleton that had a human inside of it, ensuring it didn't come off as a fully-fledged robot. We kept parts of the operator of the exo-suit visible to convey this, even though, in actuality, they would be fully protected."

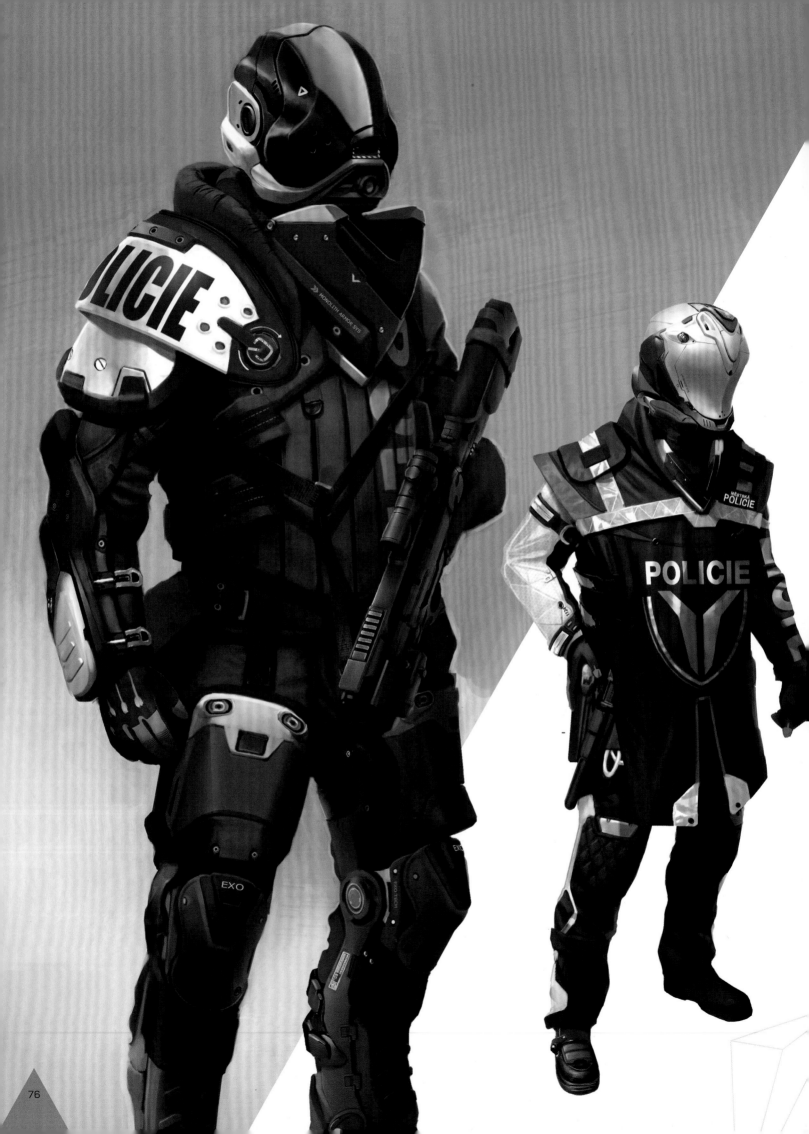

PRAGUE POLICE

The ancient history of one of Europe's oldest cities is referenced and celebrated in the design of its near-future metropolitan police force. When you know what to look for, you instantly see it. "The design of the Prague police was heavily influenced by medieval knights," reveals Dubeau. "They were designed with many medieval features (pauldrons, tabard, medieval helm shape, gauntlet, gorget, etc.). We also used the police logo as a coat of arms to reinforce the feudal aspect. Even their asymmetry was based on the image of a jousting knight."

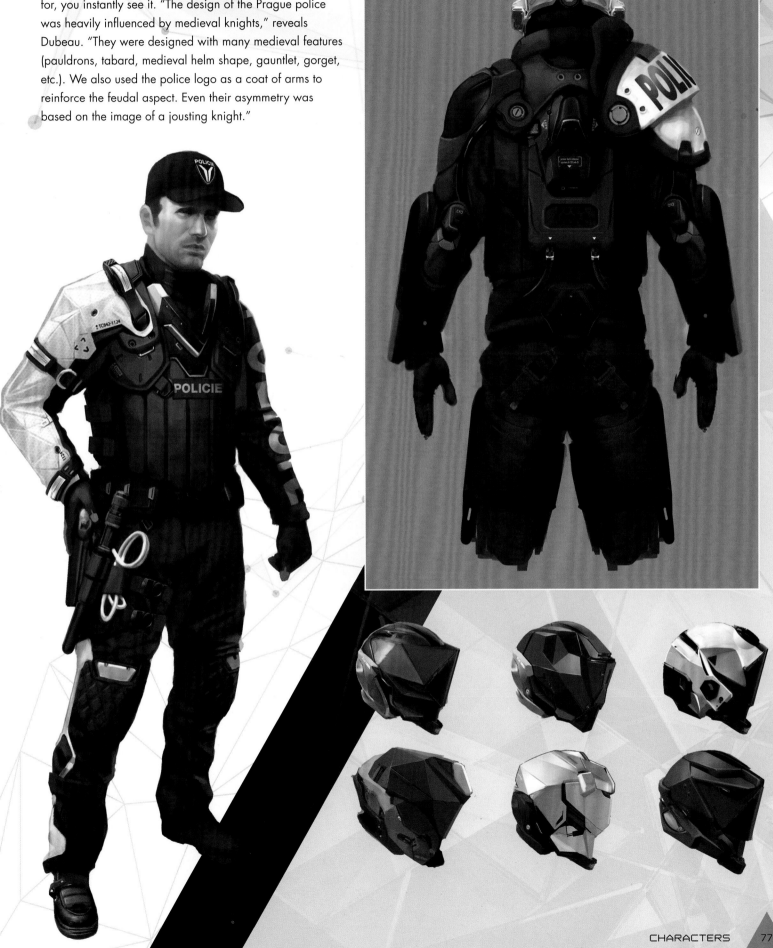

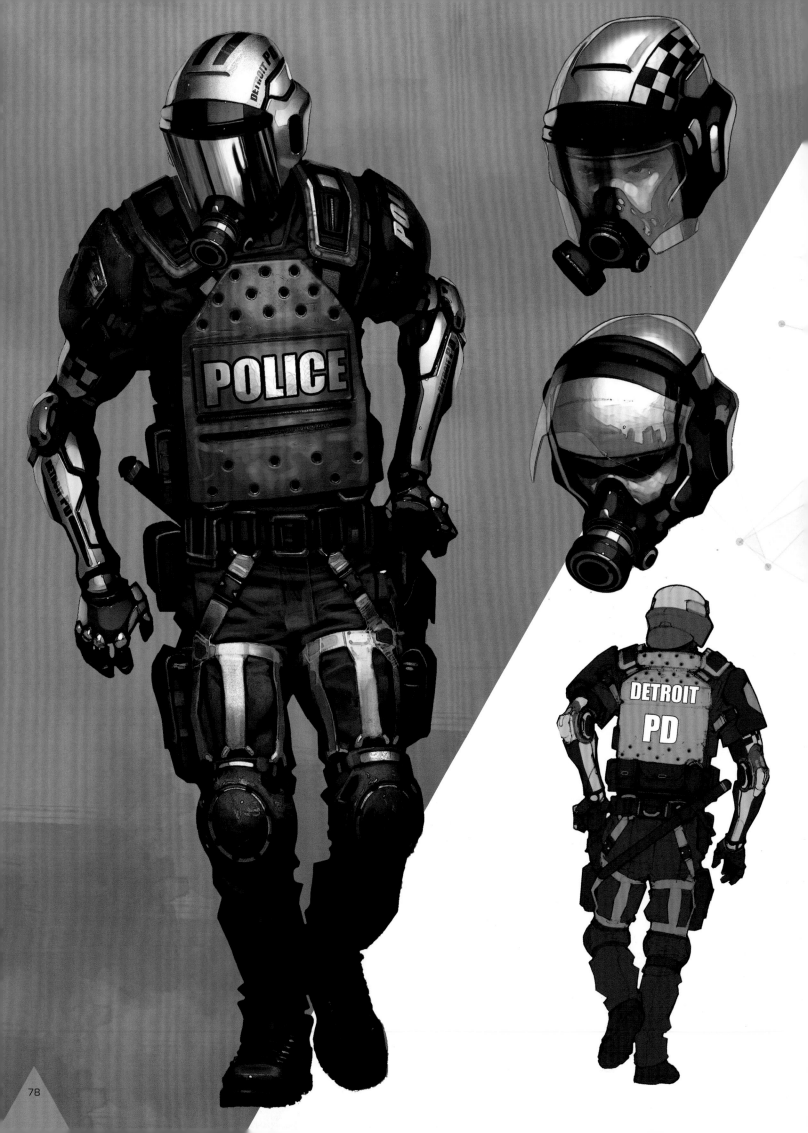

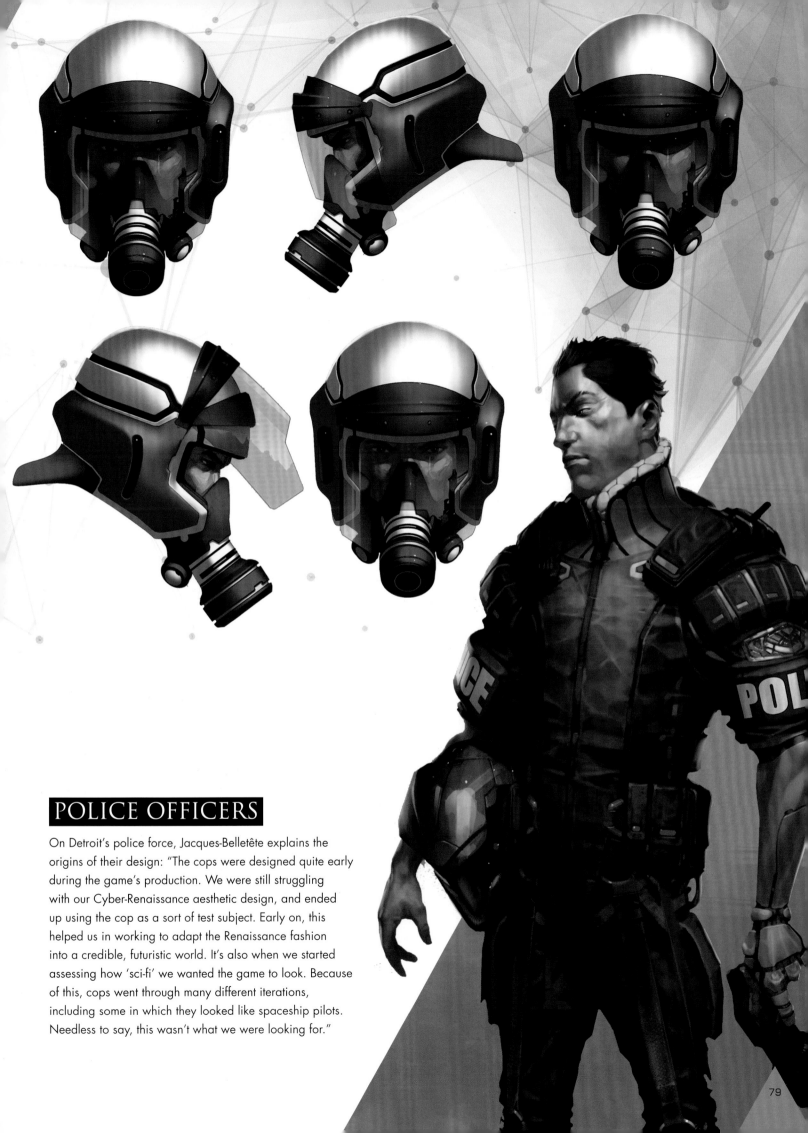

POLICE OFFICERS

On Detroit's police force, Jacques-Belletête explains the origins of their design: "The cops were designed quite early during the game's production. We were still struggling with our Cyber-Renaissance aesthetic design, and ended up using the cop as a sort of test subject. Early on, this helped us in working to adapt the Renaissance fashion into a credible, futuristic world. It's also when we started assessing how 'sci-fi' we wanted the game to look. Because of this, cops went through many different iterations, including some in which they looked like spaceship pilots. Needless to say, this wasn't what we were looking for."

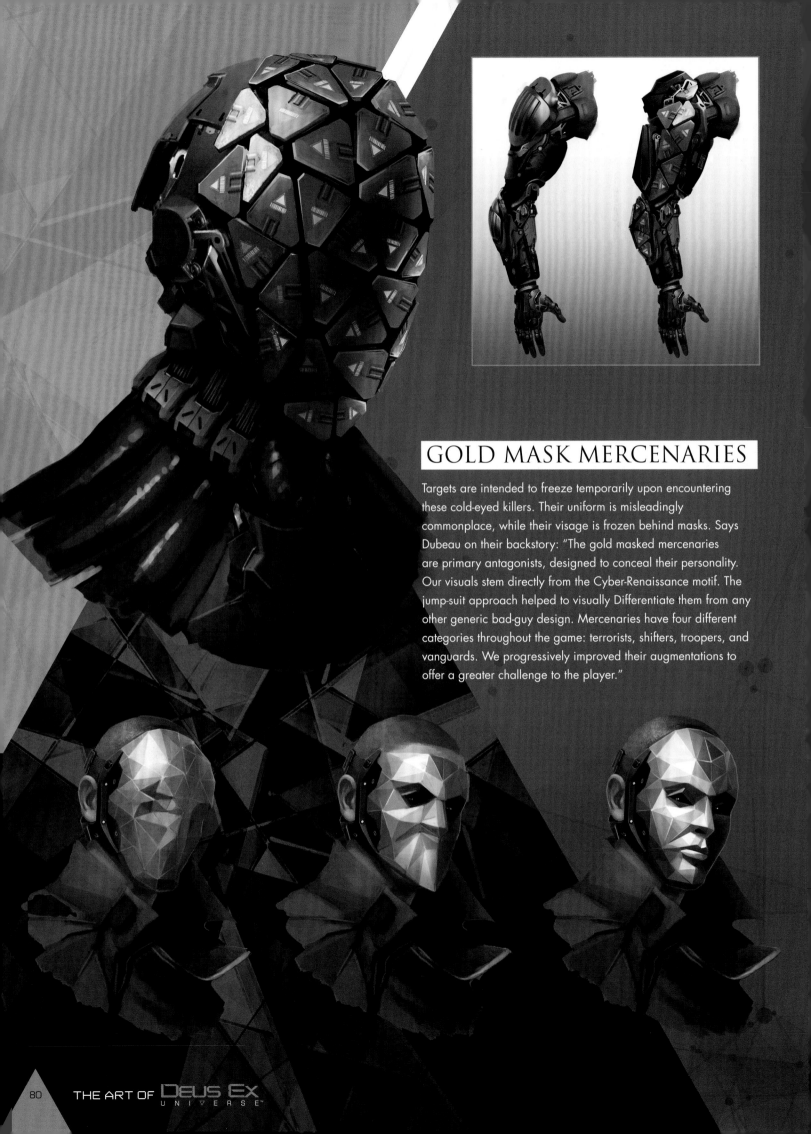

GOLD MASK MERCENARIES

Targets are intended to freeze temporarily upon encountering these cold-eyed killers. Their uniform is misleadingly commonplace, while their visage is frozen behind masks. Says Dubeau on their backstory: "The gold masked mercenaries are primary antagonists, designed to conceal their personality. Our visuals stem directly from the Cyber-Renaissance motif. The jump-suit approach helped to visually Differentiate them from any other generic bad-guy design. Mercenaries have four different categories throughout the game: terrorists, shifters, troopers, and vanguards. We progressively improved their augmentations to offer a greater challenge to the player."

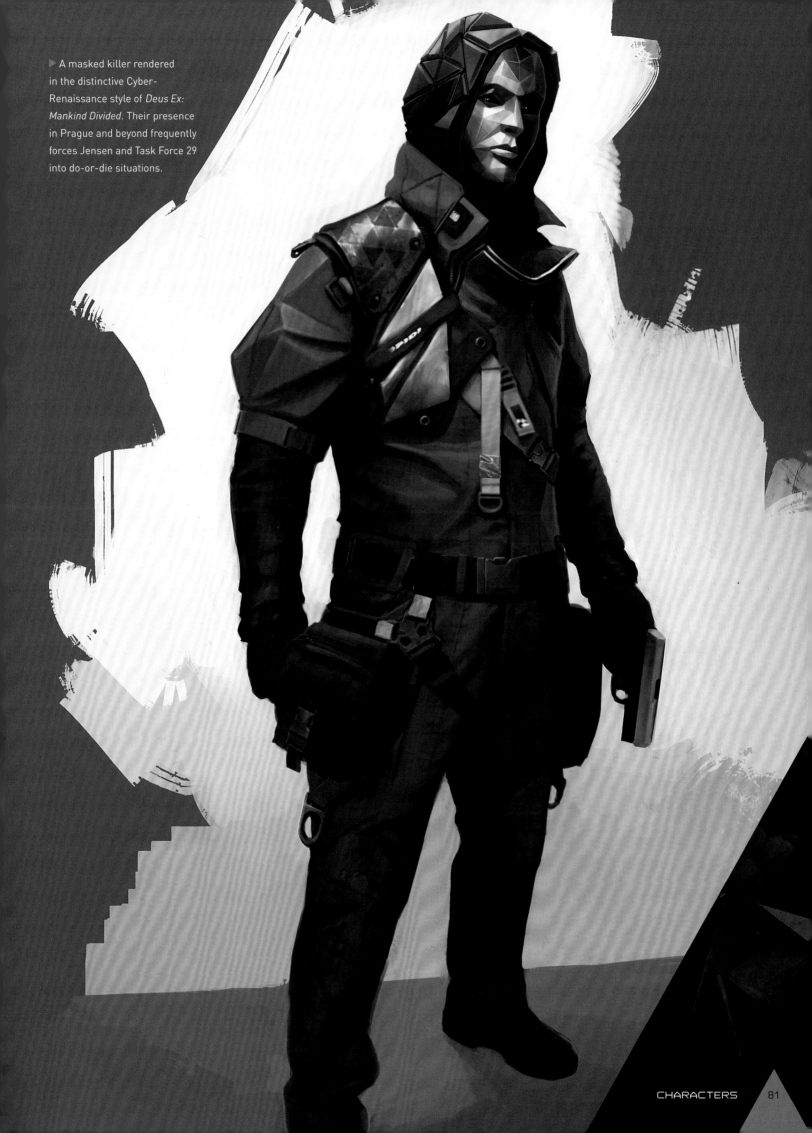

▶ A masked killer rendered in the distinctive Cyber-Renaissance style of *Deus Ex: Mankind Divided*. Their presence in Prague and beyond frequently forces Jensen and Task Force 29 into do-or-die situations.

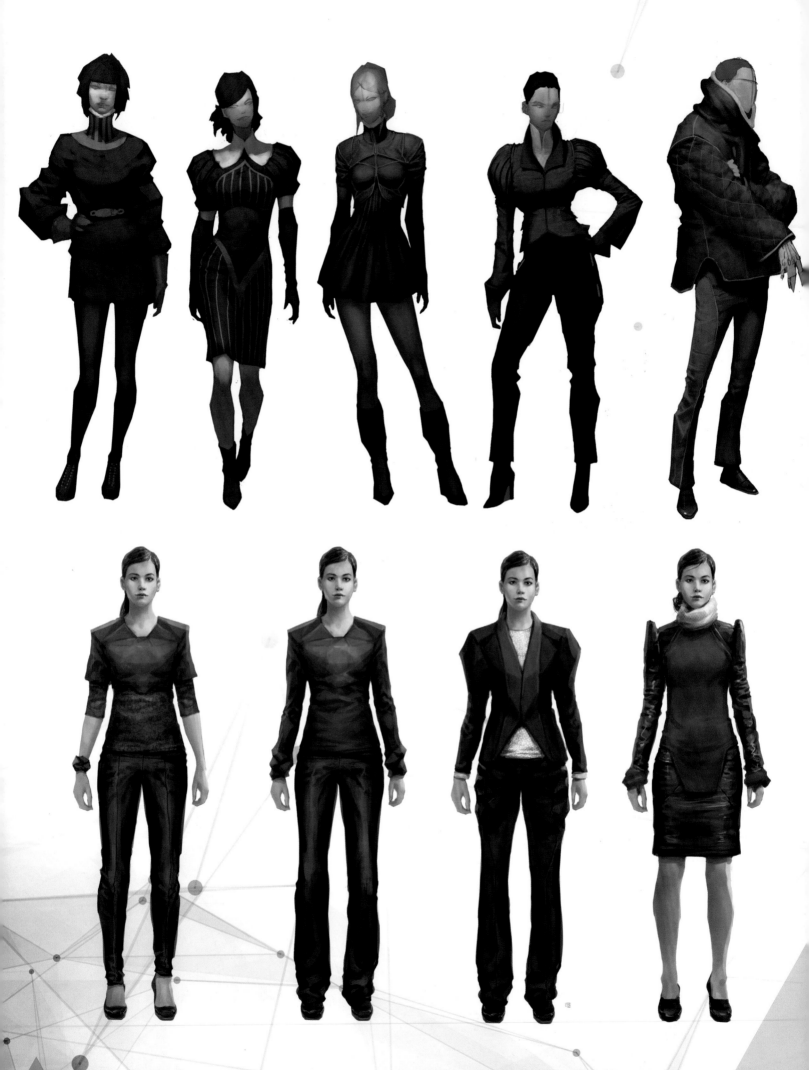

THE ART OF DEUS EX UNIVERSE

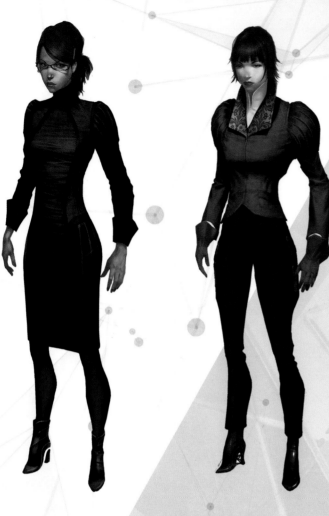

CIVILIAN NON-PLAYER CHARACTERS

"Knowing we could push the boundaries of our crazy Cyber-Renaissance ideas with main characters, the real problem was how to adapt it to 'the masses'," states Jacques-Belletête. "We wanted to ensure that civilians had our visual signature, but not to cross that threshold where everything starts to look too theatrical. We took our most efficient tricks and ideas for main characters and worked our way down, trying to soften and adapt in ways that worked for crowds and public areas. The first iterations of civilians made our world look bizarre and fairly ridiculous."

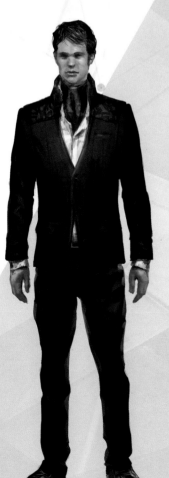
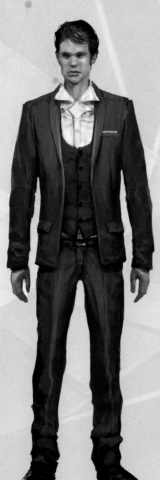

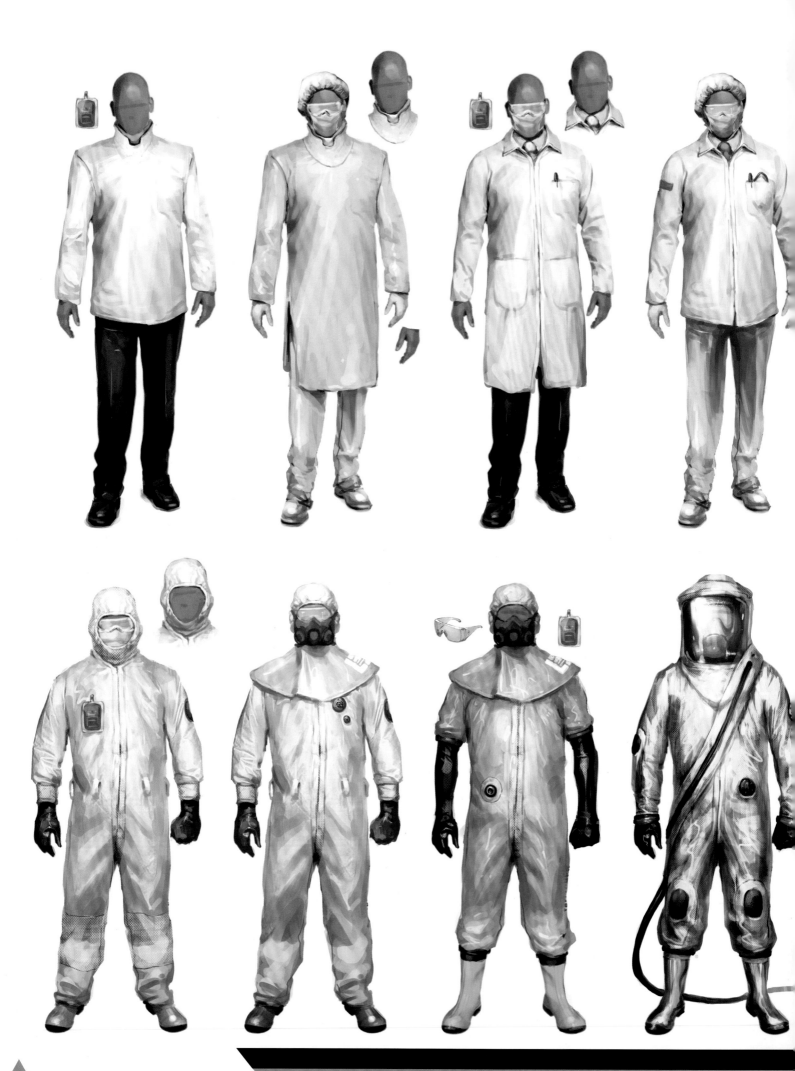

THE ART OF DEUS EX
UNIVERSE

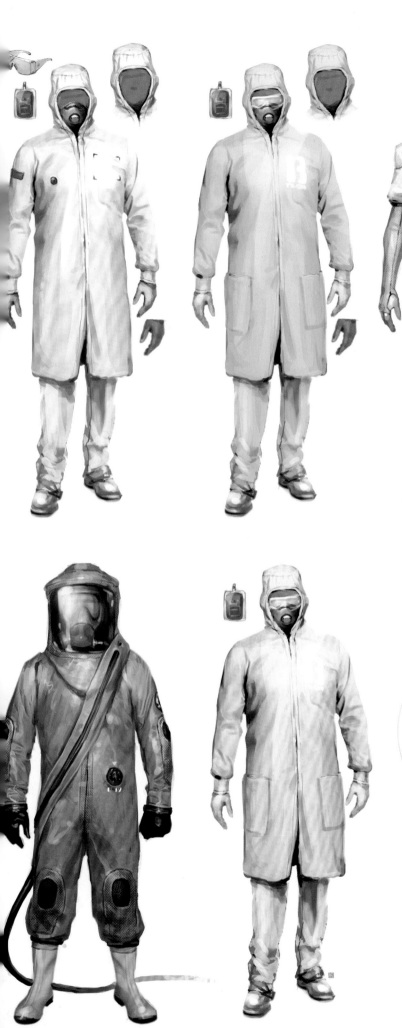

SCIENTIST NON-PLAYER CHARACTERS

A world centered around science necessitates scientists. Jacques-Belletête explains their character designs: "In *Human Revolution*, we knew that the player would be exploring a vast array of laboratories, along with other locations, within which scientific studies and experiments are taking place. There are also these strong surgical, medical, and anatomical themes in evidence throughout the game. Because of all this, we were led to design a fairly advanced 'scientist' kit system, allowing us to create a wide variety of NPC's. This ranged from regular doctors, to lab assistants, all the way up to lab workers in heavy duty, environmentally-controlled gear."

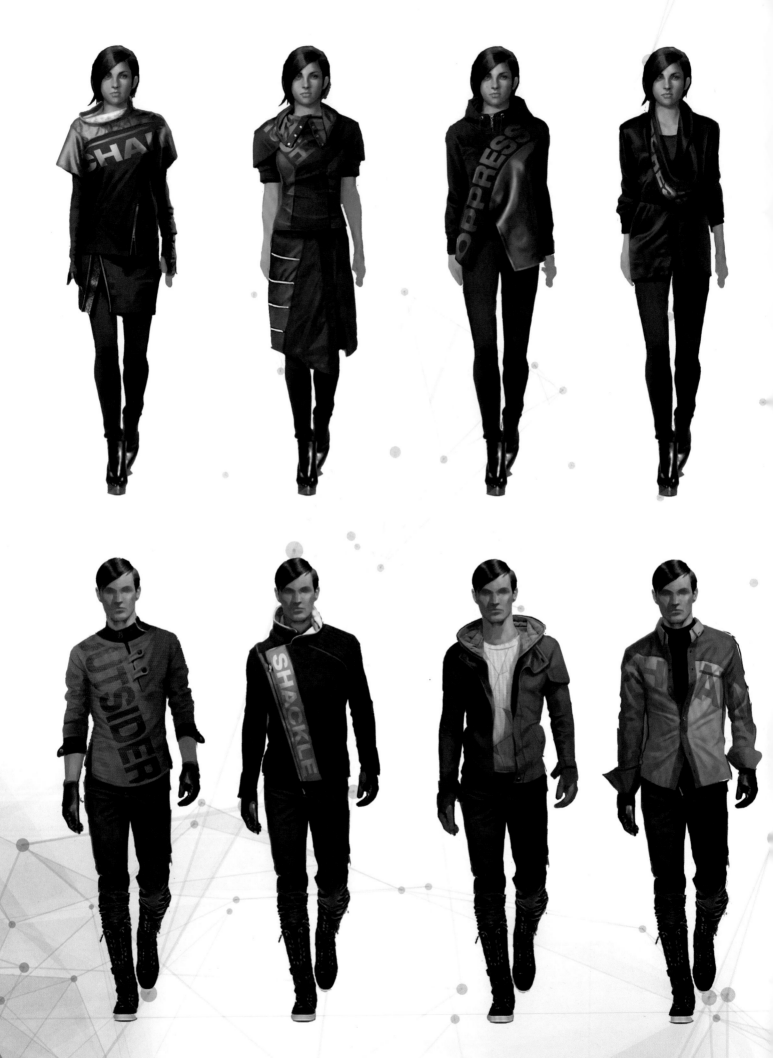

THE ART OF DEUS EX
UNIVERSE

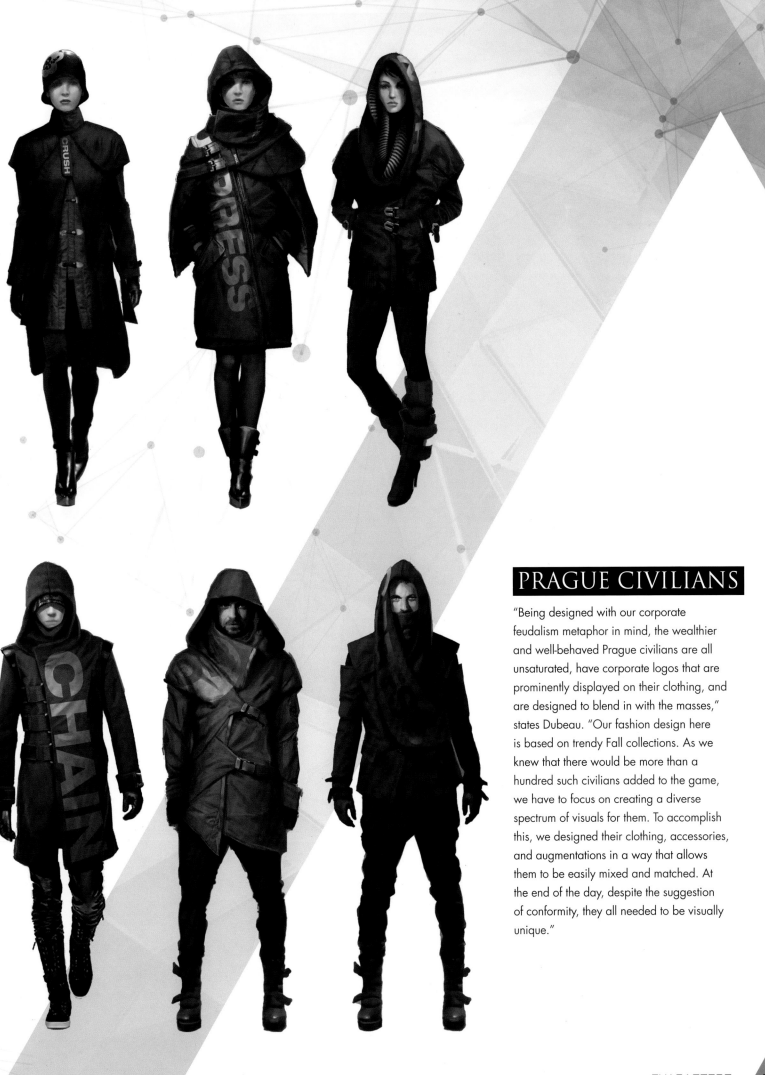

PRAGUE CIVILIANS

"Being designed with our corporate feudalism metaphor in mind, the wealthier and well-behaved Prague civilians are all unsaturated, have corporate logos that are prominently displayed on their clothing, and are designed to blend in with the masses," states Dubeau. "Our fashion design here is based on trendy Fall collections. As we knew that there would be more than a hundred such civilians added to the game, we have to focus on creating a diverse spectrum of visuals for them. To accomplish this, we designed their clothing, accessories, and augmentations in a way that allows them to be easily mixed and matched. At the end of the day, despite the suggestion of conformity, they all needed to be visually unique."

APONS AND TECH

"AT THE TIME OF *Deus Ex: Human Revolution*'s production, the technical precision, and degree of credibility attained for the design of more than 1,500 props, was seldom seen in a North American video game," states Executive Art Director Jonathan Jacques-Belletête. "The art team faced a steep learning curve in mastering such aesthetic control and industrial design guidelines, particularly for assets that were usually created without so many considerations. Since *Human Revolution*, it is now more common to see this level of commitment to industrial design in video games. Our experience on *Human Revolution* greatly helped *Mankind Divided*'s own development."

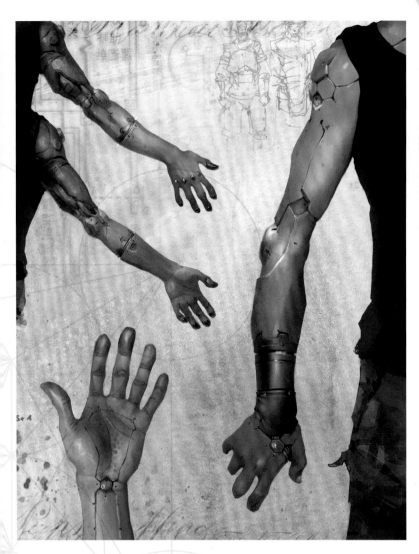
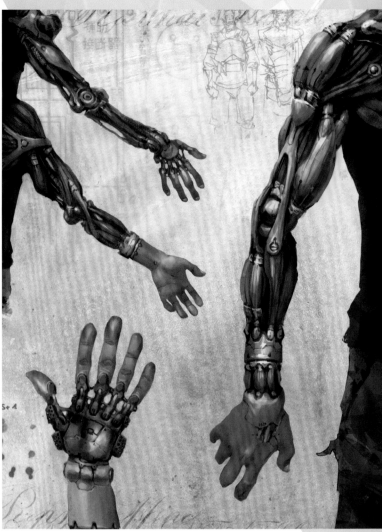

CYBERNETIC AUGMENTATIONS

In constructing a believable universe for *Deus Ex: Mankind Divided*, inspiration was extensively drawn from the real world, helping to complement and uphold the fantasy. According to Jacques-Belletête, "Artificial augmentations were one of the most important pillars of *Human Revolution*. Even before we started designing the specific augmentations for the primary and secondary characters, we had spent many months going through countless iterations and styles for how the general look of these prosthetics would appear in our game. We read and consulted extensively on the subject, and felt like we had a decent grasp on where the real technologies and possibilities were heading. Eventually, this design process would prove to be an ongoing one, lasting for the entire length of the game's production. Our designs and ideas improved with each character and prop."

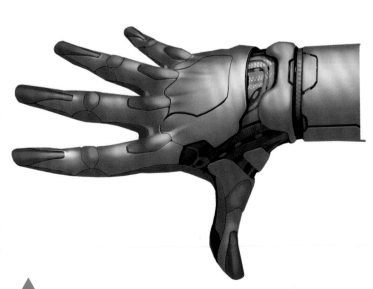
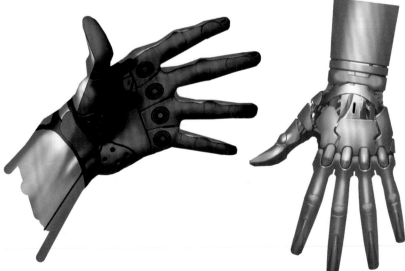

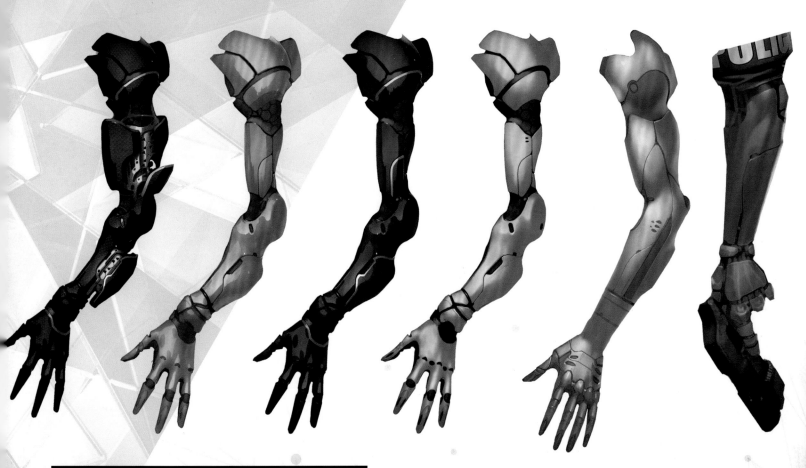

PLANNED UNCANNINESS

"We deliberately aimed for a lot of the augmentations to look uncanny," explains Jacques-Belletête. "We figured that, if you could artificially change your own anatomy to make it more resilient and perform better, why would you choose to recreate some of its natural limitations? For example, a much stronger mechanical arm didn't need to be bigger or more muscular; the pivoting and bending limitations of our natural joints didn't have to be respected, and creating holes and negative spaces in the limbs themselves proved to be a very effective visual device."

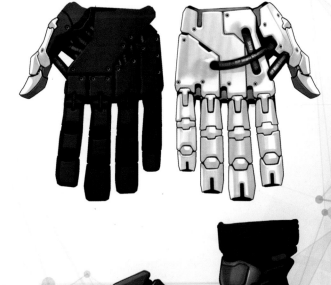

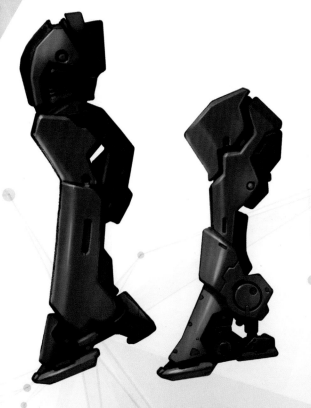

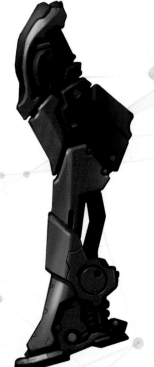

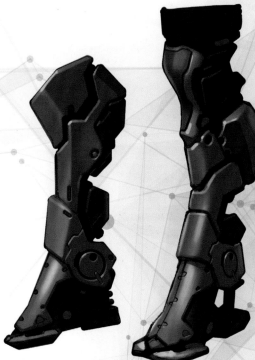

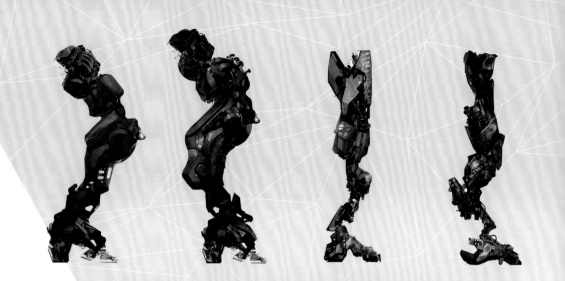

▶ In a world where augmentation was no longer welcome, the art team pursued a deconstructed motif (*right*) to, as Jacques-Belletête puts it, "return to basic function and leave aside the fashion look". The backpack (*below*) delivers Adam Jensen-like capabilities to ARC fighters, using the capacity of the Icarus augmentation.

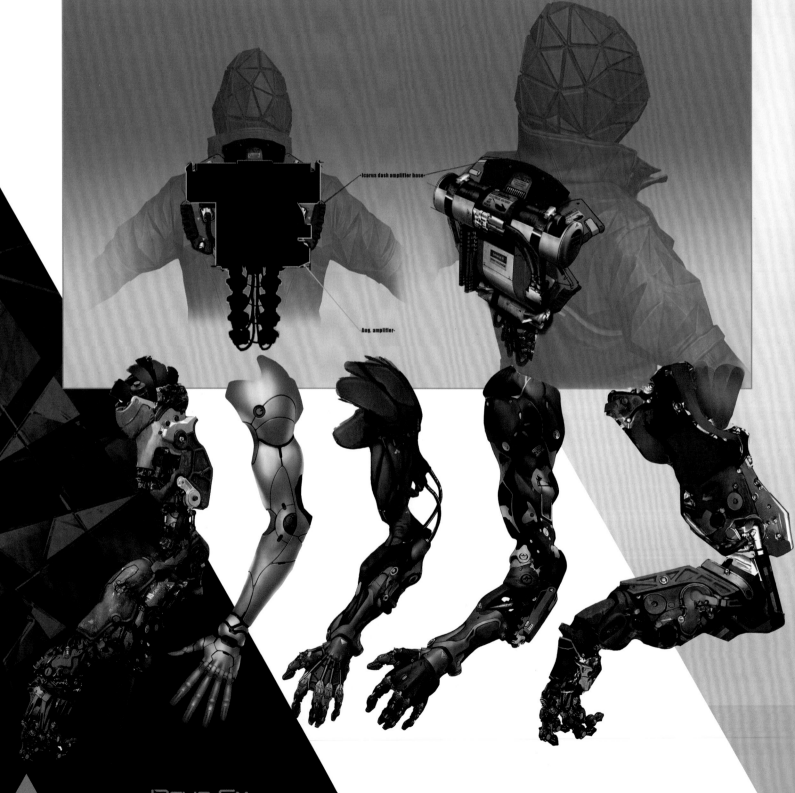

-Icarus dash amplifier base-

-Aug. amplifier-

THE ART OF DEUS EX
UNIVERSE

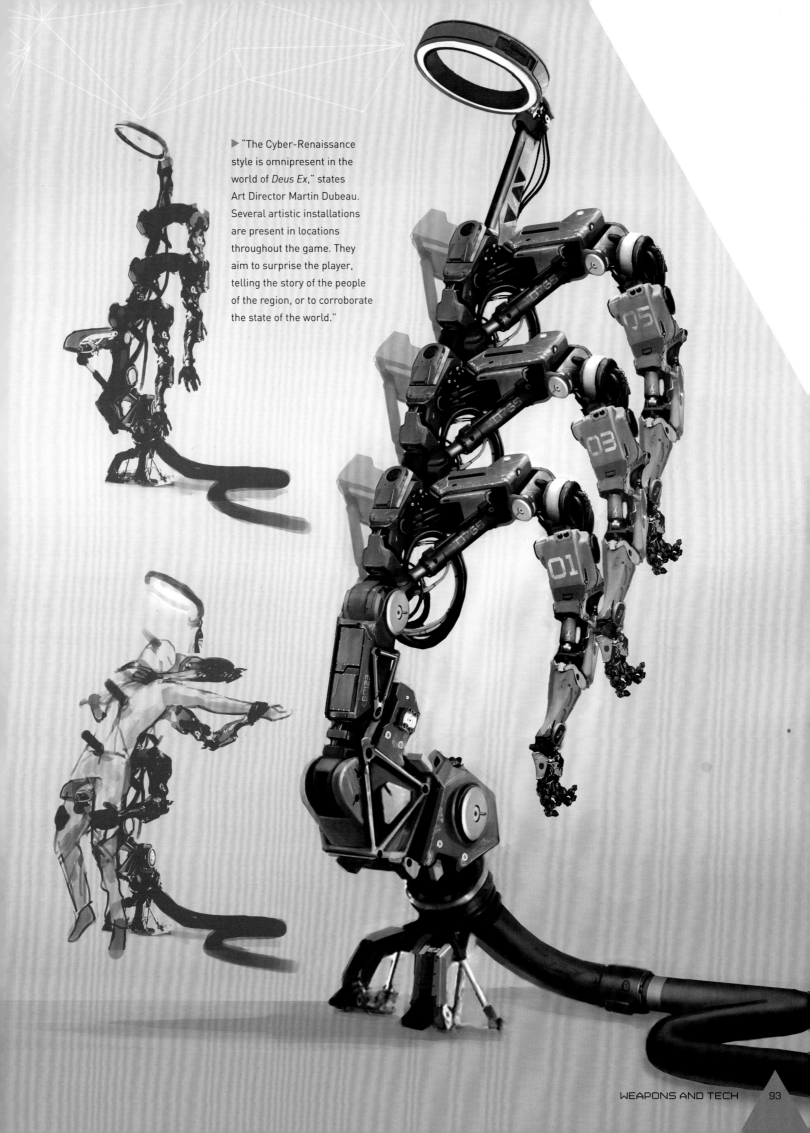

▶ "The Cyber-Renaissance style is omnipresent in the world of *Deus Ex*," states Art Director Martin Dubeau. Several artistic installations are present in locations throughout the game. They aim to surprise the player, telling the story of the people of the region, or to corroborate the state of the world."

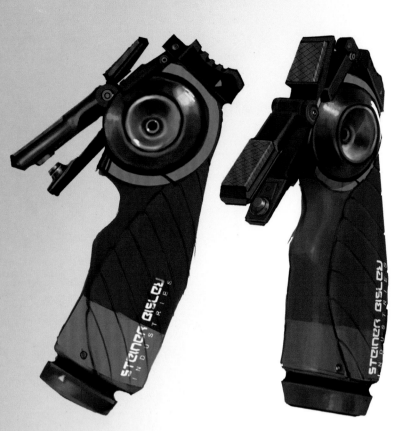

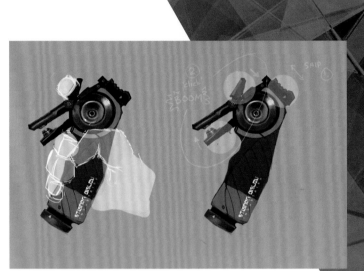

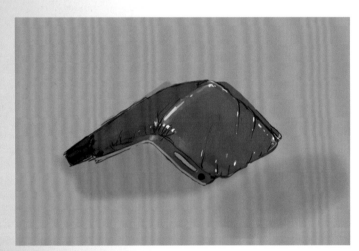

M-28 UR-DED

Every detail in *Mankind Divided* is used to substantiate the illusion of another reality; Distinct, but not too far removed from our own. Functionality should require little by way of explanation, although unusual appearances invite a closer look—particularly with objects encountered more often than others, such as Adam's kit. "We felt that remotely detonated explosives always looked the same in video games," says Jacques-Belletête. "We wanted to have a charge that would stand out, appearing almost peculiar at first. That's when we came up with this idea of having a soft transparent bag, filled with explosive gel, that could be easily dropped or thrown."

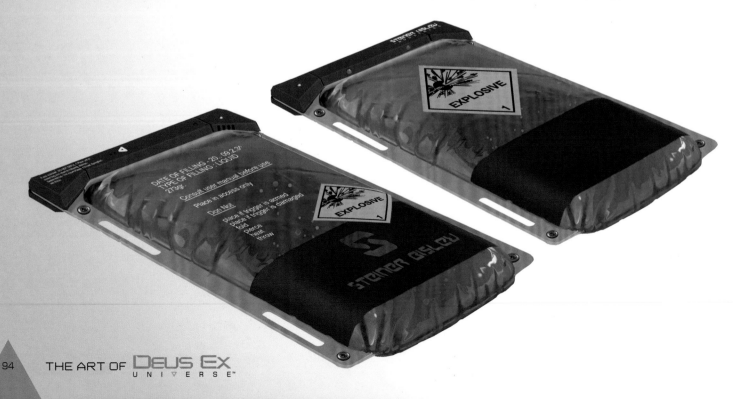

AUD
Automatic Unlocking Device.

⚠ **WARNING!**
Yet another decal that must be applied to all possible corners of this model. Please apply liberally. If you see an empty spot then stick it on.

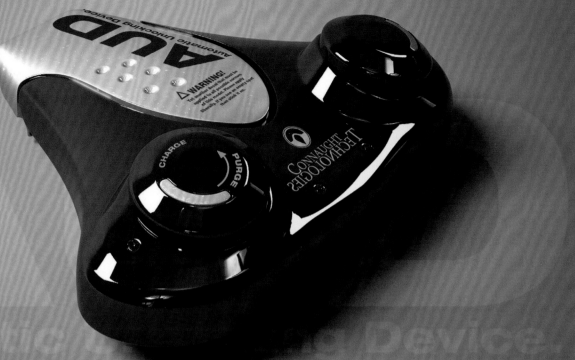

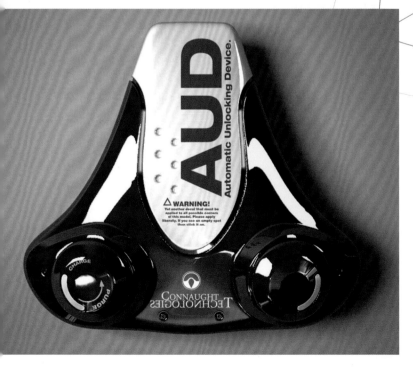

AUTOMATIC UNLOCKING DEVICE

Jacques-Belletête reveals the origins of one of Jensen's core hacking tools: "The AUD is a great example of a strong understanding of industrial design principles applied to a video game prop. It looks like it could exist in real life. This is not necessarily because of the rendering quality shown here, but mainly due to the thought process behind the shapes, surface details, material choices, and the way it informs the viewer on how it's been assembled through manufacturing." High-end 3D modeling allows for such devices to be inspected in detail, while the lines of their construction imply texture and heft. However, its exact usage can still remain mysterious.

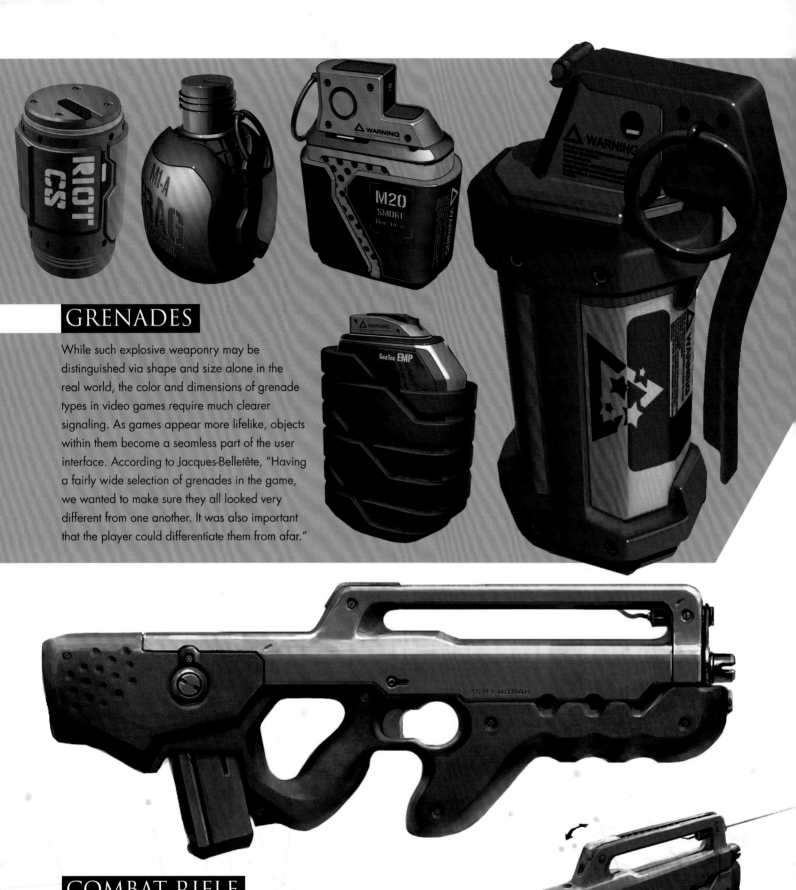

GRENADES

While such explosive weaponry may be distinguished via shape and size alone in the real world, the color and dimensions of grenade types in video games require much clearer signaling. As games appear more lifelike, objects within them become a seamless part of the user interface. According to Jacques-Belletête, "Having a fairly wide selection of grenades in the game, we wanted to make sure they all looked very different from one another. It was also important that the player could differentiate them from afar."

COMBAT RIFLE

"The combat rifle became the signature weapon of *Deus Ex: Human Revolution,* and bringing it back in *Deus Ex: Mankind Divided* was an obvious choice," says Jacques-Belletête. "Its general shape and aesthetic are influenced by a bunch of different sources, but we felt like we made it our own by placing the magazine within a sliding chamber on top of the gun, positioned right behind the barrel. It made for an interesting loading animation while playing the game."

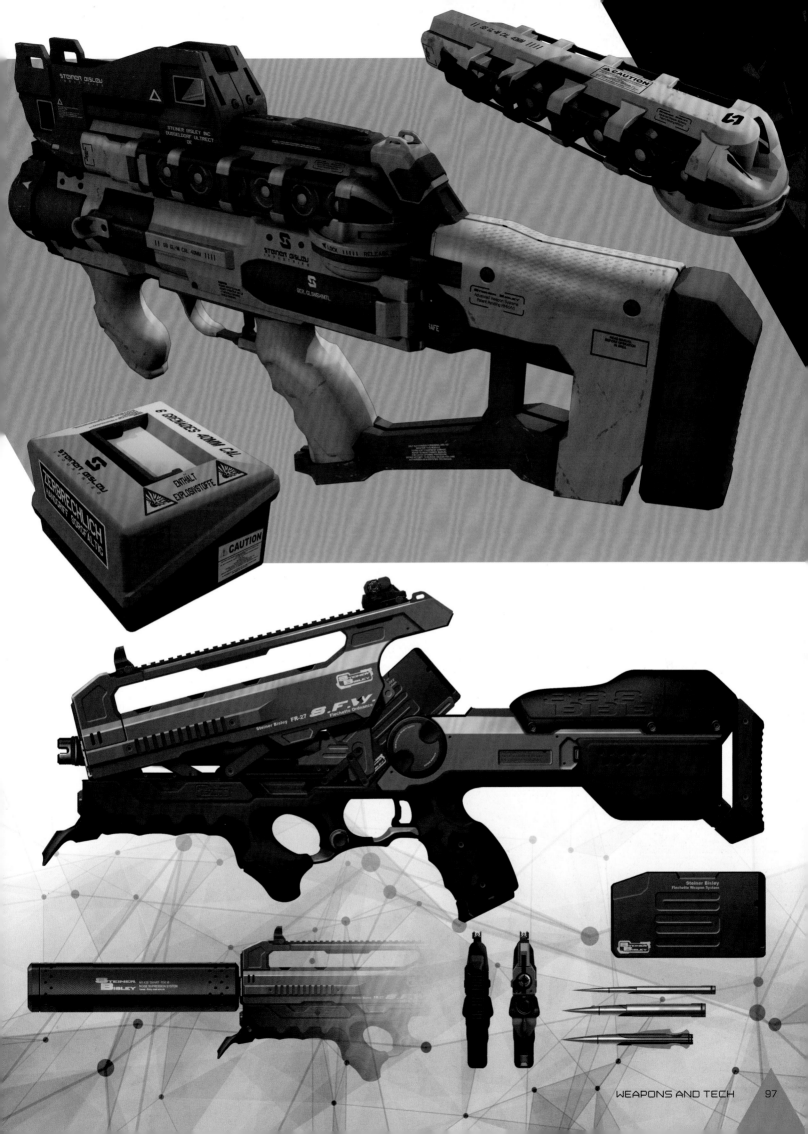

KAIGA ★

5.56 MM M404 HEAVY RIFLE

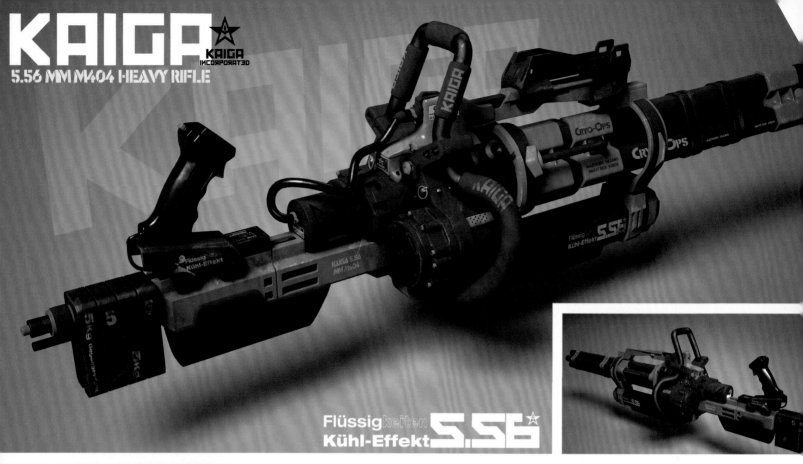

Flüssig*keiten* Kühl-Effekt **5.56** ★

HEAVY RIFLE

Jacques-Belletête reveals a weapon design that was cut from *Deus Ex*, due to functional issues. "Above is an early design for the Heavy Rifle; a futuristic yet industrial-looking Gatling gun. We designed it too fast, not considering important constraints. As a result, Adam's animations couldn't accommodate the design. It was too late in production to create the hundreds of new animations that would be needed to make it work, so we went back to the drawing board."

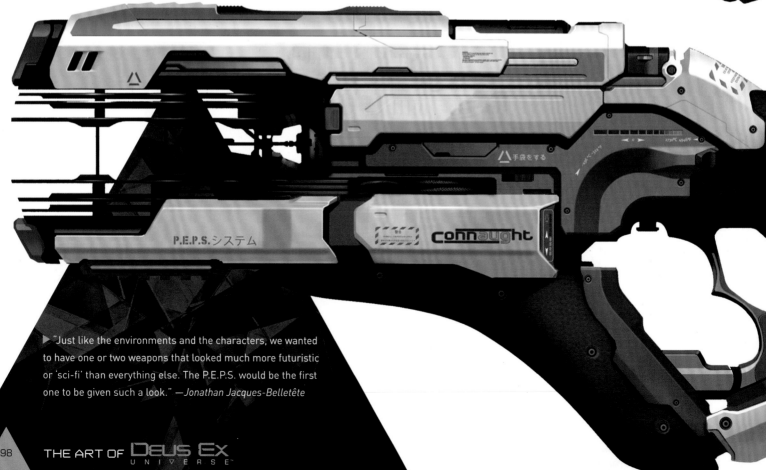

▶ "Just like the environments and the characters, we wanted to have one or two weapons that looked much more futuristic or 'sci-fi' than everything else. The P.E.P.S. would be the first one to be given such a look." —*Jonathan Jacques-Belletête*

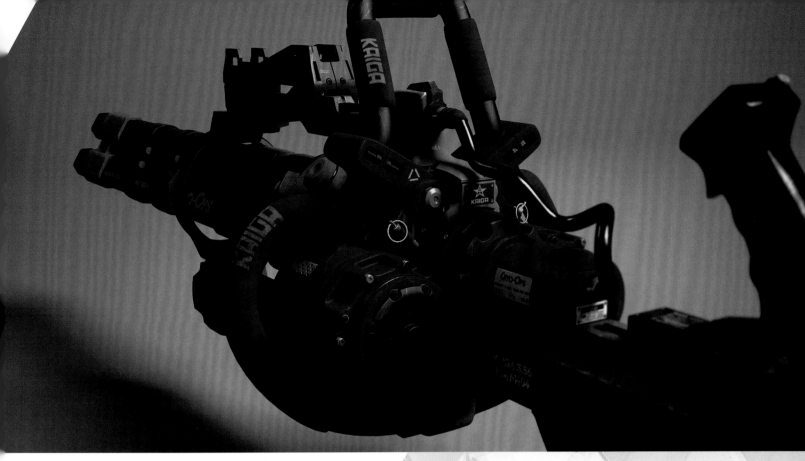

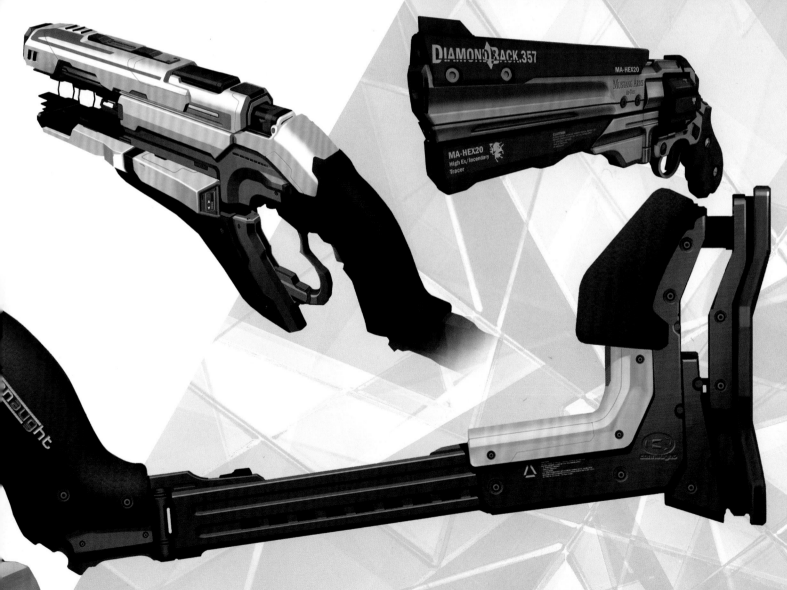

AMMUNITION

Within the stealth-based, equipment-oriented experience that is *Deus Ex: Mankind Divided*, concept art is needed to explore even the smallest of details. Players spend so many hours pondering the gear at their (Adam Jensen's) disposal; every ammo clip, every last bullet must stand up to such scrutiny. Says Jacques-Belletête on crafting detail into weapon design, "Designing the ammunition for each individual type of weapon was as important as designing the guns themselves. We really wanted them to be objects with as much character as possible. Therefore, we put a lot of time and effort into both the look of the ammo boxes and the actual projectiles. We had a few of our artists that, at one point or another, dedicated a considerable chunk of time in designing these boxes and crates." With everything needing to be perfect, from looks to precision in-game performance, you can see where development time goes.

▶ "The inspiration behind the loading mechanism of this sniper rifle came from the old 1980s Betamax players. They had this distinctive top-loading mechanism with a cool pop-up hatch that would eject the videotape at a slight angle, parallel to the player underneath it."
—Jonathan Jacques-Belletête

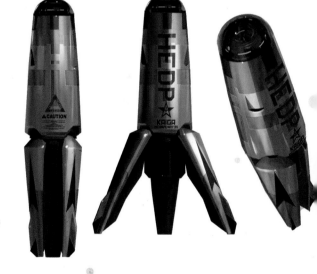

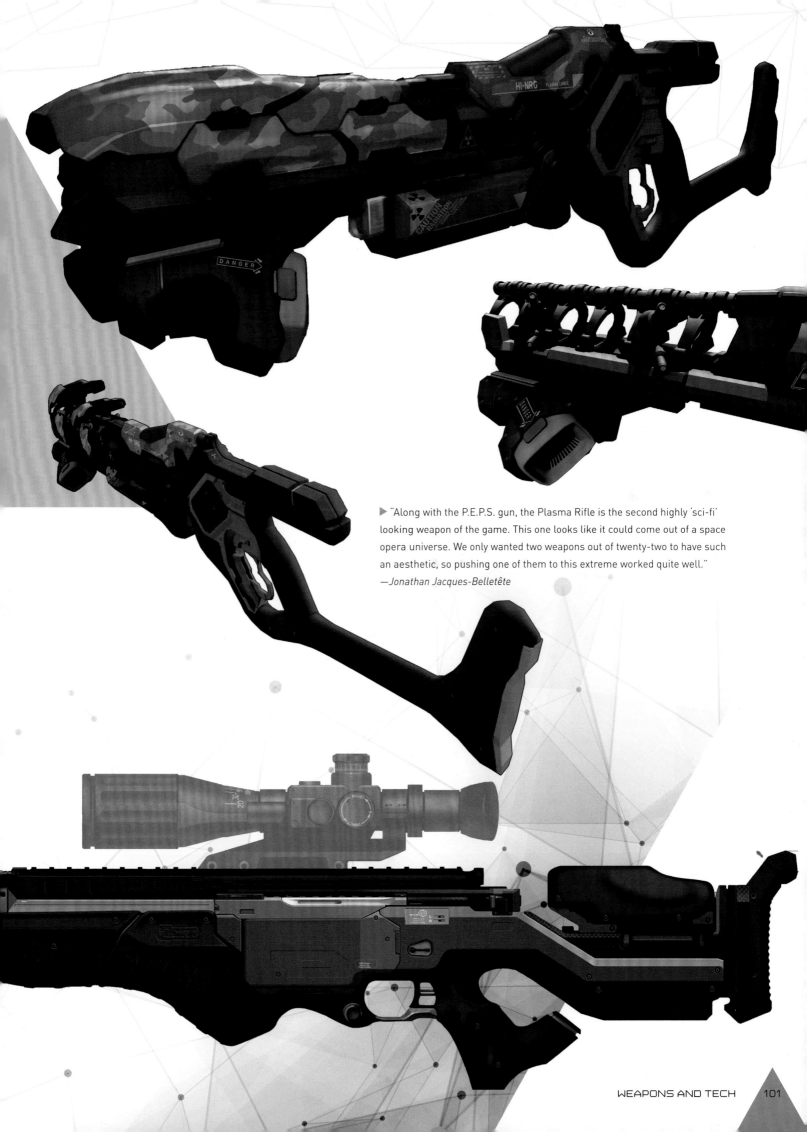

▶ "Along with the P.E.P.S. gun, the Plasma Rifle is the second highly 'sci-fi' looking weapon of the game. This one looks like it could come out of a space opera universe. We only wanted two weapons out of twenty-two to have such an aesthetic, so pushing one of them to this extreme worked quite well."
—Jonathan Jacques-Belletête

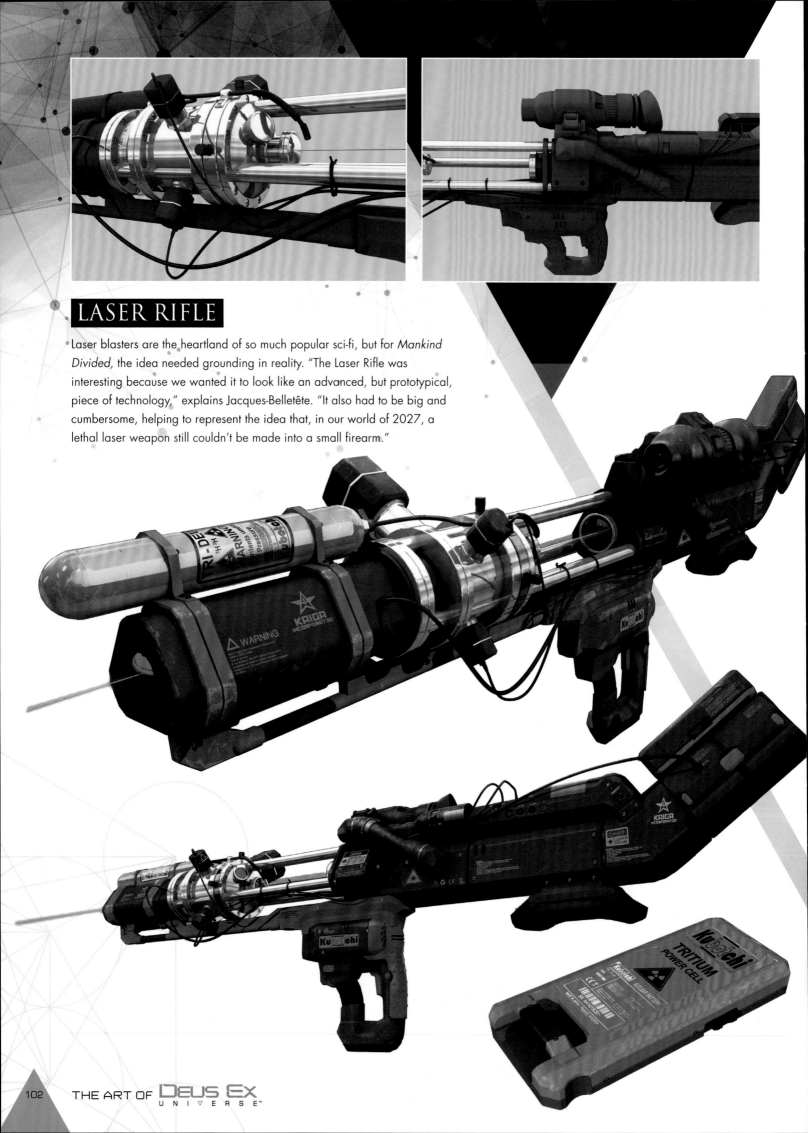

LASER RIFLE

Laser blasters are the heartland of so much popular sci-fi, but for *Mankind Divided*, the idea needed grounding in reality. "The Laser Rifle was interesting because we wanted it to look like an advanced, but prototypical, piece of technology," explains Jacques-Belletête. "It also had to be big and cumbersome, helping to represent the idea that, in our world of 2027, a lethal laser weapon still couldn't be made into a small firearm."

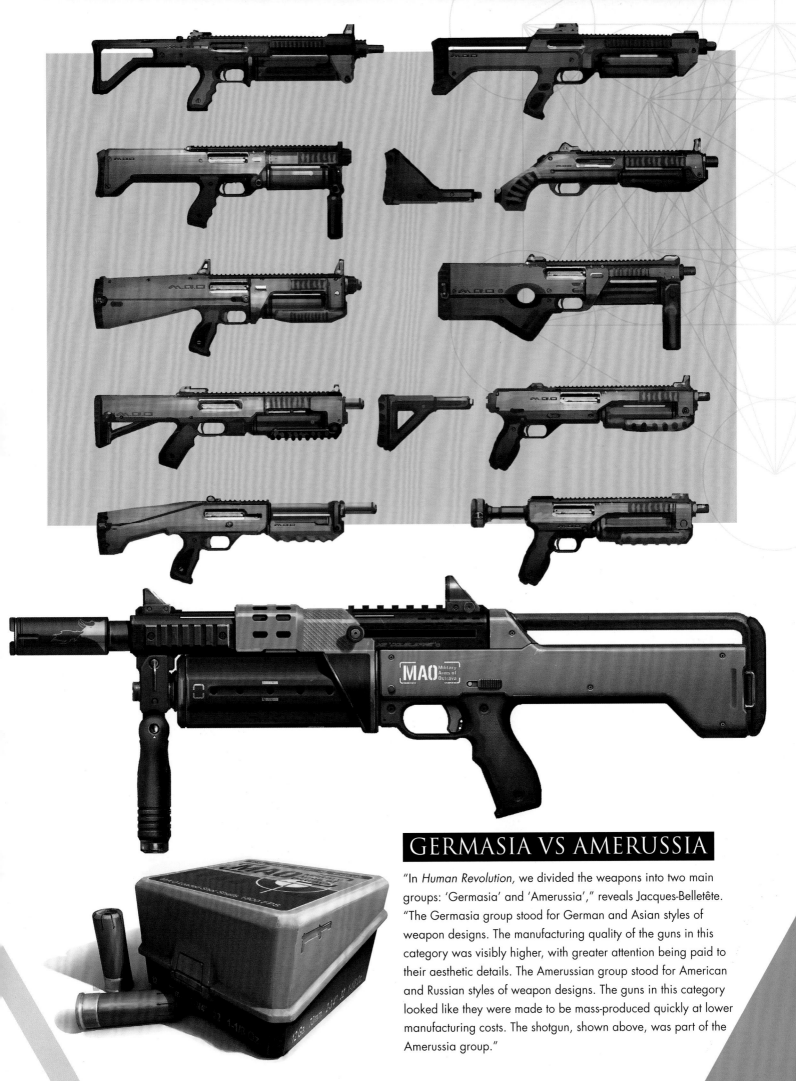

GERMASIA VS AMERUSSIA

"In *Human Revolution*, we divided the weapons into two main groups: 'Germasia' and 'Amerussia'," reveals Jacques-Belletête. "The Germasia group stood for German and Asian styles of weapon designs. The manufacturing quality of the guns in this category was visibly higher, with greater attention being paid to their aesthetic details. The Amerussian group stood for American and Russian styles of weapon designs. The guns in this category looked like they were made to be mass-produced quickly at lower manufacturing costs. The shotgun, shown above, was part of the Amerussia group."

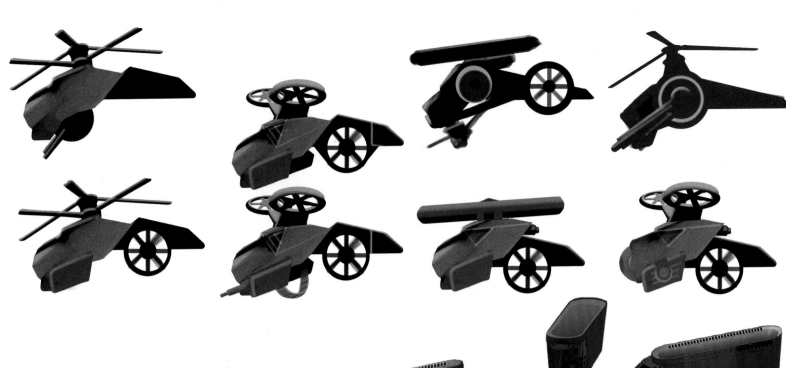

DRONES

In the present day, drones are quite marvelous, but they also have the potential to be very deadly. For the concept of drones to remain thrilling in *Deus Ex: Mankind Divided*, the team needed to dwell upon their near-future capabilities; the purposes to which they might adapt, the hardware that they could possibly carry to rain terror from the skies, or the ability to glide unnoticed during a recon mission. Also, no sci-fi scenario is really complete without the shrill humming of multi-rotor devices heard overhead, and the urge to reveal the unknown master that is controlling them.

▶ Not all drones and multi-rotors are tiny. This militarized, near-future tech propelled variant would need to be mighty enough to support the high-caliber weapon slung beneath its fuselage. Even more chilling is that it's likely to be automated.

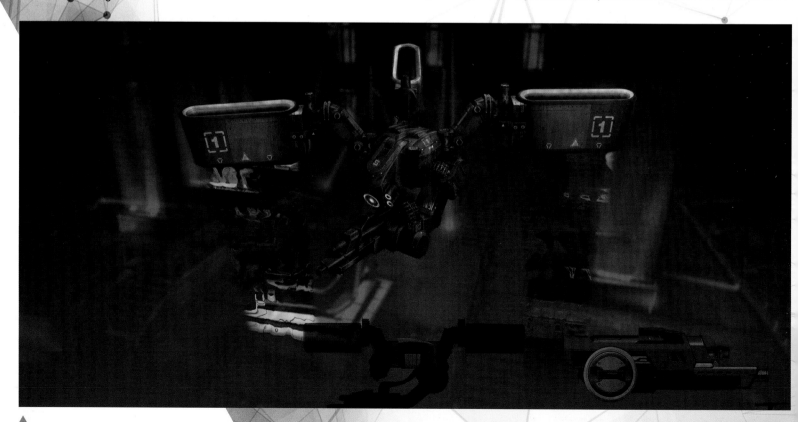

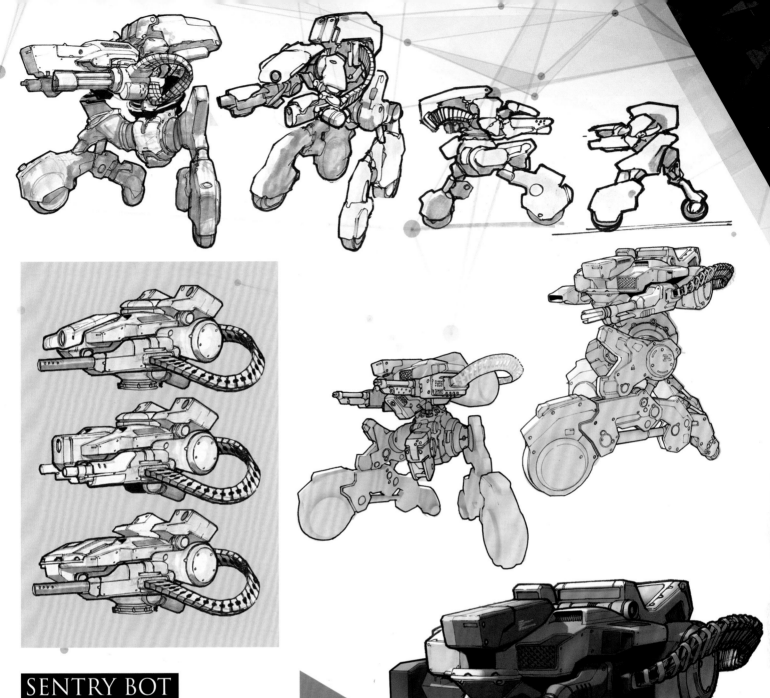

SENTRY BOT

Just because you can, doesn't always mean that you should. A truth regularly encountered during the early concept stages for *Human Revolution*, as explained by Jacques-Belletête: "The leg and wheel systems for the Sentry Bot were originally designed to allow for going up and down staircases. This would've given a lot more mobility and range to the patrolling bots. However, even after figuring out the mechanism and creating hand animated examples to support the feasibility of the concept, we decided to cut the feature as it proved too complex and costly to produce versus the actual gameplay benefits it provided. The Sentry Bots were then limited to only patrolling the floors that they started on."

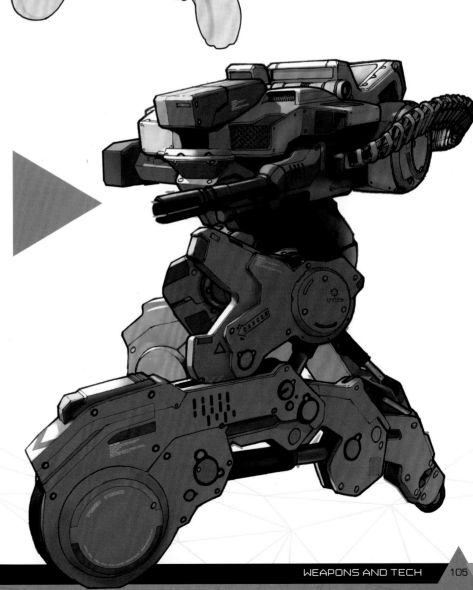

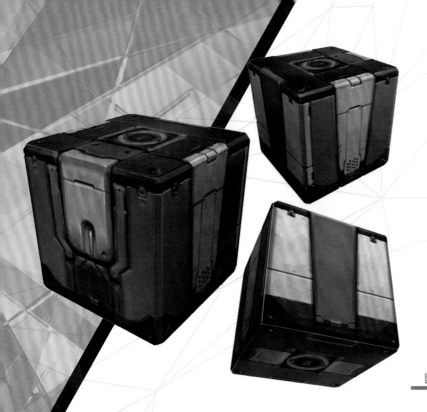

Top view

Bottom view

1.60 m

Side view

Front view

BOX GUARD

The practical side of mobilizing a large army can lead to exciting conceptual work, especially taking into consideration exactly how field drops can be made. An element of surprise is always helpful in battle too, something that is evidenced here. "The Boxguard is definitely our signature robot," says Jacques-Belletête. "The idea behind its concept came from themes related to the privatization of the military, found throughout *Human Revolution*. We imagined that both private armies and paramilitary organizations had different means and needs when compared to standing national armies. We figured that a huge attack robot, that would also be its own 'shipping crate', could be a very original idea. They would also take very little space when in their box mode, and could easily be stowed or put into cargo. This seemed very useful for a globally deployable military force, which had contracts and clients all over the world, to operate in a wide variety of environments."

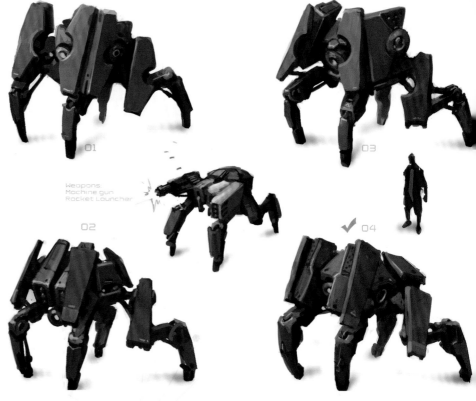

01

03

Weapons:
Machine gun
Rocket Launcher

02

04

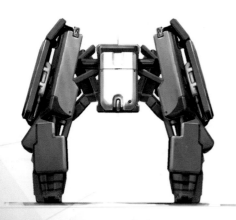

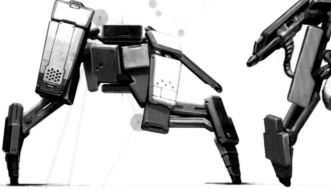

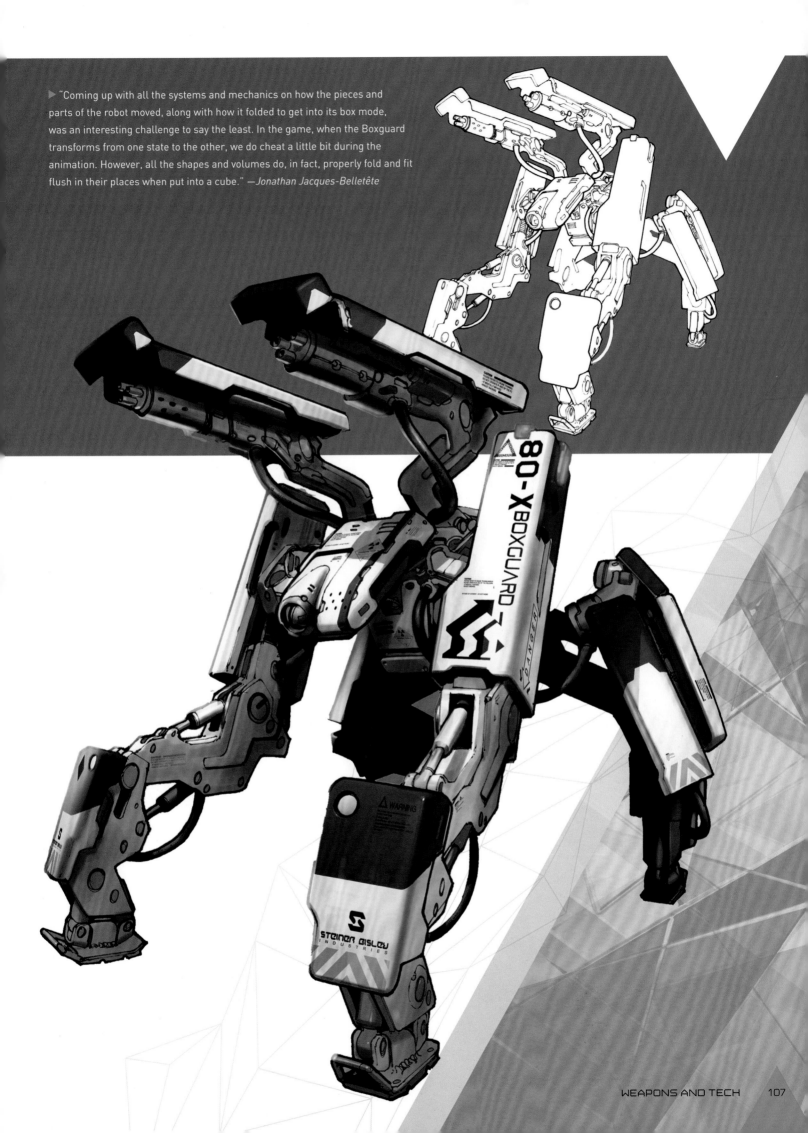

▶ "Coming up with all the systems and mechanics on how the pieces and parts of the robot moved, along with how it folded to get into its box mode, was an interesting challenge to say the least. In the game, when the Boxguard transforms from one state to the other, we do cheat a little bit during the animation. However, all the shapes and volumes do, in fact, properly fold and fit flush in their places when put into a cube." —*Jonathan Jacques-Belletête*

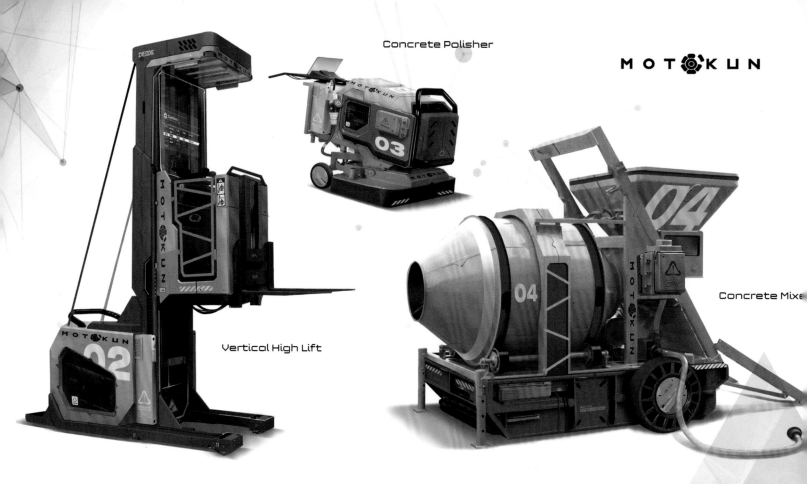

Concrete Polisher

MOTOKUN

Vertical High Lift

Concrete Mixer

CONSTRUCTION ROBOTS

"We take the mechanical design of things really seriously," states Dubeau. "In fact, it's one of our main artistic pillars. The challenge here was to bring contemporary objects into our futuristic fantasy. We anticipated the design in order to make the objects look futuristic, without going too far on the sci-fi side, keeping them recognizable in terms of their function. A lift truck is still a lift truck, but *Deus Ex* style. The key here is research, and lots of it. Great attention is put into the details, with our objects needing to be built in a functional and logical manner."

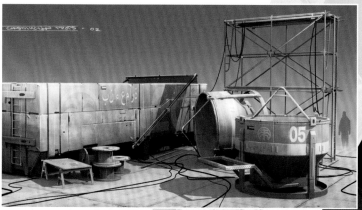

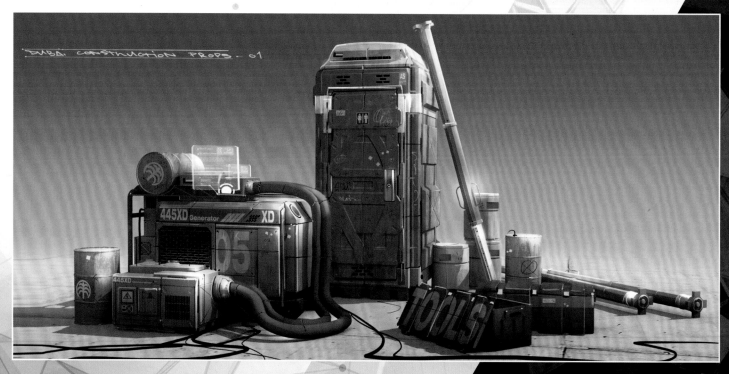

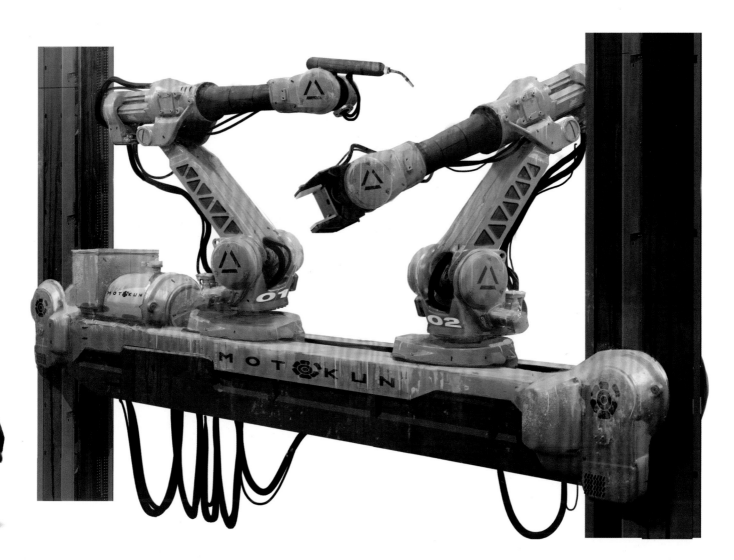

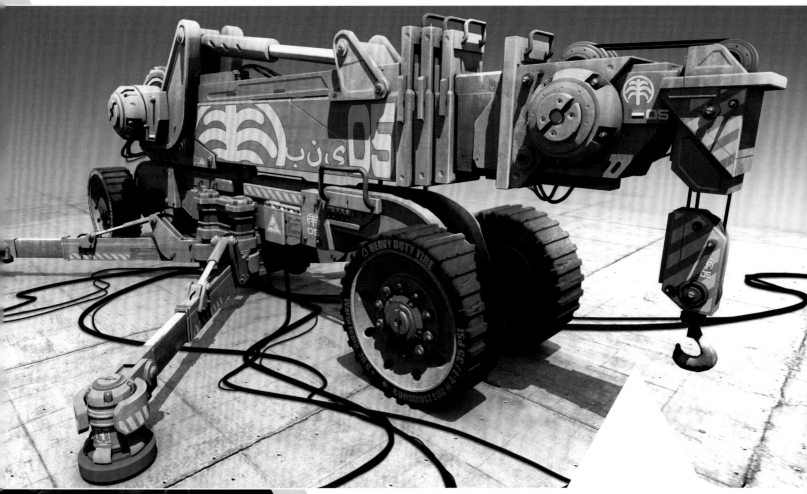

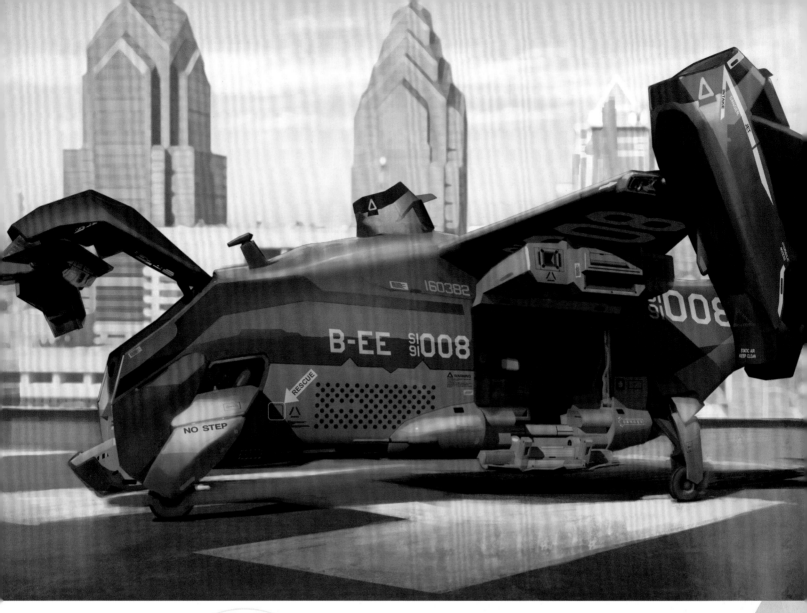

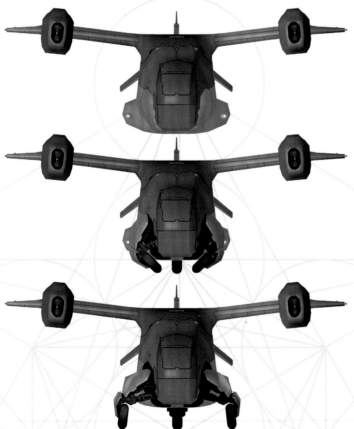

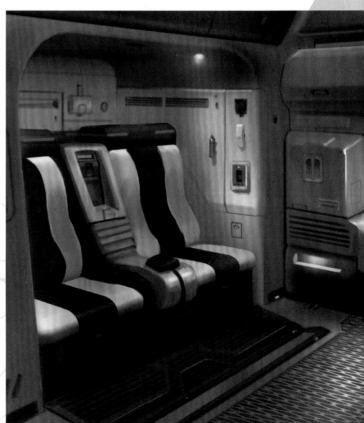

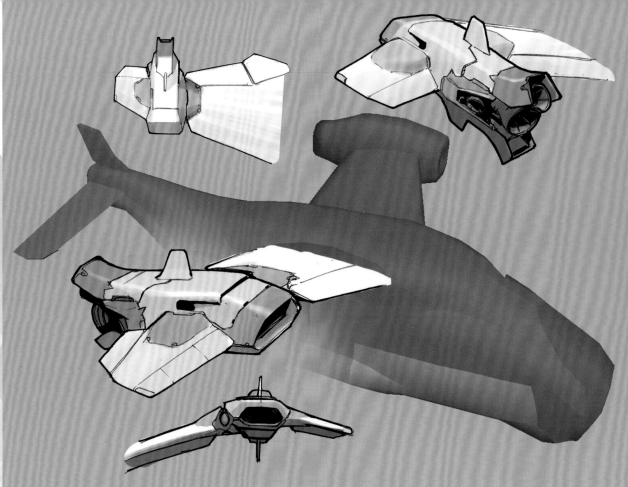

B-EE VTOL

On foot, Adam Jensen has a way—many, in fact—of making an entrance. So, when it came to his mode of transportation, his arrival also needed to be stylish. The B-EE VTOL serves this purpose well. "In the original *Deus* Ex, the chopper was an important centerpiece, so we knew we had to give a lot of attention and care to the design of our own chopper for *Human Revolution*," explains Jacques-Belletête about Adam's principal ride. "We had to ensure there would be enough room for more than one passenger, since cut-scenes with two characters would be taking place inside of it, while still keeping it compact. It also had to offer a fair degree of comfort, as it would fly Adam in long trips all over the world. All in all, we wanted something that looked like a slick and agile air transport vehicle."

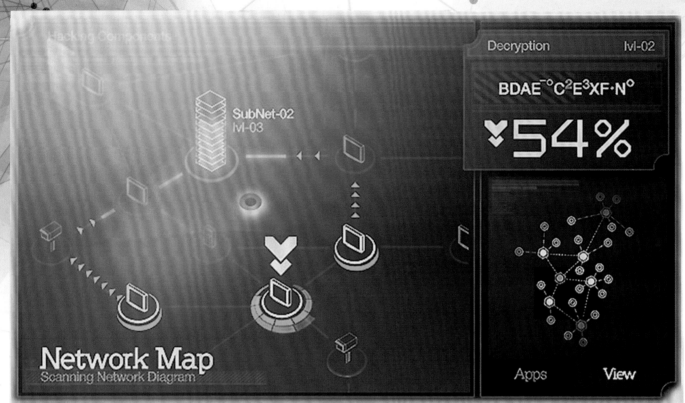

COMPUTER TERMINAL AND KEYPAD DEVICE

Jacques-Belletête tells of how the everyday PC got a refreshing new look: "These proved quite tricky to design. It had to be a consistent visual direction, as we wanted to make it clear they were made by the same company and the same technology. They also had to be easily distinguishable from all the other props, as these assets were often important and necessary variables to the player's evolution in the game. After having researched future computer and display technologies in depth, we figured out that thin, transparent, morphing displays were not too far-fetched, and decided to go along with this idea."

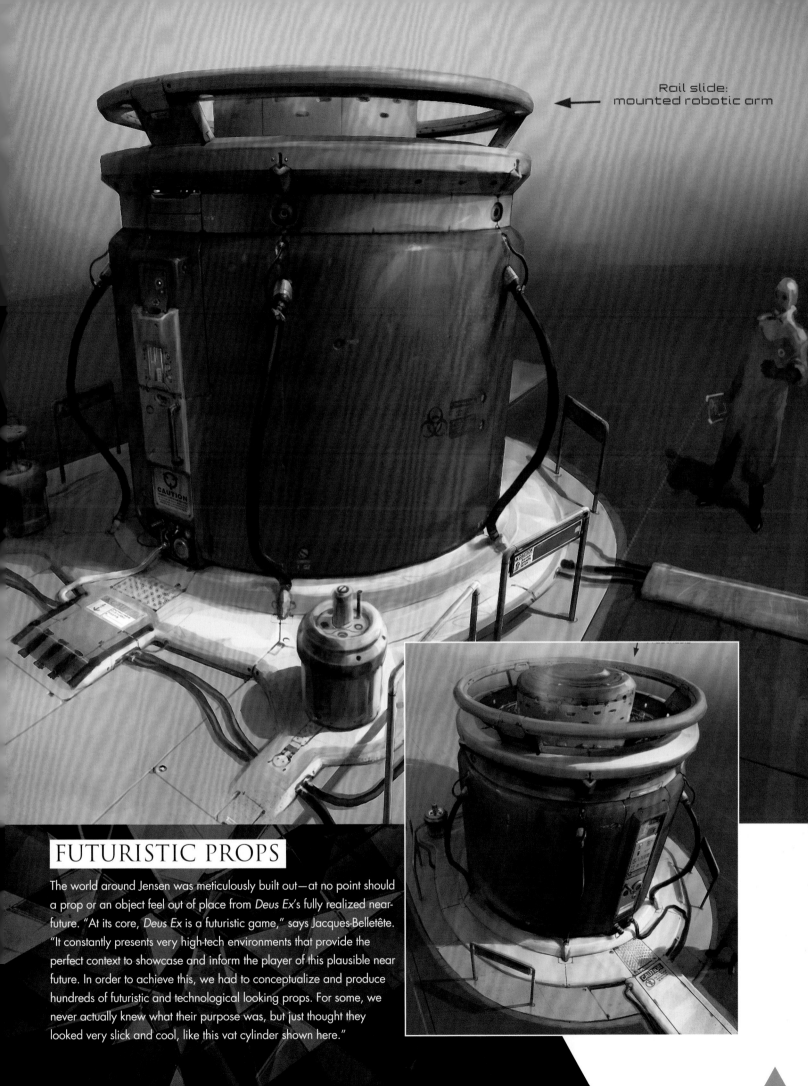

Rail slide:
mounted robotic arm

FUTURISTIC PROPS

The world around Jensen was meticulously built out—at no point should a prop or an object feel out of place from *Deus Ex*'s fully realized near-future. "At its core, *Deus Ex* is a futuristic game," says Jacques-Belletête. "It constantly presents very high-tech environments that provide the perfect context to showcase and inform the player of this plausible near future. In order to achieve this, we had to conceptualize and produce hundreds of futuristic and technological looking props. For some, we never actually knew what their purpose was, but just thought they looked very slick and cool, like this vat cylinder shown here."

ATYPICAL VEHICLES

Trends affecting the appearance of vehicles through the decades are decided by numerous factors, and are not always practical. "Other than Adam's iconic VTOL, a wide variety of vehicles were needed for different purposes and roles in the game's story," explains Jacques-Belletête. "Others had to be created simply to give credibility to the world in general. The Belltower trucks, with one of its various versions shown here, were quite successful at displaying a good combination of some iconic aesthetic variables of the game, as well as the solid, classic military lines."

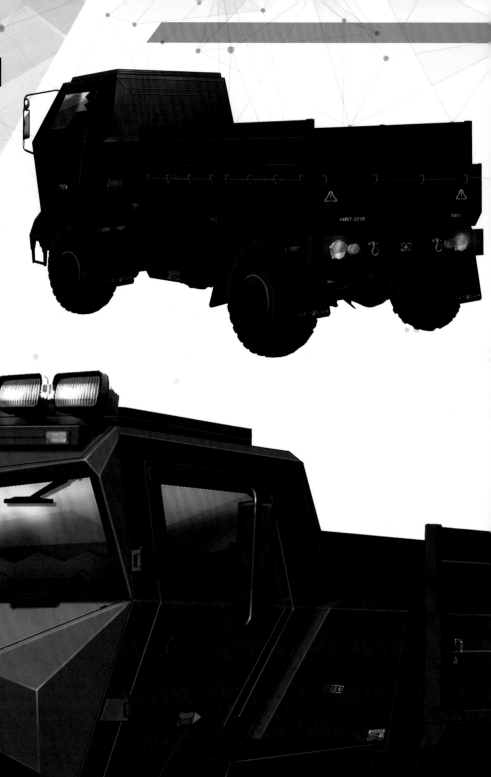

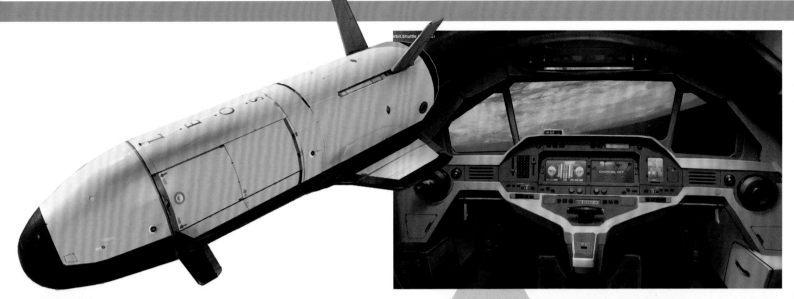

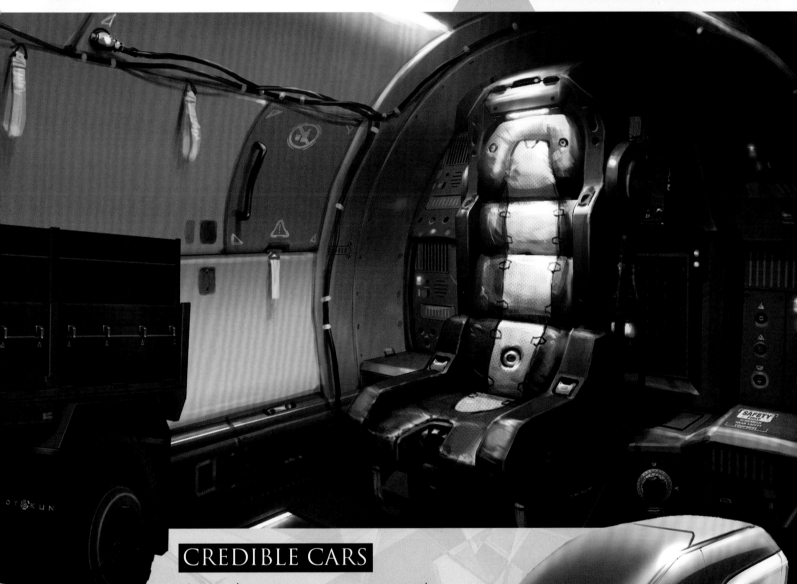

CREDIBLE CARS

"Owing to the cover system, trying to come up with car designs that looked credible and futuristic proved very difficult," notes Jacques-Belletête. "All departments had to observe this system's strict mechanical rules. For the art team, that meant creating a lot of blocky and square angled things. However, we're designing for a game, and anything that is intrinsically connected to gameplay takes precedence over everything else."

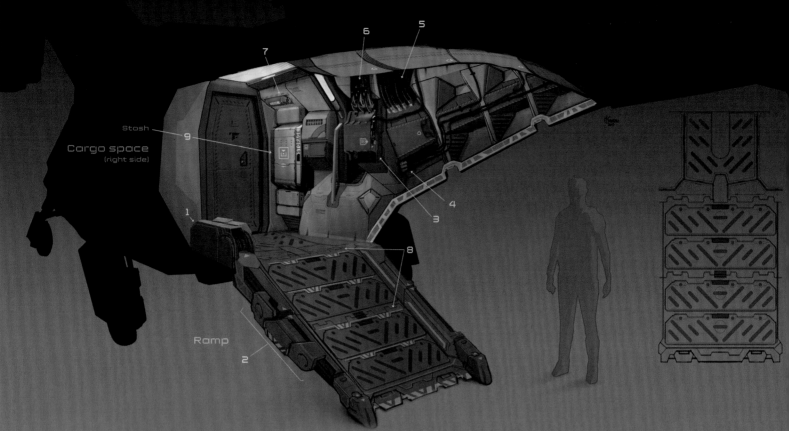

Stosh

Cargo space
(right side)

9

1

Ramp

2

8

3

4

5

6

7

VTOL

As with many great works of art, design in *Deus Ex* was often partly inspired by nature. Explains Dubeau on one of the game's most iconic vehicles: "We used the swallow as our core inspiration for the shapes used within the design of the VTOL. From those shapes, the aggressive wing shape, the front nose, and the unmistakable 'V' tail are easily distinguishable. The stealth aspect uses the edginess of an F117 bomber, respecting our no-curve feudal art style. This personal military carrier is split into three sections: the cockpit, passenger section, and the rear suite. The wings and thrusters have various configurations to accommodate different styles of flying: the Vertical Take-Off, Landing and (VTOL), high speed configuration, or hush drive.

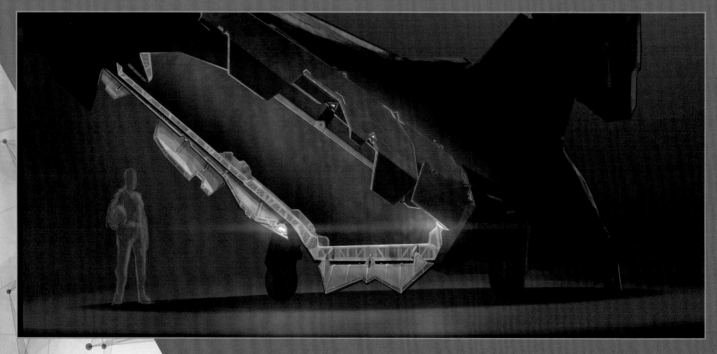

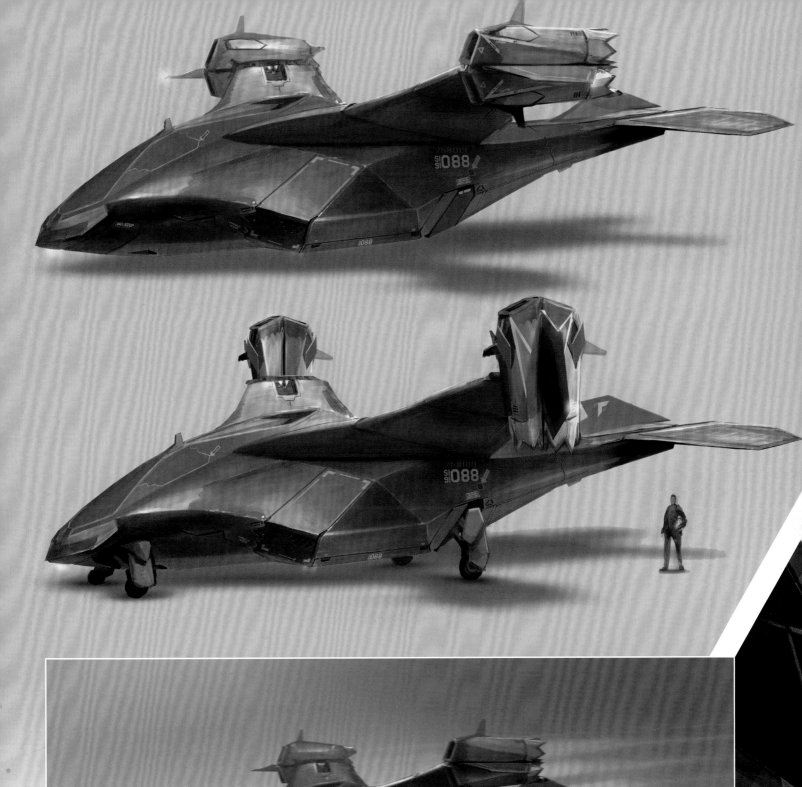
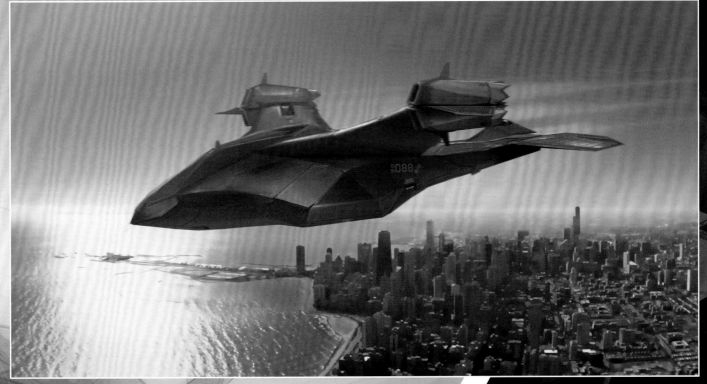

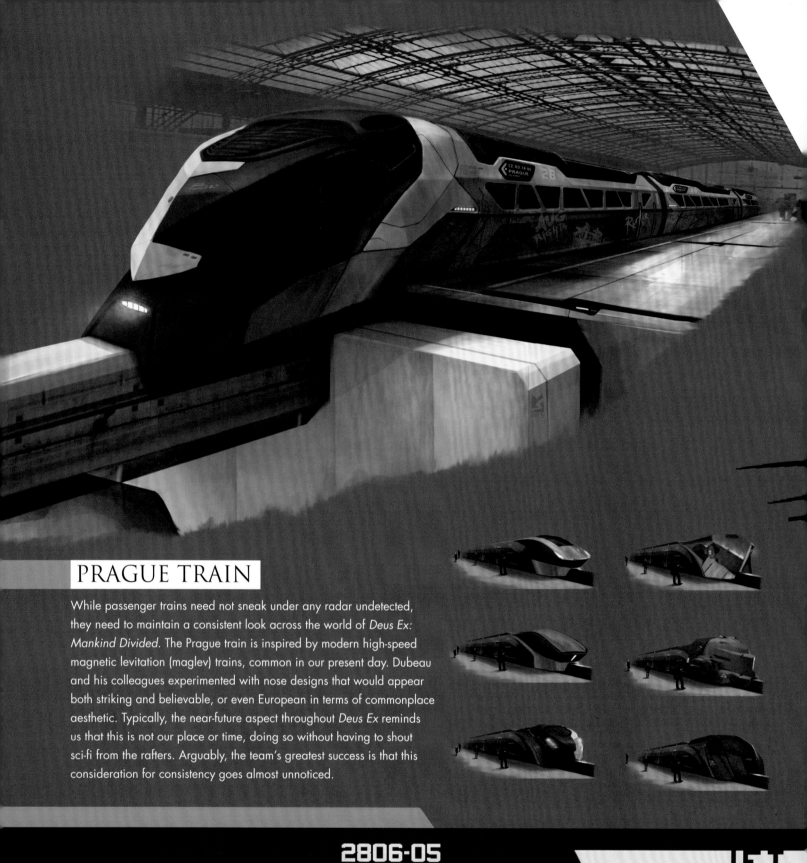

PRAGUE TRAIN

While passenger trains need not sneak under any radar undetected, they need to maintain a consistent look across the world of *Deus Ex: Mankind Divided.* The Prague train is inspired by modern high-speed magnetic levitation (maglev) trains, common in our present day. Dubeau and his colleagues experimented with nose designs that would appear both striking and believable, or even European in terms of commonplace aesthetic. Typically, the near-future aspect throughout *Deus Ex* reminds us that this is not our place or time, doing so without having to shout sci-fi from the rafters. Arguably, the team's greatest success is that this consideration for consistency goes almost unnoticed.

MOT◉KUN

2806-05

05

DANGER

JET

DANGER

INTAK

HELICOPTER

Few Hollywood blockbusters escape the helicopter flyover as a dramatic segue to the next scene, or very often as a ride into the movie's opening scheme. In *Deus Ex: Mankind Divided*, helicopters underline the military presence, a world in conflict that's ready to mobilize forces at any given moment. They police the skies, and fill the air with a foreboding, almost inaudible rumble. Their imposing bulk on the helipads atop executive buildings, or arrival at military LZs, suggests a crucial next destination.

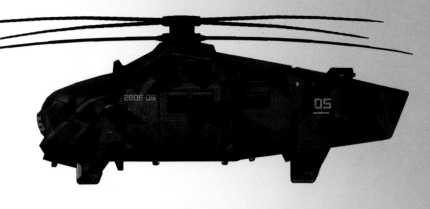

Dual rotors and an orca-like 'killer' presence makes these helicopter designs send shivers down your spine, even before the ignition button is pressed.

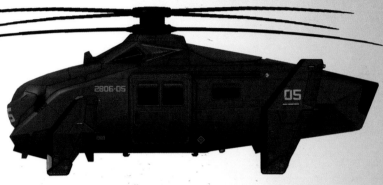

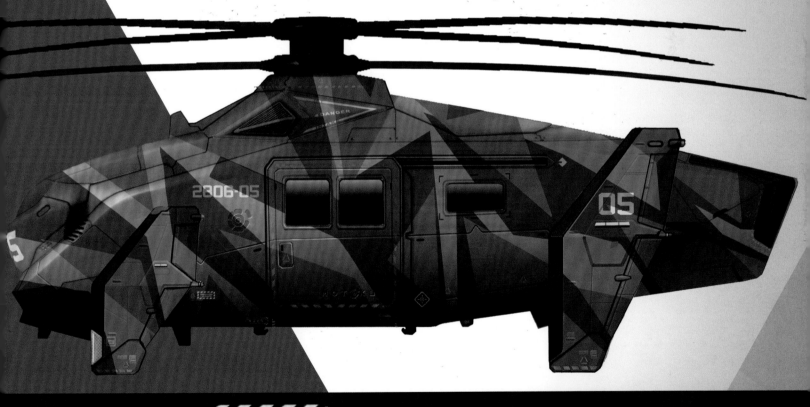

CAUTION

LASER BEAM : DO NOT LOOK INTO BEAM. HAZARD RADIATION. 1998-00987-5654800 SEA TEC COMPONENT

CAUTION APU ACCESS

APU

LASER BEAM : DO NOT LOOK INTO BEAM. HAZARD RADIATION. 1998-00987-5654800 SEA TEC COMPONENT

CAUTION

LASER BEAM : DO NOT LOOK INTO BEAM. HAZARD RADIATION. 1998-00987-5654800 SEA TEC COMPONENT

⚠ WARNING

Risk of major injury if deployed in built up HANDLE WITH CARE Trained use only. If seal is broken .

MA 9003s

AUTHORIZER PERSONNEL ONLY

LASER BEAM : DO NOT LOOK INTO BEAM. HAZARD RADIATION. 1998-00987-5654800 SEA TEC COMPONENT

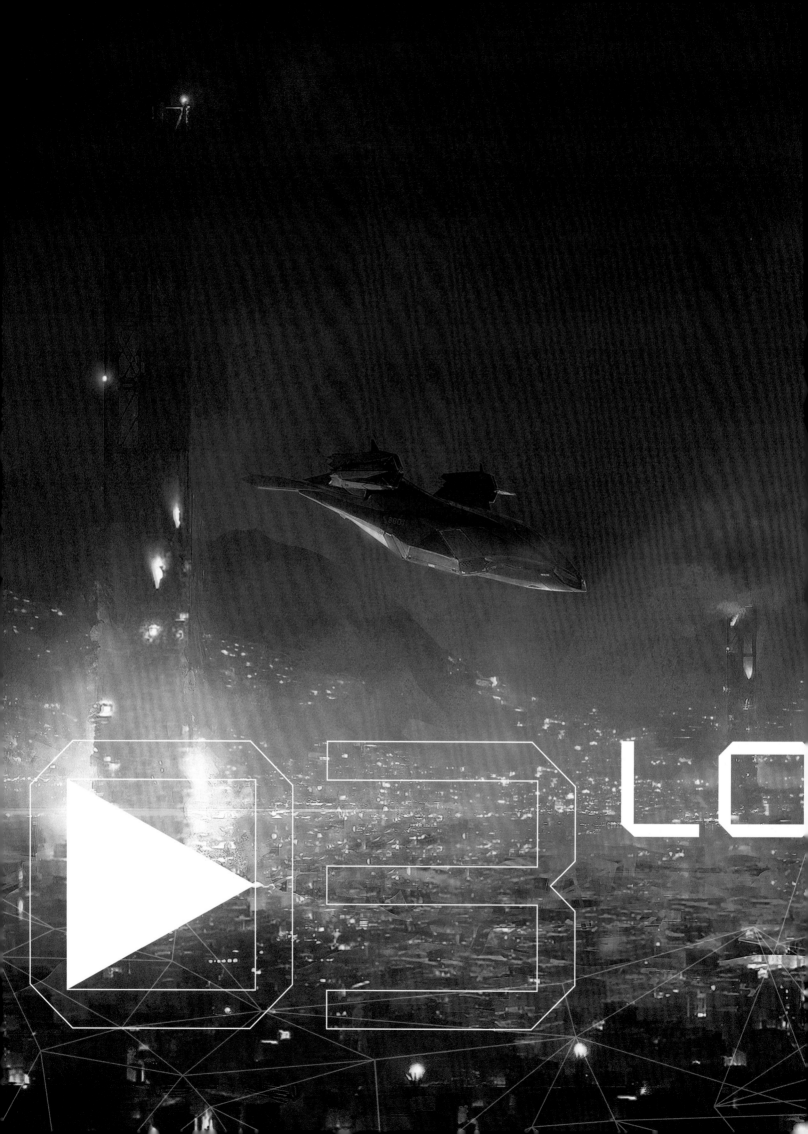

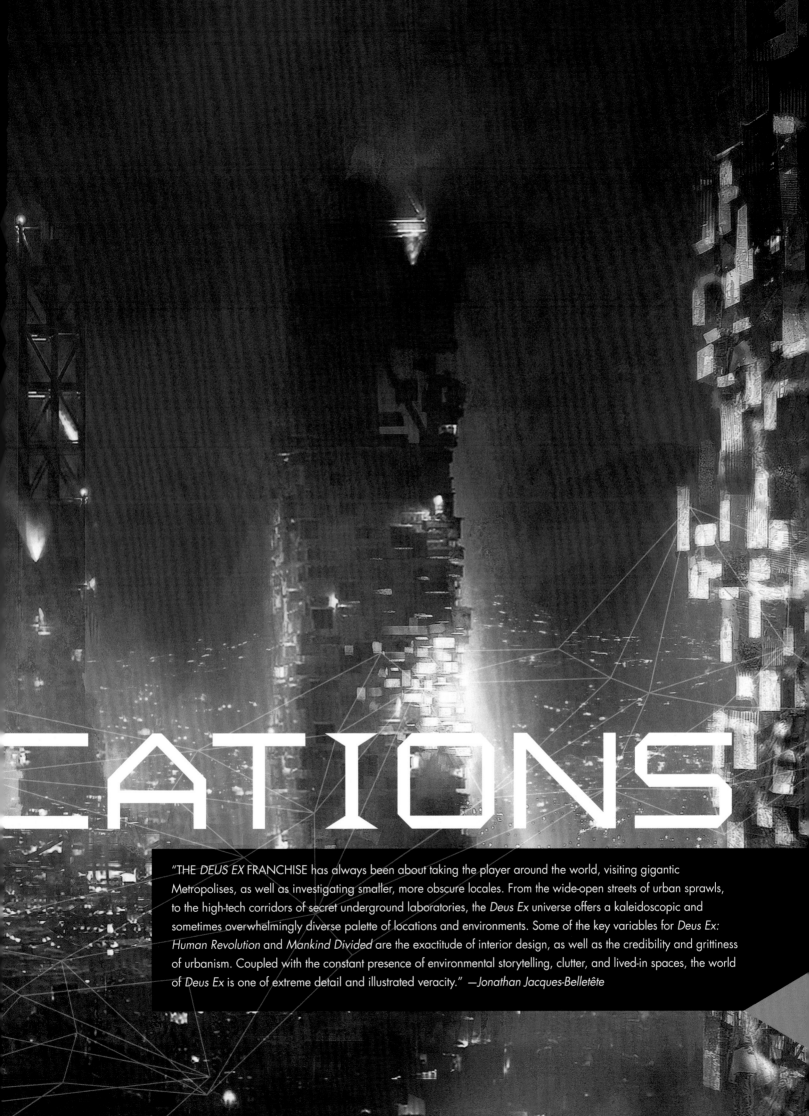

CATIONS

"THE *DEUS EX* FRANCHISE has always been about taking the player around the world, visiting gigantic Metropolises, as well as investigating smaller, more obscure locales. From the wide-open streets of urban sprawls, to the high-tech corridors of secret underground laboratories, the *Deus Ex* universe offers a kaleidoscopic and sometimes overwhelmingly diverse palette of locations and environments. Some of the key variables for *Deus Ex: Human Revolution* and *Mankind Divided* are the exactitude of interior design, as well as the credibility and grittiness of urbanism. Coupled with the constant presence of environmental storytelling, clutter, and lived-in spaces, the world of *Deus Ex* is one of extreme detail and illustrated veracity." —*Jonathan Jacques-Belletête*

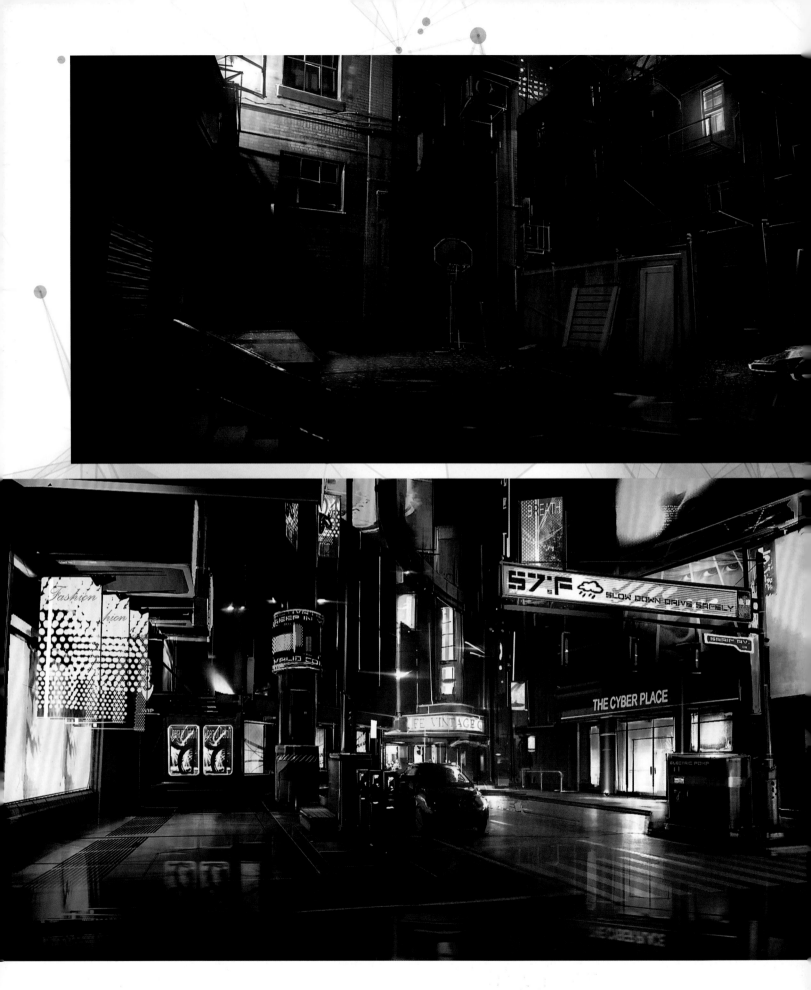

▶ "Even though the city of Detroit had been rejuvenated thanks to the cybernetics industry, we still wanted to make sure that there was a credible amount of old versus new juxtaposition. We wanted people who knew the real Detroit to recognize it, as well as indulge in its new futuristic add-ons."
—Jonathan Jacques-Belletête

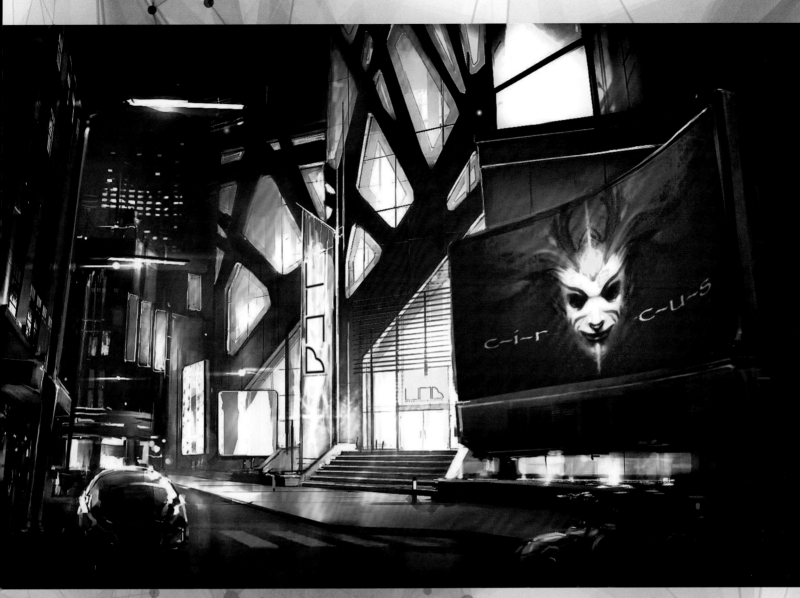

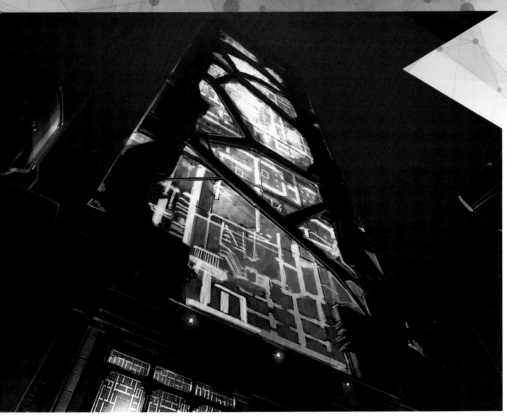

DETROIT

"The concept for Detroit in *Deus Ex* was simple and elegant—" reveals Jacques-Belletête, "—a city that had once been the heart of industrial America, thanks to its automotive industry, had eventually fallen to bankruptcy and decay. However, a visionary and ambitious entrepreneur— David Sarif—literally gave a second life to the abandoned automotive infrastructures by giving them a new purpose: research, development, and production of human cybernetic augmentations. These ideas ended up creating a powerful symbol. The car had been one of the main growth factors of the 20th century. Human augmentation would be the 21st century equivalent."

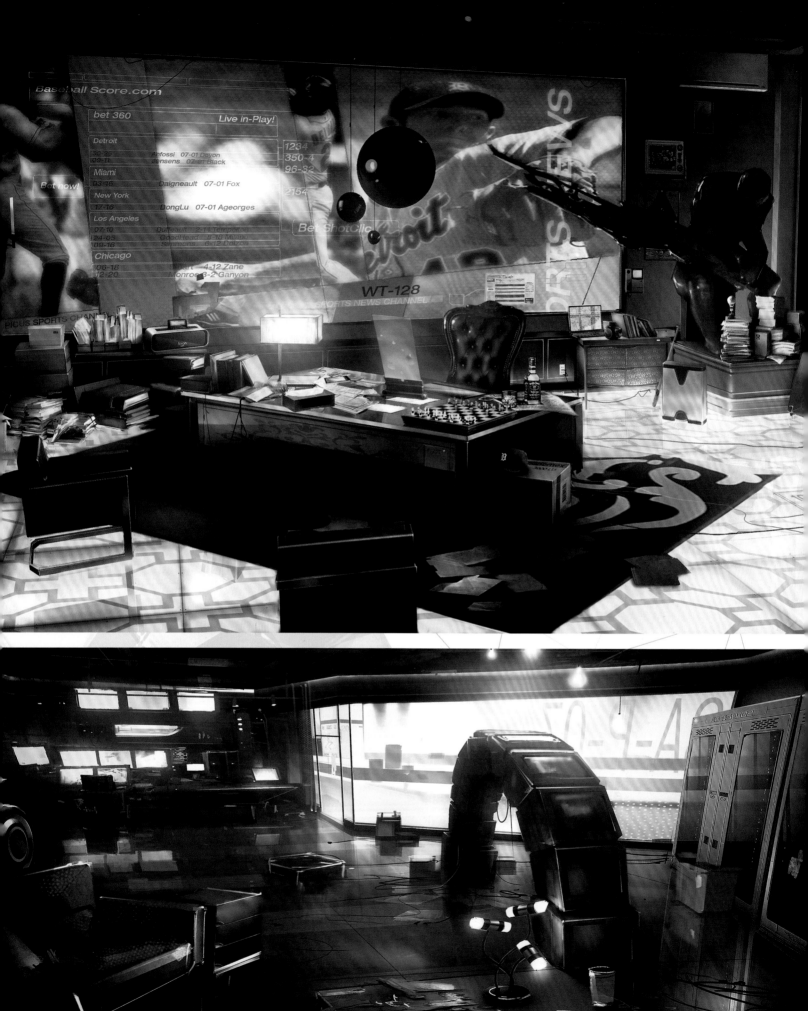

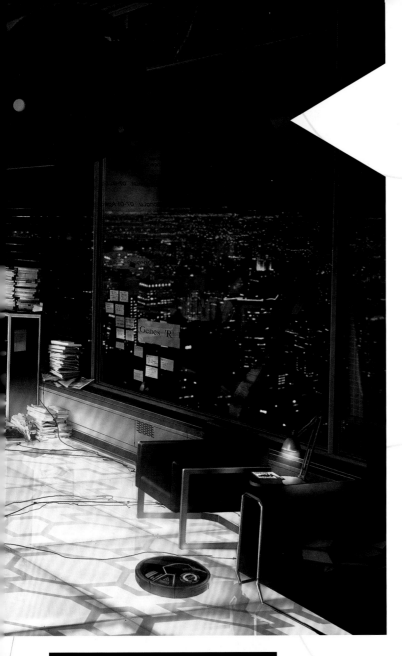

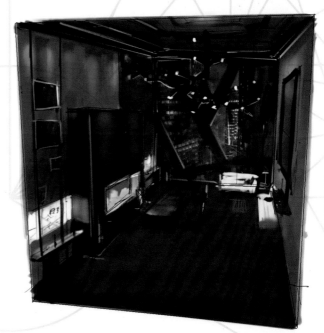
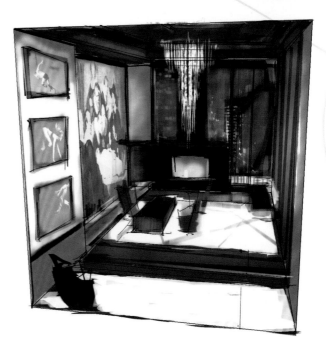

SARIF INDUSTRIES

"The headquarters of David Sarif's enterprise had to play many visual roles," explains Jacques-Belletête. "It needed to look and feel like your quintessential corporate space where employees, visitors, and business partners came in and out all day long. However, it's also where we find the personal spaces of many important characters of the game. For example, David's private office was a tough one. Getting our Cyber-Renaissance aesthetic and slick interior design flair, mixed with what is basically a businessman who likes baseball, was not an easy task. We went through so many iterations and styles. It's also definitely one of the rooms where there is the greatest amount of little visual metaphors, personal storytelling props, and physical setups."

▶ "We knew from the get-go that Pritchard's office had to look like a tech geek playground, but I always really enjoyed the extra touches that were added beyond the clichés. One great example of this is the slick, archlike sculpture, composed entirely of old CRT monitors, with another being the now fabled *Final Fantasy XXVII* poster!" —Jonathan Jacques-Belletête

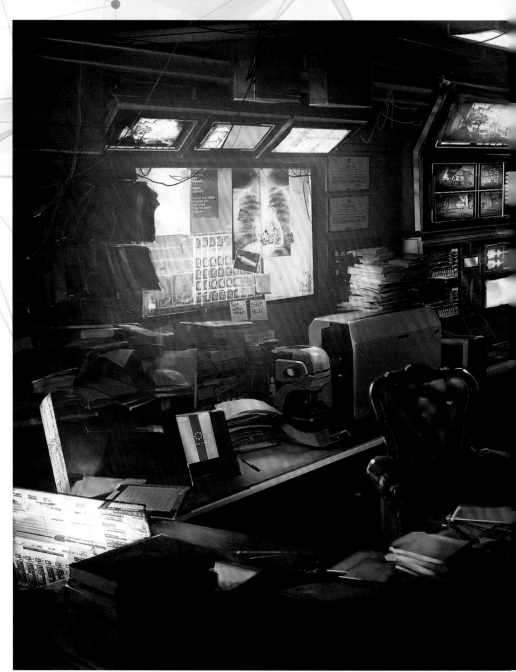

▶ "Megan's office is definitely the most cluttered and messiest personal space in the game," states Jacques-Belletête. "Why is she so messy? I honestly have no idea. The real reason is probably because the location served as a benchmark for all the clutter we wanted in the game, that all-important 'lived-in' feeling, so we went all out with it. It's also the first environment that you can properly observe in the game; either in the cut-scene, or as you gain control of Adam for the first time. It had to be both impressive and a canvas for many of our themes and visual pillars."

"Sarif Labs (below) was only used for the opening walk-and-talk sequence, and subsequent tutorial/attack. Nonetheless, we went through at least three different visual iterations, making sure they were some of the best looking environments. After all, that's what all the players would see first." —Jonathan Jacques-Belletête

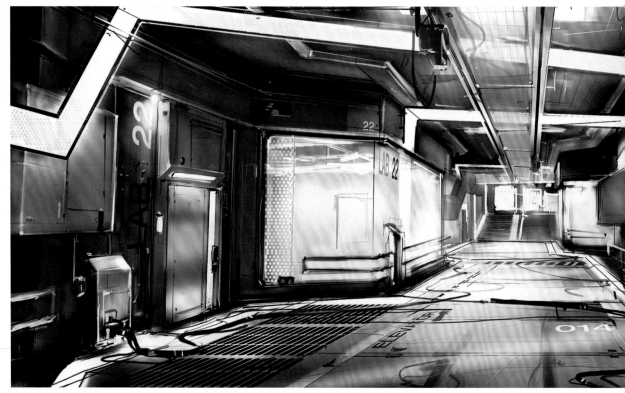

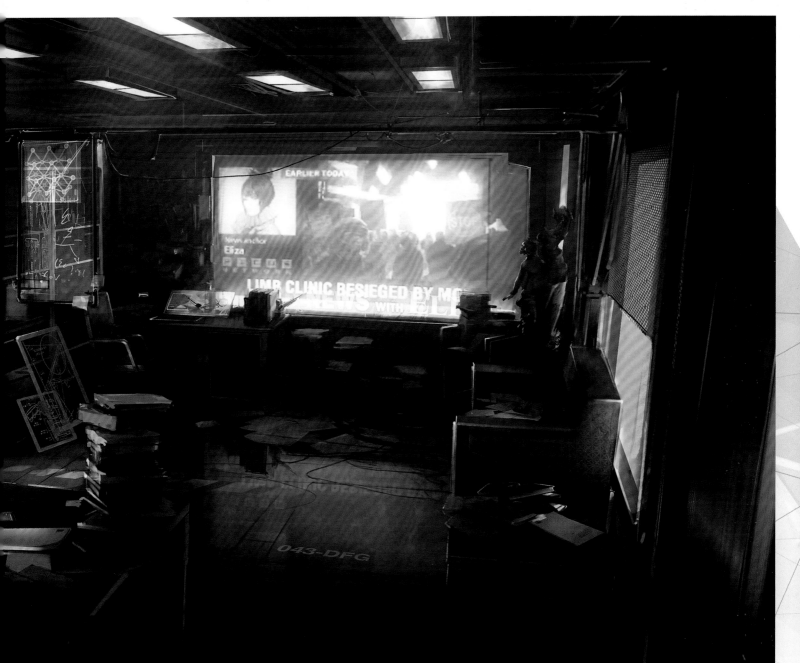

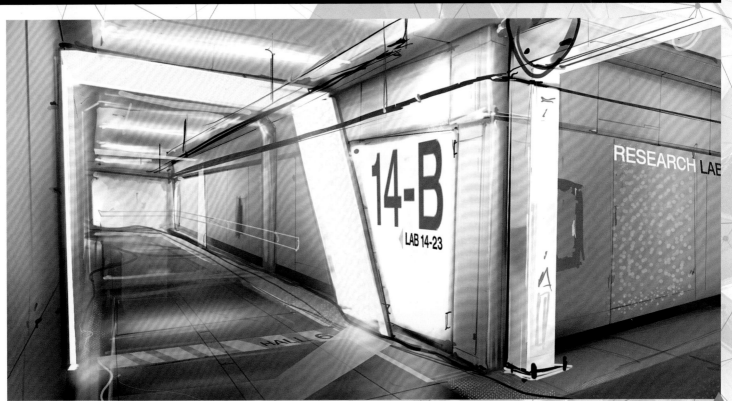

ADAM'S APARTMENT

"We wanted this location to be the epitome of 'show, don't tell'," explains Jacques-Belletête. "If you spent enough time in the room, meticulously looking at the many different props lying all over the place, you could relive the past six to twelve months of Adam's life: the still-unpacked moving boxes, the dying plants, the dust, his hobby table, and various baseball paraphernalia. In his bedroom, you could read the covers of the many get well cards on his night stand, his 'how to live with your new augmentation' self-help books, and, of course, the cereal boxes all over the place. What started as a joke ended up as something the fans really got into. There are dozens of fan art pieces out there based around this idea that Adam is a cereal aficionado.

▶ "Adam's apartment was known internally during production as 'Adam's Museum'. That's because this is precisely what we wanted it to be. We wanted players to walk through the space and learn about Adam by simply looking around, paying attention to the big stuff as well as all the little details."
—Jonathan Jacques-Belletête

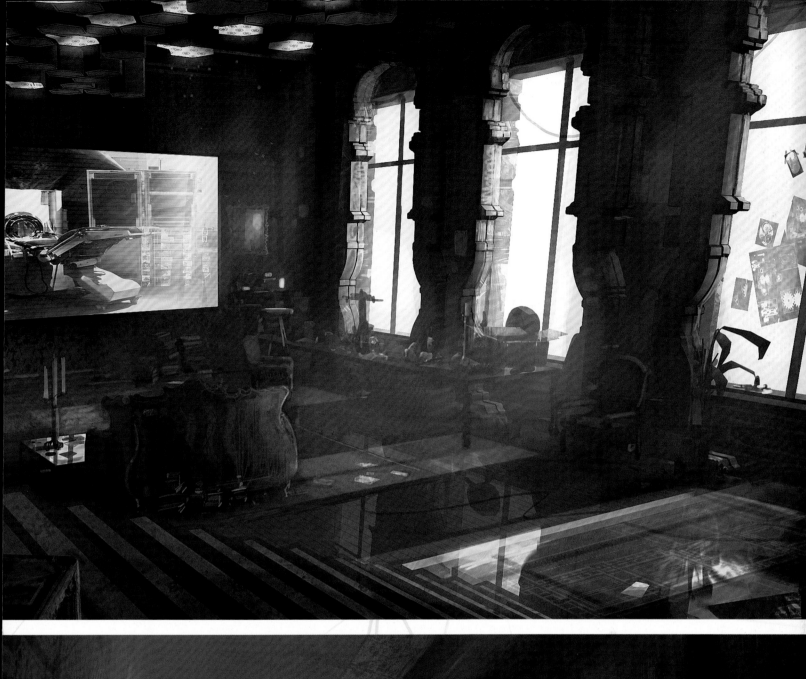
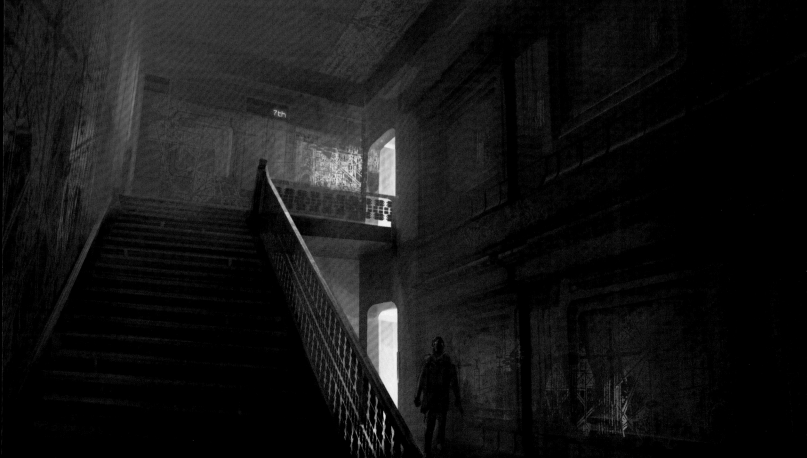

▶ "The FEMA camp was a fun location to design, as it's your classic 'evil secret base' hidden under an abandoned building. The real-world conspiracy theme is quite strong and obvious here, but somehow it did not come out as strongly as we wanted once in the game." —*Jonathan Jacques-Belletête*

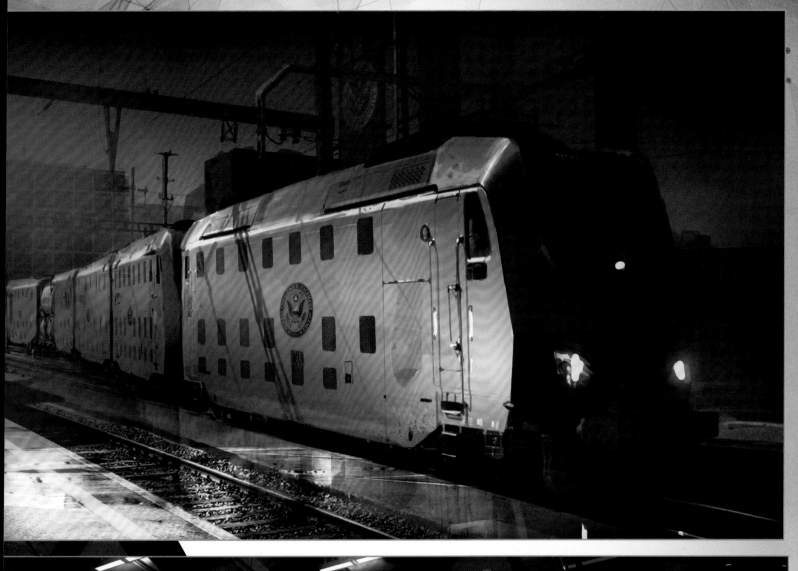

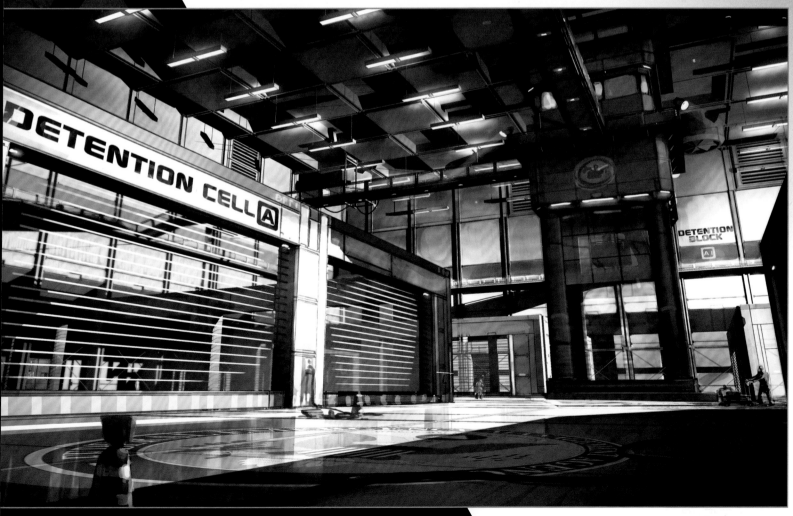

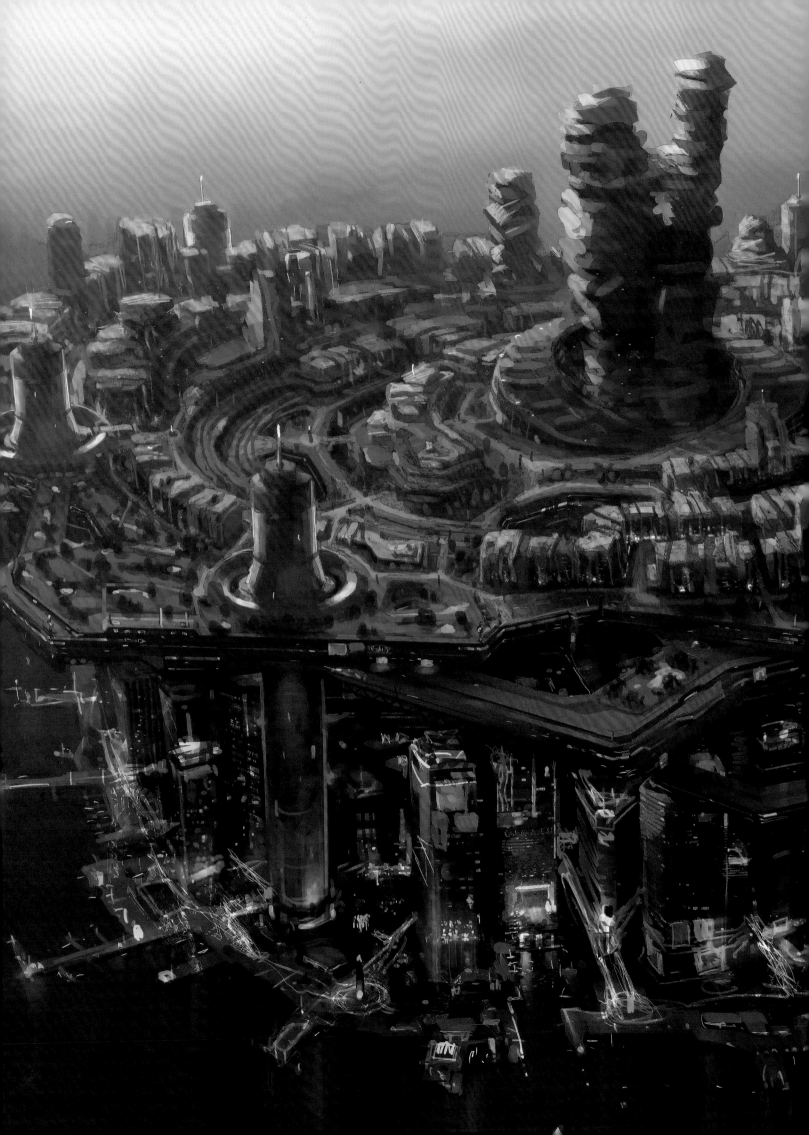

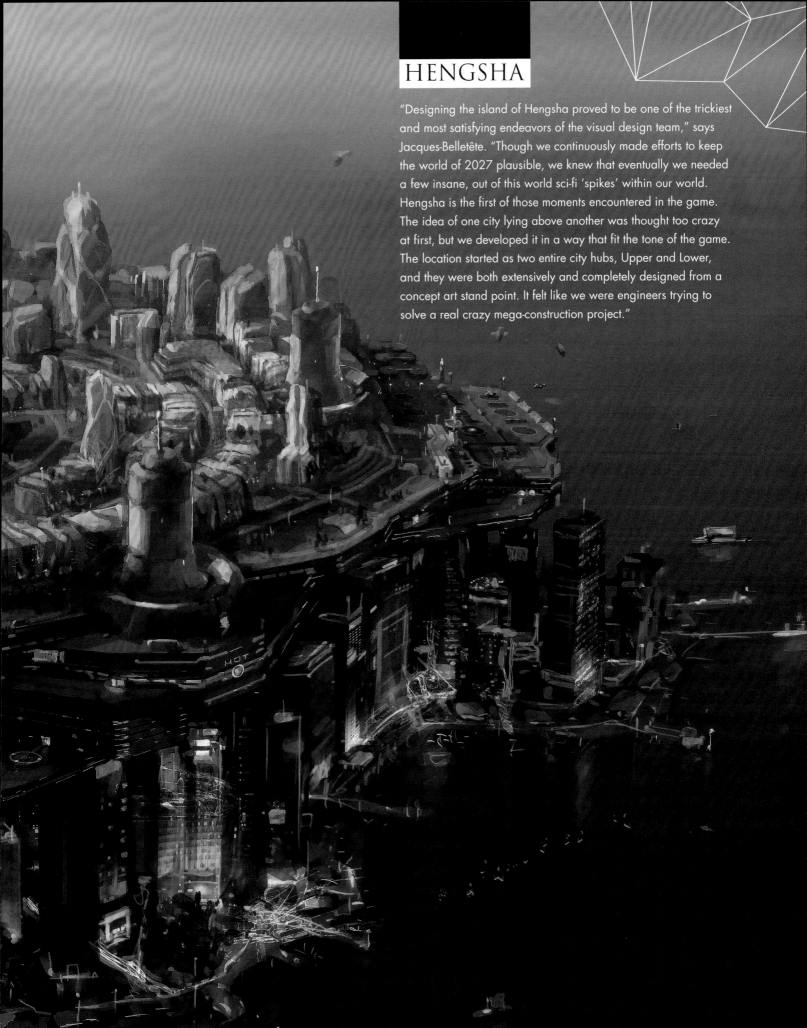

HENGSHA

"Designing the island of Hengsha proved to be one of the trickiest and most satisfying endeavors of the visual design team," says Jacques-Belletête. "Though we continuously made efforts to keep the world of 2027 plausible, we knew that eventually we needed a few insane, out of this world sci-fi 'spikes' within our world. Hengsha is the first of those moments encountered in the game. The idea of one city lying above another was thought too crazy at first, but we developed it in a way that fit the tone of the game. The location started as two entire city hubs, Upper and Lower, and they were both extensively and completely designed from a concept art stand point. It felt like we were engineers trying to solve a real crazy mega-construction project."

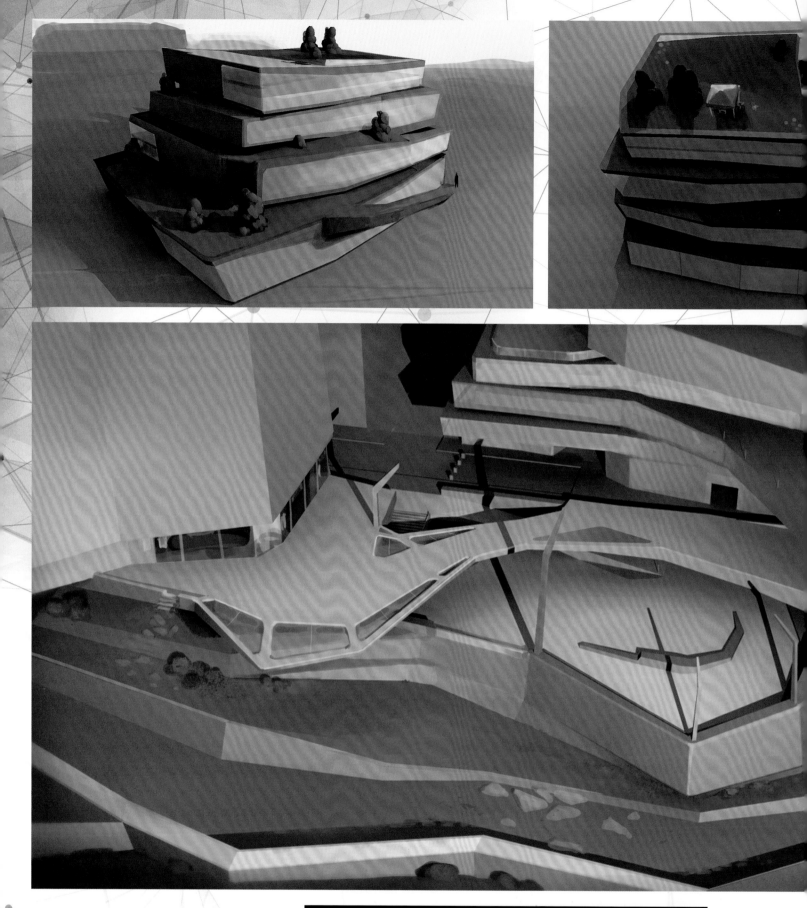

UPPER HENGSHA ARCHITECTURE

"The main idea was to create an architectural style that mimicked natural formations," notes Jacques-Belletête. "We also wanted the structures to be modular, keeping the buildings fairly low, which made the gigantic Tai Yong Medical skyscraper in the middle of the city even more impressive. It's certainly one of our proudest creations, as it captured the imagination and curiosity of gamers, along with our industry as a whole."

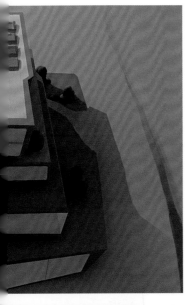
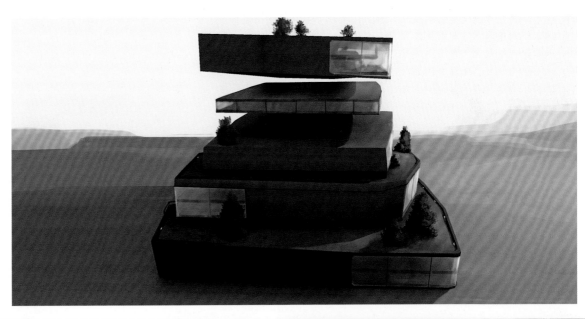

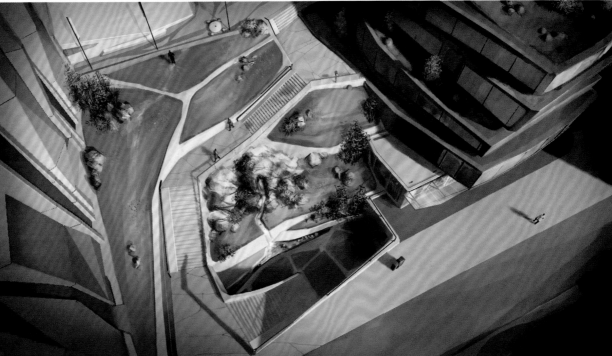
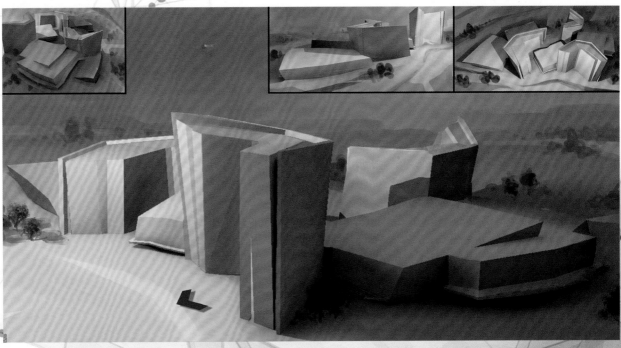

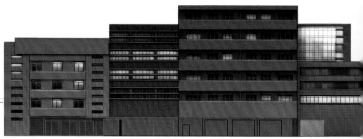

THE FLOOF

Keeping a happy, positive attitude in the workplace can be conducive to some of the greater ideas. As Jacques-Belletête fondly recalls, "During the production of the game, some of the team members started calling the superstructure supporting the upper city 'The Floof'. They combined the words floor and roof together, alluding to the fact that the structure served as both the floor of the upper city, and the roof of the lower city. We eventually thought it was pretty clever, and decided to have the actual NPC's living in Lower Hengsha use this word in the game."

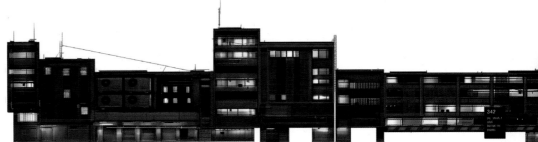

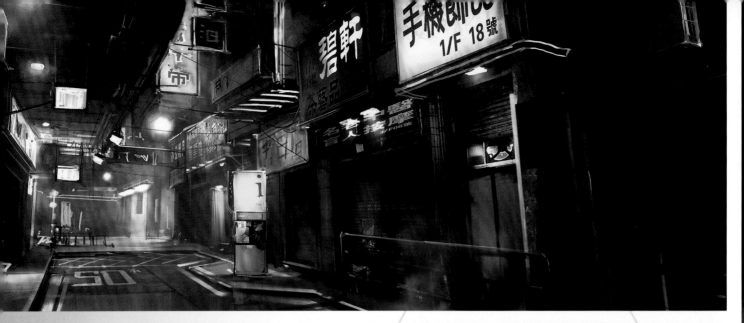

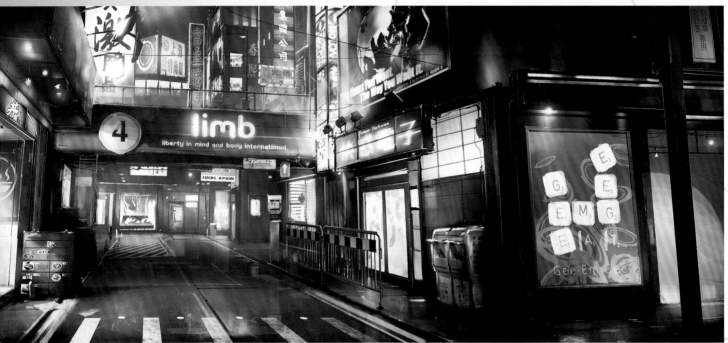

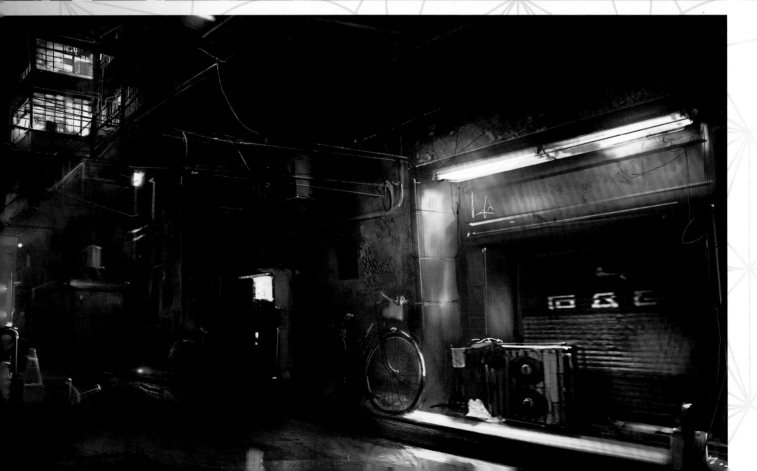

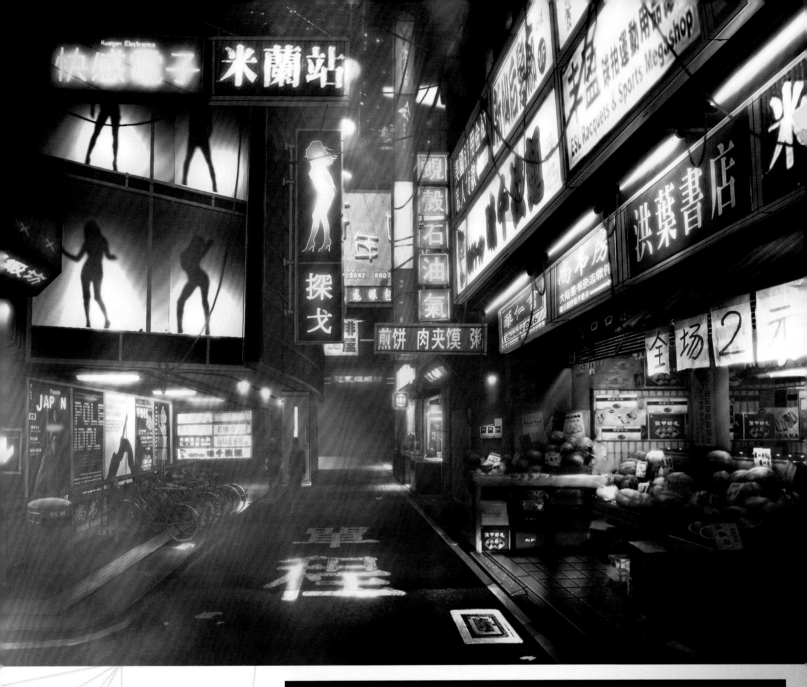

LOWER HENGSHA

Even now, the 21st century feels kind of futuristic. Says Jacques-Belletête: "Our goal was to create a major contrast between the streets and the ceiling looming above them, so we decided to keep the visual design of Lower Hengsha quite contemporary. We figured it would be easier to realistically convey a city built under a gigantic roof if the city itself was not too farfetched. However, we realized rather quickly that simply reproducing the cluttered and neon-filled aesthetic of cities such as Shanghai and Hong Kong already generated a considerably futuristic look."

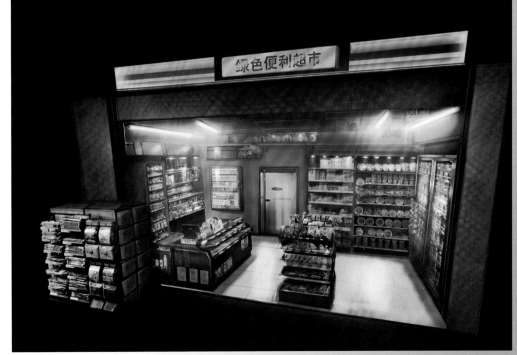

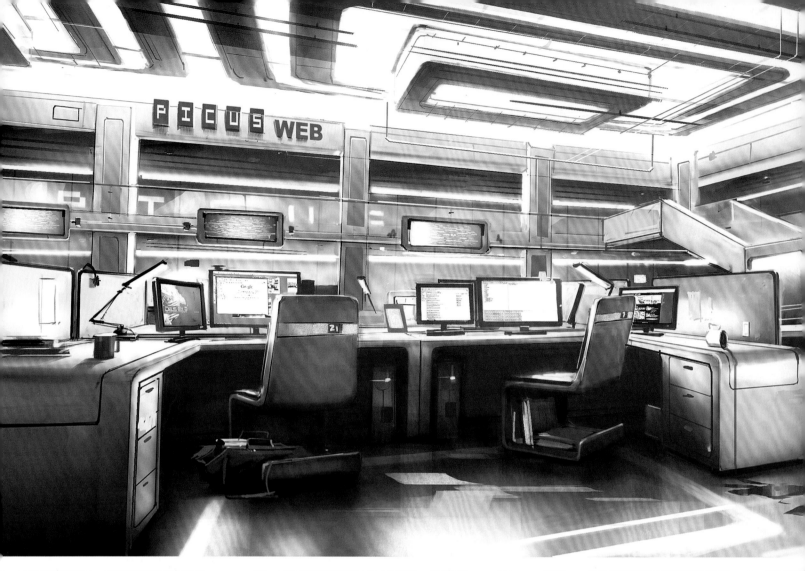

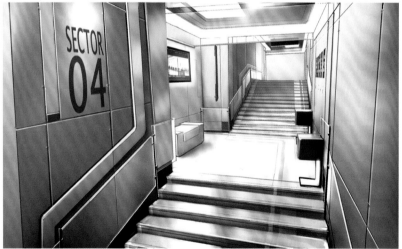

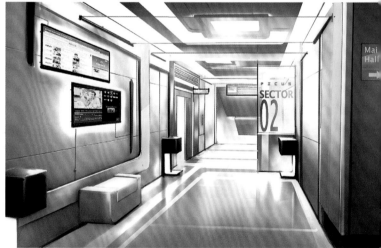

PICUS

"Originally, we planned to have an entire city hub in our home city of Montréal," explains Jacques-Belletête. "Unfortunately, due to time constraints and budget limitations, we abandoned the idea. However, we still kept on trying to find ways of having Montréal in the game somehow. We knew we could include it through some simple narrative devices, but felt it wouldn't be substantial enough. Eventually, the idea of having the Picus headquarter offices inside the Olympic Stadium (the most iconic and recognized building in Montréal) came up, and we went ahead with it. In the end, we still managed to include a piece of home in the game, just not one as big as we had originally wished."

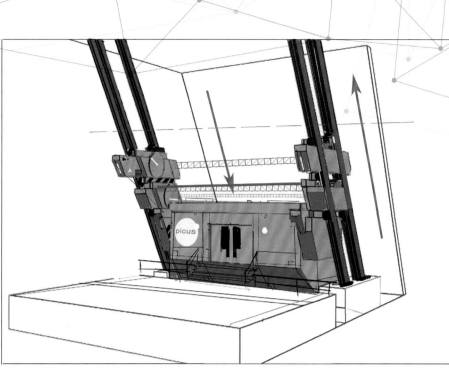

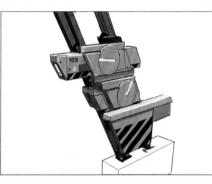

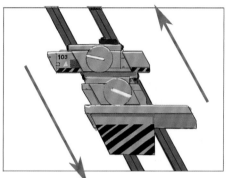

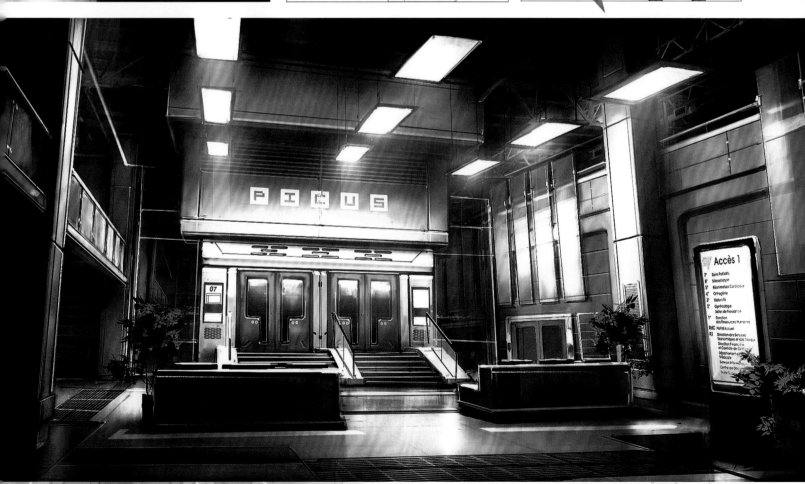

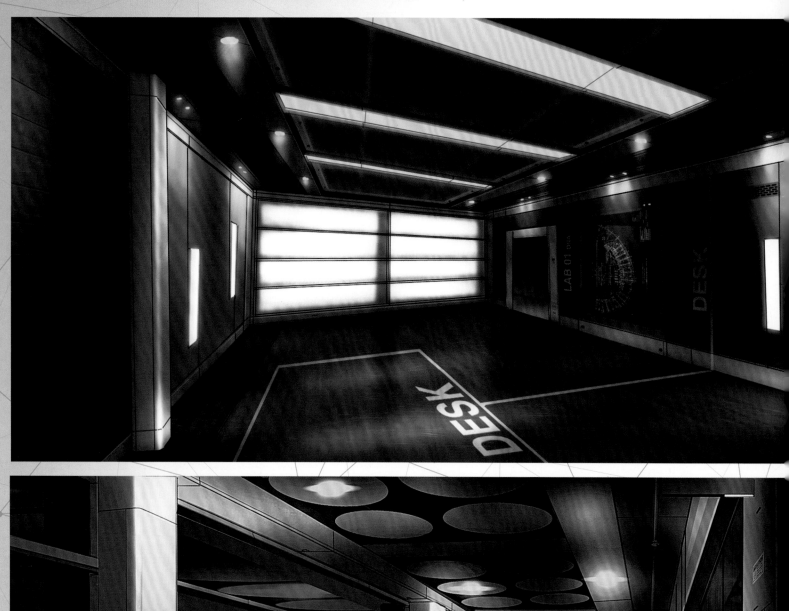

▶ One can almost imagine the smell of these pristinely maintained corridors, their routinely polished and sanitized antistatic surfaces. Says Jacques-Belletête of the location: "The hallways of Omega Ranch in Singapore had to look modern and slick, yet eerie and sinister at the same time."

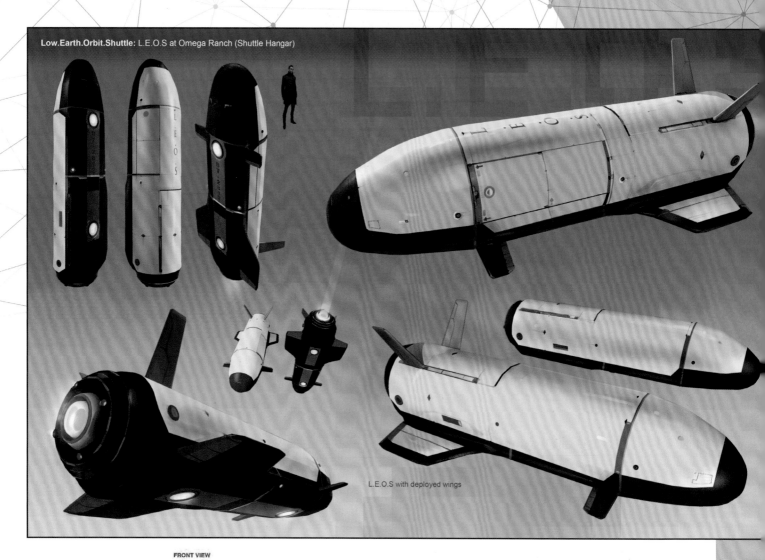

Low.Earth.Orbit.Shuttle: L.E.O.S at Omega Ranch (Shuttle Hangar)

L.E.O.S with deployed wings

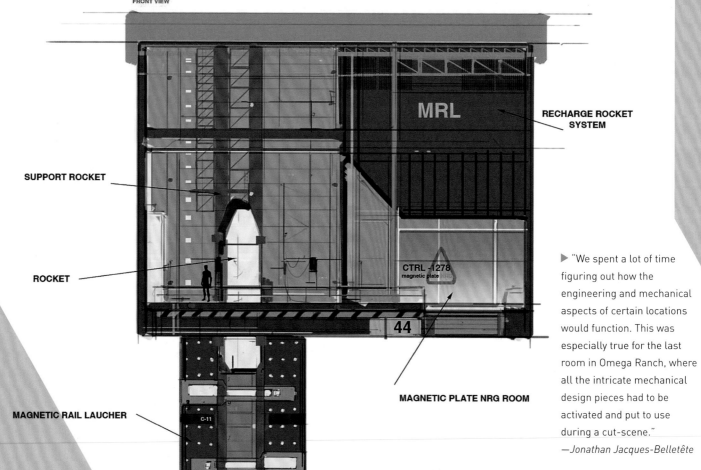

FRONT VIEW

RECHARGE ROCKET SYSTEM

SUPPORT ROCKET

ROCKET

MRL

CTRL-1278
magnetic plate

44

MAGNETIC PLATE NRG ROOM

MAGNETIC RAIL LAUCHER

C-11

C-11

▶ "We spent a lot of time figuring out how the engineering and mechanical aspects of certain locations would function. This was especially true for the last room in Omega Ranch, where all the intricate mechanical design pieces had to be activated and put to use during a cut-scene."
—Jonathan Jacques-Belletête

THE ART OF DEUS EX UNIVERSE™

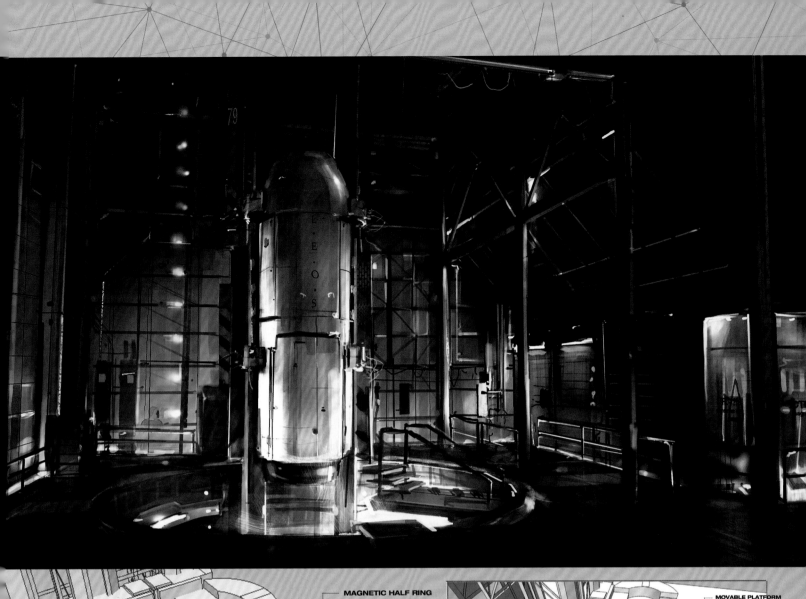

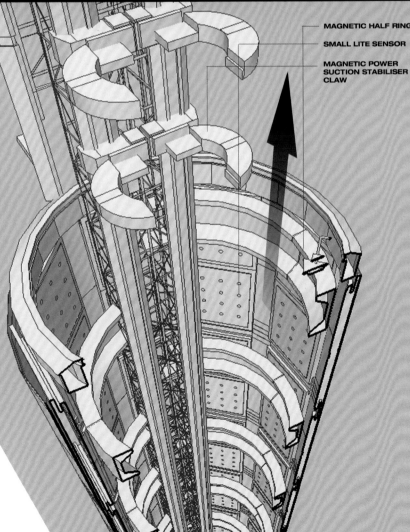

MAGNETIC HALF RING

SMALL LITE SENSOR

MAGNETIC POWER
SUCTION STABILISER
CLAW

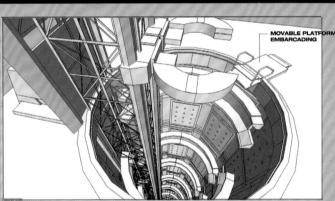

MOVABLE PLATFORM
EMBARCADING

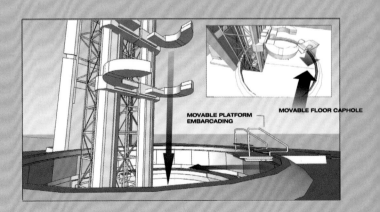

MOVABLE PLATFORM
EMBARCADING

MOVABLE FLOOR CAPHOLE

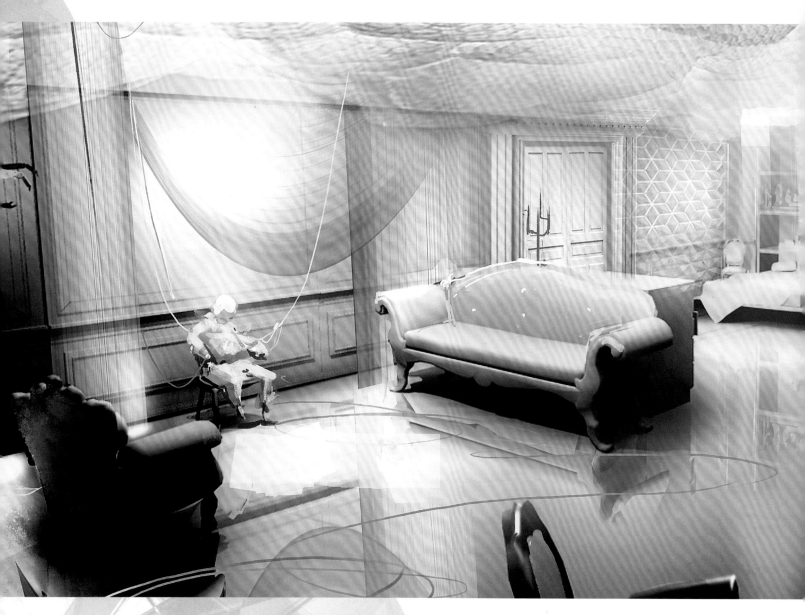

Long-term experience in your professional field can sometimes come to the rescue, as Jacques-Belletête remembers: "This was also called the 'white room' during production, and proved to be a bigger challenge than we had originally anticipated. We quickly realized that our engine was not well suited to properly render an entirely white room in a convincing manner. Because of this, we resorted to using some old school tricks of the trade, as well as allowing the lighting team to employ certain techniques we hadn't previously used in the game. It became a bit of a concern, and we weren't sure if we could pull it off properly. Eventually, the results started shaping up, and we realized it would be one of the great and iconic locations of the game."

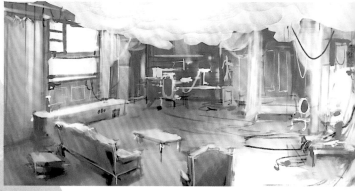

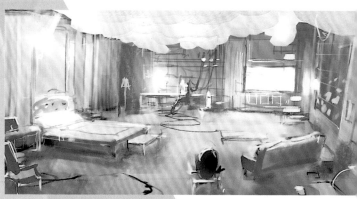

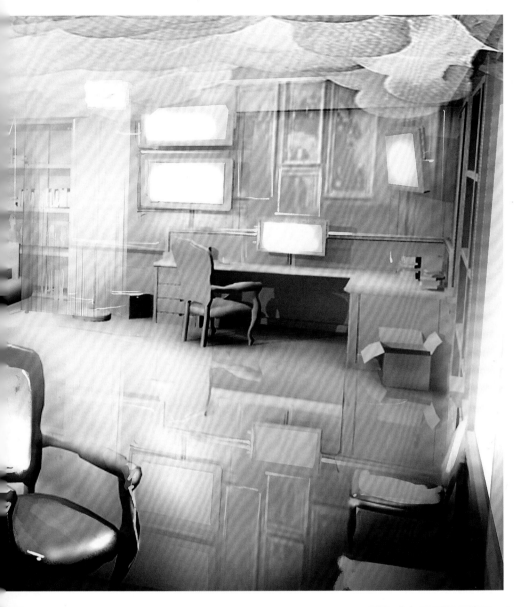

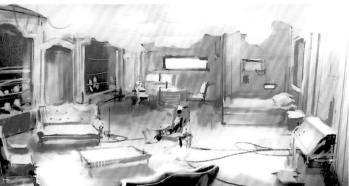

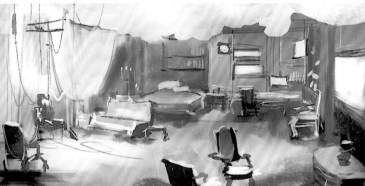

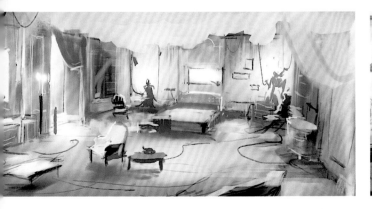

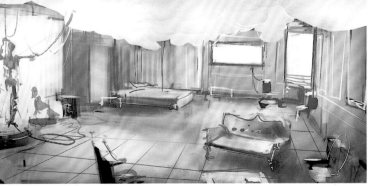

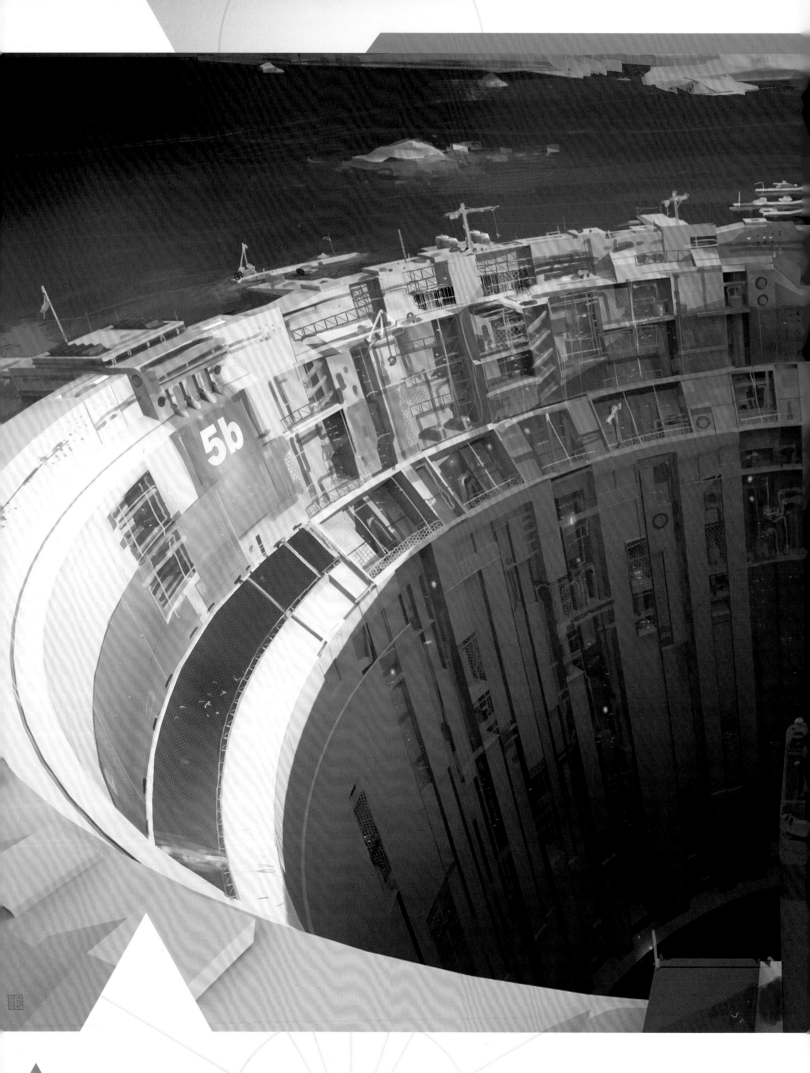

5b

PANCHAEA

"Panchaea is the second biggest crazy sci-fi 'spike' in the game," notes Jacques-Belletête. "The concept of having a gigantic gaping hole in the middle of an ocean, somewhere around the globe, came up quite early during conception. We thought it would make for quite a sight to fly above the ocean, and then suddenly witness water disappearing inside a massive tube in the middle of nowhere. We just didn't know why or what it would be at this point."

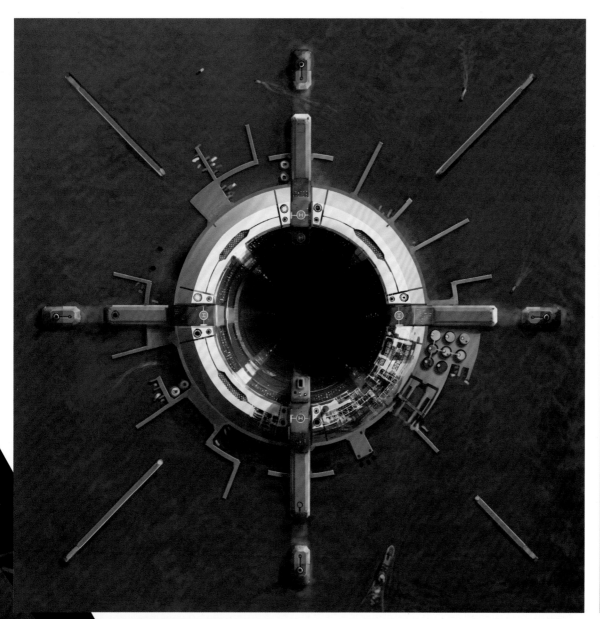

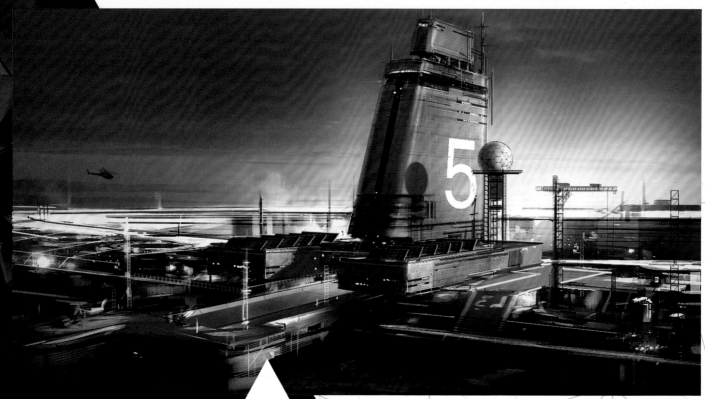

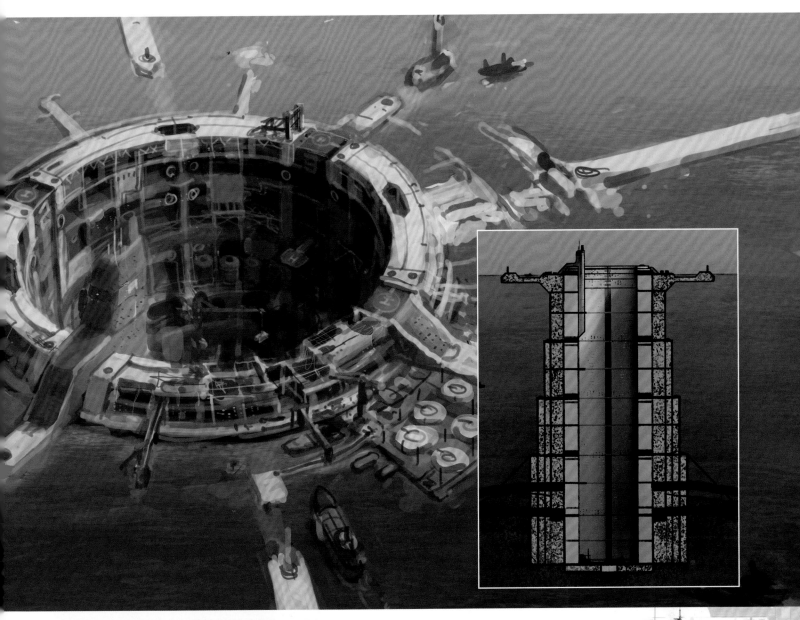

JUSTIFYING THE IDEA

Finding method to the mystery of Panchaea required the team to look elsewhere for inspiration. Reveals Jacques-Belletête: "During our research, we stumbled upon articles about seeding massive amounts of iron particles in the ocean, meant to absorb heat and reduce global warming. Scientists were thinking of filling cargo ships with rust particles and spreading them over areas of the Pacific Ocean. That's when justification for this gigantic cylinder, built from the surface to the bottom of the Arctic Ocean, came up. It would be a giant iron particle generator to combat global warming. We now had our excuse to go ahead and have fun with this crazy idea!"

▶ "Such a complex and imposing installation needed to have an adequately imposing control center. That's when the idea of a huge control Tower, looming above the empty cylinder, came up."
—Jonathan Jacques-Belletête

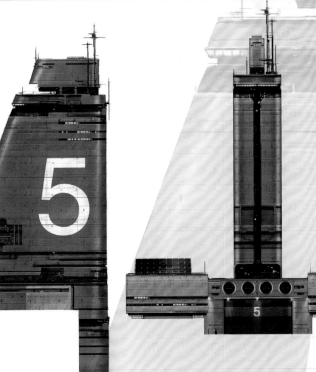

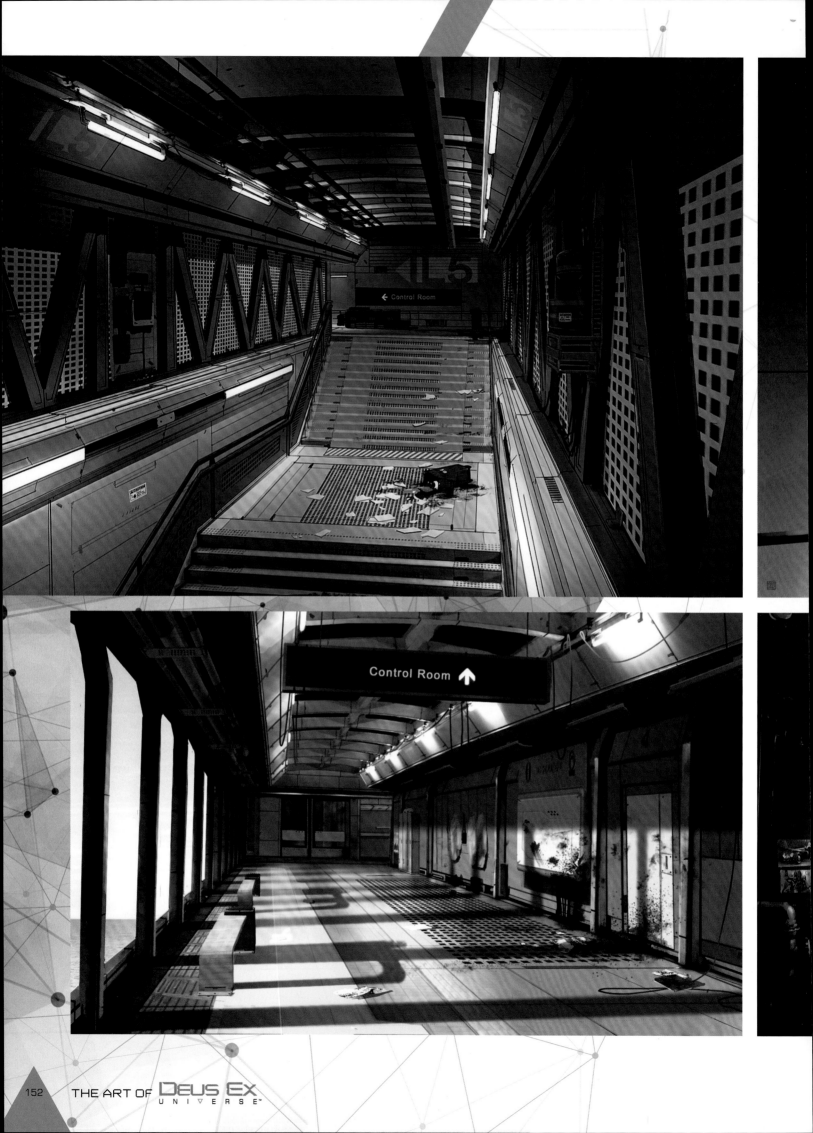

THE ART OF DEUS EX UNIVERSE

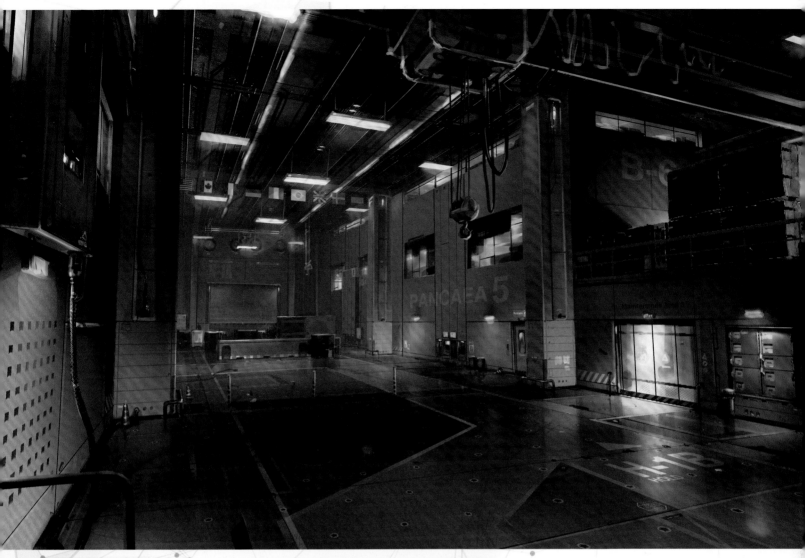

▶ "Even though the high concept for the Panchaea installations was way out of this world, we wanted to make sure that, just like everything else in the game, everything felt credible and believable once you zoomed in; almost like it could have been built during our time." —*Jonathan Jacques-Belletête*

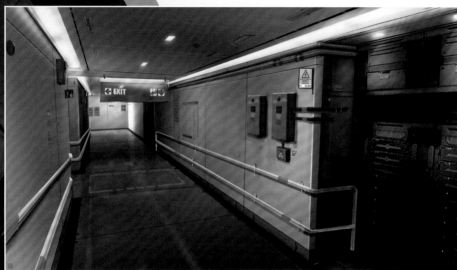

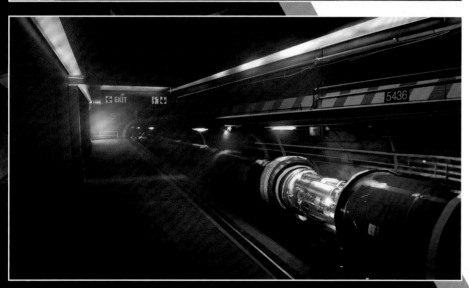

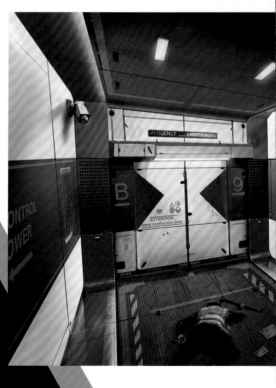

PANCHAEA INTERIOR

"Panchaea was one of those complex locations where we needed a wide variety of location palettes," explains Jacques-Belletête. "There was one for the exterior, one for the interior of the control tower, and another exterior one for areas that were still under construction—we needed imposing vistas to properly convey the size and scope of this huge installation. We also had to design the different rooms for each of the characters associated with the game's endings, the gigantic shaft with the freight elevator, the final boss room… Needless to say, this map ended up costing way more than originally anticipated."

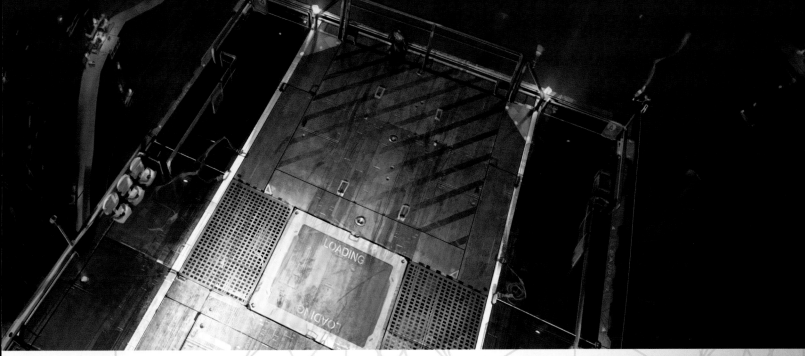

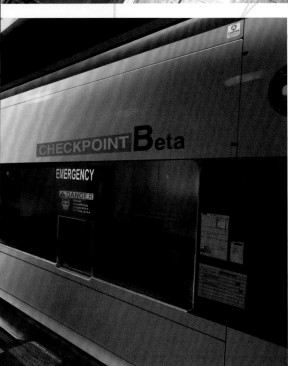

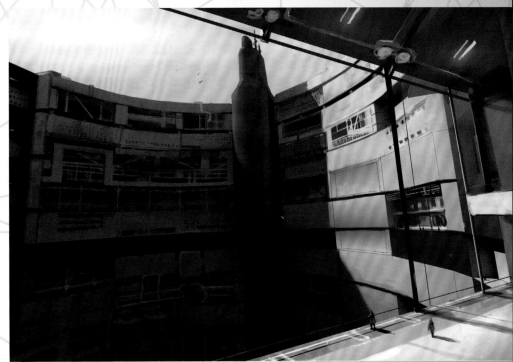

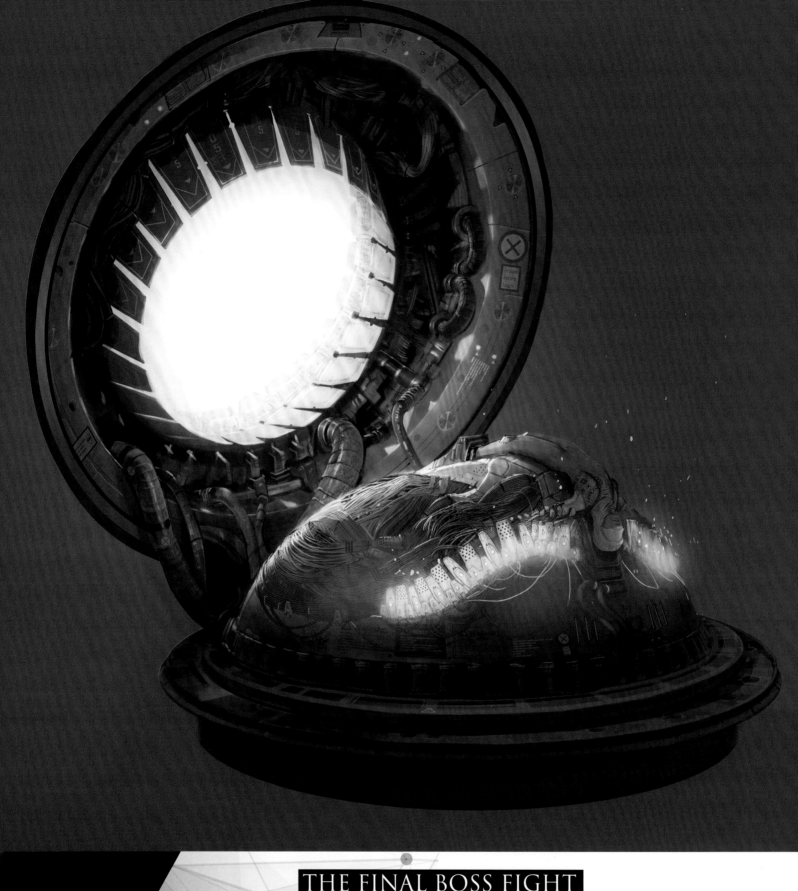

THE FINAL BOSS FIGHT

"The Icarus myth theme was strong in this location," states Jacques-Belletête. "Not only because of the presence of Zhao Yun Ru, but also due to the dire situation, with all of the augmented people around the world going crazy at this very moment in the game. In order to represent this, we played around with a few ideas. We wanted some powerful iconography representing the myth itself, but we didn't want to plaster the walls with it. Eventually, we decided to have the 'precogs' attached, putting some sort of reactor apparatus inside the room, which mimicked both the burning sun and the melting wings."

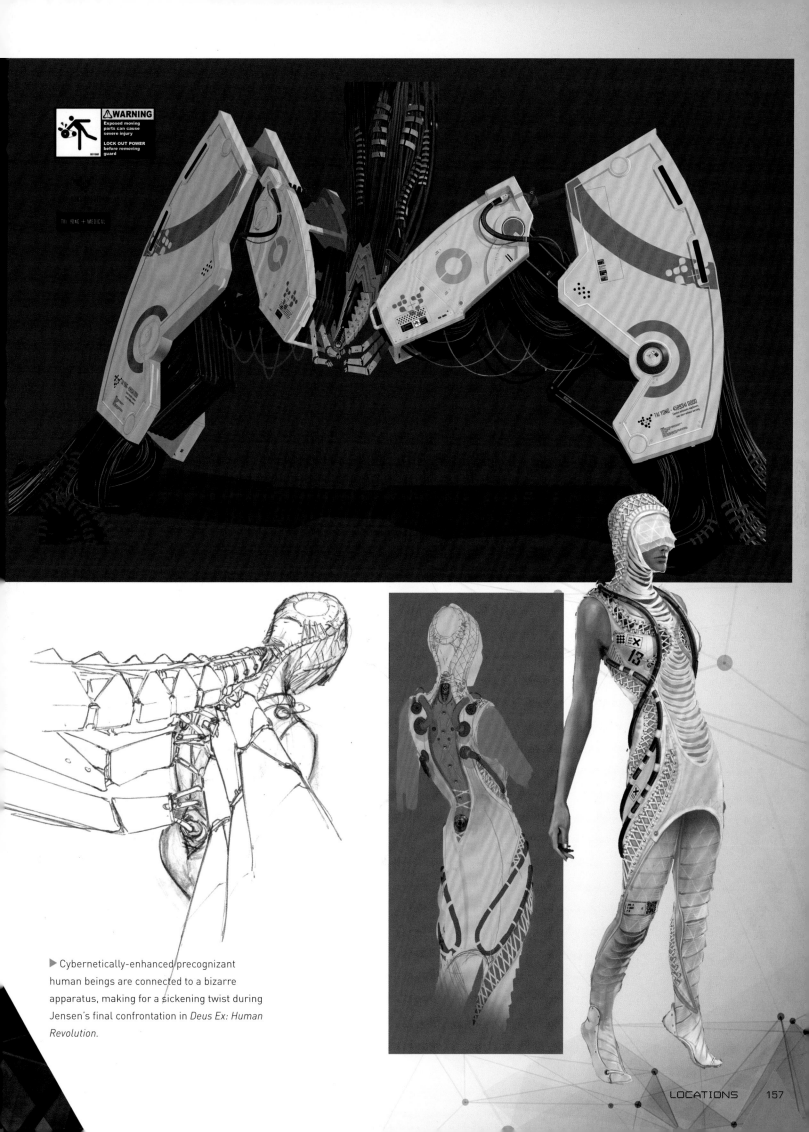

WARNING
Exposed moving parts can cause severe injury
LOCK OUT POWER before removing guard

TAI YONG + MEDICAL

TAI YONG · 4589341 0000

▶ Cybernetically-enhanced precognizant human beings are connected to a bizarre apparatus, making for a sickening twist during Jensen's final confrontation in *Deus Ex: Human Revolution*.

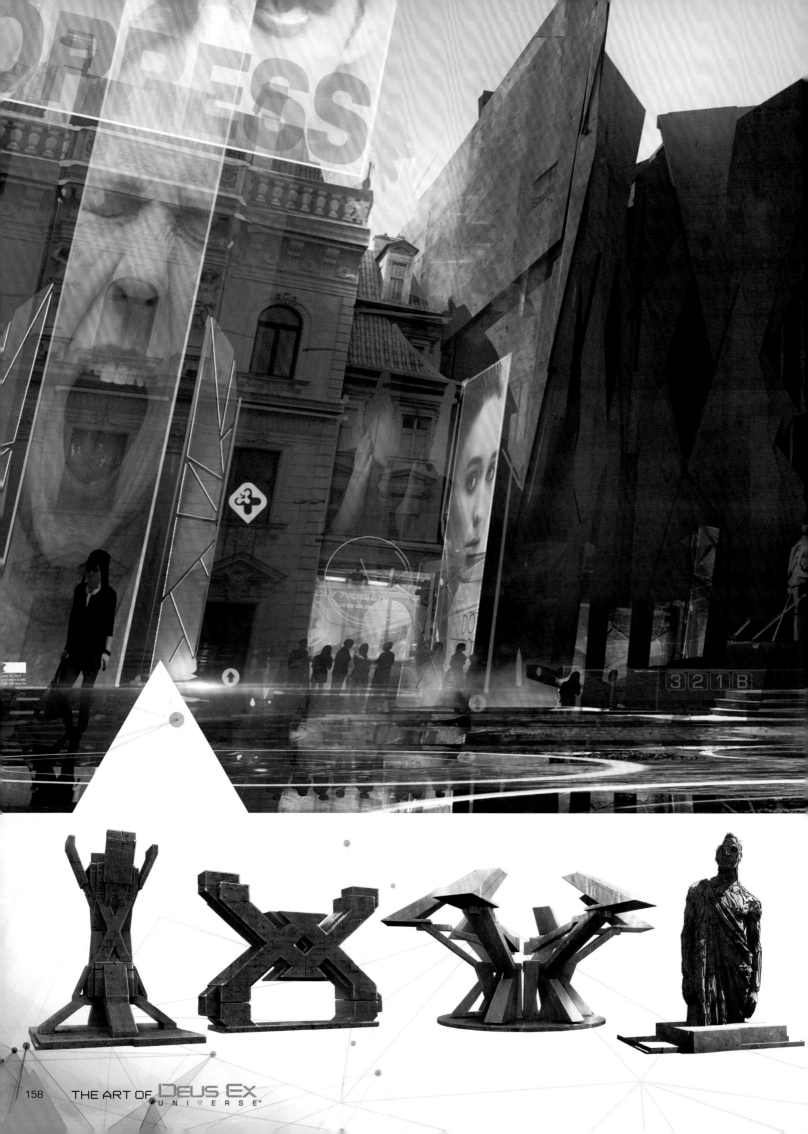

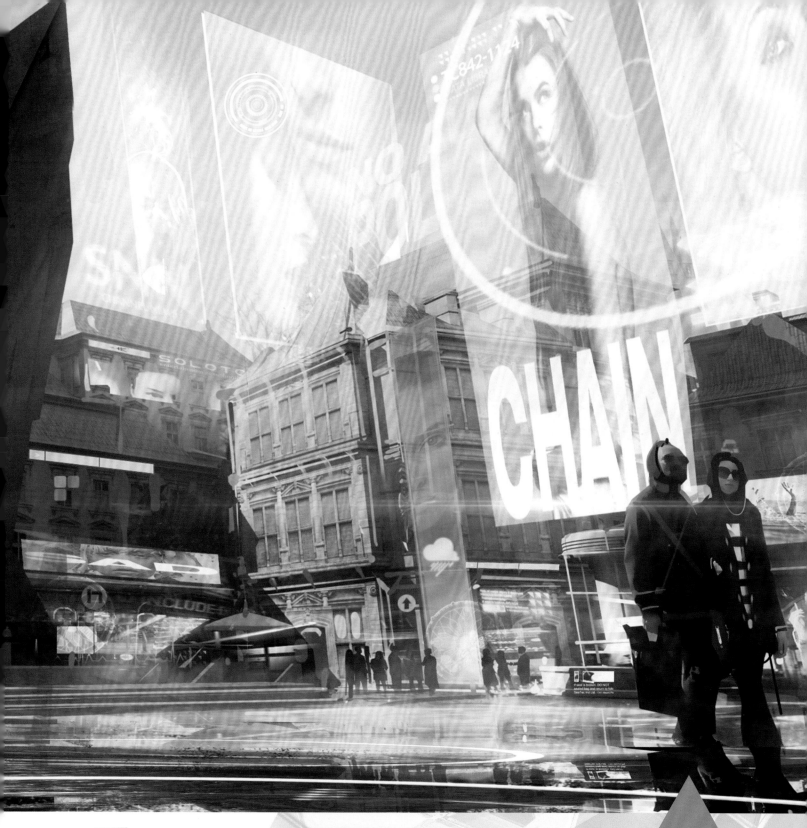

PRAGUE

Among the civilized world's richest assets, the architecturally blessed city of Prague cried out for a near-future vision of astonishing juxtaposition. "Prague, the capital of the Czech Republic, contains more than a thousand years of history, providing ample inspiration for us, especially when it came down to the finer details of our design"," explains Art Director Martin Dubeau. "Spared during the Second World War, Prague was able to preserve its Gothic architectural gems: Baroque, Cubist, Romanticism, and even Rococo. All these treasures provided so much inspiration to construct a dystopian future in juxtaposition to it. The core of the different districts has been respected, transferred into our universe to retain the essence of the city. Its labyrinthine maze of streets helped to recreate the mysterious and dark atmosphere we were looking for."

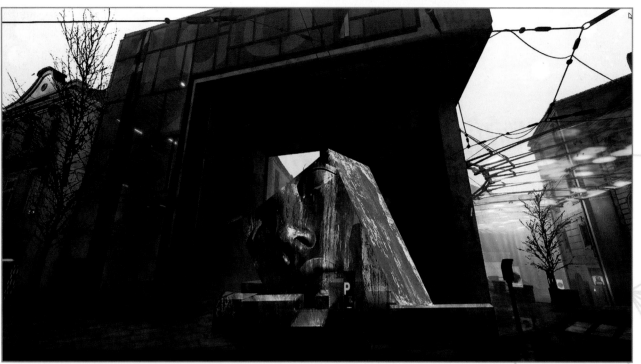

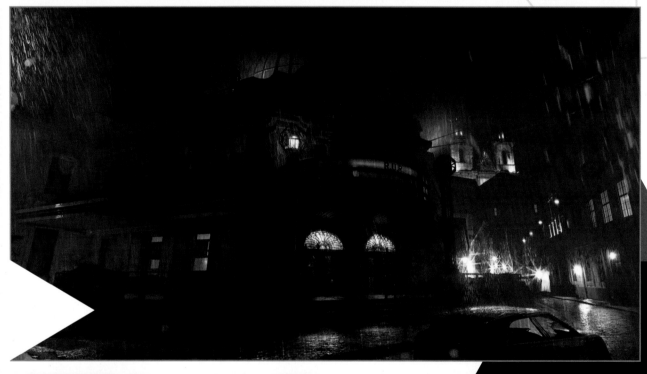

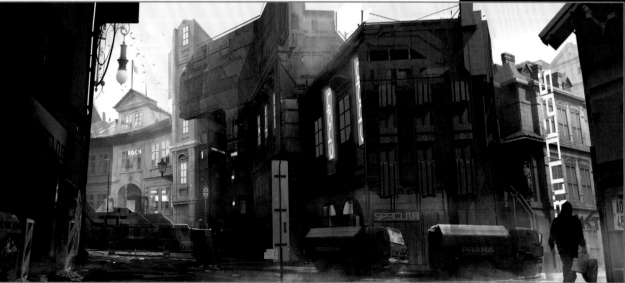

THE ART OF DEUS EX UNIVERSE

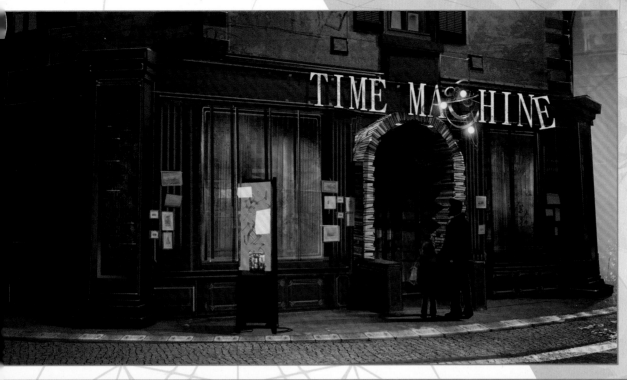

▶ "The Brutalism and the architecture of the Middle Ages (Dark Ages) are the trends that influenced us, inspiring our near future visuals," says Dubeau. "The balance of these different styles resulted in the conception of a repressed thematic, our so called 'Mechanical Apartheid'."

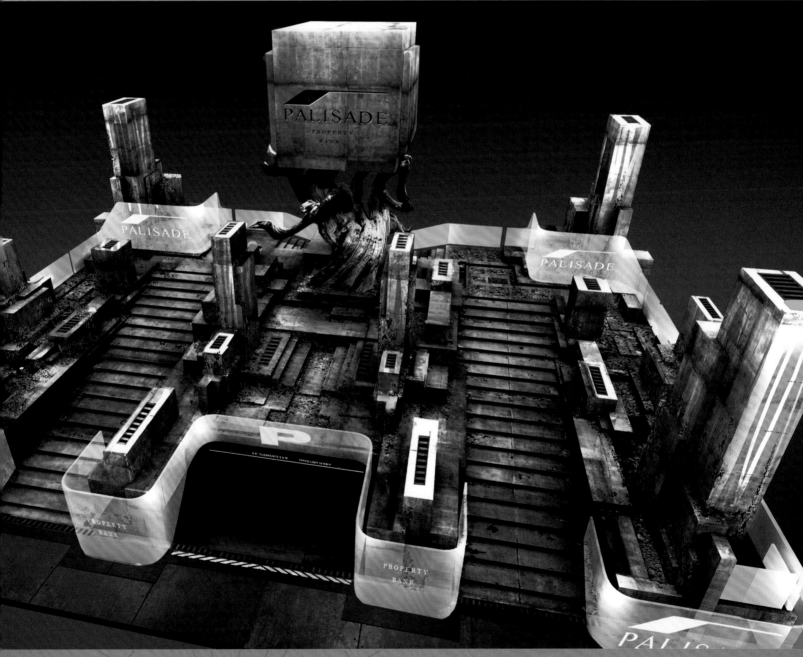

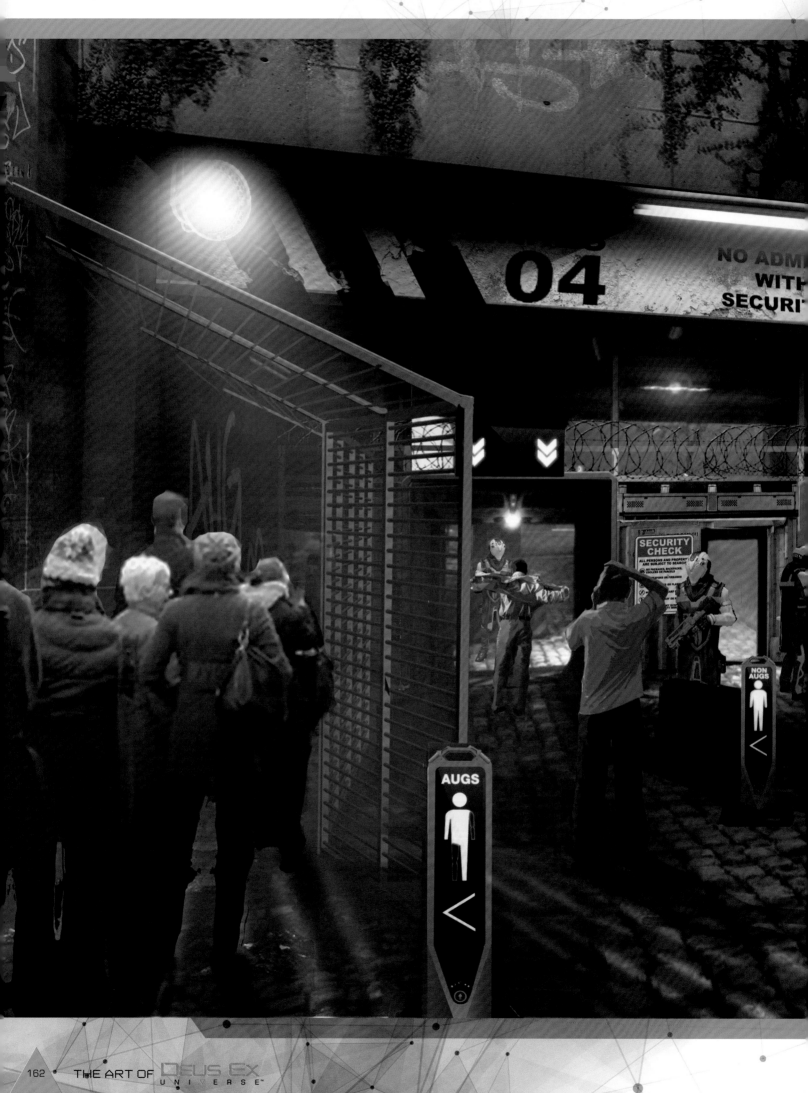

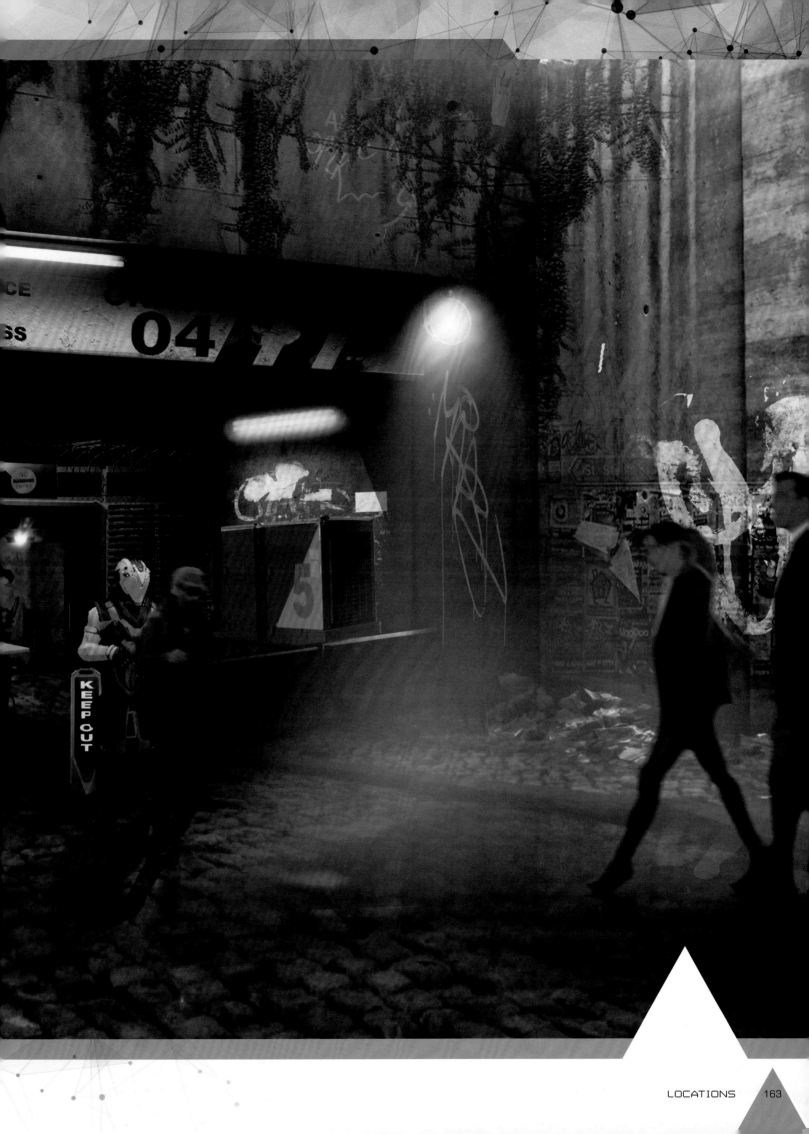

▶ "Each night, Prague reveals its darker side. A portion of the Modern District transforms itself into a red light district, where revelry, prostitution, and gambling are at the forefront... all under the supervision of the town's local mafia, the Dvali family." —*Martin Dubeau*

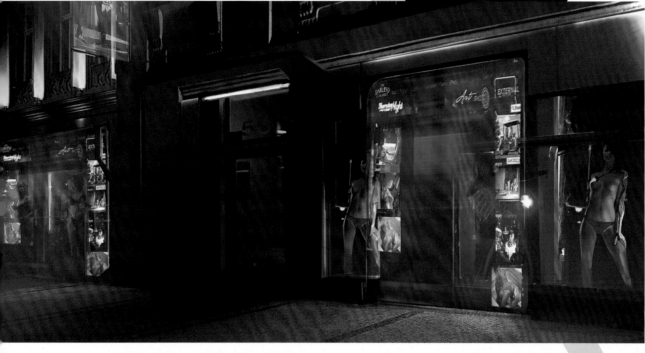

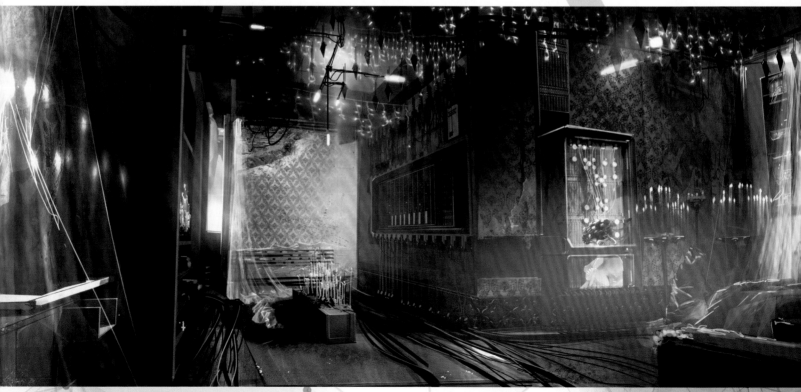

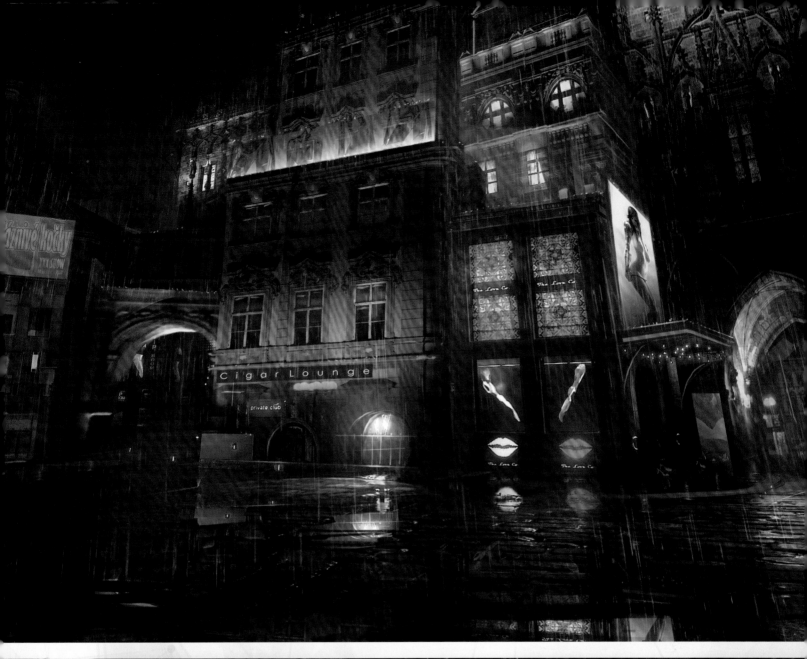

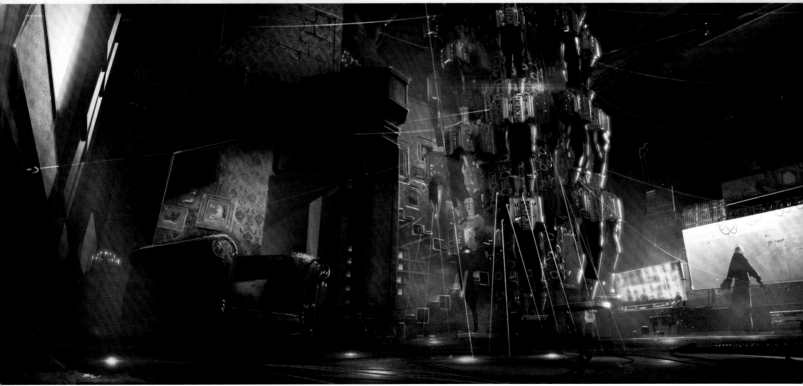

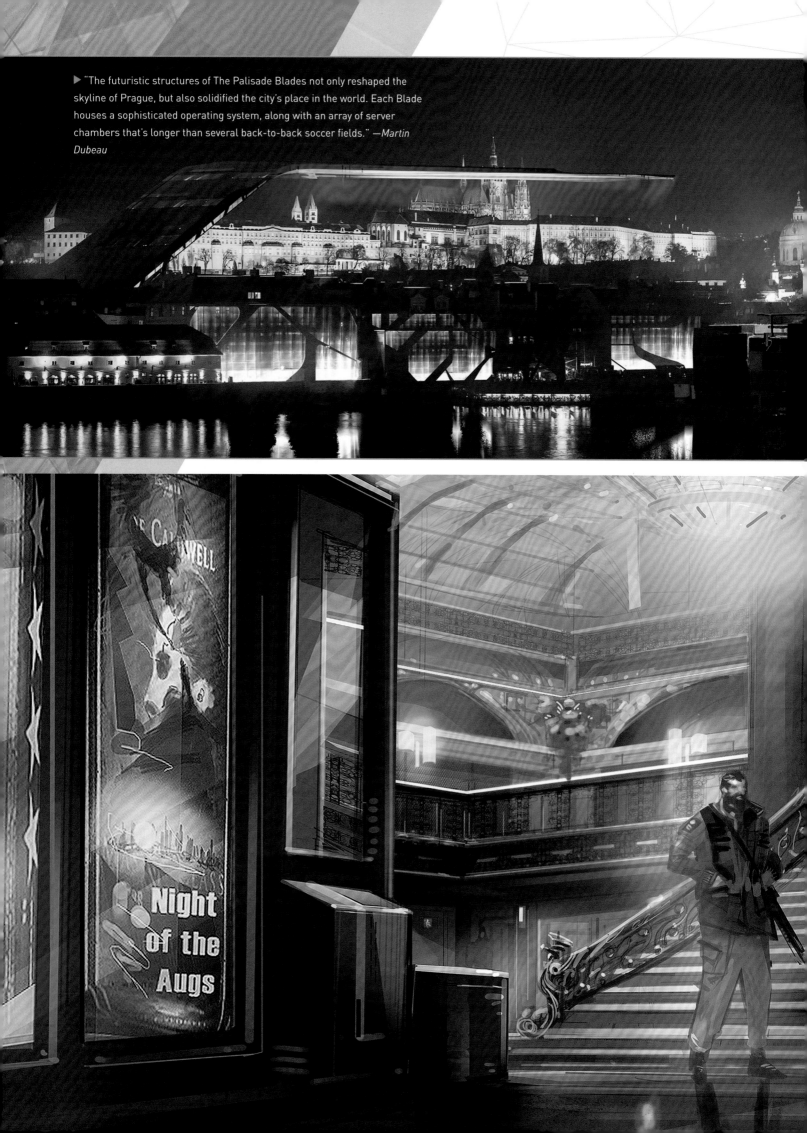

▶ "The futuristic structures of The Palisade Blades not only reshaped the skyline of Prague, but also solidified the city's place in the world. Each Blade houses a sophisticated operating system, along with an array of server chambers that's longer than several back-to-back soccer fields." —*Martin Dubeau*

Night of the Augs

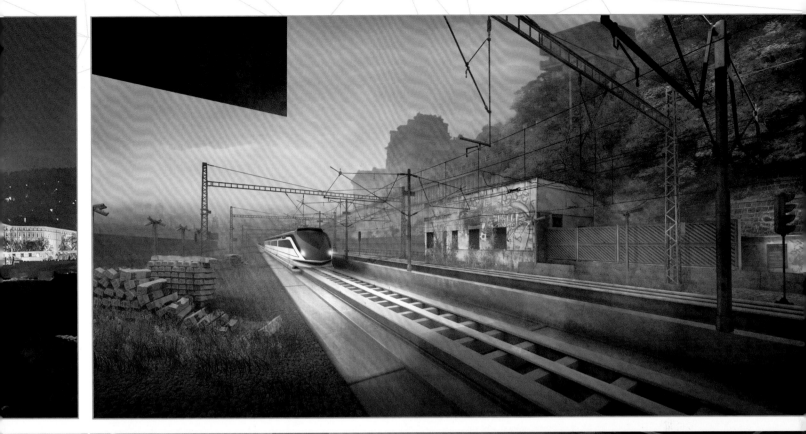
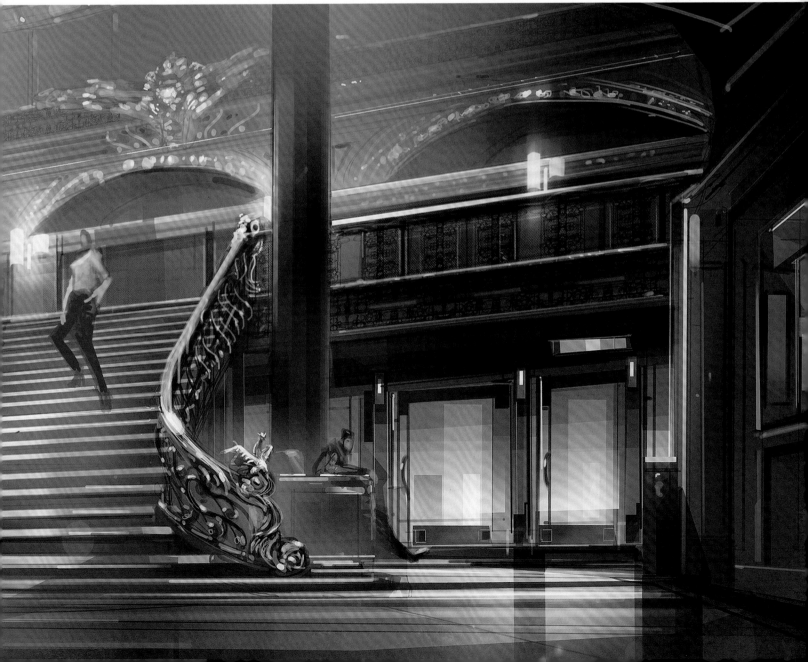

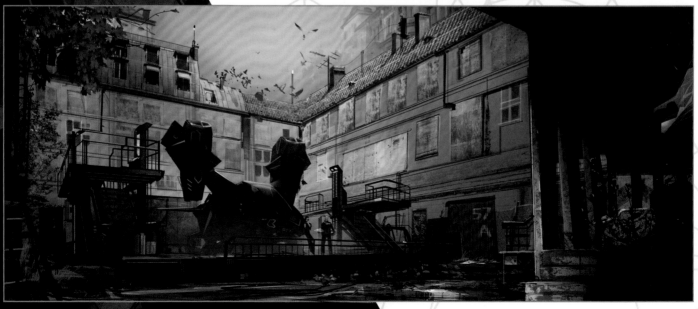

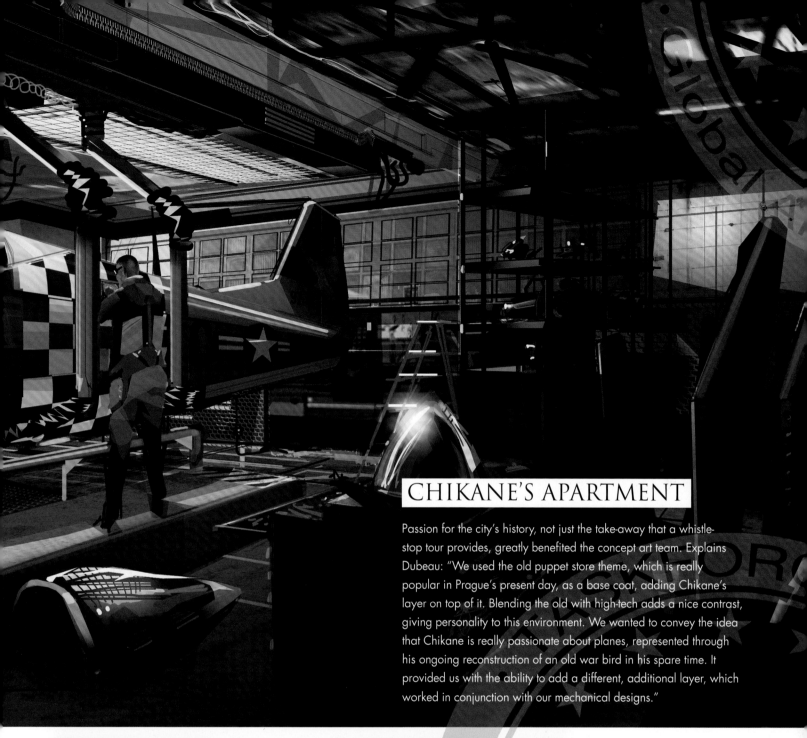

CHIKANE'S APARTMENT

Passion for the city's history, not just the take-away that a whistle-stop tour provides, greatly benefited the concept art team. Explains Dubeau: "We used the old puppet store theme, which is really popular in Prague's present day, as a base coat, adding Chikane's layer on top of it. Blending the old with high-tech adds a nice contrast, giving personality to this environment. We wanted to convey the idea that Chikane is really passionate about planes, represented through his ongoing reconstruction of an old war bird in his spare time. It provided us with the ability to add a different, additional layer, which worked in conjunction with our mechanical designs."

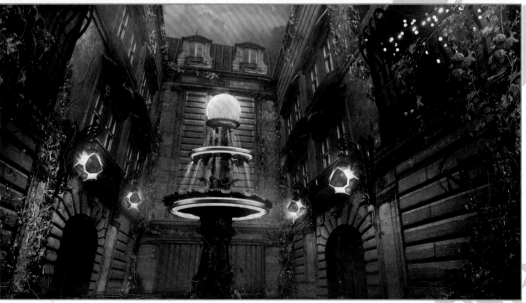

▶ Chikane's backcourt area is a derelict place, well protected from curious eyes. It serves as the perfect home for the TF-29 secret landing pad, presenting a terrific contrast with the fragile buildings; Prague's juxtaposition in full effect.

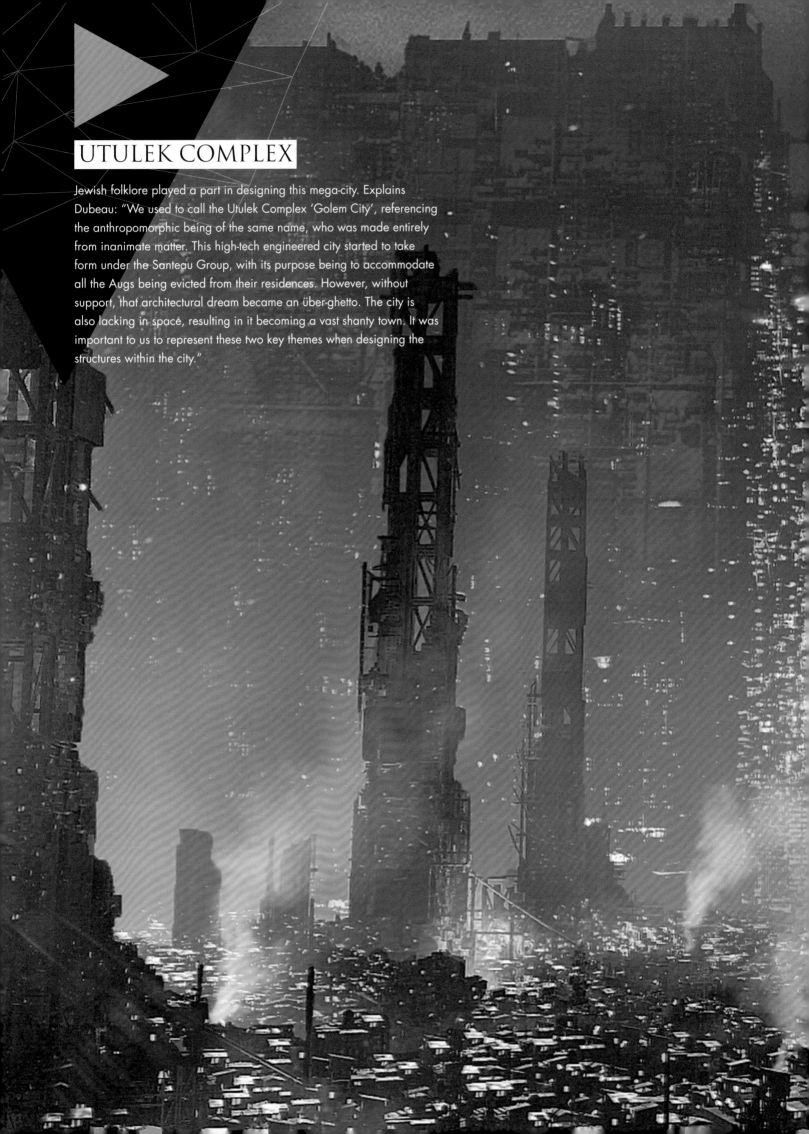

UTULEK COMPLEX

Jewish folklore played a part in designing this mega-city. Explains Dubeau: "We used to call the Utulek Complex 'Golem City', referencing the anthropomorphic being of the same name, who was made entirely from inanimate matter. This high-tech engineered city started to take form under the Santeau Group, with its purpose being to accommodate all the Augs being evicted from their residences. However, without support, that architectural dream became an über-ghetto. The city is also lacking in space, resulting in it becoming a vast shanty town. It was important to us to represent these two key themes when designing the structures within the city."

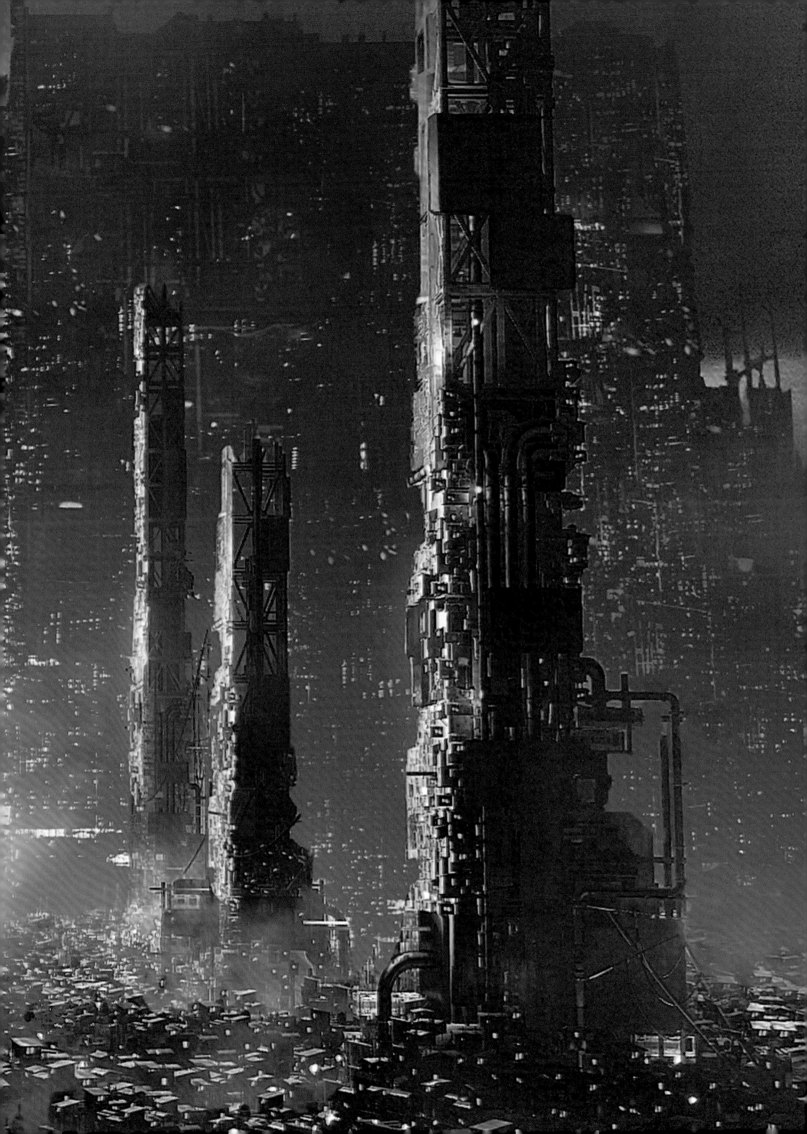

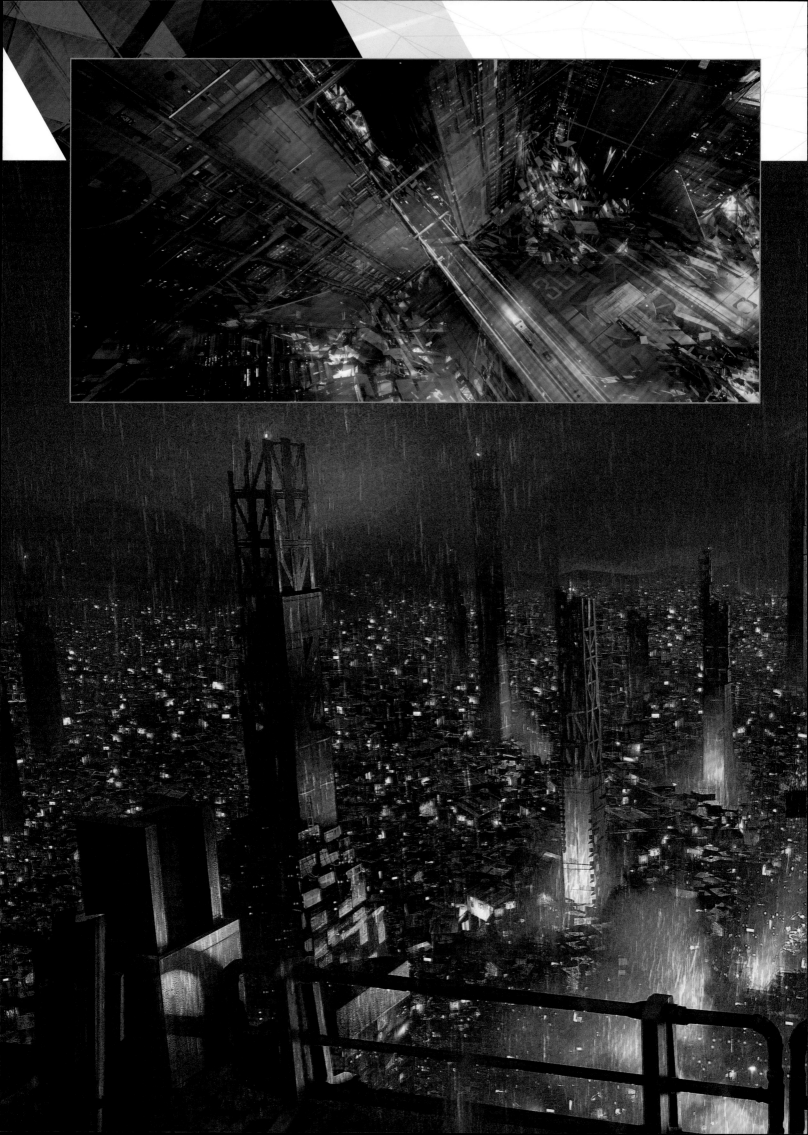

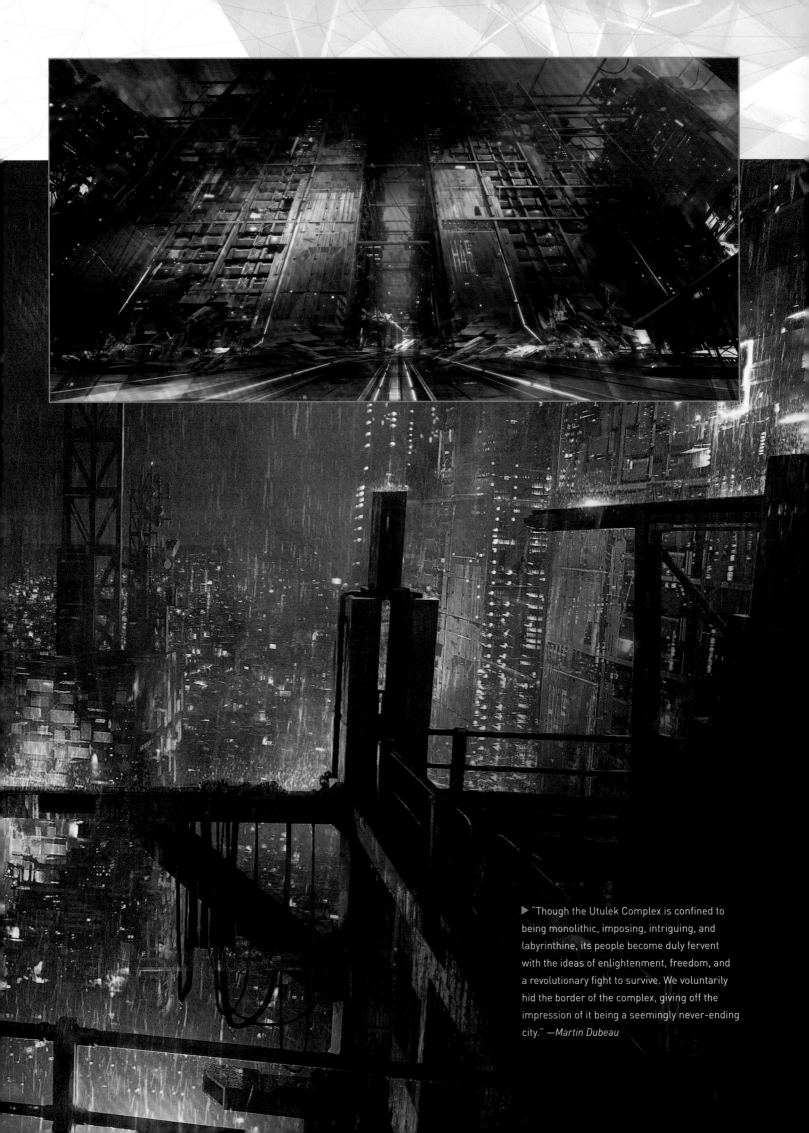

▶ "Though the Utulek Complex is confined to being monolithic, imposing, intriguing, and labyrinthine, its people become duly fervent with the ideas of enlightenment, freedom, and a revolutionary fight to survive. We voluntarily hid the border of the complex, giving off the impression of it being a seemingly never-ending city." —*Martin Dubeau*

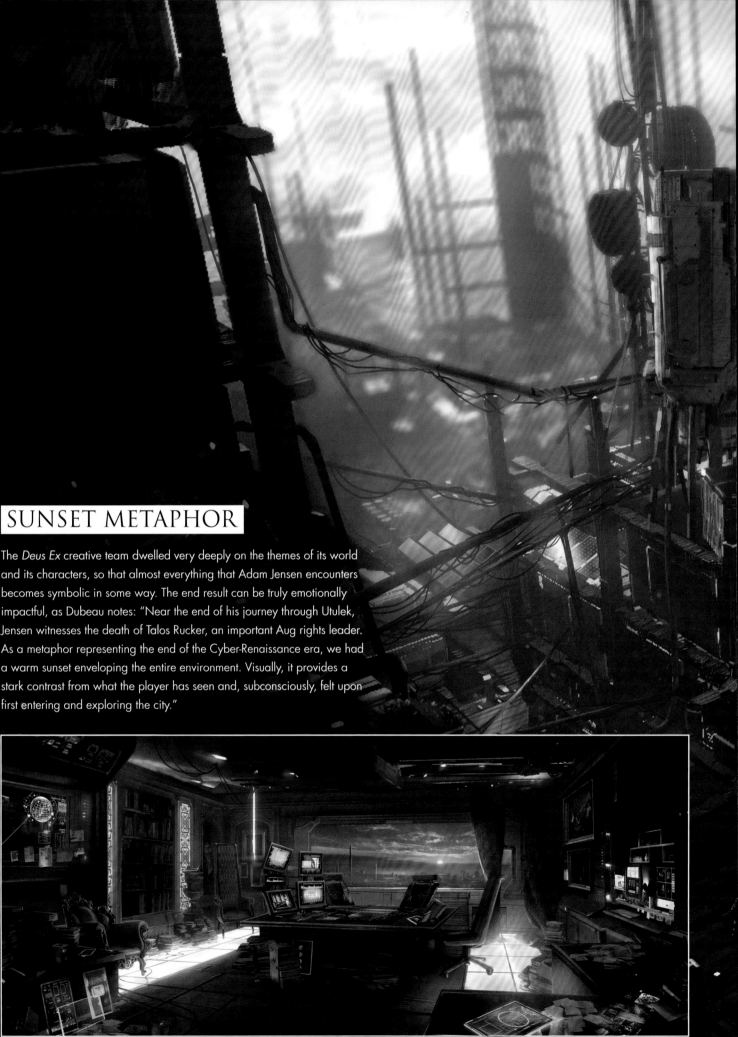

SUNSET METAPHOR

The *Deus Ex* creative team dwelled very deeply on the themes of its world and its characters, so that almost everything that Adam Jensen encounters becomes symbolic in some way. The end result can be truly emotionally impactful, as Dubeau notes: "Near the end of his journey through Utulek, Jensen witnesses the death of Talos Rucker, an important Aug rights leader. As a metaphor representing the end of the Cyber-Renaissance era, we had a warm sunset enveloping the entire environment. Visually, it provides a stark contrast from what the player has seen and, subconsciously, felt upon first entering and exploring the city."

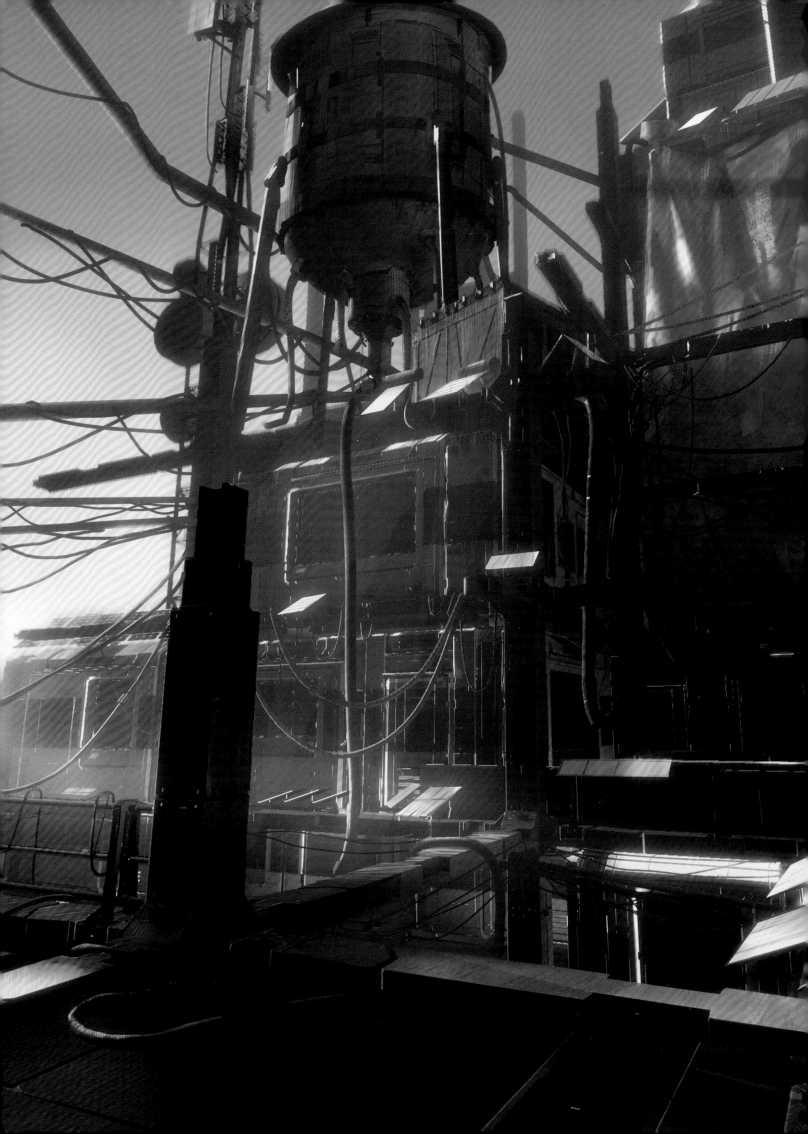

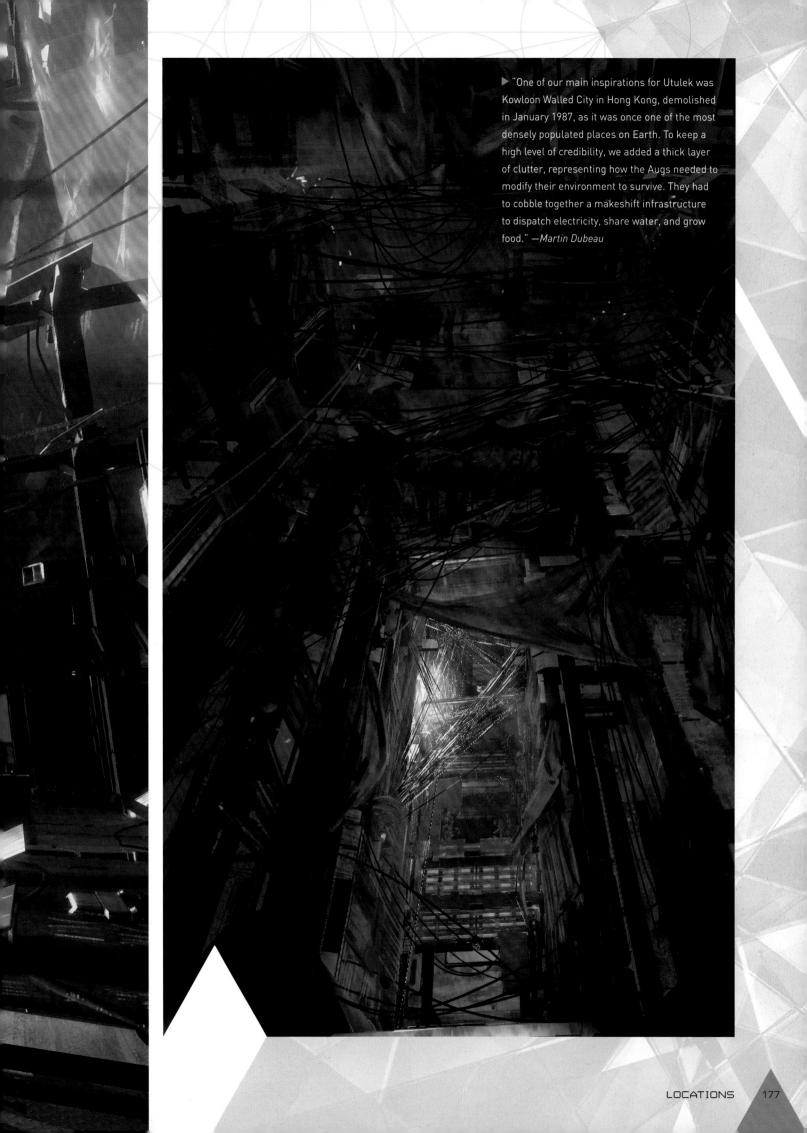

▶ "One of our main inspirations for Utulek was Kowloon Walled City in Hong Kong, demolished in January 1987, as it was once one of the most densely populated places on Earth. To keep a high level of credibility, we added a thick layer of clutter, representing how the Augs needed to modify their environment to survive. They had to cobble together a makeshift infrastructure to dispatch electricity, share water, and grow food." —*Martin Dubeau*

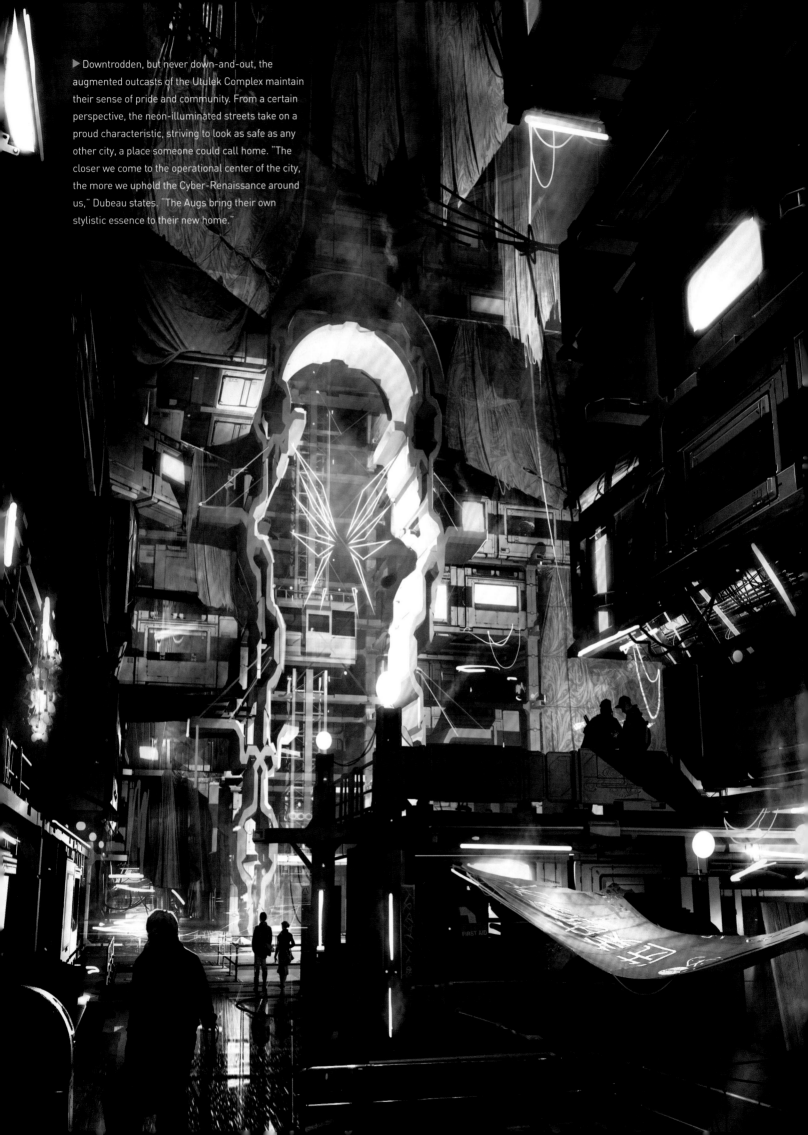

▶ Downtrodden, but never down-and-out, the augmented outcasts of the Utulek Complex maintain their sense of pride and community. From a certain perspective, the neon-illuminated streets take on a proud characteristic, striving to look as safe as any other city, a place someone could call home. "The closer we come to the operational center of the city, the more we uphold the Cyber-Renaissance around us," Dubeau states. "The Augs bring their own stylistic essence to their new home."

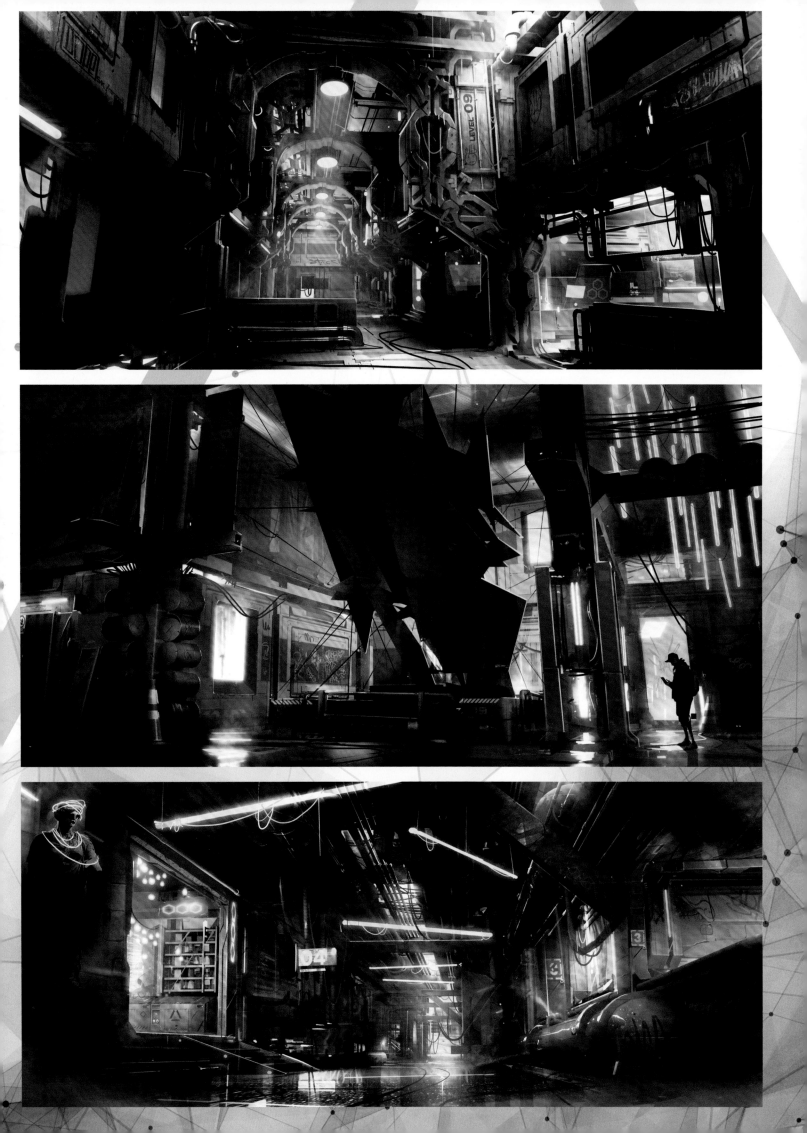

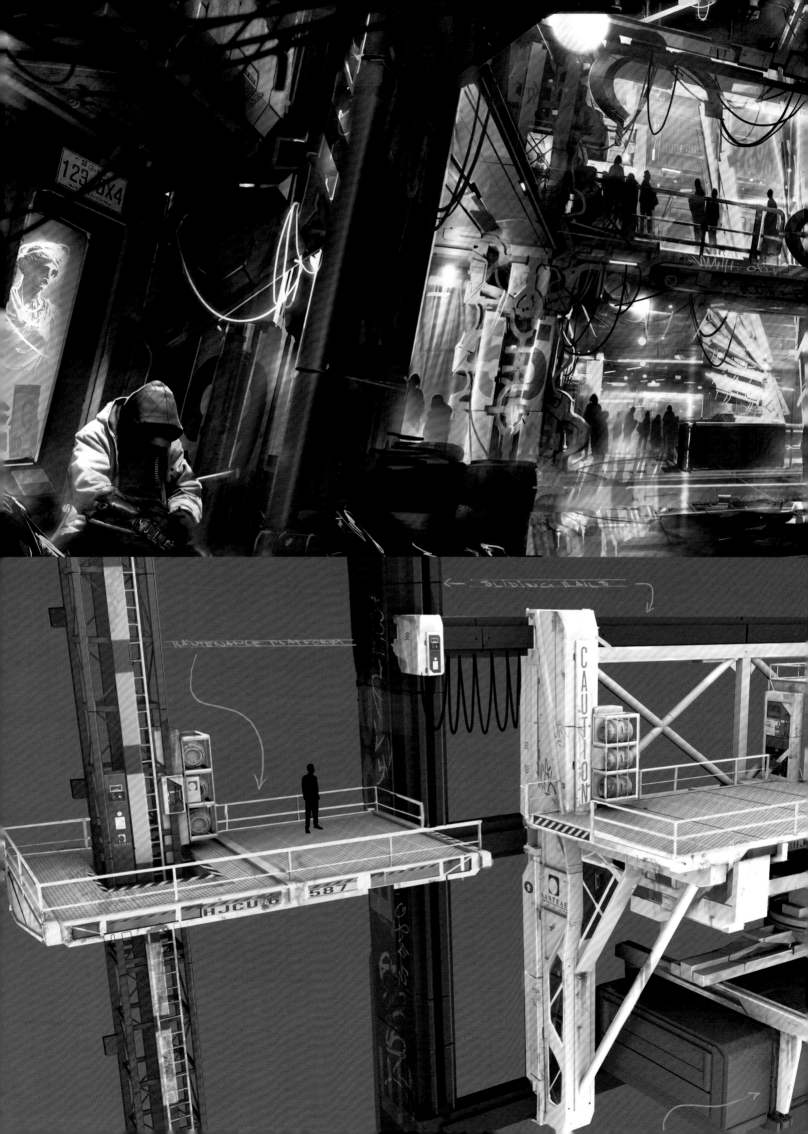

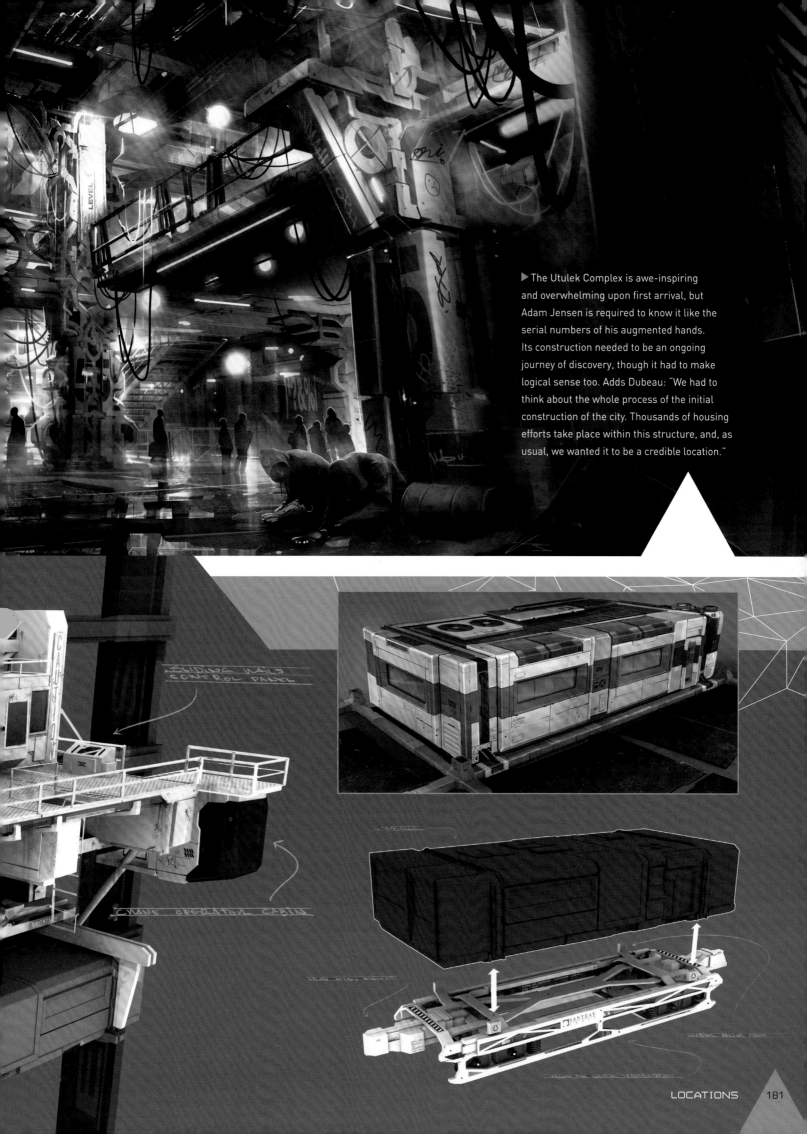

▶ The Utulek Complex is awe-inspiring and overwhelming upon first arrival, but Adam Jensen is required to know it like the serial numbers of his augmented hands. Its construction needed to be an ongoing journey of discovery, though it had to make logical sense too. Adds Dubeau: "We had to think about the whole process of the initial construction of the city. Thousands of housing efforts take place within this structure, and, as usual, we wanted it to be a credible location."

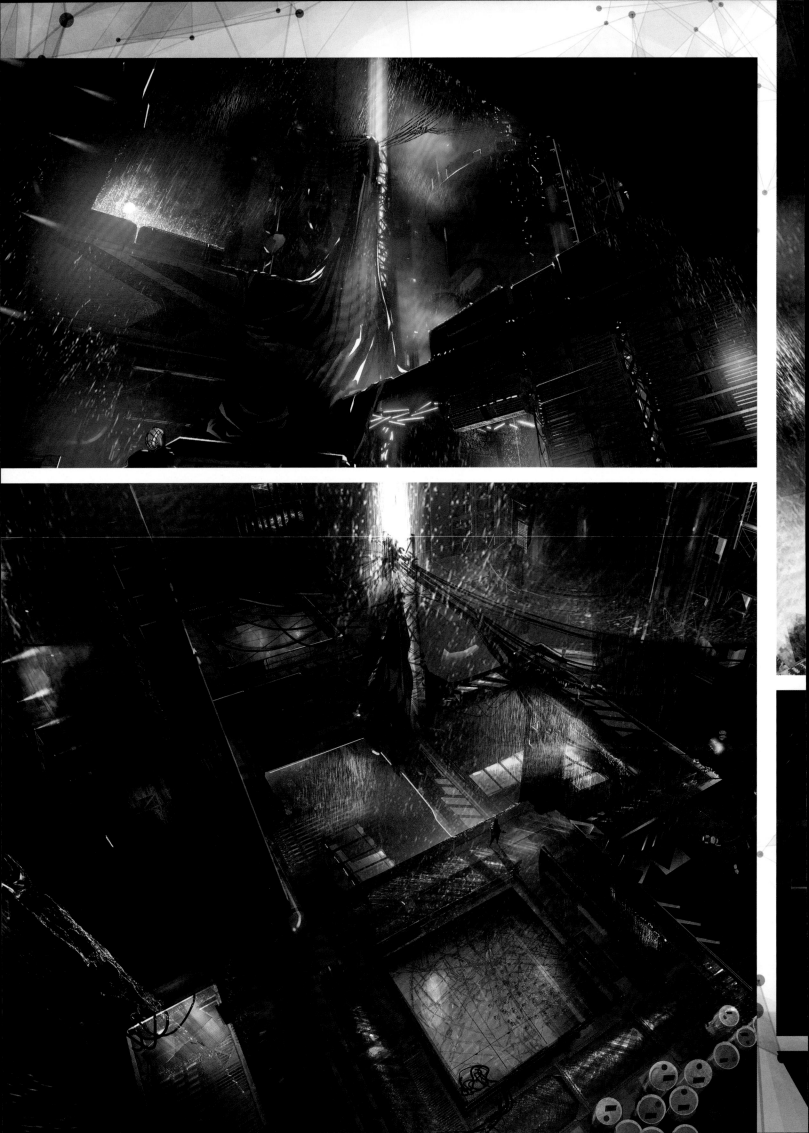

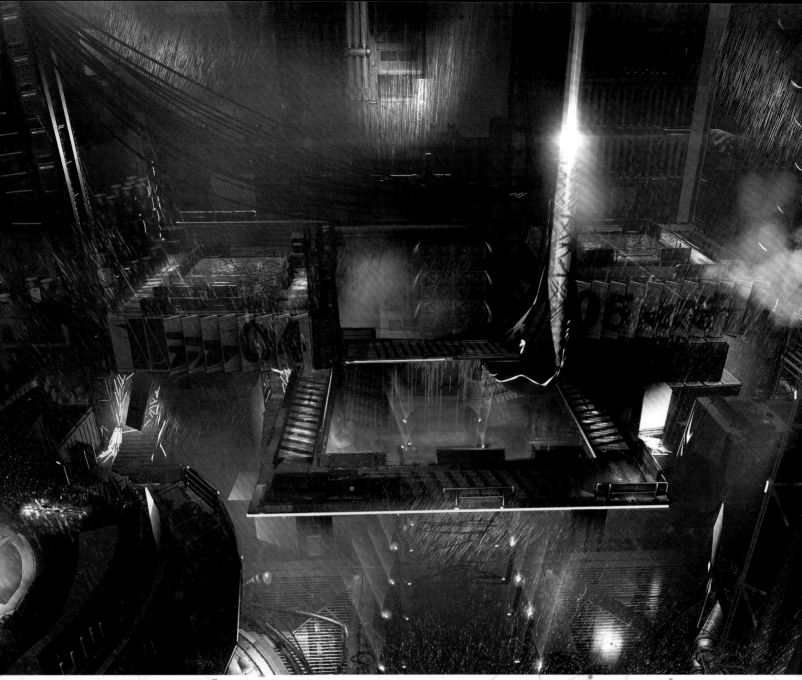

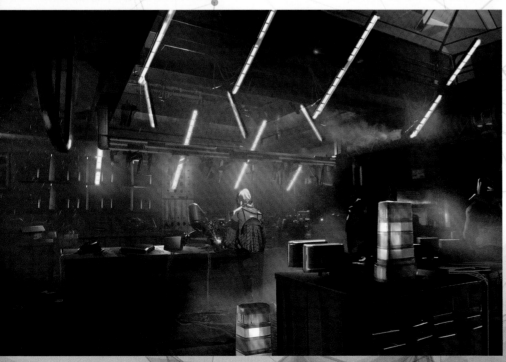

▶ Major confrontations in *Deus Ex* are required to be both challenging and memorable, offering a wide variety of potential solutions. The layout here is designed to offer multiple vantage points, stealth areas, and kill zones, with the atmosphere being tied to each villain as a metaphor. Explains Dubeau: "We had originally aimed to have a boss fight with Marchenko during a second visit to Utulek, but this was cut from the game. For that purpose, we designed a hideout/workshop right inside a mega-pillar, comprising many layers of catwalks, in order to highlight the verticality of our gameplay."

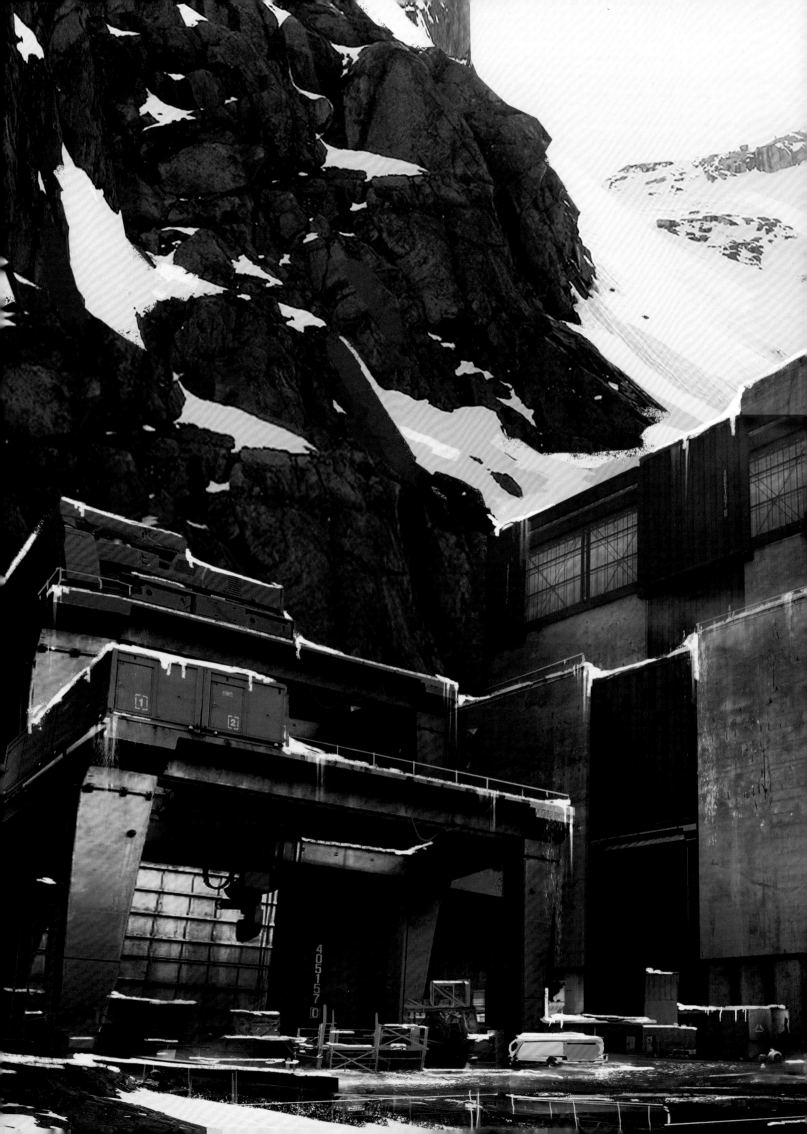

GARM—SWISS ALPS

Adam Jensen's journey throughout *Deus Ex: Mankind Divided* takes him to far-reaching global locales: enormous cityscapes, historic streets, and icy, frozen bases. Such a destination is this Swiss installation, which is supposedly hidden away in the region's famous mountains. Dubeau explains the facility's presence in *Mankind Divided*: "The GARM (Geological Alpine Research Megacomplex) research plant is based at the bottom of one the longest alpine glaciers in Switzerland, close to France. The center provided baseline geological data, crucial to the European Union's efforts to better understand discovered and undiscovered natural resources. It quickly fell into anonymity, enabling Belltower to transform it into a training ground and base of operations for spec op soldiers. That is, until the Aug Incident occurred."

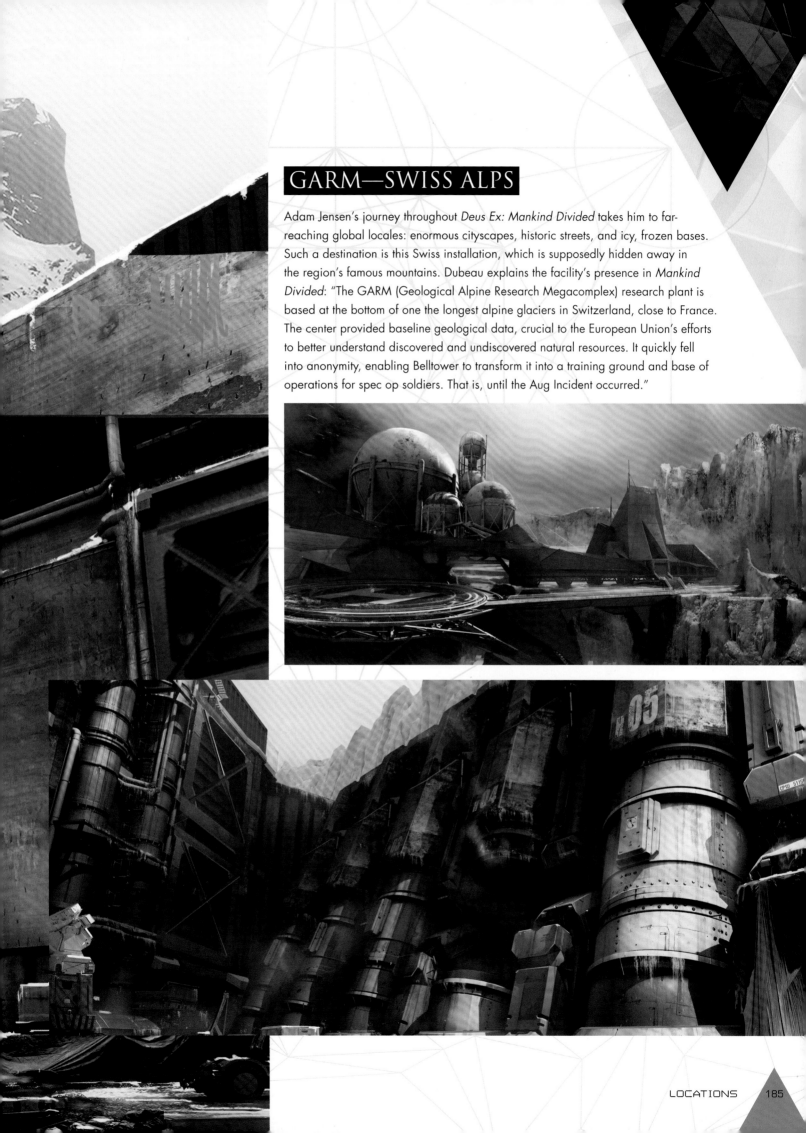

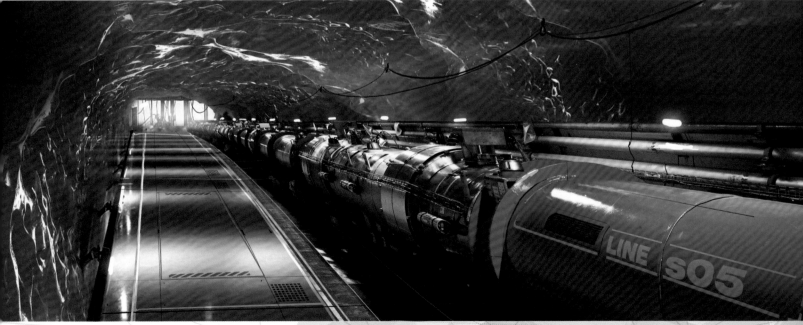

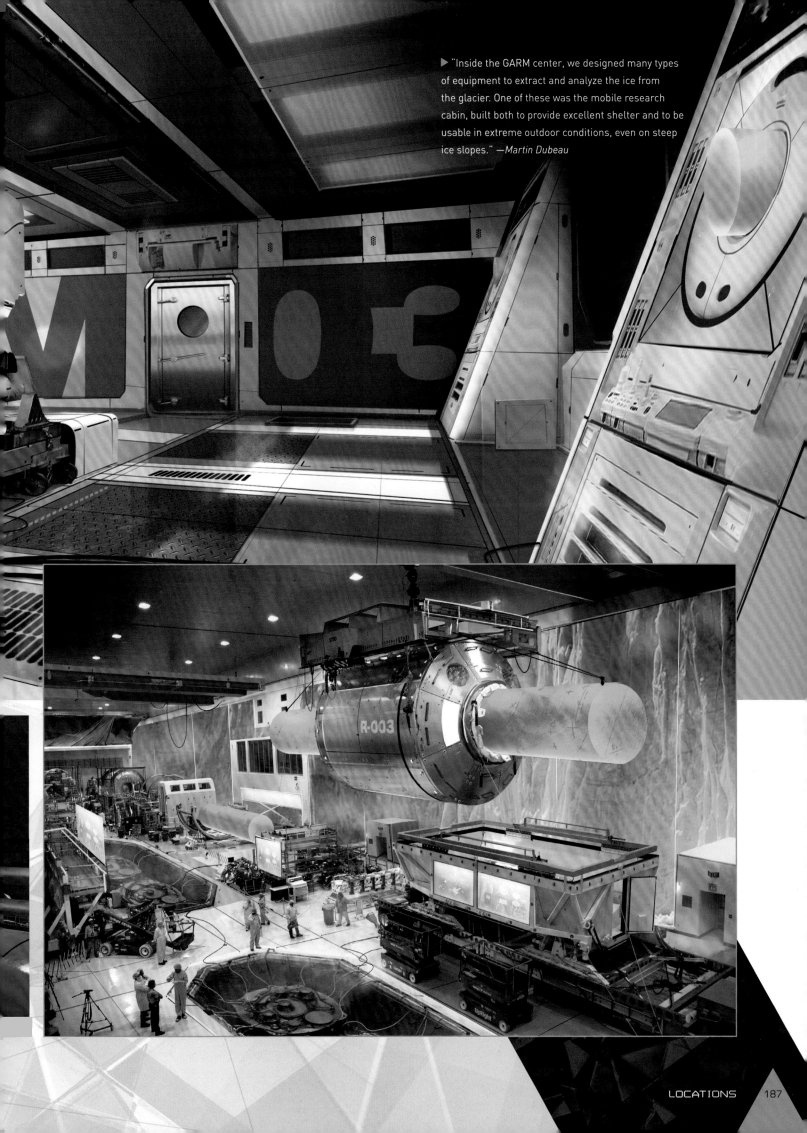

▶ "Inside the GARM center, we designed many types of equipment to extract and analyze the ice from the glacier. One of these was the mobile research cabin, built both to provide excellent shelter and to be usable in extreme outdoor conditions, even on steep ice slopes." —*Martin Dubeau*

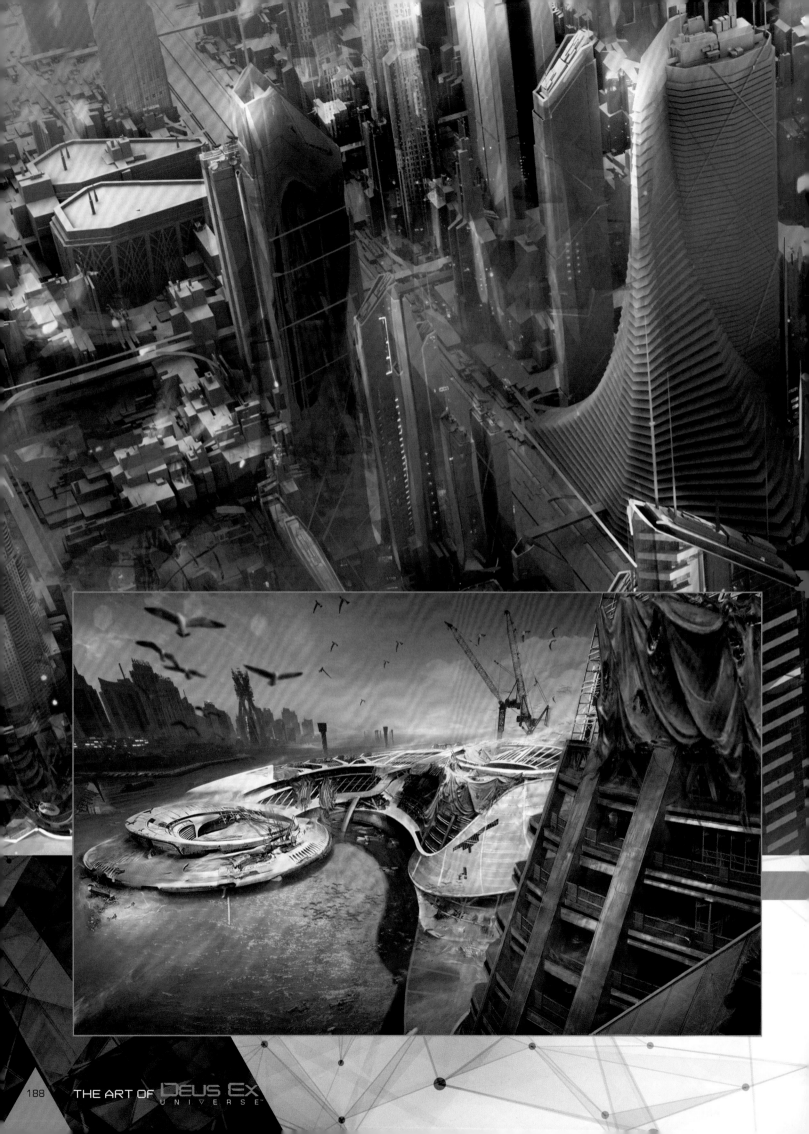

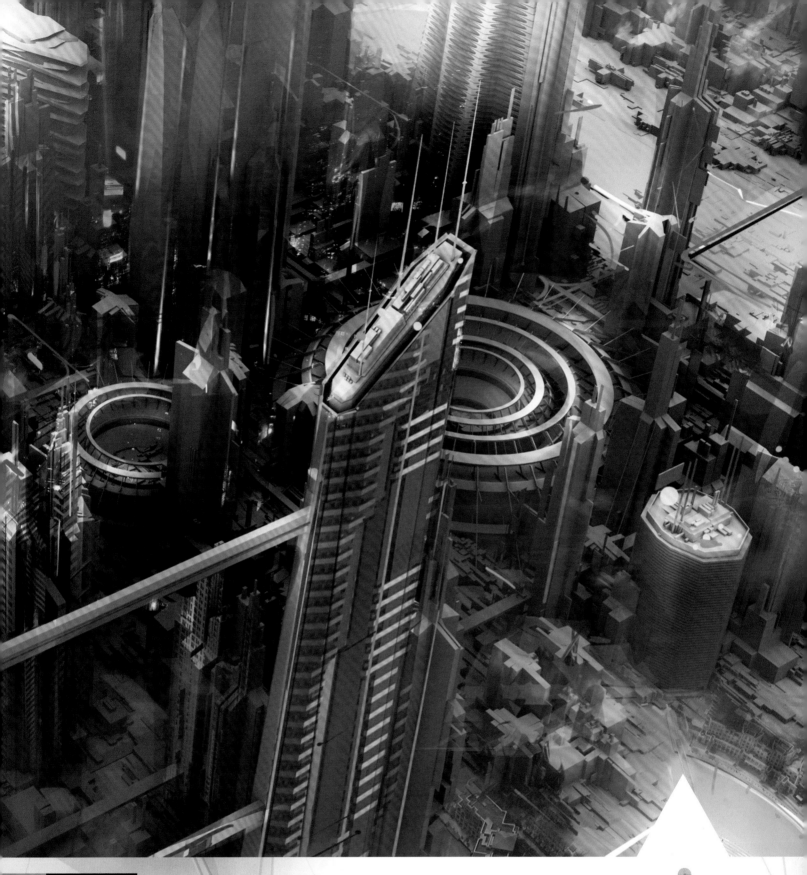

DUBAI

With its elegant skyscrapers, present day Dubai is an astonishing sight; a commercial center that primarily invites the very wealthy to hunt down bespoke luxury goods. Such frivolity is turned onto its head for *Deus Ex*, repurposing the locale for darker dealings. Dubeau outlines the *Mankind Divided* version of Dubai in more detail, "Since the Aug Incident, all the infrastructure developments surrounding Dubai have been abandoned. In turn, we created an unfinished Arabian coastal resort, meant to house a weapons deal. Obviously, with many Augs having died during the Aug Incident, there are many corpses scattered on the ground, helping to create a grim and desolate atmosphere."

▶ Tossed aside like an unwanted toy, this once great city is in a state of complete disrepair. No longer aesthetically appealing, it is still useful as a trading center. However, the items traded here would not be the kind that royalty and world famous figures would flaunt in the society pages.

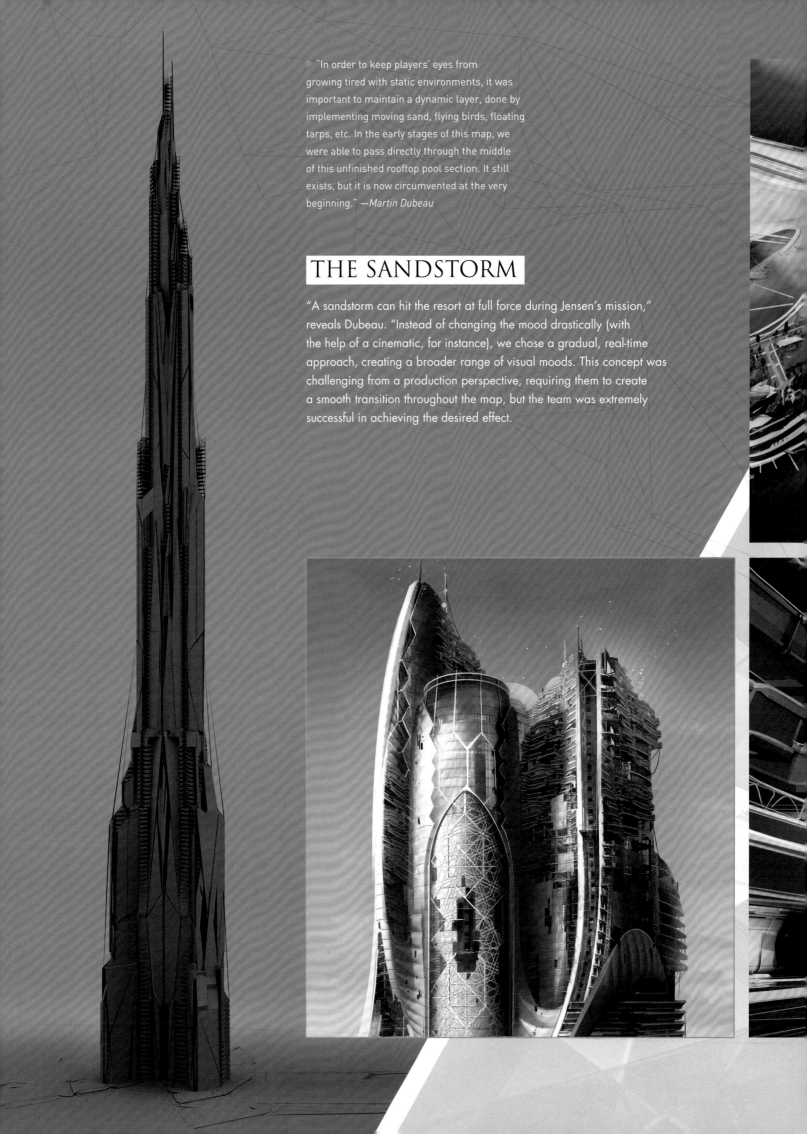

"In order to keep players' eyes from growing tired with static environments, it was important to maintain a dynamic layer, done by implementing moving sand, flying birds, floating tarps, etc. In the early stages of this map, we were able to pass directly through the middle of this unfinished rooftop pool section. It still exists, but it is now circumvented at the very beginning." —*Martin Dubeau*

THE SANDSTORM

"A sandstorm can hit the resort at full force during Jensen's mission," reveals Dubeau. "Instead of changing the mood drastically (with the help of a cinematic, for instance), we chose a gradual, real-time approach, creating a broader range of visual moods. This concept was challenging from a production perspective, requiring them to create a smooth transition throughout the map, but the team was extremely successful in achieving the desired effect.

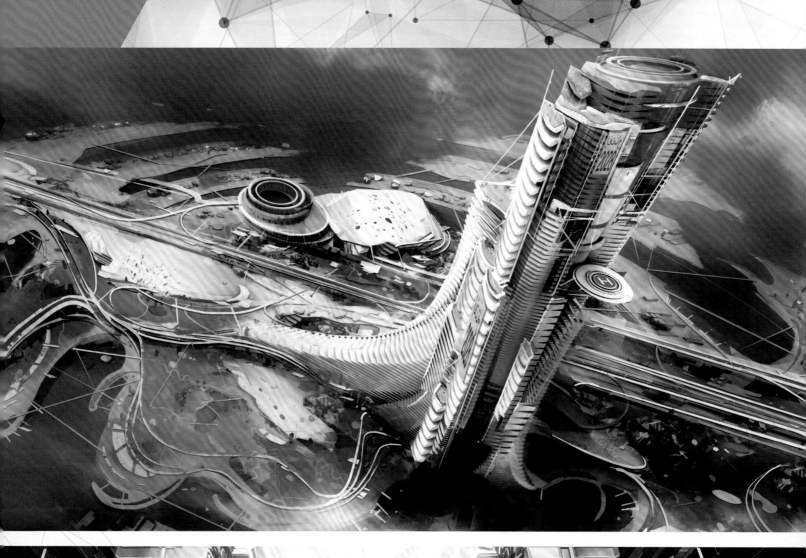

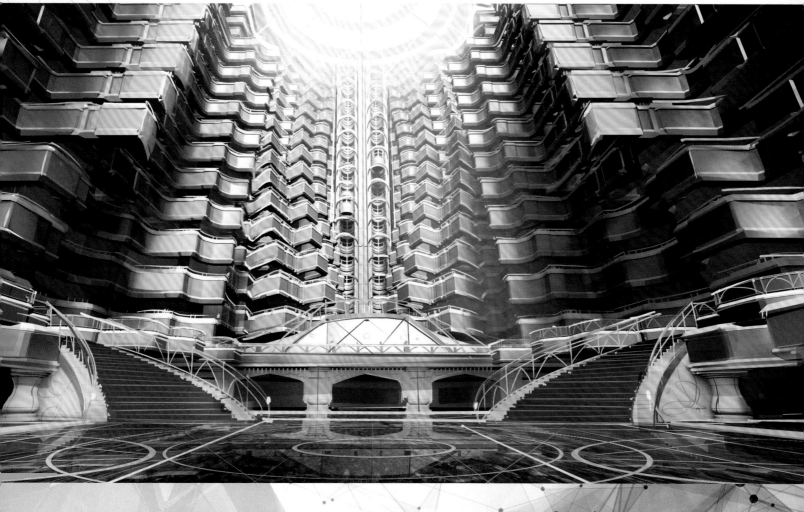

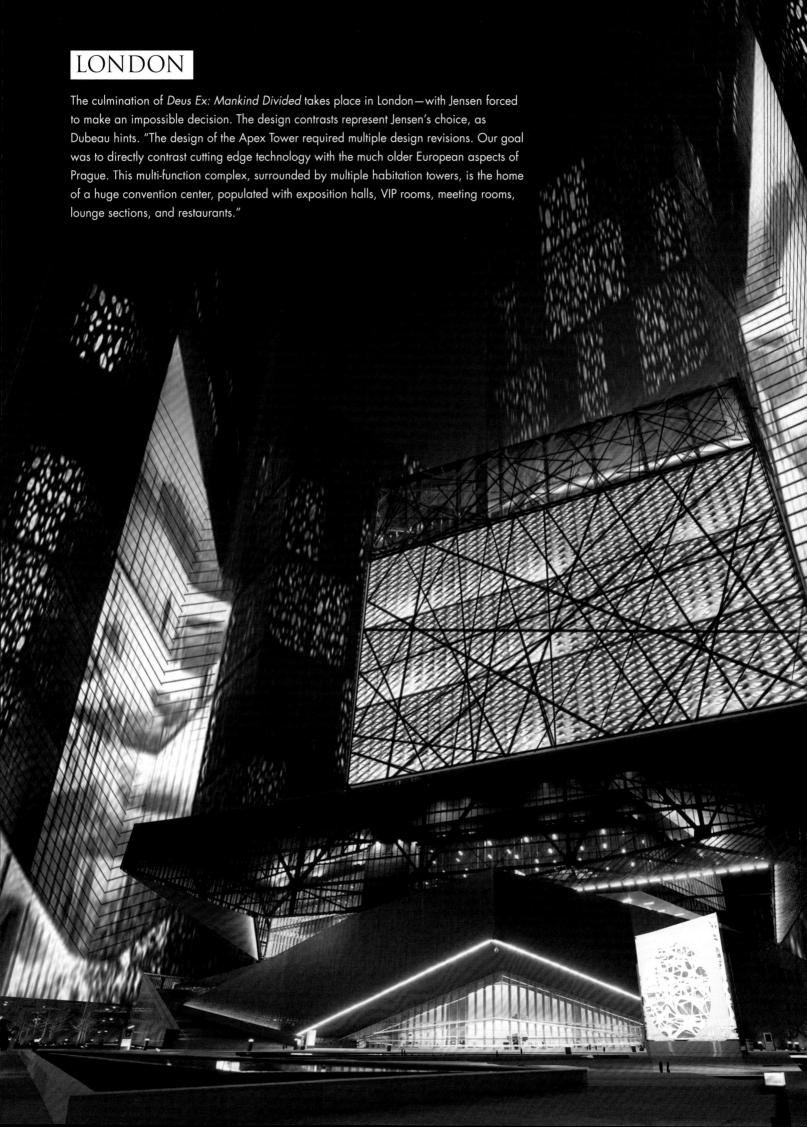

LONDON

The culmination of *Deus Ex: Mankind Divided* takes place in London—with Jensen forced to make an impossible decision. The design contrasts represent Jensen's choice, as Dubeau hints. "The design of the Apex Tower required multiple design revisions. Our goal was to directly contrast cutting edge technology with the much older European aspects of Prague. This multi-function complex, surrounded by multiple habitation towers, is the home of a huge convention center, populated with exposition halls, VIP rooms, meeting rooms, lounge sections, and restaurants."

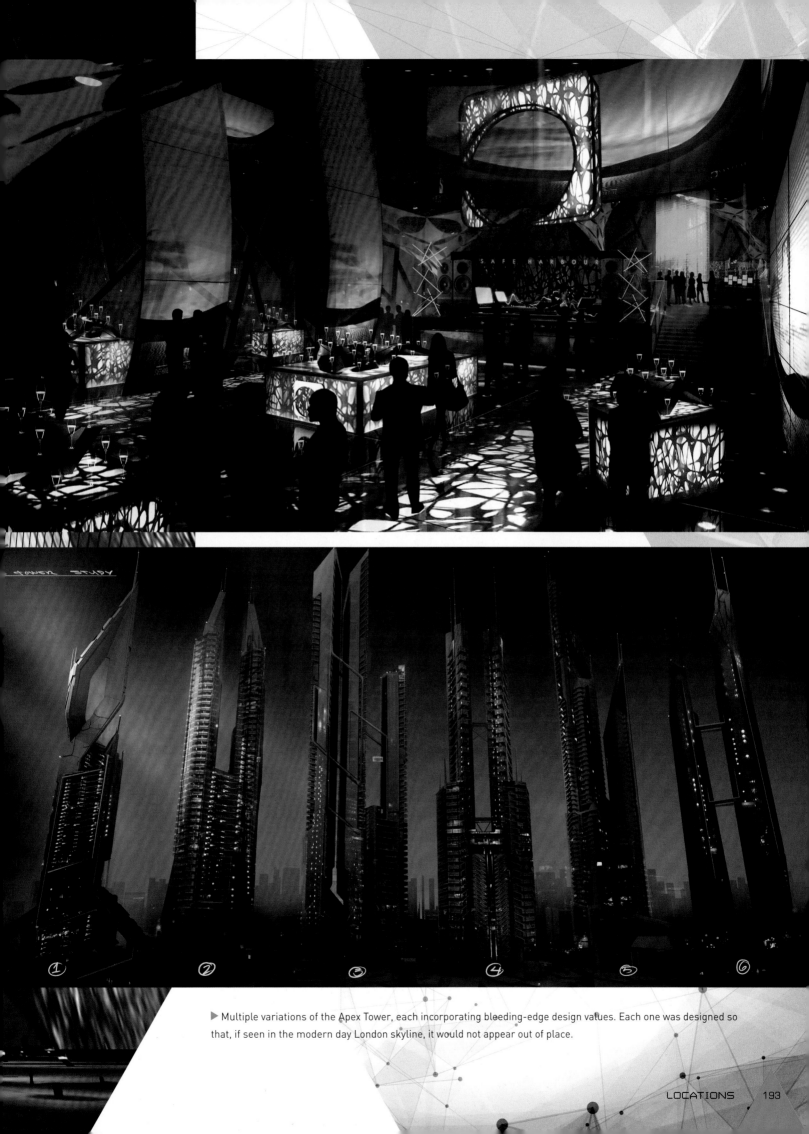

SAFE HARBOUR

TOWER STUDY

① ② ③ ④ ⑤ ⑥

▶ Multiple variations of the Apex Tower, each incorporating bleeding-edge design values. Each one was designed so that, if seen in the modern day London skyline, it would not appear out of place.

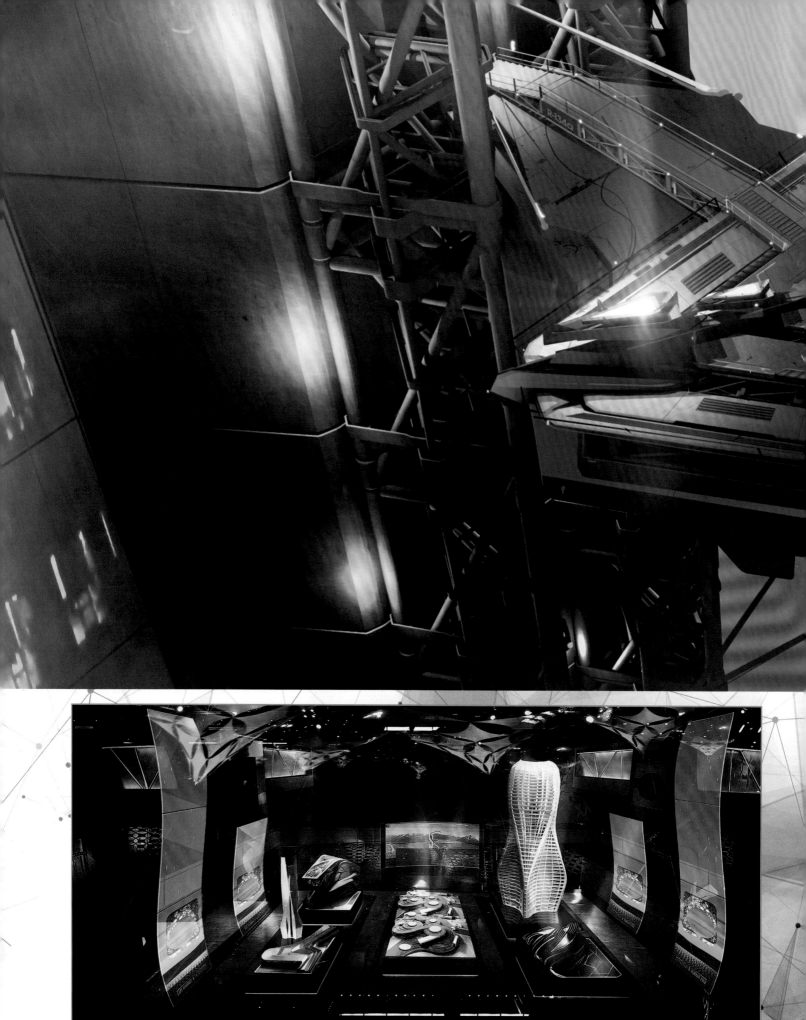

THE ART OF DEUS EX
UNIVERSE

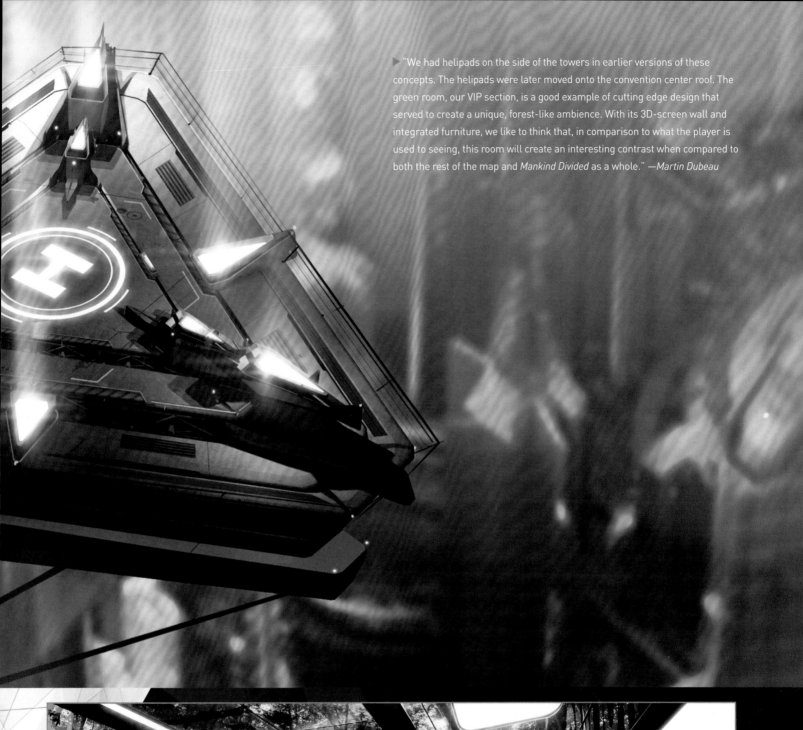

▶ "We had helipads on the side of the towers in earlier versions of these concepts. The helipads were later moved onto the convention center roof. The green room, our VIP section, is a good example of cutting edge design that served to create a unique, forest-like ambience. With its 3D-screen wall and integrated furniture, we like to think that, in comparison to what the player is used to seeing, this room will create an interesting contrast when compared to both the rest of the map and *Mankind Divided* as a whole." —*Martin Dubeau*

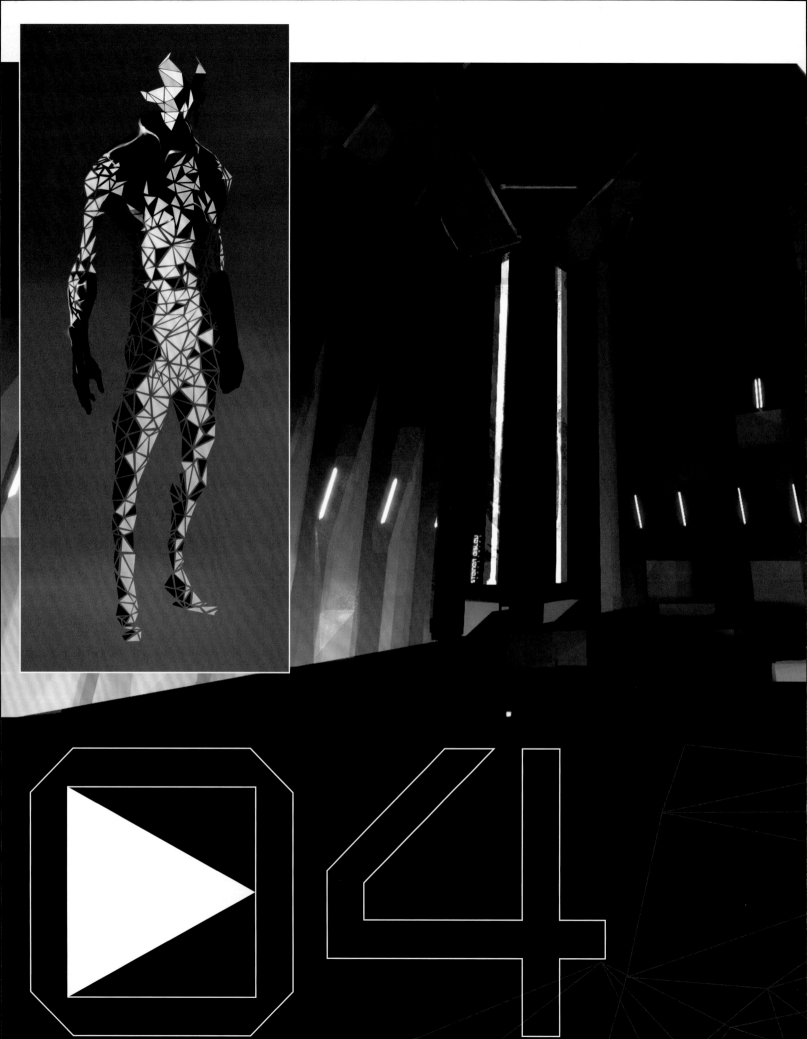

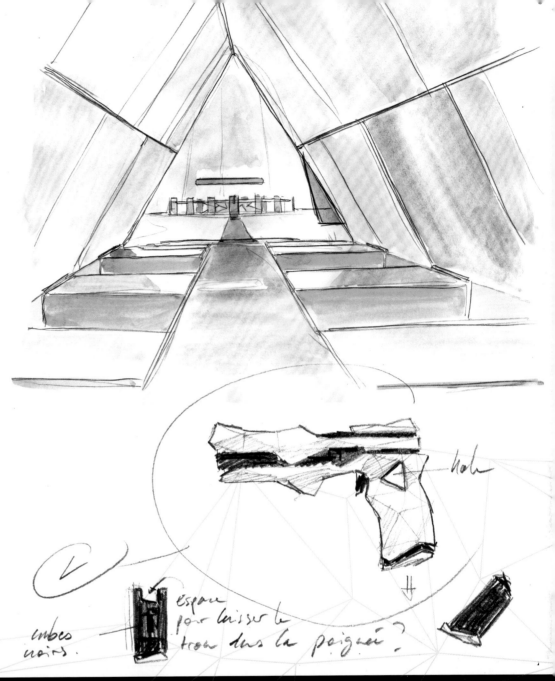

DEUS EX: MANKIND DIVIDED
BREACH

"BREACH TAKES PLACE IN THE virtual world of *Deus Ex: Mankind Divided*," explains Breach concept artist Matthieu Gallais. "While cyberspace has been explored many times throughout the history of the entertainment industry, it was an interesting exercise for us to figure out how our version could separate itself from the rest. One challenge was that we had to ensure that it followed the same design rules and sensibilities as *Deus Ex* whilst still offering something new. We also avoided some of the more common VR representations, done by putting more emphasis on the physicality of the world of Breach, while still strictly adhering to the rules we had created for it."

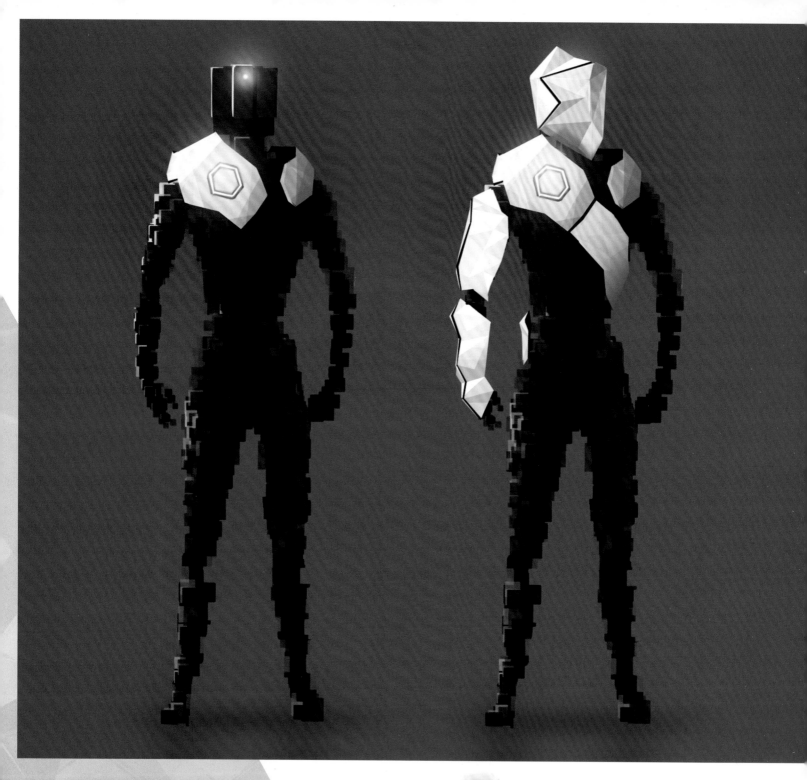

CHARACTERS

With the world of *Deus Ex* already markedly strange, to suggest something beyond this in terms of cyber fantasy needed something extra special. The above avatars are striking examples of the concept team's efforts to lock down the virtual reality motif, in distinctly *Deus Ex*-style presentation. In the broadest sense, they are 'dummies', similar to those used by the military for bayonet practice. Matthieu Gallais details their design origins: "One of the main design rules for the Breach universe was to ensure the world was made of two main components: white triangles and black cubes, which stood true for both the environments and characters alike. It drove their look, but also their structural logic. Once the rules were set, everything fell into place in a logical manner."

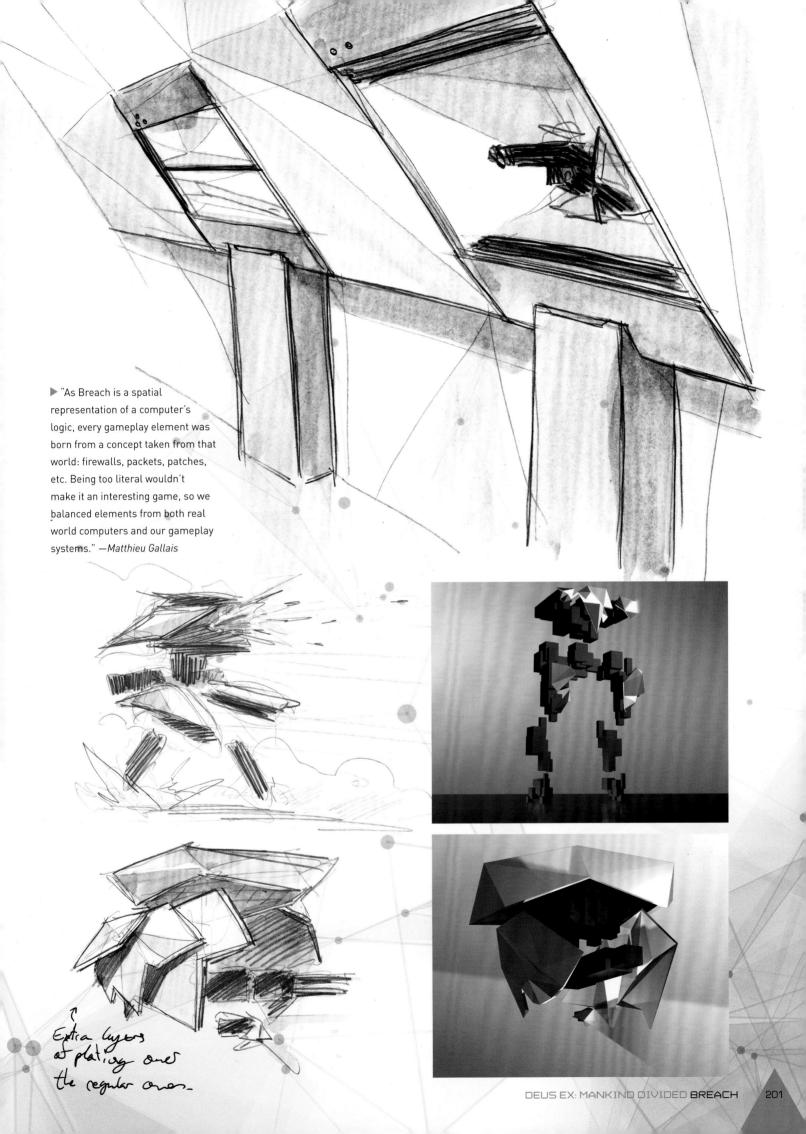

▶ "As Breach is a spatial representation of a computer's logic, every gameplay element was born from a concept taken from that world: firewalls, packets, patches, etc. Being too literal wouldn't make it an interesting game, so we balanced elements from both real world computers and our gameplay systems." —*Matthieu Gallais*

Extra layers
of plating over
the regular ones.

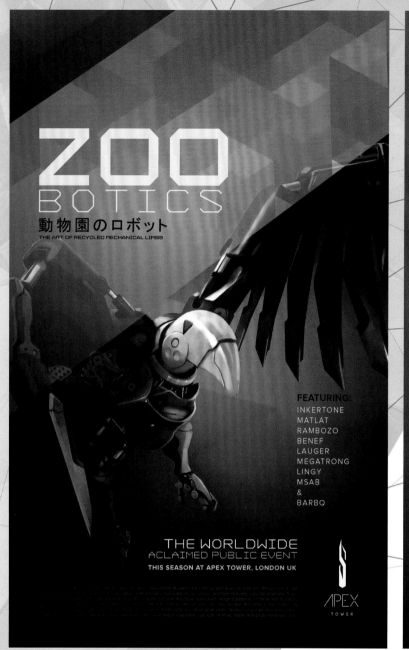

ZOO
BOTICS

動物園のロボット
THE ART OF RECYCLED MECHANICAL LIMBS

FEATURING:
INKERTONE
MATLAT
RAMBOZO
BENEF
LAUGER
MEGATRONG
LINGY
MSAB
&
BARBQ

THE WORLDWIDE
ACLAIMED PUBLIC EVENT
THIS SEASON AT APEX TOWER, LONDON UK

APEX
TOWER

ZOO
BOTICS

動物園のロボット
THE ART OF RECYCLED MECHANICAL LIMBS

APEX

TOWER

Lorem ipsum dolor sit amet, class nisl quis, fusce hendrerit suspen aenean augue hendrerit mus, est aenean porta, posuimus quam ut praesent pellentesque sagittis, vitae placerat tortor orci posuere, do licitudin. In consectetuer varius nibh praesent egestas nisl eractr tu

FEATURING:

INKERTONE
MATLAT
RAMBOZO
BENEF
LAUGER
MEGATRONG
LINGY
MSAB
&
BARBQ

ORLDWIDE ACLAIMED PUBLIC EVENT

THIS SEASON AT APEX TOWER, LONDON UK

nisl ultricies, eget id vel purus fringilla. Posuere purus odio pede erat. Sociis vestibulum placerat luctus rutrum, erat ultricies vehicula proin morbi, ut arcu, sed bibendum wisi sed amet amet felis. Turpis a quisque est, integer dui eget sit nisl fames nam. A integer erat Neque amet, nonummy ipsam eu libero, bibendum eu distinctie etiam eu sed, nec purus, nec eros volutpat. Ante aenean, amet adipiscing pede quam etiam. Vehicula arcu amet dolor arcu ornare, nulla vestibulum magna, vitae vitae mauris, consequat in libero elementum vitae tortor, bibendum sit lectus. Donec felis ipsam metus nec, ut ac sol rk at. Ut vehicula sit donec ut, et gravida id facilisi aliquam. Orci eleifend sed mattis diam per accumsan. Orci phasellus nec dui imperdi mauris, imperdiet praesent arcu, vel sapien mollis vel fusce molestie

GAME ADVERTS

OUR EVERYDAY LIVES WITHIN our own heavily commercialized world are mirrored by the products that humans and Augs alike are compelled to buy in the *Deus Ex* universe. Such things speak to what's considered most important by society, placing values on beauty and the personal lifestyle freedoms we aspire to. This week's must-see movies are billed alongside health products, interspersed with propaganda from the body politic—all with an augmented tint. Paying closer attention to the messages being broadcast, in grand ways or more underground, shows the overwhelming corporate culture that dominates Adam Jensen's world.

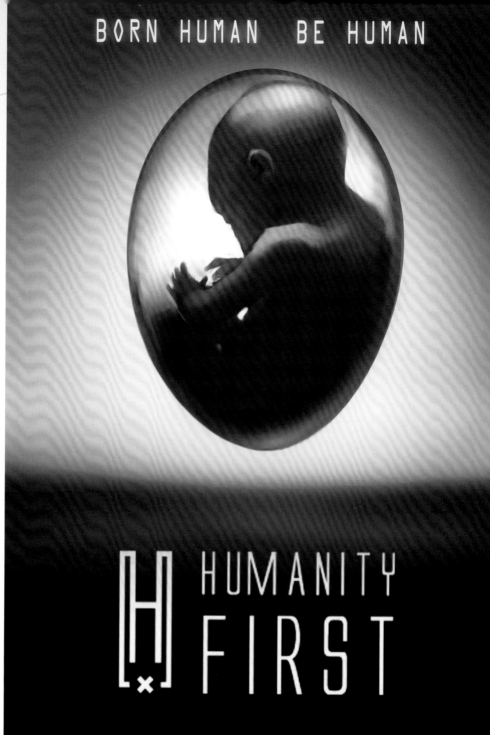

BORN HUMAN BE HUMAN

POLITICAL MESSAGING

Across these pages are a selection of in-game advertisements that point to the hopes and fears of humanity in the *Deus Ex* universe. Each side of the transhumanism debate pushes its intentions strongly. The entertainment world shamelessly embraces these opposing themes, finding not-too subtle ways of feeding off emotions—from 'enemy within' style Aug thrillers to Aug championship fighting leagues. Similarly, the highly politicized pro- and anti-Aug movements can be instantly discredited by a simple scrawled message. There are signs of revolution everywhere you look in *Deus Ex*, showcasing a world on the cusp of the future.

HUMANITY FIRST

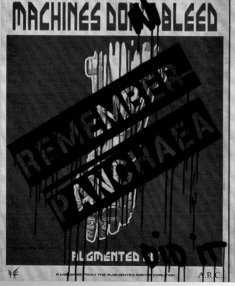

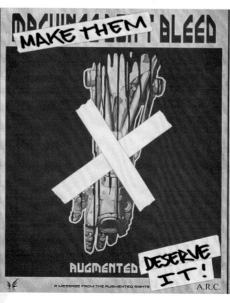

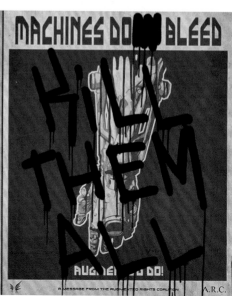

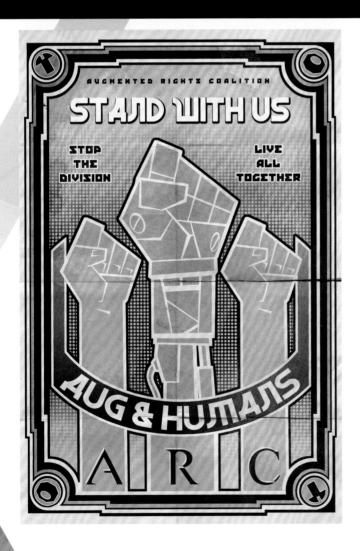

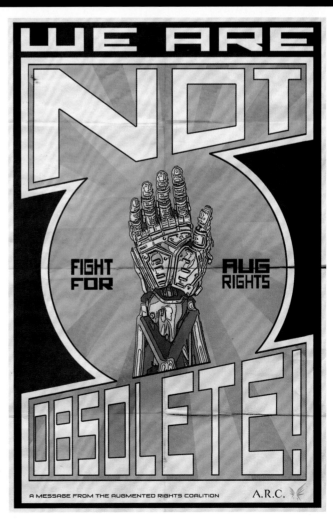

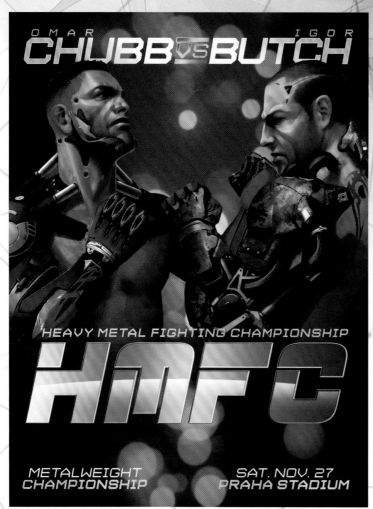

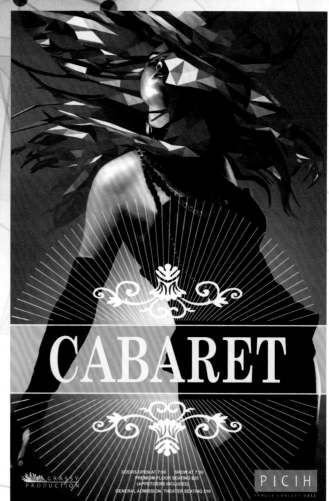

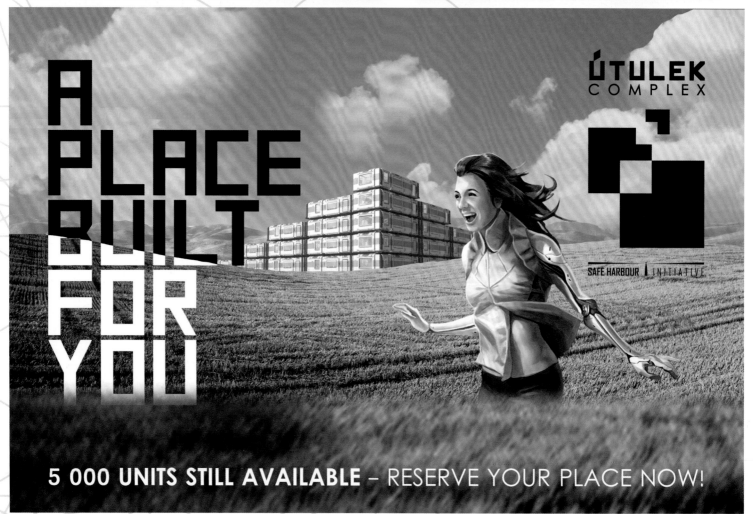

THE ART OF DEUS EX UNIVERSE™

SCAN

M△NKIND DIVIDED™

ART TEAM

JONATHAN JACQUES-BELLETÊTE | EXECUTIVE ART DIRECTOR

MARTIN DUBEAU | ART DIRECTOR

DOMINIQUE DEMERS | ASSOCIATE ART DIRECTOR

BENOIT PERREAULT | PRESENTATION DIRECTOR

ALP ALLEN ALTINER | ADDITIONAL ASSISTANT ART DIRECTOR

BRUNO GAUTHIER LEBLANC | CONCEPT ARTIST

FRÉDÉRIC BENNETT | CONCEPT ARTIST

MATHIEU LATOUR-DUHAIME | CONCEPT ARTIST

MARTIN SABRAN | CONCEPT ARTIST

TRONG-KIM NGUYEN | CONCEPT ARTIST

YUN LING | CONCEPT ARTIST

MICHEL CHASSAGNE | CONCEPT ARTIST

HERVÉ GROUSSIN | CONCEPT ARTIST

NICOLAS LIZOTTE | CONCEPT ARTIST

LOUIS AUGER | UI ARTIST

GABRIEL VAN DE WALLE | ADDITIONAL CONCEPT ARTIST

NICOLAS FRANCOEUR | ADDITIONAL CONCEPT ARTIST

MACIEJ KUCIARA | ADDITIONAL CONCEPT ARTIST

NIVANH CHANTHARA | ADDITIONAL CONCEPT ARTIST

THOMAS PRINGLE | ADDITIONAL CONCEPT ARTIST

BRAND MARKETING TEAM

ANDRE VU | EXECUTIVE BRAND DIRECTOR

RODNEY LELU | BRAND MANAGER

PAUL GORDON | MARKETING COORDINATOR

JOHN TSOUPANARIAS | WEB CONTENT MANAGER

DEUS EX
UNIVERSE™
DEUSEX.COM

eidos
MONTRÉAL

SQUARE ENIX